清代宫廷生活

清代宮廷生活

主編：萬依・王樹卿・陸燕貞　商務印書館（香港）有限公司出版

DAILY
LIFE
IN
THE
FORBIDDEN
CITY

THE QING DYNASTY
1644 – 1912

CHIEF COMPILERS:

WAN YI
WANG SHUQING
LU YANZHEN

TRANSLATED BY ROSEMARY SCOTT
AND ERICA SHIPLEY

VIKING

VIKING

Penguin Books Ltd., Harmondsworth, Middlesex, England
Viking Penguin Inc., 40 West 23rd Street, New York, New York 10010, U.S.A.
Penguin Books Australia Ltd., Ringwood, Victoria, Australia
Penguin Books Canada Ltd., 2801 John Street, Markham, Ontario, Canada L3R 1B4
Penguin Books (N.Z.) Ltd., 182–190 Wairau Road, Auckland 10, New Zealand

First published in Chinese under the title Quin Dai Gong Ting Sheng Huo by
The Commercial Press, Ltd., 1985
This translation first published by Viking 1988

Chief Compiler: Wan Yi, Wang Shuqing and Lu Yanzheng
Executive Editor: Chan Man Hung and Kwan Pui Ching
Arts Editor: Wan Yat Sha
Photographer: Hu Chui
Designer: Yau Pik Shan

Typeset in Linotron Palatino by Wyvern Typesetting Ltd., Bristol
Printed in Hong Kong by C & C Joint Printing Co., (H.K.) Ltd.

British Library Cataloguing in Publication Data

Daily life in the forbidden city
 1. Forbidden city (Peking, China) —
Social life and customs
I. Yi, Wan II. Shuqing, Wang
III. Yanzheng, Lu
951' 15603 DS795.2

ISBN 0–670–81164–5

FOREWORD

The Forbidden City, which is now the Palace Museum, Beijing, was the Imperial Palace in both the Ming (AD 1368–1644) and Qing (AD 1644–1911) dynasties. It is a noteworthy example of traditional Chinese architecture as well as being the largest museum in the People's Republic of China, and it is renowned for its immense collection of historical relics and works of art. The architecture and art objects of the Forbidden City have already been introduced to readers in our publications *Palaces of the Forbidden City* (1982) and *Treasures of the Forbidden City* (1983).

As the Imperial Palace of the Ming and Qing dynasties, the Forbidden City was not merely the living-quarters of the imperial house but also the political centre of the empire. It was always regarded in former times as a place of solemnity and mystery, which was forbidden to the common people. After the overthrow of the Qing (the last imperial dynasty in Chinese history) in the revolution of 1911, the front section of the Forbidden City was converted into a museum of historical relics, while the rear section was still occupied by Puyi, the emperor who had abdicated. It was only in 1924, when the Nationalist Army invaded the palace, that the Qing imperial family finally left the Forbidden City where they had lived for 281 years. It is remarkable that, in spite of the frequent disturbances, the articles for daily use inside the palace, especially the relics of the Qing period, have to a large extent remained intact. On a worldwide basis such a body of material is very rare. The articles of the imperial household therefore constitute an important element in the Palace Museum, and are among the features which make it unique among the world's museums.

Using the museum's vast collection of articles for daily use, valuable relics and historical records, together with the existing palace buildings and their decoration, *Daily Life in the Forbidden City* endeavours to give a comprehensive and thorough account of life inside the Imperial Palace, ranging from the solemn, important aspects such as grand ceremonies, government administration and military activities, inspection tours and hunting trips, to the small details of daily life, dress, entertainment, customs and beliefs. Through an understanding of the court life of China's last imperial dynasty as presented in this book, the reader will be able to achieve a basic grasp of the workings of the more than two-thousand-year-old monarchic tradition in China, as well as the life of the imperial families.

The Qing emperors did not restrict their activities to the Forbidden City. Therefore the touring palaces and parks of the region around Beijing, and such places as Chengde (Jehol), Nanjing, Yangzhou, Wuxi, Suzhou, Hangzhou, and the relics of the Qing emperors' inspection tours south and hunting trips north are also presented in this book.

Daily Life in the Forbidden City is a large-size illustrated volume describing the life of the imperial house in all its aspects. A number of the historical relics presented here have never been published before, and it will be seen that the articles belonging to the Qing imperial house are not only items of considerable rarity and value, but also demonstrate craftsmanship of the highest quality.

At the turn of this century the Forbidden City in Beijing was still a heavily guarded Imperial Palace, inaccessible to the common people. In the 490 years from its beginnings in 1421 during the Ming dynasty to the end of the Qing in 1911, this restricted 720,000-square-metre area was the scene of real tragedies and comedies, in which a succession of emperors and dignitaries had a role to play, each coming onstage and stepping into the shoes of his predecessor. These people, playing their various parts, have vanished with the passing years, but their legacies – the imposing palaces with their sumptuous furniture, rare jewellery, elegant antiques and articles for daily use – are able even now to evoke vivid images of the past. From such remains as the square bricks that have been worn down by cloth-soled shoes, it is possible to imagine the overlapping footprints left by the members of the imperial house and descendants of noble families, generals and ministers, eunuchs and palace serving-maids, artisans and labourers.

Imperial records had always tried to keep a veil of secrecy over life in the Forbidden City, especially the lives of the Qing emperors, empresses and imperial concubines, and thus have added much to the aura of mystery. Numerous unofficial histories, novels, plays and films about those lives have been produced since the Revolution of 1911, but many of these owed more to the imagination of their authors than to factual information. Works of literature such as these, while they may be appreciated for their own merits, are nevertheless no substitute for accurate historical research. It is incumbent upon our museum staff and historians to furnish accurate historical information for the reader. Anyone interested in Chinese history will surely appreciate being informed about the solemn and extremely elaborate ceremonies of the palace; the way the emperors, occupied with a myriad of state affairs, conducted the administration of the empire; the arrangements made for the daily lives of the emperors and their consorts; the cultural activities of the emperors; the customs and beliefs observed by the imperial house, and other aspects of life at court.

While there are voluminous annals of the major historical events of the Qing dynasty, records of life in the Forbidden City in that period are very scarce. Detailed historical studies of the subject are also lacking, and so it is only possible to obtain glimpses of life in the Qing palace through the meticulous observation of the relics contained therein and from the scanty descriptions that are available in the written records. For instance, from the list of names of persons responsible for the making of astronomical instruments for the Qing court, which was compiled in the palace, we know that the Belgian missionary, Ferdinand Verbiest, was involved in making some of those instruments. A low table in the palace, inscribed all over with mathematical data, reveals that Emperor Kang Xi was a keen student of mathematics. A study of the musical instruments made during the reigns of the various Qing emperors indicates a disparity in the interest shown in the subject between, for instance, the Emperors Kang Xi and Qian Long. From the series of auspicious words written by the Emperor Qian Long each year on New Year's Day, we can see that in the early years his calligraphy was not of a very high standard but that with practice he made progress in that art over the next few years. Historical records provide us with a major source of information regarding life in the Forbidden City of the Qing dynasty, as do the many scroll paintings in the collection of the Palace Museum. Although, for example, official documents of the Qing court give no explicit description of the interment of Emperor Shun Zhi, we can gather by reading between the lines of the historical records such as *A Compendium of Qing State Regulations* (*Qing Hui Dian Shi Li*) and *A Comprehensive Study of Qing Historical Documents* (*Qing Chao Wenxian Tong Kao*) that after his death, Emperor Shun Zhi was cremated before his ashes were buried in an underground palace. In like manner, we know from an imperial edict issued by Emperor Qian Long forbidding the Manchus to continue the practice of cremation that cremation was a traditional custom of the Manchu people. According to a wealth of data in the Qing archives, Empress Dowager Ci Xi planned to erect decorative arches along the route from the Summer Palace (Yiheyuan) to the West Flowery Gate to celebrate her sixtieth birthday. However, it is noted in documentary records and also in the diary of Weng Tonghe, that just before her sixtieth birthday Ci Xi lived not in the Forbidden City but in Zhongnanhai. It is also recorded that due to the set-backs China suffered on land and at sea in her war against Japan, the empress dowager had to give orders to stop preparations for her birthday celebrations, and in the event decorative arches were put up only along a section of North Chang'an Boulevard. All these examples show that we cannot be sure of accuracy regarding the details of life in the Forbidden City of the Qing dynasty unless conscientious research is undertaken.

This volume provides access to many things denied visitors to the Palace Museum. It contains not only photographs of an abundance of palace relics that have not previously been published, but also special photographs of the palace (sometimes involving all-night vigils to get a particularly difficult shot) intended to bring the historical atmosphere to life. In addition, the photographer travelled thousands of miles in search of any traces of Emperors' Kang Xi and Qian Long's tours of inspection in the south and their hunting expeditions in the north, many of his pictures taken in extremely difficult conditions.

This book is a bold venture: with its wide-ranging subjects and the huge amount of work involved, it could not have been completed by the three chief compilers without the collaboration of many of their colleagues in the Research Department, Relics Maintenance Office, Exhibition Department, Exhibits Preservation Office, Library and Forbidden City Press of the Palace Museum. Thanks are also due to Liu Beisi of the Forbidden City Press, and to Deputy Editor-in-Chief Chan Man Hung, Chief Designer Yao Pik Shan, Art Editor Wan Yat Sha and Assistant Editor Kwan Pui Ching of the Hong Kong Branch of the Commercial Press Ltd., for their repeated guidance and suggestions. Hu Chui, the photographer, took all the art photographs; while Liu Lu, formerly researcher of the Palace History Division of the Research Department and now Director of the Editorial Affairs Office of the Forbidden City Press, wrote much of the text and supervised the photographing of the imperial tours of inspection and hunting expeditions. Liu Lu also wrote the texts for the chapters on military affairs, inspection tours and entertainment, the external affairs section of the chapter on government administration and the sacrifices section of the chapter on the offering of sacrifices. Vice-Director Ji Hongzhang of the Research Department was responsible for the co-ordination of the photographic work, with the help of Liu Zhigang and Guo Yuhai. It is only fair to say therefore that this volume is the result of a collective effort.

Wan Yi
Wang Shuqing
Lu Yanzheng

EDITORS' NOTE

As readers will see from the Genealogical Table, Chinese emperors are usually referred to not by their personal names, but by a name given to their reign period. An emperor should properly, therefore, be called (for instance) 'the Kang Xi Emperor'. However, the editors felt that this might lead to confusion among western readers and so the less formally correct, but more commonly employed, form, 'Emperor Kang Xi' has been adopted.

The pinyin system has been used for transliterating Han Chinese personal and place names. Conventional forms have been used for Manchu and other minority names where no minority pinyin forms are available.

Rosemary Scott
Erica Shipley

ROSEMARY SCOTT graduated in Art and Archaeology of China from the School of Oriental and African Studies, University of London, where she went on to do research into early Chinese lacquer. Thereafter she was Deputy Keeper at the Burrell Collection, Glasgow, with curatorial responsibility for the Oriental material. She is currently Curator of the Percival David Foundation of Chinese Art, University of London. She has visited China on a number of occasions as a lecturer and researcher.

ERICA SHIPLEY graduated in Chinese at the School of Oriental and African Studies in London. For a number of years she worked at the Permanent Committee on Geographical Names for British Official Use, specializing in Chinese place names, and was a member of the United Nations Group of Experts on Geographical Names. She has visited China.

CONTENTS

THE GENEALOGY OF THE QING HOUSE

The Qing dynasty began with the reign of Emperor Shun Zhi, or Aisin-Gioro Fulin, and ended with Emperor Xuan Tong, or Aisin–Gioro Puyi; it was ruled by ten emperors for a total of 268 years.

公元 | 1610 | 1630 | 1650 | 1670 | 1690 | 1710 | 1730 | 1750 |

Title of Reign | Tian Ming | Tian Cong | Chong De | Shun Zi | Kang Xi | Yong Zheng | Qian Long |

太祖
名：努爾哈赤
（1559-1626）
后：孝慈高
皇后
陵名：福陵

Tai Zu
Name: Nurhachi
(1559–1626)
Empress:
 Xiao Ci Gao
Name of tomb:
 Fuling

太宗
名：皇太極
（1592-1643）
后：孝端文皇后
　孝莊文皇后
陵名：昭陵

Tai Zong
Name: Abahai
(1592–1643)
Empresses:
 Xiao Duan Wen
 Xiao Zhuang Wen
Name of tomb:
 Zhaoling

世祖
名：福臨
（1638-1661）
后：孝惠章皇后
　孝康章皇后
　孝獻章皇后
陵名：孝陵

Shi Zu
Name: Fulin
(1638–61)
Empresses:
 Xiao Hui Zhang
 Xiao Kang Zhang
 Xiao Xian Zhang
Name of tomb:
 Xiaoling

聖祖
名：玄燁（1654-1722）
后：孝誠仁皇后
　孝昭仁皇后
　孝懿仁皇后
　孝恭仁皇后
陵名：景陵

Sheng Zu
Name: Xuanye
(1654–1722)
Empresses:
 Xiao Cheng Ren
 Xiao Zhao Ren
 Xiao Yi Ren
 Xiao Gong Ren
Name of tomb:
 Jingling

世宗
名：胤禛
（1678-1735）
后：孝敬憲皇后
　孝聖憲皇后
陵名：泰陵

Shi Zong
Name: Yinzhen
(1678–1735)
Empresses:
 Xiao Jing Xian
 Xiao Sheng Xian
Name of tomb:
 Tailing

1770 1790 1810 1830 1850 1870 1890 1910

Jia Qing Dao Guang Xian Feng Tong Zhi Guang Xu Xuan Tong

(1-1799)
后
后

仁宗

名：顒琰 (1760-1820)
后：孝淑睿皇后
　　孝和睿皇后
陵名：昌陵

宣宗

名：旻寧 (1782-1850)
后：孝穆成皇后
　　孝慎成皇后
　　孝全成皇后
　　孝靜成皇后
陵名：慕陵

文宗

名：奕詝
　　(1831-1861)
后：孝德顯
　　皇后
　　孝貞顯
　　皇后
　　孝欽顯
　　皇后
陵名：定陵

穆宗

名：載淳
　　(1856-1874)
后：孝哲毅皇后
陵名：惠陵

德宗

名：載湉 (1871-1908)
后：孝定景皇后
陵名：崇陵

遜帝

名：溥儀
　　(1906-1967)
后：婉容
葬 北京八寶山公墓

Gao Zong
Name: Hongli
(1711–99)

Ren Zong
Name: Yongyan
(1760–1820)

Xuan Zong
Name: Minning
(1782–1850)

Wen Zong
Name: Yizhu
(1831–61)

De Zong
Name: Zaitian
(1871–1908)

Xun Di
Name: Puyi
(1906–67)

resses:
ao Xian Chun
ao Yi Chun
e of tomb:
ıling

Empresses:
　Xiao Shu Rui
　Xiao He Rui
Name of tomb:
　Changling

Empresses:
　Xiao Mu Cheng
　Xiao Shen Cheng
　Xiao Quan Cheng
　Xiao Jing Cheng
Name of tomb:
　Muling

Empresses:
　Xiao De Xian
　Xiao Zhen Xian
　Xiao Qin Xian
Name of tomb:
　Dingling

Empress:
　Xiao Ding Jing
Name of tomb:
　Chongling

Empress:
　Wan Rong
Buried in
　Babaoshan Cemetery,
　Beijing

Mu Zong
Name: Zaichun
(1856–74)
Empress:
　Xiao Zhe Yi
Name of tomb:
　Huiling

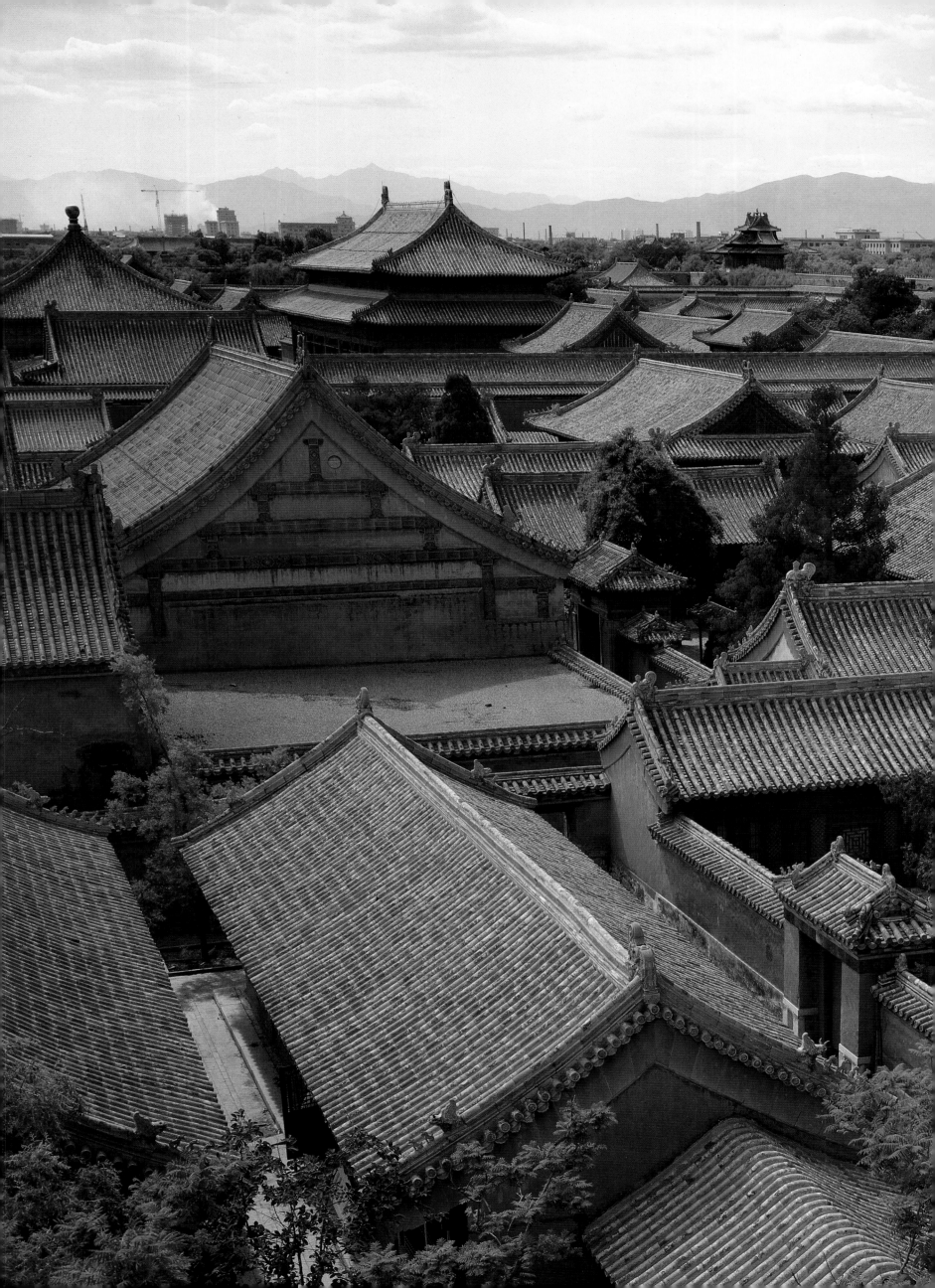

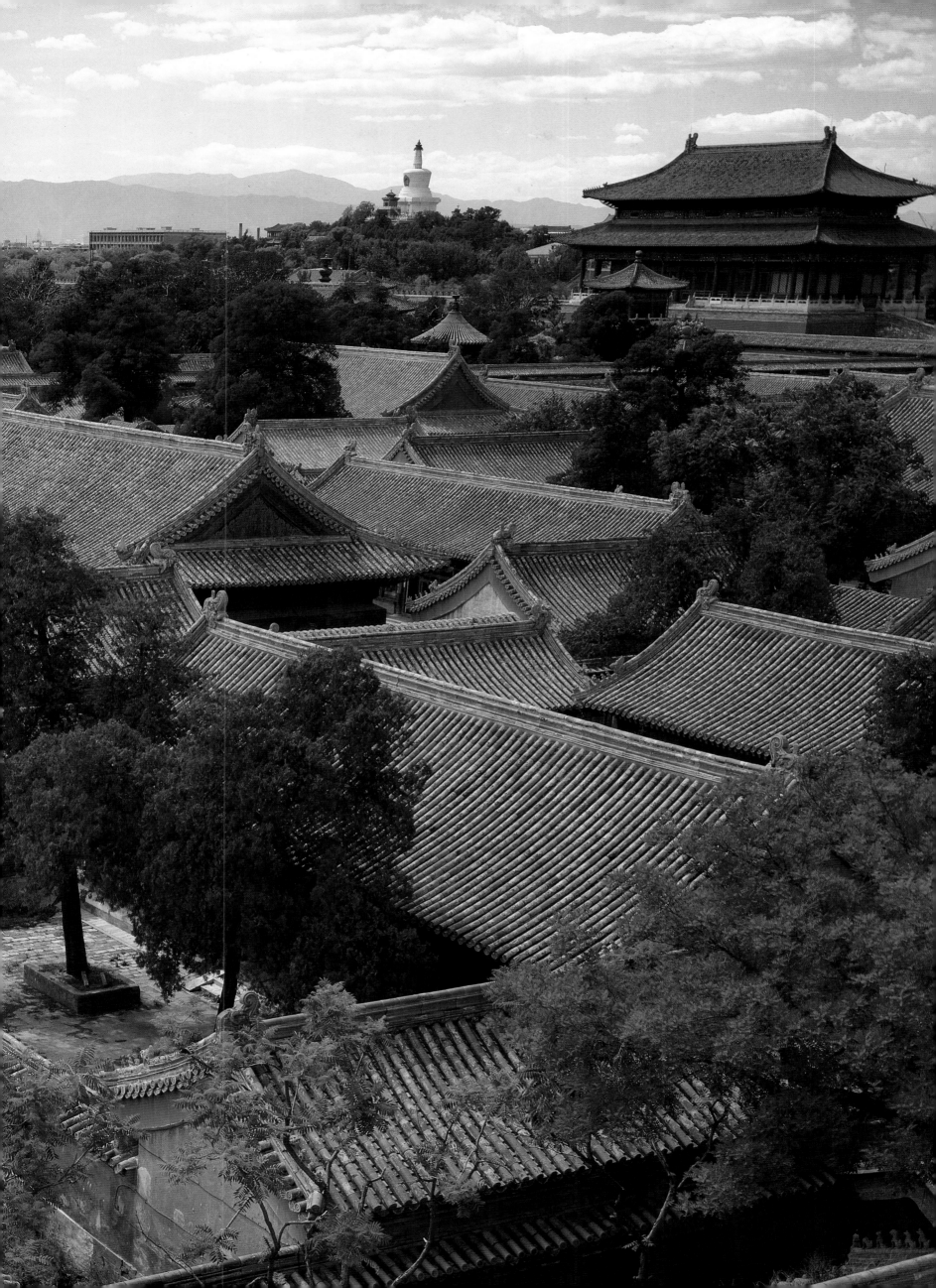

典禮編

RITES
AND
CEREMONIES

Rites and ceremonies played a significant part in life within the palaces of the Qing dynasty, and many important events were marked by magnificent ceremonies. Although today the word *dianli* is understood simply as 'grand ceremony', the meaning in former times was somewhat different. In ancient literature *dianli* was sometimes shortened to either *dian* or *li* and both these not only had the implication of ceremonies, rites and etiquette, but also touched upon social ethics, codes of practice and institutions. Taking this latter interpretation, Confucius saw the proper observance of *li* (rites) as being fundamental to the stability of the nation as a whole. Despite the change in emphasis that the term had undergone since the time of Confucius, the Qing dynasty, nevertheless, basically inherited the old traditional concept of *li*. Indeed, the rites and ceremonies described in the *Regulations of the Qing State* (*Qing Hui Dian*) are in essence the same as the 'Five Rites', covering all aspects of state ritual, recorded in the *Rites of the Zhou Dynasty* (*Zhou Li*) and adopted by successive dynasties.

The most important of all the palace ceremonies was that held when a new emperor ascended the throne, marking the end of the old reign and the transference of power into the hands of a new ruler. Ten of these ascension ceremonies took place after the Manchu dynasty made Beijing its capital and in two cases the circumstances were somewhat unusual.

One of these special cases was the enthronement of the child-emperor, Aisin-Gioro Fulin, which took place in the Forbidden City in Beijing on the first day of the tenth lunar month in the year designated the first year of the reign of Shun Zhi (A D 1644). This enthronement was unusual in that Fulin had already ascended the throne in the imperial palace in Shenyang on the twenty-sixth day of the eighth month of the previous year, following the death of his father Abahai (Huangtaiji). However, after the Manchus had crossed the Great Wall and taken Beijing as their national capital, another enthronement ceremony was conducted. This took place at the Gate of Imperial Supremacy (later renamed the Gate of Supreme Harmony) rather than in the Hall of Imperial Supremacy (later renamed the Hall of Supreme Harmony). The Hall of Imperial Supremacy had been reduced to ruins during the war and, since Dorgon, the Prince of Rui, and his vanguard units had only been in Beijing for five months, it had not been possible to repair it in time for the enthronement ceremony.

At the beginning of the ceremony Fulin took his place on the improvised throne while the princes, dukes and other nobles stood on the north side of the Golden River Bridge and the high-ranking civil and military officials stood on the south side. After these dignitaries had presented, on bended knee, their congratulatory memorials, which were read out by the Grand Secretaries, they then executed the elaborate ritual of prostration (three prostrations and nine kowtows) before the emperor. The ceremony was then at an end. Subsequent enthronements were much more protracted affairs.

The other unusual accession ceremony was that of the Emperor Jia Qing, who was personally placed on the throne by his father, Qian Long. This ceremony was termed the 'Give and Take Ceremony'; and while it was very impressive it had a festive air that would have been out of place in a normal enthronement ceremony, for on each of the other eight occasions the new emperor succeeded to the throne while the Imperial Palace was still in mourning for his predecessor.

Even the other eight accessions, all less unusual, did not take place each under precisely the same conditions. Early in the morning of the day of the ascension ceremony, while each of the gates to the Forbidden City was guarded by imperial foot-soldiers, members of the Grand Secretariat, together with officials of the Board of Rites and the Department of Protocol, set a *bao'an* (a long, narrow table on which the imperial seal was placed) in the centre of the Hall of Supreme Harmony, to the south of the throne. South of the east chamber of the hall was a table stacked high with congratulatory memorials from the high-ranking officials. North of the east chamber was a table on which the imperial accession edict was placed. In the west chamber of the hall was another table for writing materials, and a yellow table stood in the middle of the open space at the top of the flight of stairs outside the hall. Officers of the Imperial Guard of Honour positioned the *lubu* in front of the Hall of Supreme Harmony and in the courtyard below. While initially the *lubu* might have served as the emperor's bodyguard, as time went on it became merely a symbol of imperial authority.

In the Qing dynasty the emperor's *lubu* was constituted in accordance with one of four categories depending upon the occasion. It was the *fa jia lubu* that was used for the ascension ceremony, and on such an occasion the Imperial Way from the Hall of Supreme Harmony to the Gate of Heavenly Peace was lined on either side with the numerous members of the Imperial Guard of Honour and the palace musicians. An atmosphere of great dignity prevailed, and for this ceremony the role of the *lubu* was simply to symbolize that dignity and solemnity.

The Zhongheshaoyue musicians were positioned under the east and west eaves of the Hall of Supreme Harmony. Zhongheshaoyue music was a type of ancient court music known as the 'Eight Tones', for it employed instruments (see illustrations) made of eight materials: metal, stone, silk, bamboo, gourds, pottery, leather and wood. There were in all sixteen different types of instrument and the whole orchestra ran to more than sixty pieces. In addition, there were four singers. This music was played at court audiences, imperial weddings and royal banquets, as well as on the occasions when the emperor accepted congratulations, issued edicts and mounted or left the throne. It was also played when the empress or empress dowager accepted congratulations in the Inner Court and mounted or left the throne.

At the ascension ceremony the Danbidayue musicians were stationed under the east and west eaves inside the Gate of Supreme Harmony. This orchestra used large drums, *fangxiang* (a set of iron slabs struck by iron mallets), various types of gongs, flutes, pipes, smaller drums and clappers – twenty pieces in all. There were no singers required for this music which was usually played when the civil and military officials and other dignitaries kowtowed to the emperor. Outside the Meridian Gate were more musicians who played to greet the officials entering the palace. Also outside the Meridian Gate was the Dragon Pavilion, for housing imperial edicts, and the Incense Pavilion, for incense-burners.

The enthronement of Hongli, who became the Emperor Qian Long, took place in the Hall of Supreme Harmony in the ninth lunar month of the thirteenth year of the reign of the Emperor Yong Zheng (1735). Yong Zheng had died in the Garden of Perfection and Brightness (Yuanmingyuan) on the twenty-third day of the eighth lunar month of the thirteenth year of his reign. That same day, his coffin was taken to the Forbidden City and placed in the Palace of Heavenly Purity. In that palace his successor, Hongli, designated the Upper Study in the south wing as his own 'mourning room', while Hongli's mother, Niuhuru, High Consort Xi (thereafter honoured as empress dowager), kept vigil in the Eastern Warm Chamber.

On the third day of the ninth lunar month, when all the preparations for the ceremony had been completed, the President of the Board of Rites invited the new emperor to ascend the throne. Dressed in his white mourning-garments, Hongli first went up to the coffin of the deceased emperor to inform him of his own imminent accession and to execute the elaborate ritual of prostrations in the presence of his dead predecessor. Hongli then went into a side hall and changed into the imperial ceremonial robes. The empress dowager also returned to her palace to change into ceremonial attire before mounting her throne to receive the greetings of her son.

By this time a screen had been hung over the main doorway of the Palace of Heavenly Purity, to indicate that mourning for the deceased emperor was temporarily suspended. Hongli therefore came out of the left gate of the Palace of Heavenly Purity, seated himself in the gold sedan-chair and, with his ministers, the 'leopard-tail troop' and guards, he set off. He dismounted at the Hall of Preserving Harmony and took his seat in the Hall of Complete Harmony to accept the greetings of the various officials, after which each official took his place according to his rank. Then the President of the Board of Rites announced that the Emperor was about to be enthroned and, accompanied by his entourage, Hongli left for the Hall of Supreme Harmony. Here he formally ascended the throne as the new emperor, amid the chiming of bells and the beating of drums by the musicians at the Meridian Gate. According to the strict

rules of protocol the Zhongheshaoyue musicians should have played at this point, but they refrained from doing so out of respect for the deceased emperor; their presence was on this occasion purely symbolic.

Below the steps of the Hall of Supreme Harmony the ceremonial whips were cracked three times and the ministers, at the instigation of the master of ceremonies, executed the elaborate ritual of prostrations. According to protocol the Danbidayue musicians should have played when the officials prostrated themselves and the congratulatory memorials should have been read out, but again, court mourning precluded this.

The final part of the ascension ceremony was the announcement of the new emperor's administrative programmes, the granting of an amnesty and the issuing of an imperial edict to show that the emperor was the true 'Son of Heaven', who ruled the nation under heaven and conducted the affairs of state in accordance with the will of heaven and his ancestors. This ceremony of issuing edicts was a solemn and impressive affair. First the Grand Secretary entered the hall by the left door, took the edict from the table in the north of the east chamber and put it on the long, narrow *bao'an* table. After a member of the Grand Secretariat had stamped it with the imperial seal, the Grand Secretary handed the edict to the President of the Board of Rites. He gave it to one of his subordinates who placed it on a wooden tray decorated with cloud designs. This official, accompanied by a member of the Imperial Guard of Honour, who held a yellow canopy, went out through the Gate of Supreme Harmony. The ceremonial whips were cracked again and the Emperor Qian Long returned to his palace. The civil and military officials then went out through the Gate of Luminous Virtue and the Gate of Correct Conduct on either side of the Gate of Supreme Harmony and escorted the edict out through the Meridian Gate. The edict was then placed in the Dragon Pavilion before being carried up to the tower of the Gate of Heavenly Peace, where it was proclaimed aloud. In the Hall of Sedateness the emperor changed back into his mourning robes and returned to his 'mourning room'. The Grand Secretary and other officials carried the imperial seal back to its proper place. The other seven ascension ceremonies were conducted along similar lines. During the Qing dynasty the enthronement of a new emperor normally took place one month after the death of his predecessor.

In addition to the ascension and 'Give and Take' ceremonies, other grand court occasions included the ceremonies when a child-emperor came of age and took over the reins of government; when an empress dowager started to 'hold court from behind the screen' (as in the late Qing period); when a grand empress dowager or empress dowager was honoured with a laudatory or posthumous title; and the one occasion when an emperor was honoured with a laudatory title – conferred on Nurhachi before crossing the Great Wall.

Empresses dowager were quite frequently honoured with laudatory titles, and this involved a rather impressive ceremony, as when the Emperor Shun Zhi so honoured his mother. This took place in the eighth year of his reign (1651), when he came of age and took up the reins of government. The ceremony was divided into three parts.

Firstly, on the ninth day of the second lunar month, the day before the ceremony of presenting the title of honour was to take place, a document giving the details was presented as a memorial to the throne. On that day the empress dowager's insignia, the Zhongheshaoyue musicians and the Danbidayue musicians were positioned in front of her palace. Meanwhile, the Grand Secretary in court dress placed the memorial on a table in the Hall of Complete Harmony. After the Emperor Shun Zhi had personally read the memorial, the Grand Secretary placed it in front of the empress dowager's palace. Presently the Emperor Shun Zhi was conveyed to the doors of her palace in his sedan-chair, and there he waited until the empress dowager, dressed in ceremonial robes, entered the palace. As she did so the Zhongheshaoyue orchestra began playing. When she had seated herself on her throne the music ceased. The emperor then went down on his knees and presented the memorial to the empress dowager, and this was accepted on her behalf by the Grand Secretary, also on his knees. An official then read out the memorial. The

Danbidayue orchestra began playing while the emperor executed the elaborate ritual of prostrations. When he had finished the music stopped, but began again as the empress dowager came down from her throne. She officially took the memorial and this part of the ceremony was complete.

The second part took place on the tenth day of the second lunar month, when the empress dowager was formally honoured with the title 'Empress Dowager Zhao Sheng Ci Shou' ('Empress Dowager of Brightness, Holiness, Kindness and Longevity') and a gold book and gold seal were presented to her. Once again the insignia and the orchestras were positioned in front of her palace. The *fa jia lubu* was deployed in front of the Hall of Supreme Harmony, the Gate of Supreme Harmony and the Meridian Gate. After he had examined the gold book and seal in the Hall of Supreme Harmony the Emperor Shun Zhi, accompanied by princes and officials, proceeded to his mother's palace where he respectfully presented the book and seal to her, in a ceremony similar to the previous one.

The final part of the ceremony took place on the eleventh day of the second lunar month, when the emperor graced the Hall of Supreme Harmony with his presence. The princes and officials presented him with memorials and went through the ceremony of official congratulations. An edict recording the whole event was then proclaimed. It was only at this point that the entire procedure was deemed to be complete.

Besides the ceremonies described above, other large court functions were also held in the Hall of Supreme Harmony, such as the New Year's Day celebration, the Imperial Birthday celebration and the Winter Solstice Prayers to Heaven. These were known as the Three Major Festivals. In addition there were three regular audiences with the emperor on the fifth, fifteenth and twenty-fifth day of each lunar month, when officials paid their respects to the emperor or thanked him for favours bestowed upon them, but they did not report matters to him. On each of these occasions (which were termed *dianli*) the emperor came to the Hall of Supreme Harmony to accept the obeisances of his ministers, and the ceremonial procedures were similar to those at ascension ceremonies. If for some reason the emperor failed to appear in the Hall of Supreme Harmony or was not in his palace on the days of regular audience, the princes and dukes would remain outside the Gate of Supreme Harmony while the civil and military officials remained outside the Meridian Gate in two rows – one to the east and one to the west. After the protocol officials had noted their presence, the princes and dukes left by the Meridian Gate, to be followed by the civil and military officials.

Ceremonies for the Three Major Festivals were also held separately in the Inner Court of the empress and empress dowager. The procedures on these occasions were similar to those observed when an empress dowager was honoured with a laudatory title. On the birthday of an empress, she would first lead the imperial consorts and concubines in kneeling and bowing to the empress dowager and the emperor before going to the Hall of Union to accept congratulations.

The empress's insignia would have already been deployed to the right and left of the hall, with the Zongheshaoyue musicians beneath the eaves of the Hall of Union and the Danbidayue musicians beneath the eaves at the rear of the Palace of Heavenly Purity. The ceremony began with the empress, in ceremonial robes, mounting the throne in the Hall of Union while Zhongheshaoyue music was played. When the music ceased, the palace eunuchs led in the imperial concubines of all ranks as well as the princesses, the first wives of the aristocracy and the wives of ministers who had royal titles bestowed upon them. While Danbidayue music was played, they all prostrated themselves before the empress. When the prostrations had been performed, this music ceased and the empress left the throne, accompanied by music from the Zhongheshaoyue orchestra. The empress then returned to her palace where she was greeted by her sons and grandsons, who also prostrated themselves before her. Meanwhile, the palace eunuchs, led by the chief eunuch, kowtowed below the east and west steps leading to the empress's throne. This particular birthday ceremony was the prerogative of the empress alone.

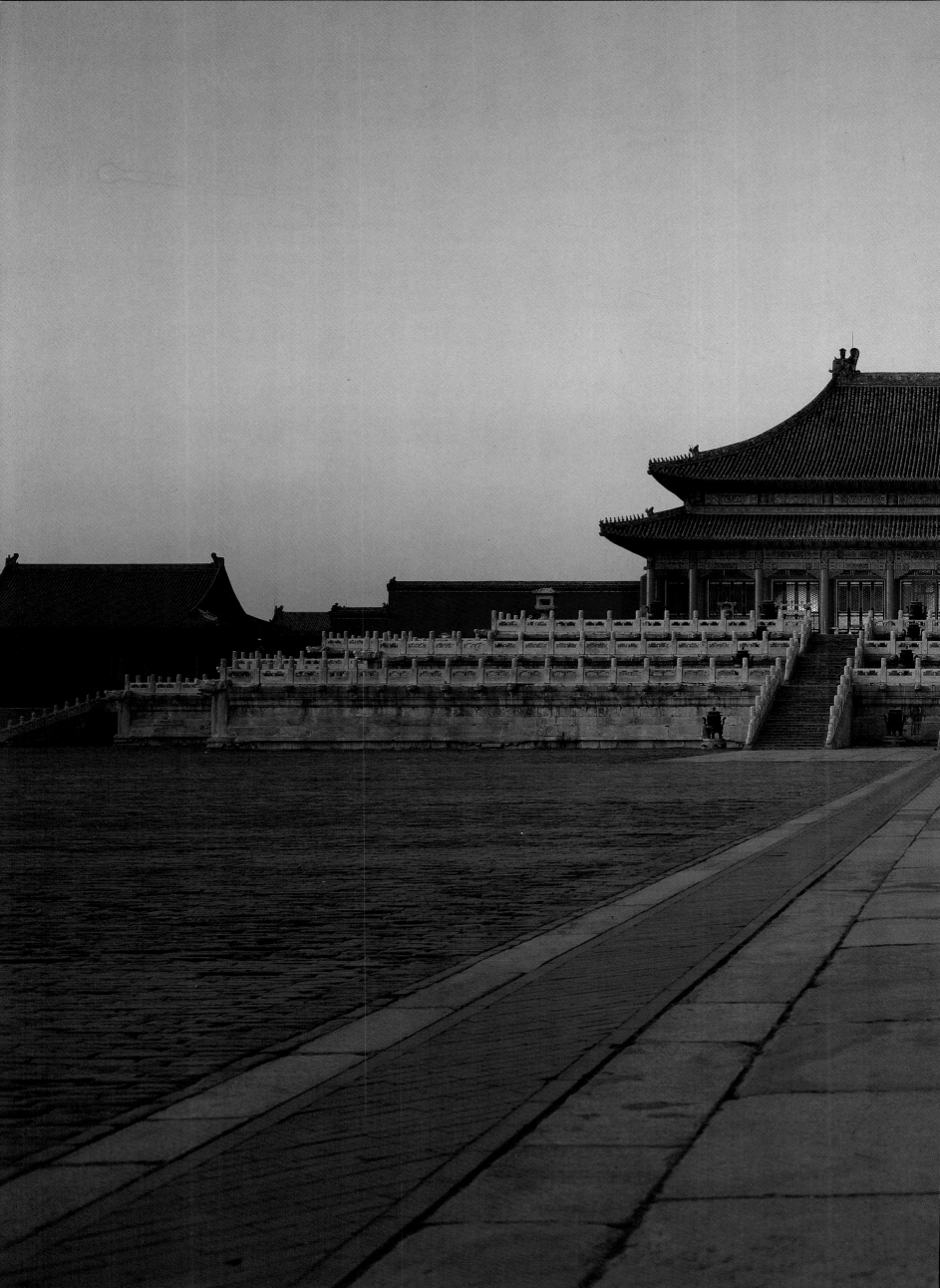

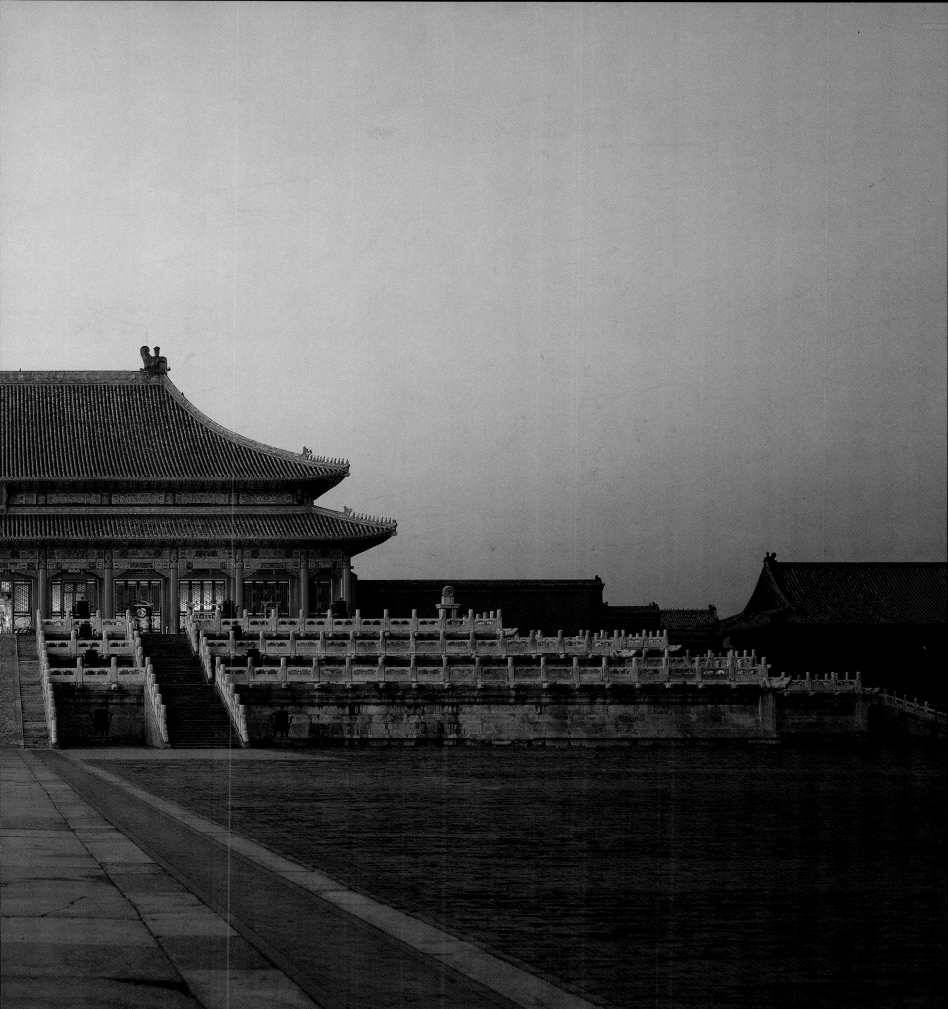

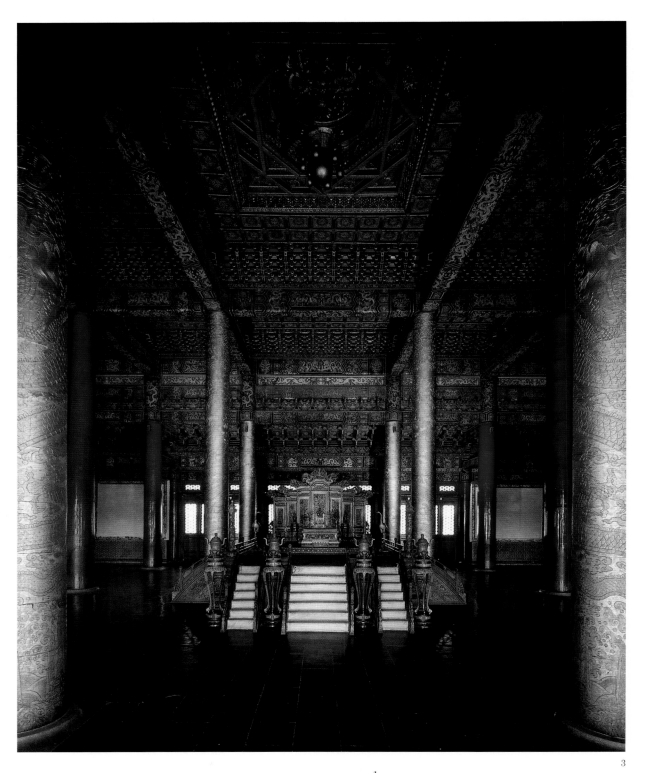

3

1. The rear palaces of the Forbidden City, looking towards the Beihai lake.

2. The Hall of Supreme Harmony.

Popularly known as the Throne Hall, this is the largest and the highest of all the palace buildings in the Forbidden City. The emperor would grace the hall with his presence each year on the Three Major Festivals – New Year's Day, the Imperial Birthday and the Winter Solstice – and also when he ascended the throne, granted regular audiences, gave a banquet, appointed a general to command an expedition, announced the results of the *dianshi* (the final imperial examination presided over by the emperor) and received newly appointed officials. Major ceremonies were usually held at dawn. On such occasions candles were lit inside and outside the hall, and sandalwood, pine, cypress and other aromatic woods were burned in the tripod censers and tortoise- and crane-shaped incense-burners in the hall, and on and below the dais. Bells chimed and drums were beaten at the Meridian Gate and music was played beneath the eaves of the hall, emphasizing the solemn and mystical atmosphere of the ceremonies.

3. A view of the interior of the Hall of Supreme Harmony and the throne.

The throne and the screen behind it stand on a platform in the centre of the hall with seven steps leading up to it. It is completely gilded, and is the largest, most splendidly carved and elaborately decorated of all the emperor's thrones in the Forbidden City. Around the throne are elephants with precious flasks on their backs – symbols of peace; mythical creatures, signifying the virtue and wisdom of the monarch whose subjects will be virtuous in return; cranes, symbolic of longevity; and incense-burners. The six gilded columns flanking the throne are decorated with writhing dragons, as are the beams and crossbeams. The

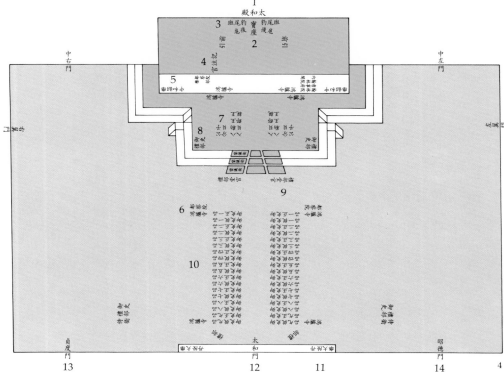

1 Hall of Supreme Harmony
2 The throne
3 'Leopard-tail troop'
4 record clerk
5 Zhongheshaoyue orchestra
6 Department of Protocol
7 relatives of emperor and noblemen
8 censor of Board of Rites
9 president and vice-president of Board of Rites
10 first rank to lower ninth rank censors
11 Danbidayue orchestra
12 Gate of Supreme Harmony
13 Gate of Correct Conduct
14 Gate of Luminous Virtue

4

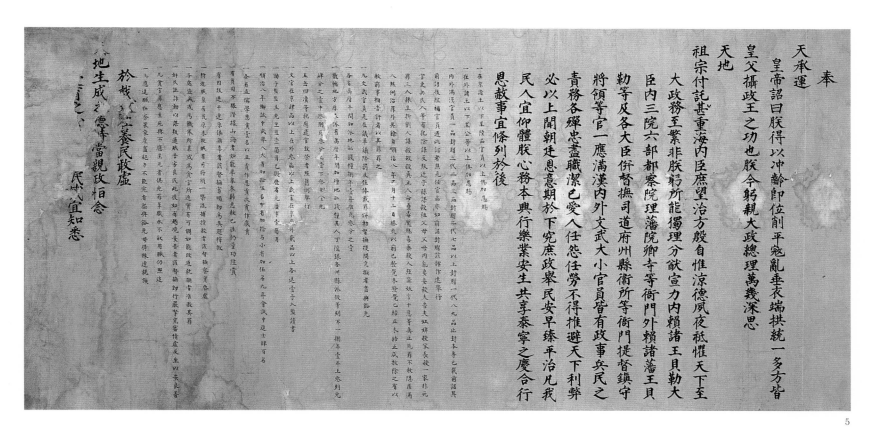

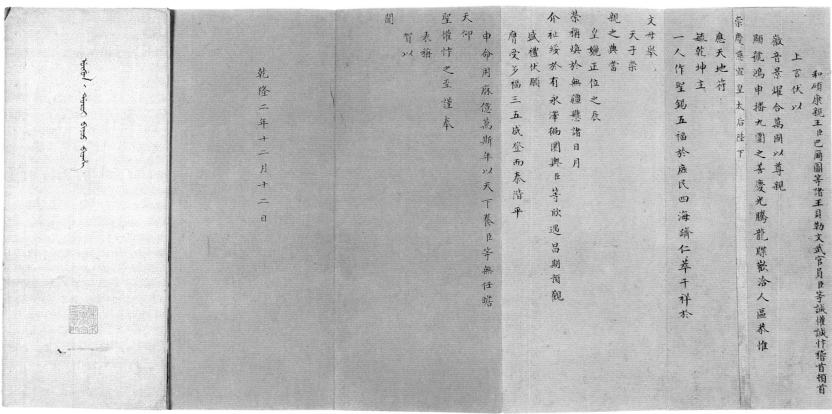

coffered, gilded ceiling high above the throne is decorated with coiled dragons with pearls in their mouths. These decorations added to the atmosphere of sumptuousness and awe which surrounded those who sat on the throne. After Shun Zhi, nine emperors ascended this throne, an act which symbolized their acquisition of power.

4. A diagram showing the position of officials at court functions.

The positioning of officials, on duty or paying their respects to the emperor, was decreed with strict regard to rank.

5. An edict issued by the Emperor Shun Zhi when he took control of the government of the empire.

Shun Zhi was six when he ascended the throne and his uncle, Dorgon, acted as prince regent. In 1651, in the eighth year of his reign, he issued an edict to all his subjects 'under heaven' indicating that he was personally taking over the reins of government. The main points of the edict were: to recall the 'achievements' of his predecessor; to announce, in modest terms, his ascension to the throne; to proclaim the adoption of the title of his reign; and to urge his civil and military offi-

cials of all ranks to be loyal so as to ensure the lasting rule of the Qing dynasty. The edict also included confirmation of official posts, tax cuts and pardons.

6. A congratulatory memorial.

On every festive occasion ministers were required to present congratulatory memorials to the emperor or empress dowager. These all conformed to a standard formula. A typical memorial might read as follows: 'I, such-and-such an official, sincerely rejoice and applaud, kowtowing and touching the ground with my head, at

such-and-such a festival or event. I present this memorial and congratulate the emperor and empress dowager.' This shows the congratulatory memorial jointly presented by Prince Kang and other princes, nobles and officials on the eleventh day of the twelfth lunar month of 1737 (the second year of Qian Long's reign), when Fucha was named empress, and the empress dowager was honoured with the title 'Empress Dowager Chong Qing Ci Xuan' ('Respectability, Felicity, Propriety and Kindness').

19

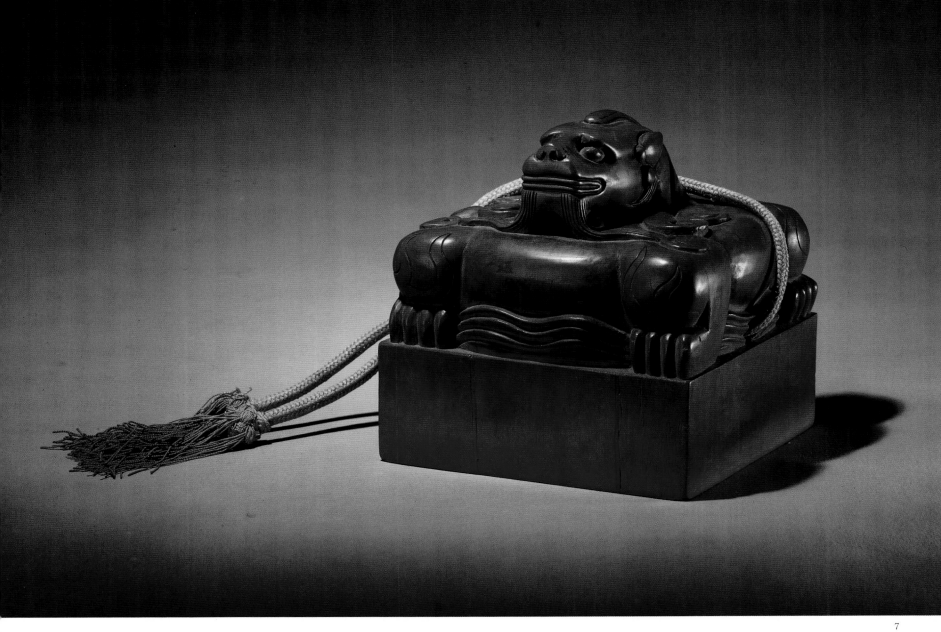

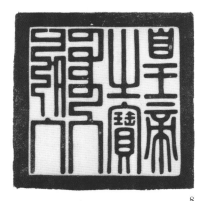

8

7. The emperor's official seal. (15.4 cm square)

In ancient times the seal was called a *xi*, but in Tang times the term *bao* began to be adopted, and was also used in Ming and Qing times. During the Qian Long period it was stipulated that the emperor had to have twenty-five seals. This sandalwood seal (one of the twenty-five) was used exclusively for imperial edicts.

8. An impression from the emperor's seal.

The left side is in Manchu script and the right in Han-Chinese.

9. A seal box. (41.6 cm high, 38.4 cm square)

The seal was kept in this box, which is wood outside and gold inside. It stood on a wooden table and was usually covered with yellow satin.

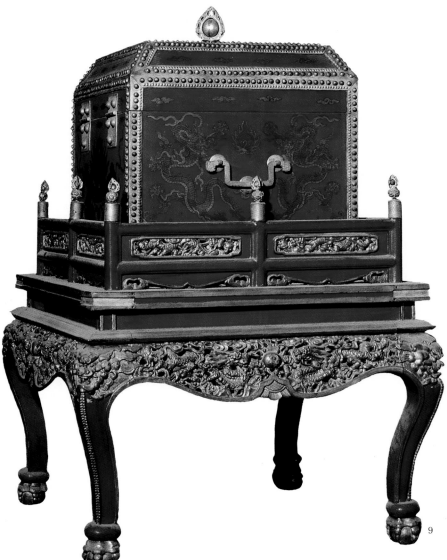

9

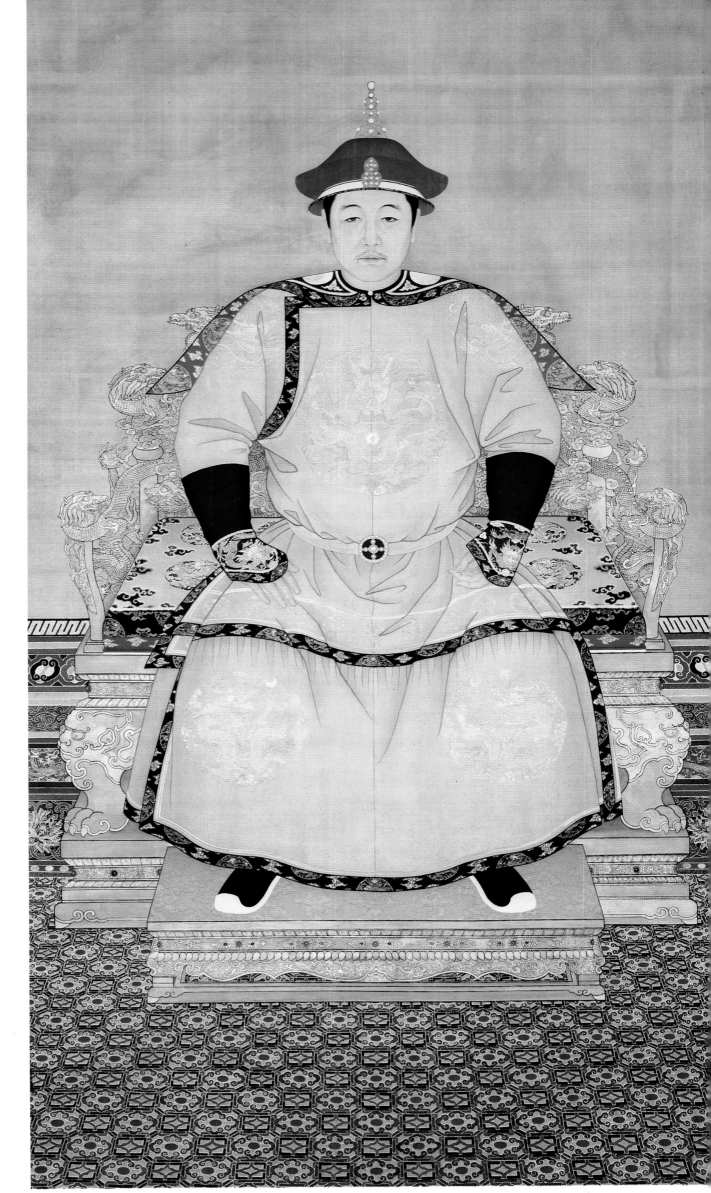

10. A portrait of Emperor Shun Zhi in court dress. (270.5 cm × 143 cm)

Emperor Shun Zhi (Fulin) was the first emperor of the Qing dynasty after the Manchu conquest of north China. He was born in the Palace of Lasting Happiness in Shenjing (now called Shenyang) in the third year of the Chong De period (1638). His mother was Borjigit (Consort Zhuang), who became the Empress Dowager Zhao Sheng. He was enthroned when he was six, took personal control of the government at fourteen and died at twenty-four (the eighteenth year of his reign) in the Hall of Mental Cultivation in the Forbidden City. Because of his youth when he ascended the throne, Dorgon took charge of state affairs as prince regent. However, after he took control, Shun Zhi handled the relations between the Manchus and the Han-Chinese well, and this helped to consolidate Qing rule south of the Great Wall in the early days of the dynasty.

Official portraits were painted of all the emperors and empresses in court dress. Some were painted during their lifetime, others produced posthumously. Records indicate that these portraits were frequently hung for worship after their deaths at the Hall of Imperial Longevity on Coal Hill, the Palace of Preserving Peace in the Garden of Perfection and Brightness or at other appropriate palaces.

11. The Hall of Tranquillity and Sincerity in the Summer Palace.

The Summer Palace, where the imperial family retreated to escape the heat of the summer in the Forbidden City, is situated in Chengde City, Hebei Province. It was built during the reign of the Emperor Kang Xi. Because Kang Xi, Qian Long, Jia Qing and other emperors were often in residence there during the summer and autumn, many important ceremonies were held in the Hall of Tranquillity and Sincerity during this period. The Emperor Qian Long frequently celebrated his birthday here on the thirteenth day of the eighth lunar month. Ceremonies were also often held in the Hall of Honesty and Open-mindedness in the Garden of Perfection and Brightness.

12. The interior of the Hall of Union.

Located between the Palace of Heavenly Purity and the Hall of Earthly Peace, the Hall of Union was where the empress accepted congratulations on festive occasions. Behind the throne and on either side of it were the boxes covered with yellow satin which contained the twenty-five imperial seals. On the west side of the hall was a large clock for sounding the night watches, and on the east side a large bronze clepsydra (water-clock).

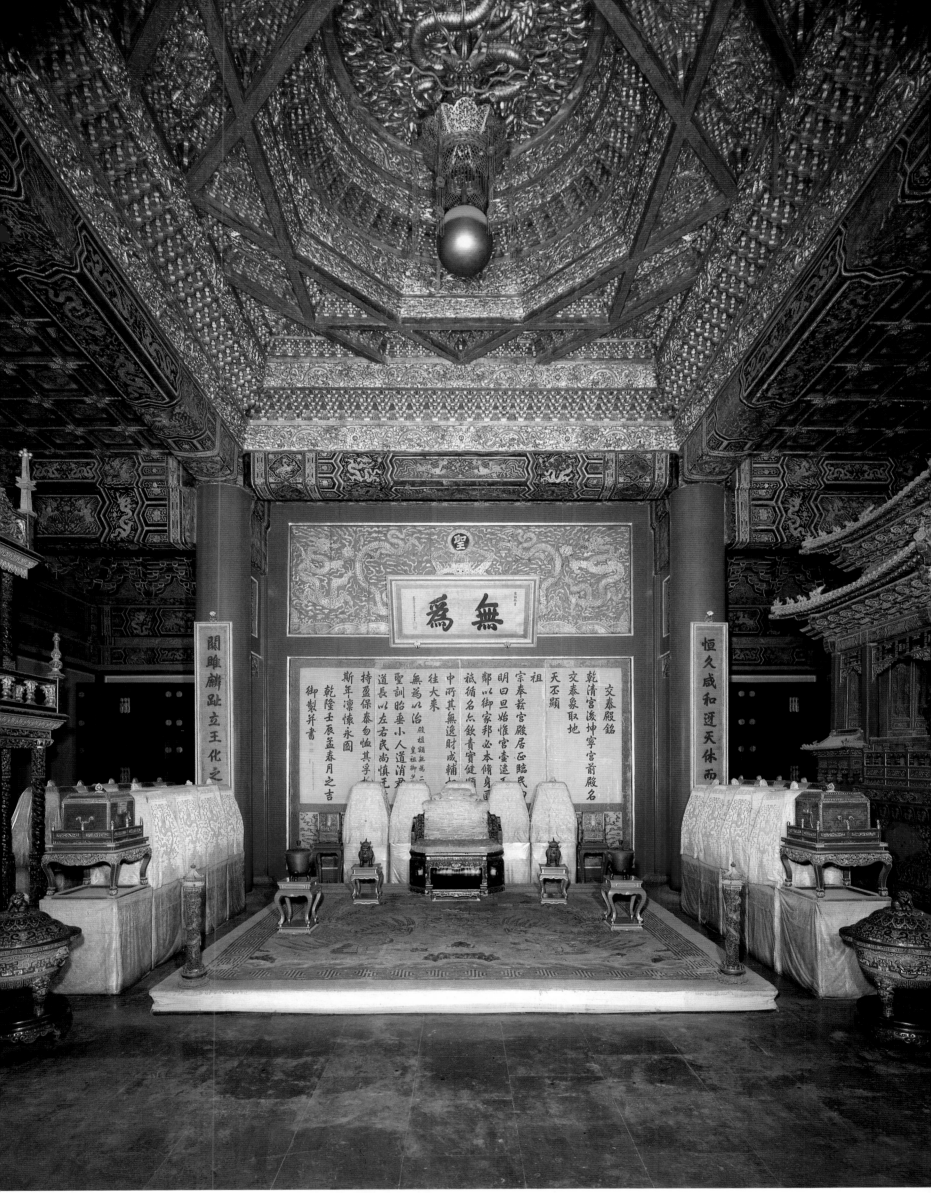

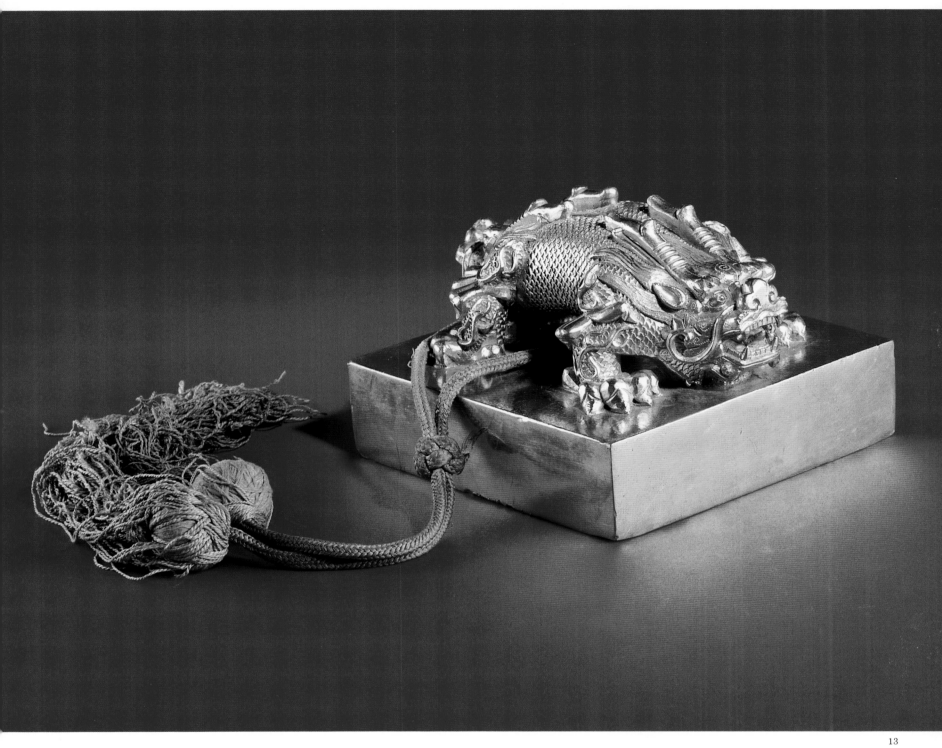

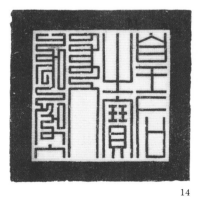

13. The empress's official seal. (14 cm square)

This gold seal, an identification token of the empress, weighs 1,800 g. When an empress was established she was issued with a gold seal and a gold book as a sign of her status.

14. Impression from the empress's seal.

The left side is in Manchu script and the right in Han-Chinese.

14

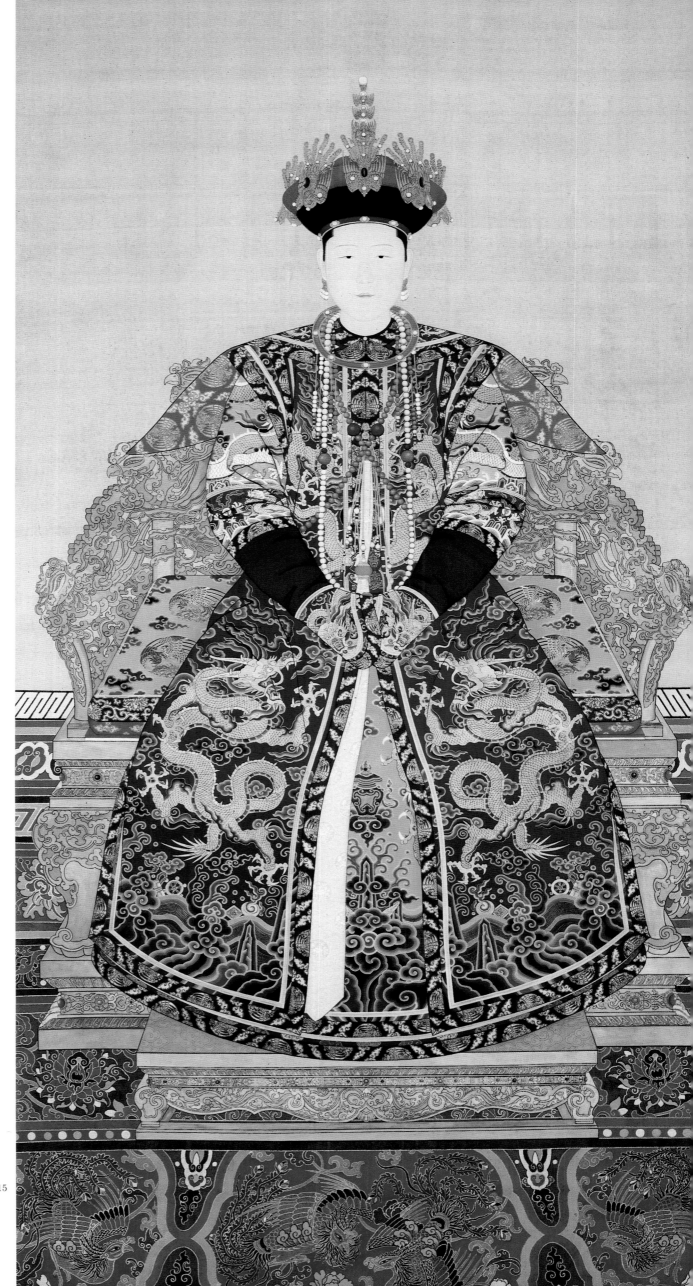

15. A portrait of the Empress Shun Zhi. (245.8 cm × 116.8 cm)

Empress Shun Zhi (Tunggiya) was Han-Chinese rather than Manchu. She first entered the Forbidden City as an imperial concubine and, at fifteen, gave birth to Xuanye (later Emperor Kang Xi). When the Emperor Shun Zhi died Xuanye was, at the age of eight, named heir apparent (at least in part because he was immune to smallpox). Tunggiya was thus honoured as empress dowager when she was only twenty-two. She died two years later and was given many posthumous titles, including Empress Xiao Kang Ci He Zhuang Yi Rong Wen Mu Duan Qing Chong Tian Yu Sheng Zhang, but she was usually known as Empress Xiao Kang Zhang.

16. A front view of the Gate of Benevolent Peace.

The Gate of Benevolent Peace is the main entrance to the Palace of Benevolent Peace, the latter being the place where the empress dowager held ceremonies. On the days of important festivals or on other happy occasions, such as honouring the empress dowager with a laudatory title, or imperial weddings, the palace was permeated with an atmosphere of festivity. On such occasions, the emperor, the empress and the imperial concubines would come here to pay their respects to the empress dowager. Only the ceremonies held in honour of the emperor were more impressive than these.

17. The inscription over the Gate of Benevolent Peace.

Han-Chinese script on the left, Manchu on the right.

18. A portrait of Empress Xiao Zhuang Wen in ordinary dress. (255.5 cm × 262 cm)

Empress Xiao Zhuang Wen was later known as Empress Dowager Zhao Sheng. Her Mongolian name was Borjigit and she was born in the forty-first year of the reign of the Ming dynasty emperor Wan Li (1613). She was honoured as the empress dowager in the first year of the Shun Zhi period (1644) and grand empress dowager in the first year of the Kang Xi period (1662). She died in the twenty-sixth year of the Kang Xi period (1687) at the age of seventy-five, having helped to attend to state affairs from 'behind the screen' while the Emperors Shun Zhi and later Kang Xi were still under age.

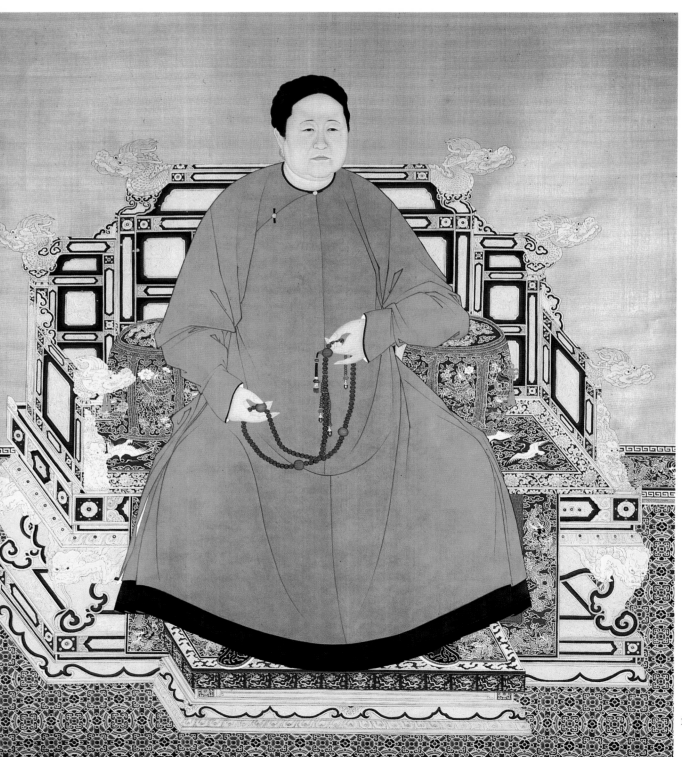

18

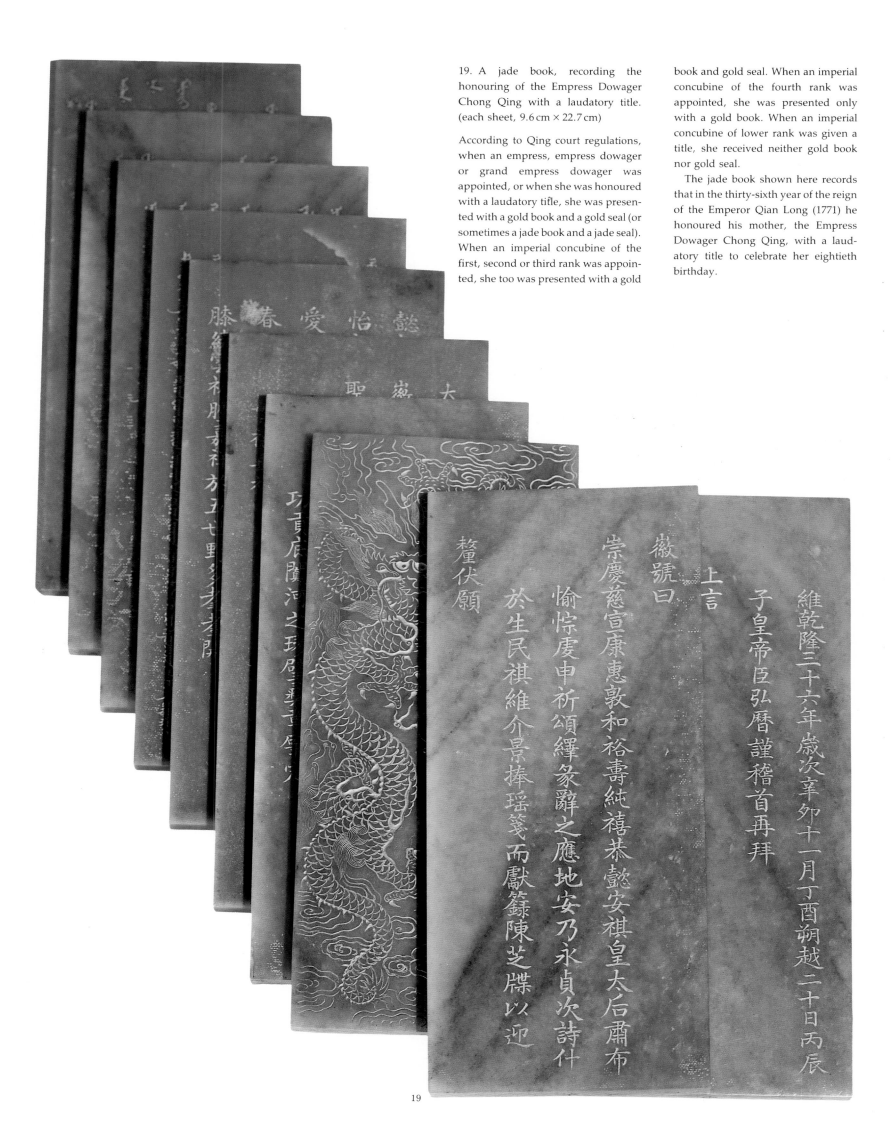

19. A jade book, recording the honouring of the Empress Dowager Chong Qing with a laudatory title. (each sheet, 9.6 cm × 22.7 cm)

According to Qing court regulations, when an empress, empress dowager or grand empress dowager was appointed, or when she was honoured with a laudatory tifle, she was presented with a gold book and a gold seal (or sometimes a jade book and a jade seal). When an imperial concubine of the first, second or third rank was appointed, she too was presented with a gold book and gold seal. When an imperial concubine of the fourth rank was appointed, she was presented only with a gold book. When an imperial concubine of lower rank was given a title, she received neither gold book nor gold seal.

The jade book shown here records that in the thirty-sixth year of the reign of the Emperor Qian Long (1771) he honoured his mother, the Empress Dowager Chong Qing, with a laudatory title to celebrate her eightieth birthday.

19

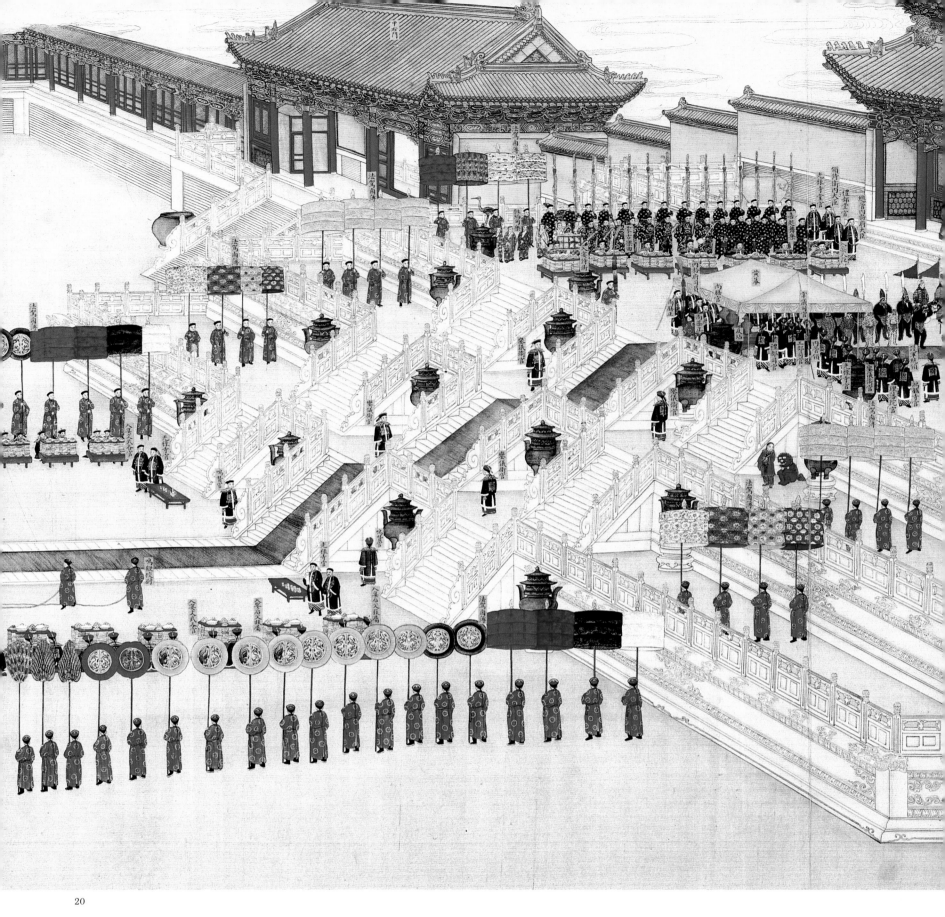

20

28

21

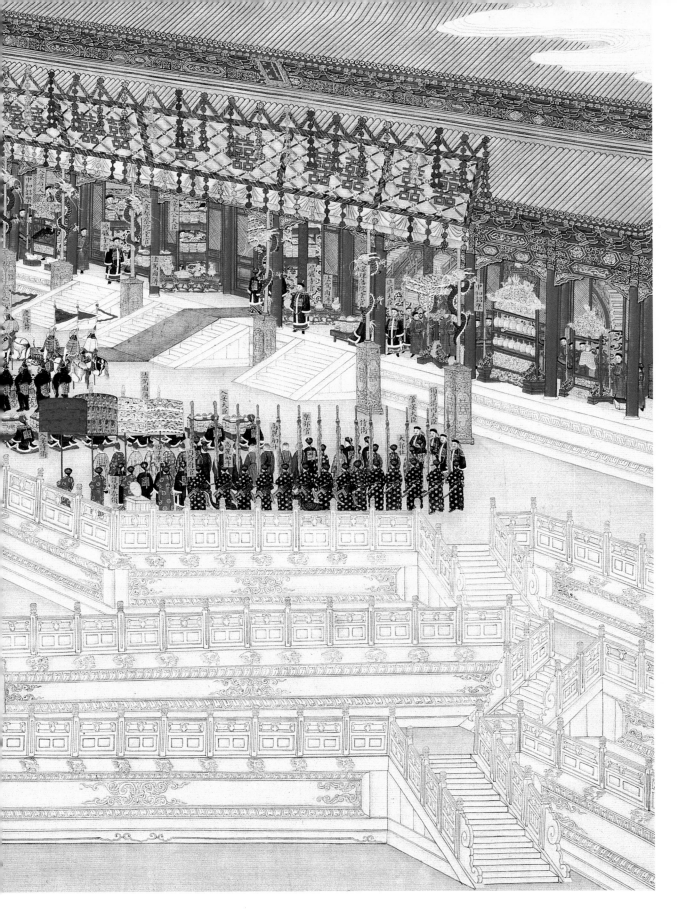

20. A painting of the imperial insignia (*lubu*) in front of the Hall of Supreme Harmony, taken from Emperor Guang Xu's album, *The Grand Imperial Wedding*.

The Grand Imperial Wedding is a full-sized pictorial album depicting the entire wedding of Emperor Guang Xu in the first lunar month of the fifteenth year of his reign (1889). The paintings were done by court-painters. This illustration shows a banquet in the Hall of Supreme Harmony. The *fa jia lubu* is arrayed in front of the hall in the manner customary for court functions and other ceremonies.

21. Part of the *fa jia lubu* shown in *The Grand Imperial Wedding* of the Emperor Guang Xu.

The items between the pillars are (from right): a portable censer, a dressing-case, a wash-basin and a water-bottle – all gold.

22. The 'Eight Gold Articles' of the emperor's insignia.

22

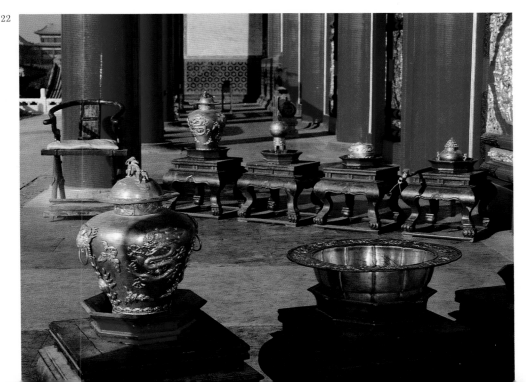

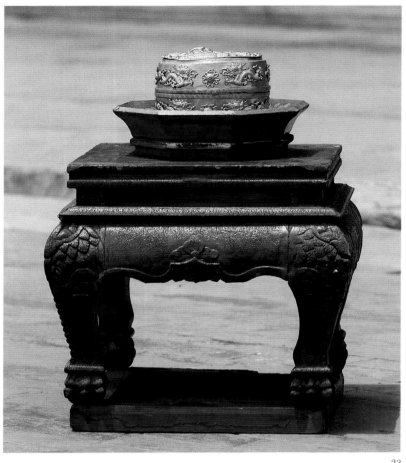

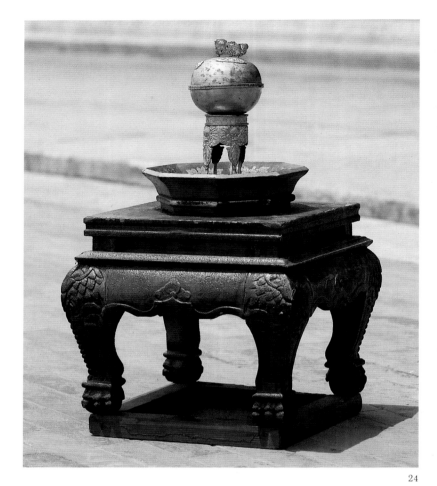

23

24

25

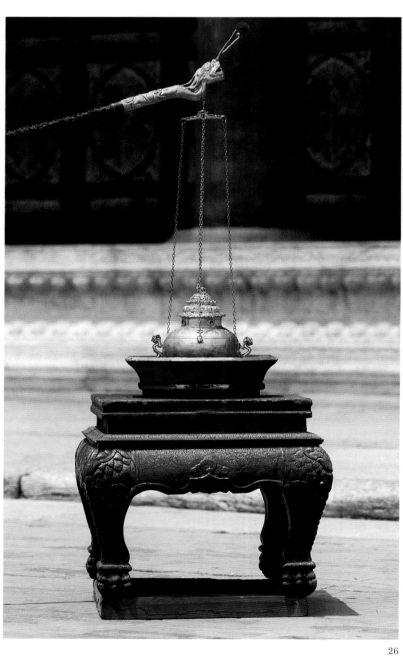

23. A gold dressing-case. (11.2 cm high, 20.16 cm in diameter)

24. A gold spittoon. (16 cm high, 4.8 cm in diameter)

25. A gilded stool. (48 cm high, 57.6 cm each side)

26

27

28

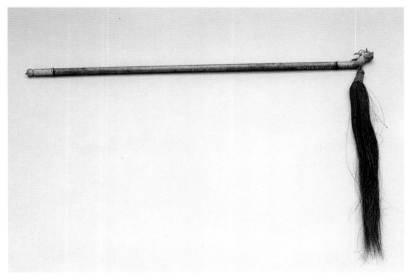

30

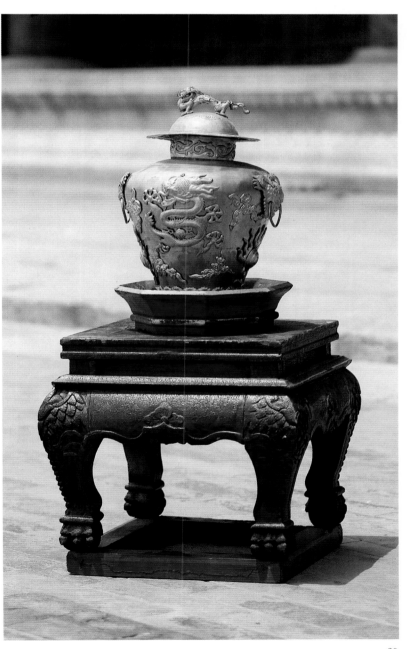

29

26. A portable gold censer.

The emperor's insignia included two portable censers, one spittoon, two water-bottles, two dressing-cases and one wash-basin, all made of gold. They were known as the 'Eight Gold Articles'. In addition, there were also a gilded whisk, a gilded stool and a gilded chair. Originally these were among the emperor's articles of daily use, but later they became part of his ceremonial insignia.

27. A gold wash-basin. (14.4 cm high, 48 cm in diameter)

28. A gilded chair. (93.44 cm × 70.4 cm)

29. A gold water-bottle. (50.2 cm high)

30. A gilded whisk. (length of hair, 64 cm, length of handle, 86.4 cm)

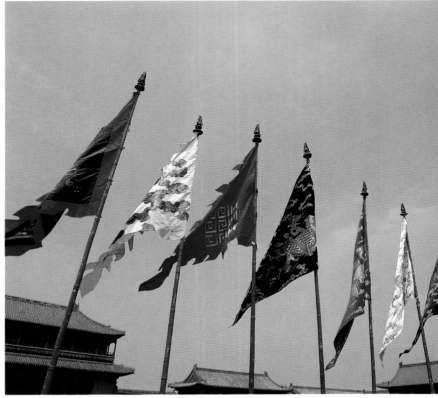

31

32

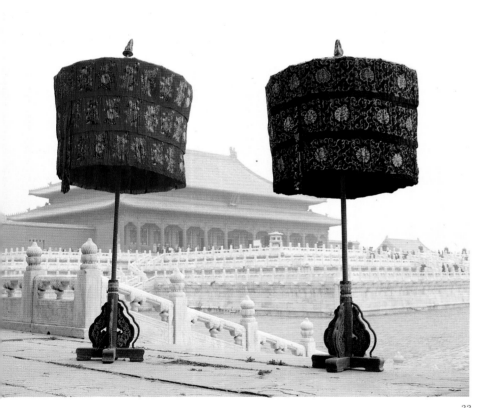

33

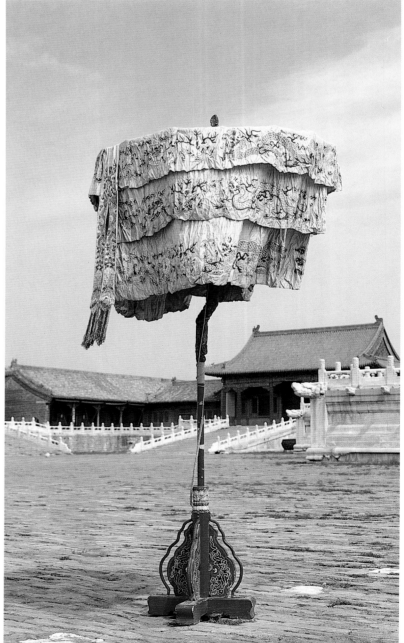

34

32

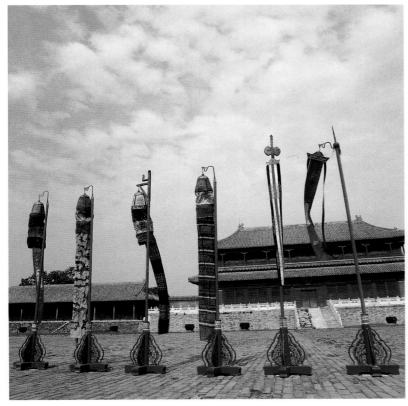

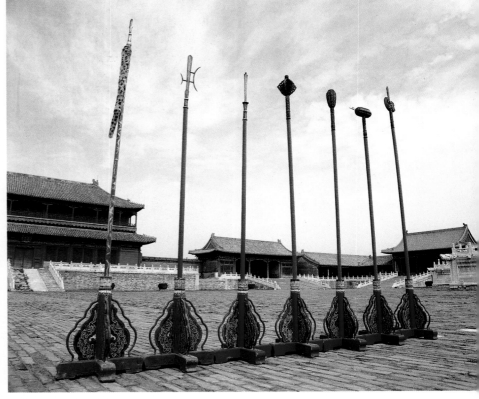

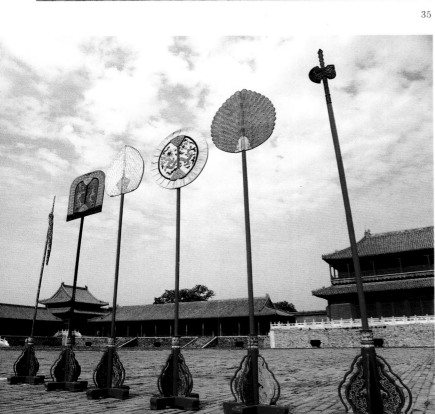

31. 'Cracking the whips' – part of the *fa jia lubu* from *The Grand Imperial Wedding* of Emperor Guang Xu.

In major ceremonies the whip-cracking officials were positioned on either side of the Imperial Way in front of the Hall of Supreme Harmony. The whips, made of silk, were cracked to ensure respect during major ceremonies. They also signified the beginning and end of ceremonies.

32. The banners and flags of the emperor's insignia.

There were 120 or more banners and flags emblazoned with a variety of designs: the sun, the moon, clouds, thunderbolts, wind, rain, constellations, the Five Stars, the Five Mountains and the Four Rivers. Banners and flags constituted the largest number of objects in the *lubu*.

33. The colourful canopies of the emperor's insignia.

34. The state canopy, with the crooked handle of the emperor's insignia.

This canopy, embroidered with yellow dragons, was positioned in the centre of the open space in front of the Hall of Supreme Harmony during court functions.

35. The streamers and pennants of the emperor's insignia (of which there were more than fifty).

36. Weapons of the emperor's insignia.

From left to right these are models of: a 'leopard-tail' spear, a halberd, a *shu* (bamboo weapon), a *xing*, a *ligua*, a *wogua* and a battle-axe. These were originally weapons of the Imperial Guard.

37. Fans of the emperor's insignia.

These fans, whether red or yellow, square or round, are all emblazoned with single or double dragons. On the extreme right is an imitation battle-axe, and on the extreme left is a 'leopard-tail' spear used by members of the 'leopard-tail troop'. The 'leopard-tail troop' brought up the rear when the emperor was in procession and stood on either side of the throne at the rear when the emperor held court.

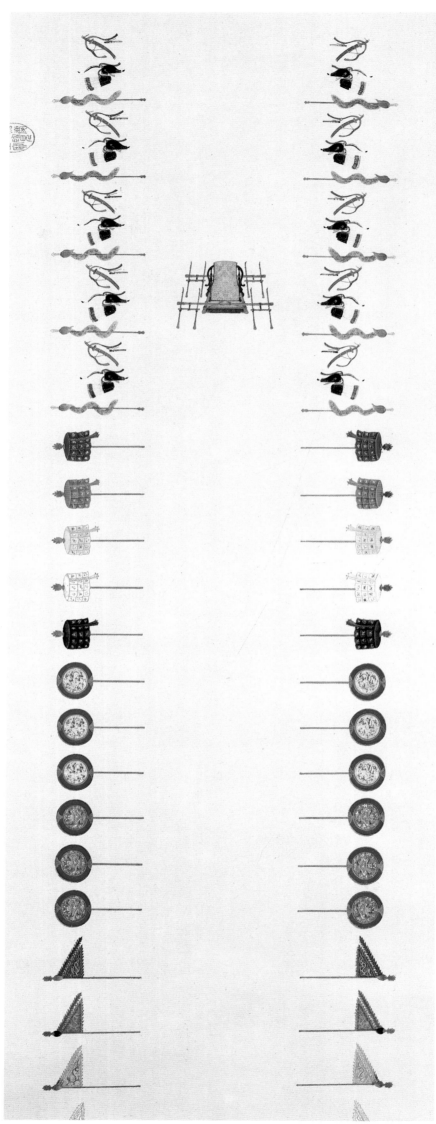

38. A painting of part of the *qi jia lubu* of the emperor on his tour of inspection.

The first five articles on both sides form a group which includes a knife, a bow and arrow and a 'leopard-tail' spear. The items below are the various banners, flags and fans, and in the middle is a light imperial sedan-chair.

38

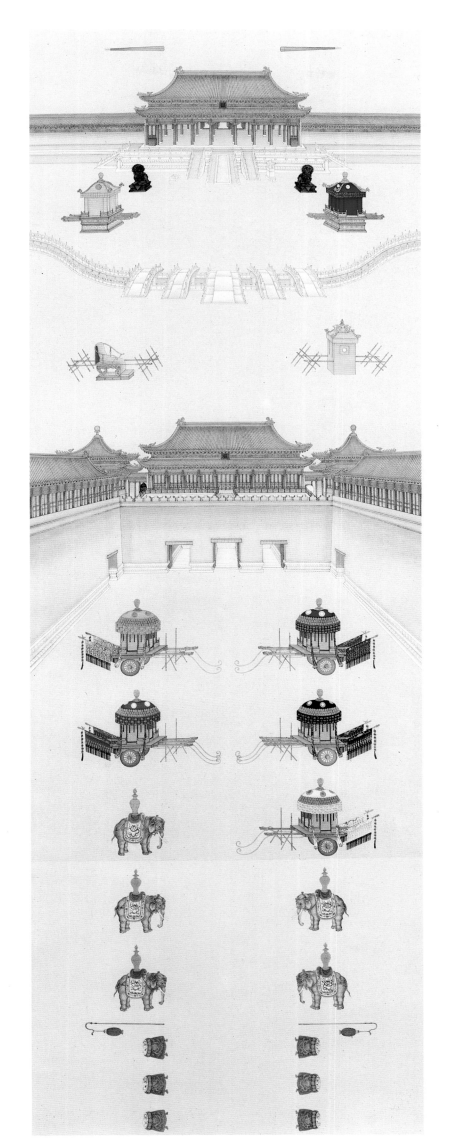

39. A painting of part of the *fa jia lubu* for court functions.

In front of the Gate of Supreme Harmony at the top are the Jade Sedan, Gold Sedan, Ritual Sedan and Walking Sedan. Outside the Meridian Gate below are the Gold Carriage, Jade Carriage, Elephant Carriage, Leather Carriage and Wooden Carriage (collectively called the 'Five Carriages'). Their tops are adorned, respectively, with gold, jade, ivory, leather and wood. Below them are elephants and the drums used by the orchestras.

39

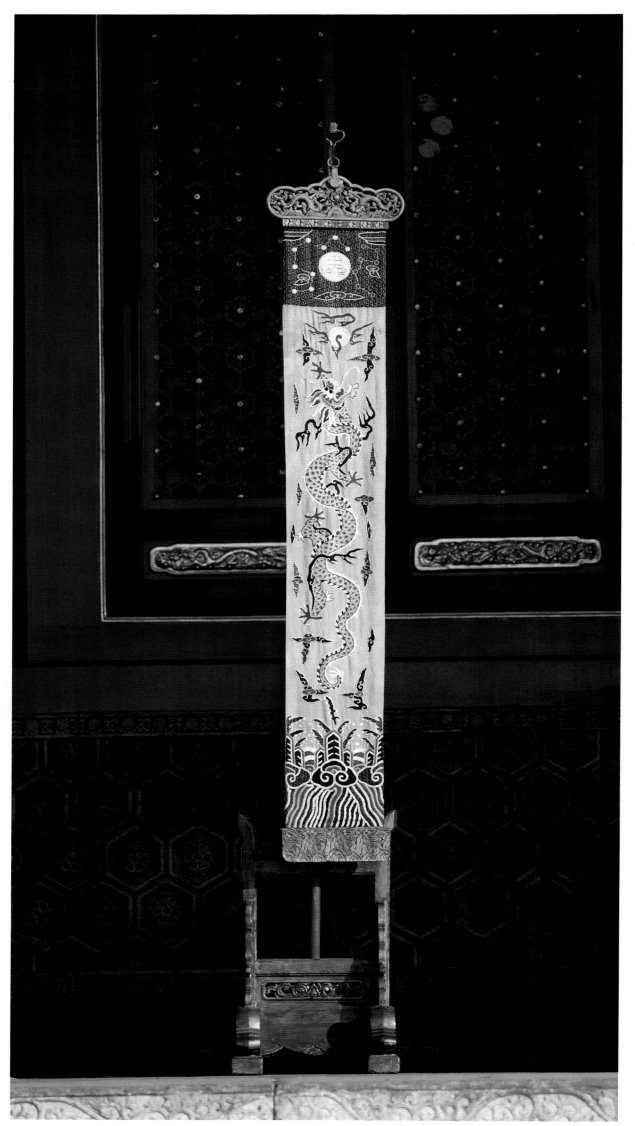

40. A signal flag of the conductor of the Zhongheshaoyue orchestra. (174.96 cm long)

The Zhongheshaoyue orchestra performed the refined court music of ancient China. All the instruments except the flute had come into existence by the eighth century BC. The signal flag (*hui*) was raised to start the music and lowered to stop it.

41. The *bozhong*.

Neither the *bozhong* (a large bell suspended from a frame) nor the *teqing* (a musical instrument made of stone which was struck with a wooden mallet) were used in the Zhongheshaoyue music of the Qing dynasty. When eleven ancient bells were unearthed in Jiangxi in the twenty-fourth year of the Qian Long period (1759), the emperor ordered twelve bells of gilded bronze to be made in accordance with the twelve-tone temperament on the model of the ancient bells, each to be installed on a frame. The imitation bells were ready for use two years later. The *bozhong* was struck once before the band started to play. The largest of the twelve bells is 68 cm high.

40

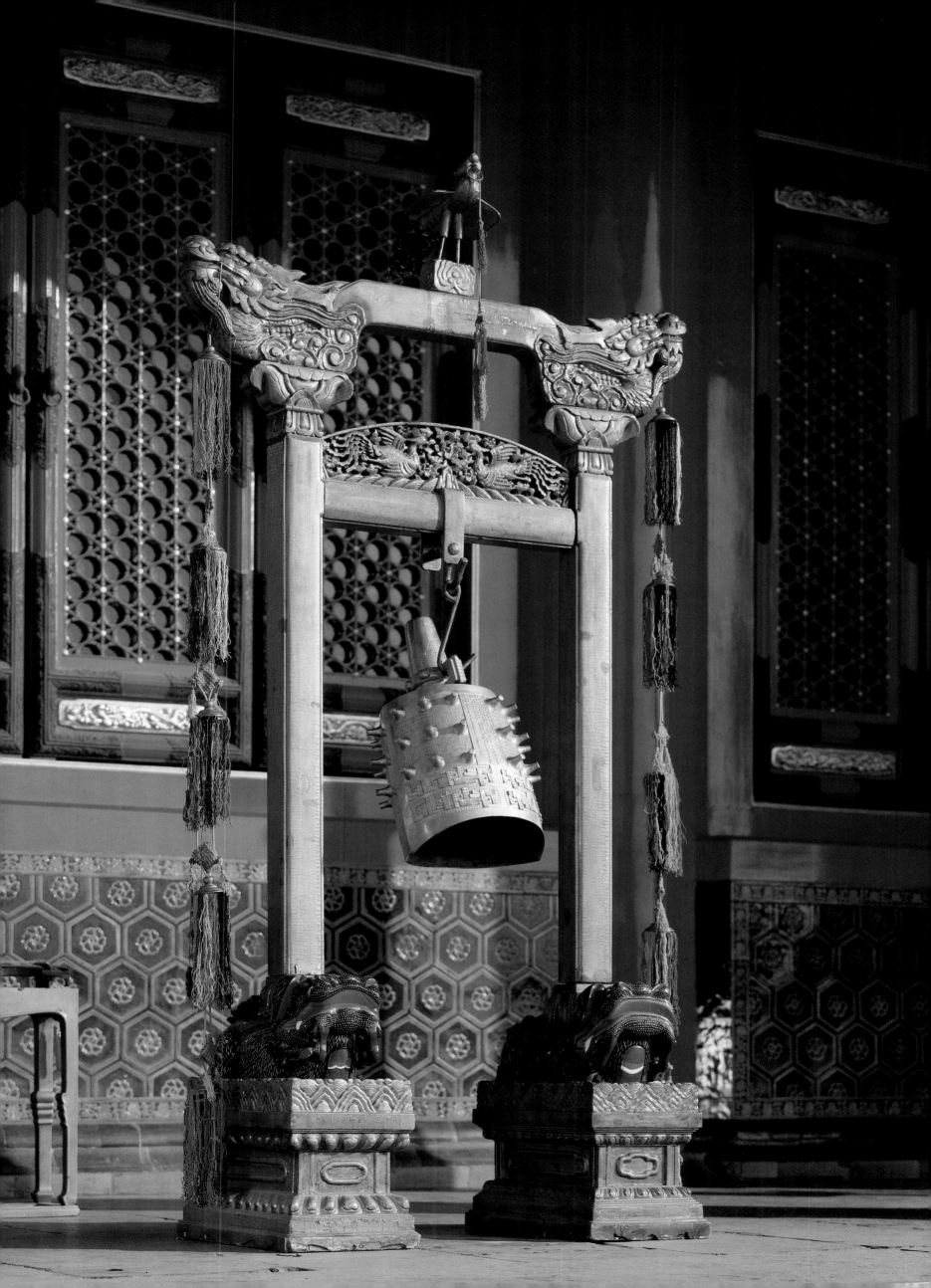

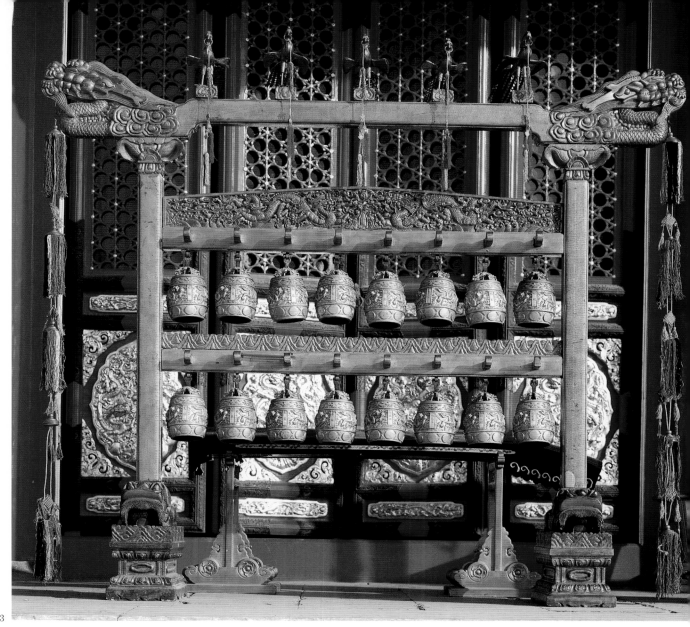

43

42. The *teqing*.

The jade *teqing* was made at the same time as the *bozhong*, also in accordance with the twelve-tone temperament. Each *teqing* had its own frame. It was struck once at the end of a composition. The largest *teqing* is 46.66 cm × 69.98 cm.

43. The *bianzhong*. (23.84 cm high)

The *bianzhong* was made of gold or gilded bronze. It consisted of sixteen bells hanging from a rack. All of the bells are similar in size and shape, and their timbre is melodious and mellow, with a mystical quality.

44. The *bianqing*. (the shorter section, 23.33 cm, the longer section, 34.99 cm)

The stones of the *bianqing* were carved from green jade or other hard stone. The *bianqing* consists of sixteen stones hanging from a rack and its chimes are clear and melodious, but not resonant.

44

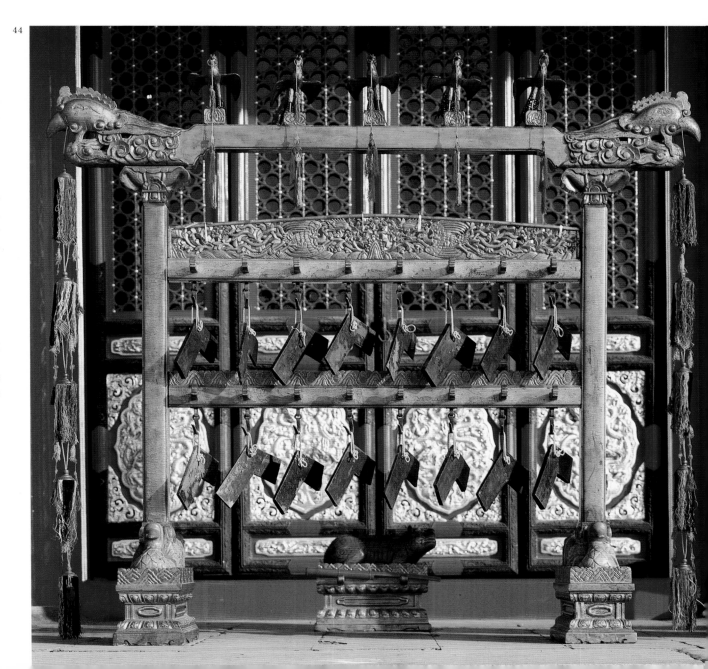

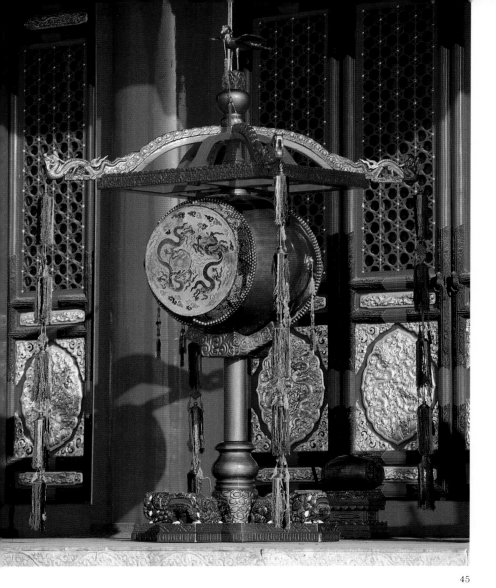

45. The *jiangu*. (73.73 cm across the top)

It was the custom to beat the *jiangu* three times at the end of each phrase of the Zhongheshaoyue music.

47. The *xun*. (7.14 cm high)

The *xun* is a pottery musical instrument. Among archaeological finds of the Neolithic period in China, there is a *xun* with three sound-holes. In the Qing period, the *xun* had a mouthpiece at the top, four finger-holes on the front and two finger-holes on the back. These were for regulating the pitch.

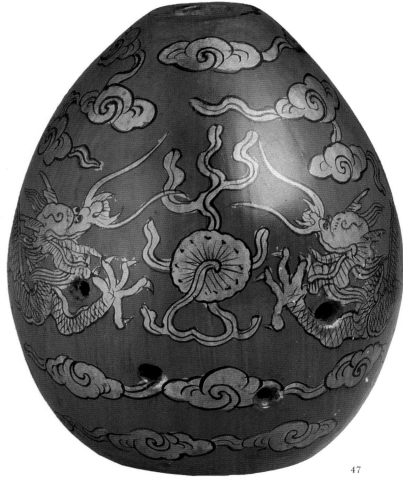

47

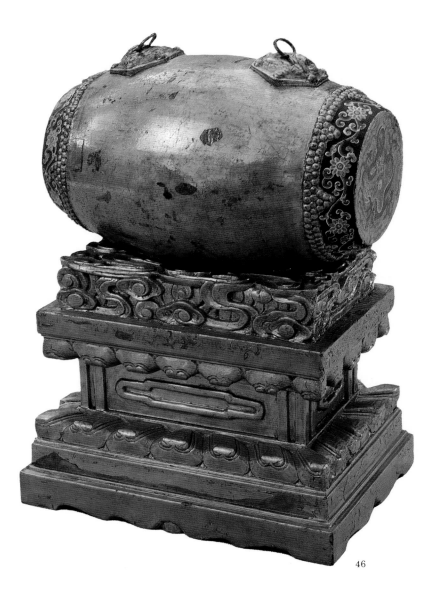

46. The *bofu*. (23.33 cm across the top)

The ancient *bofu* was a leather bag stuffed with bran which, when beaten, produced sounds which were rhythmic but not resonant. In the Ming and Qing periods the *bofu* was elongated in shape and both its ends could be beaten. It was used in concert with the *jiangu*, both ends being beaten once to every beat of the latter.

46

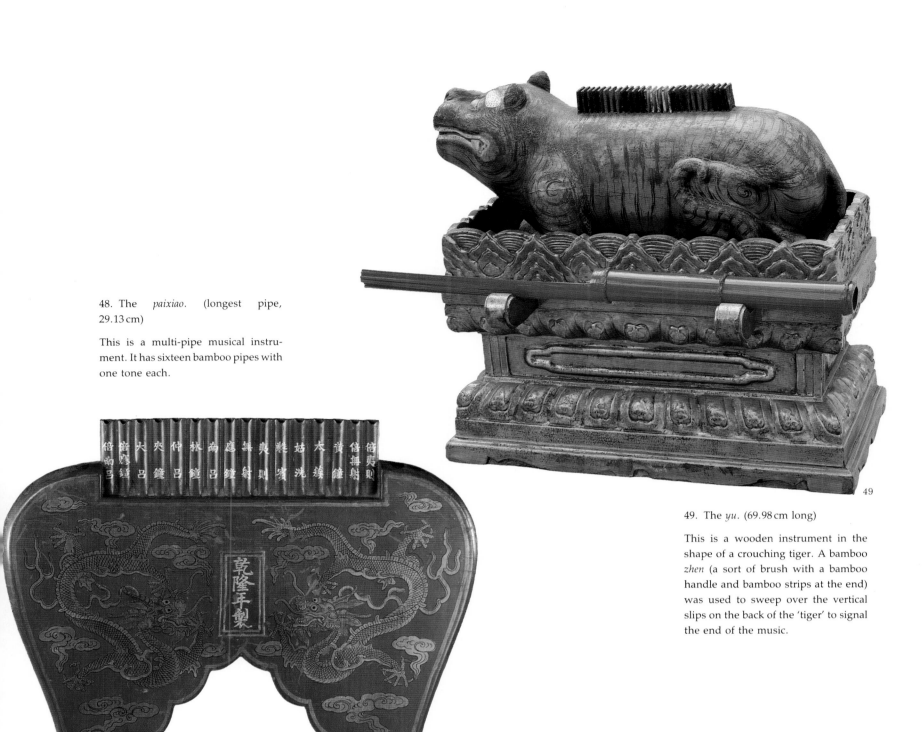

48. The *paixiao*. (longest pipe, 29.13 cm)

This is a multi-pipe musical instrument. It has sixteen bamboo pipes with one tone each.

49. The *yu*. (69.98 cm long)

This is a wooden instrument in the shape of a crouching tiger. A bamboo *zhen* (a sort of brush with a bamboo handle and bamboo strips at the end) was used to sweep over the vertical slips on the back of the 'tiger' to signal the end of the music.

49

48

50. The *zhu*. (69.98 cm square at the mouth)

This wooden percussion instrument was struck with a wooden mallet to start the music.

50

51

52

51. The *di* (58.52 cm long); the *chi* (44.8 cm long).

The bamboo *di* (top) is similar to a modern flute. The *chi*, also of bamboo, is like a flute, but thicker. It has five sound-holes facing outwards and another facing inwards. Its mouth-piece is on top.

52. The *xiao*. (56.66 cm long)

This bamboo flute, played vertically, is similar to its modern counterpart.

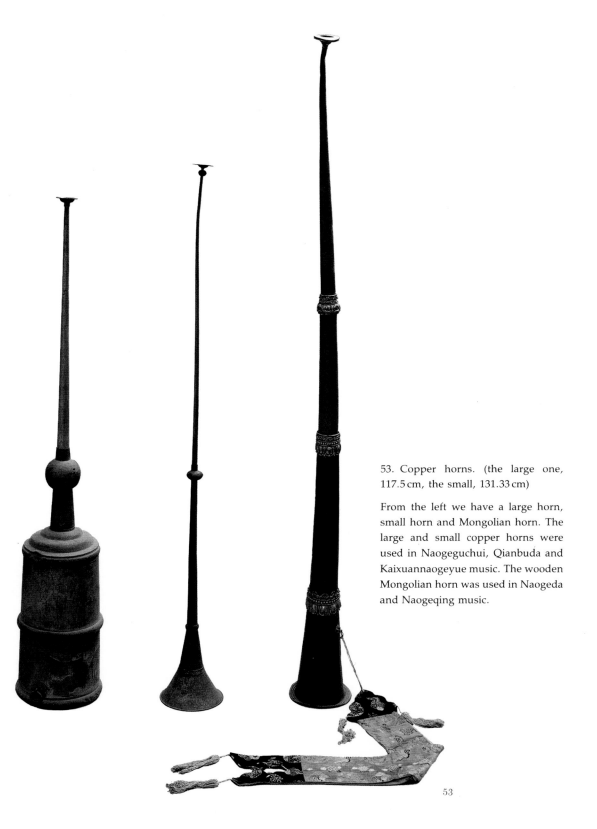

53. Copper horns. (the large one, 117.5 cm, the small, 131.33 cm)

From the left we have a large horn, small horn and Mongolian horn. The large and small copper horns were used in Naogeguchui, Qianbuda and Kaixuannaogeyue music. The wooden Mongolian horn was used in Naogeda and Naogeqing music.

53

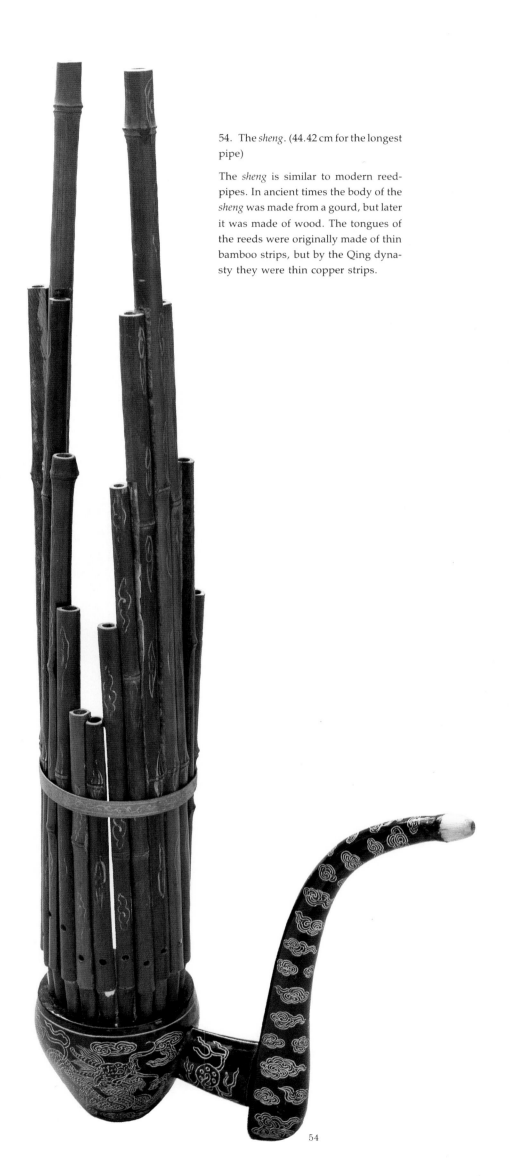

54. The *sheng*. (44.42 cm for the longest pipe)

The *sheng* is similar to modern reed-pipes. In ancient times the body of the *sheng* was made from a gourd, but later it was made of wood. The tongues of the reeds were originally made of thin bamboo strips, but by the Qing dynasty they were thin copper strips.

55. The *huajiao*. (174.76 cm long)

The *huajiao* was made of wood and was used by the Naogeguchuiyue and the Qianbudayue orchestras. When blown, it was fitted with a wooden whistle. It produces no scales.

54

55

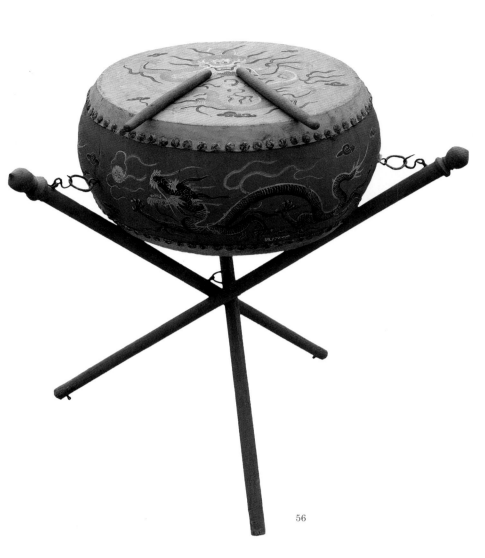

56

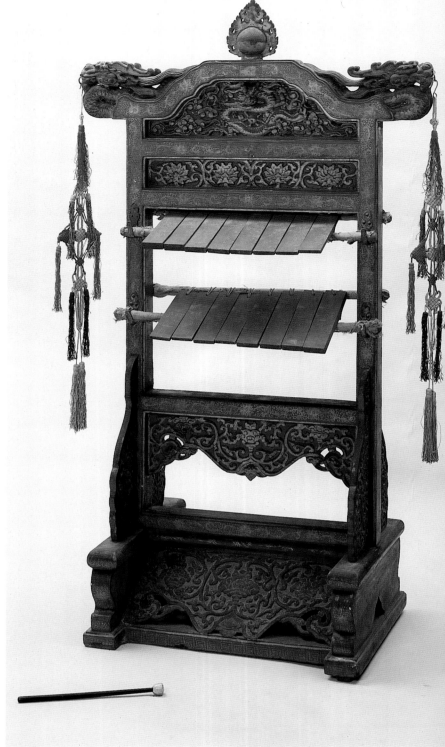

57

56. The *longgu*. (the diameter of the top, 49.15 cm)

The *longgu*, or 'dragon drum', was invariably used in the Naoge-guchuiyue orchestra and in music for the *lubu*. Twenty-four drums often formed a unit. When they were all played together, they produced a magnificent sound.

57. The *fangxiang*.

This percussion instrument for the Danbidayue music was played when the emperor held court. The sound was produced by rectangular steel plates. Each rack contains sixteen plates. Each of the plates is 23.328 cm in length.

58. The *qin*. (101.09 cm long)

The top of this instrument was made of paulownia wood and its base of catalpa wood. It has seven silk strings of varying thickness.

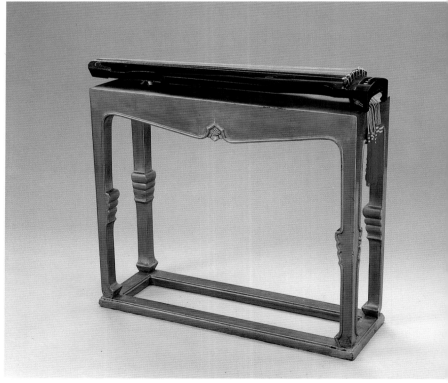

58

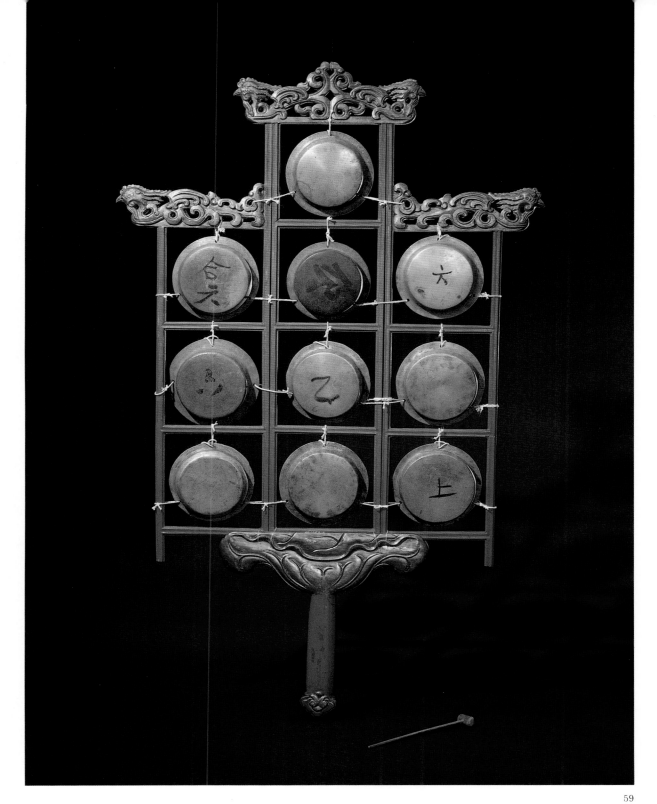

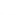

59. The *yunluo*. (the outer diameter of each gong-face, 11.29 cm)

This percussion instrument was used by the Danbidayue orchestra. Each rack has ten copper gongs.

60. The *se*. (209.95 cm long)

This, like the *qin*, is classed as a silk instrument. The *se* is larger than the *qin* and also made of paulownia wood. It has twenty-five silk strings of the same thickness. Each of the strings can be adjusted by moving the bridge to regulate its pitch.

59

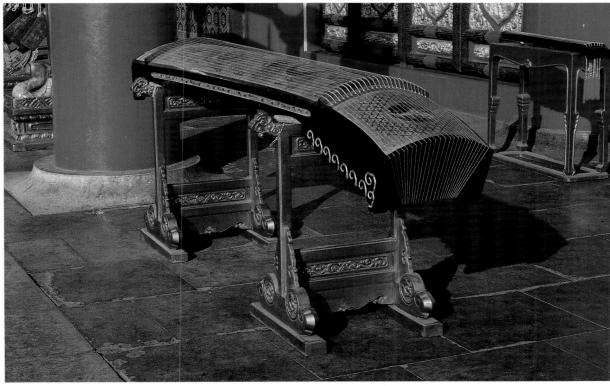

60

45

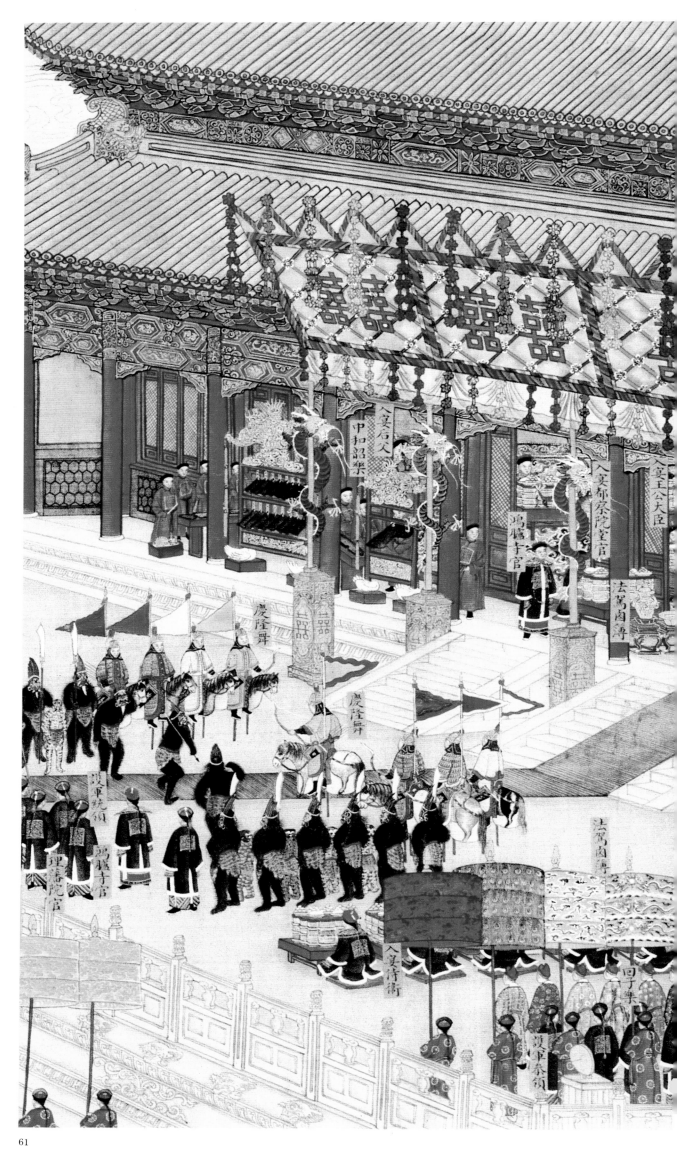

61. The Zhongheshaoyue orchestra from Emperor Guang Xu's *The Grand Imperial Wedding*.

GOVERNMENT ADMINISTRATION

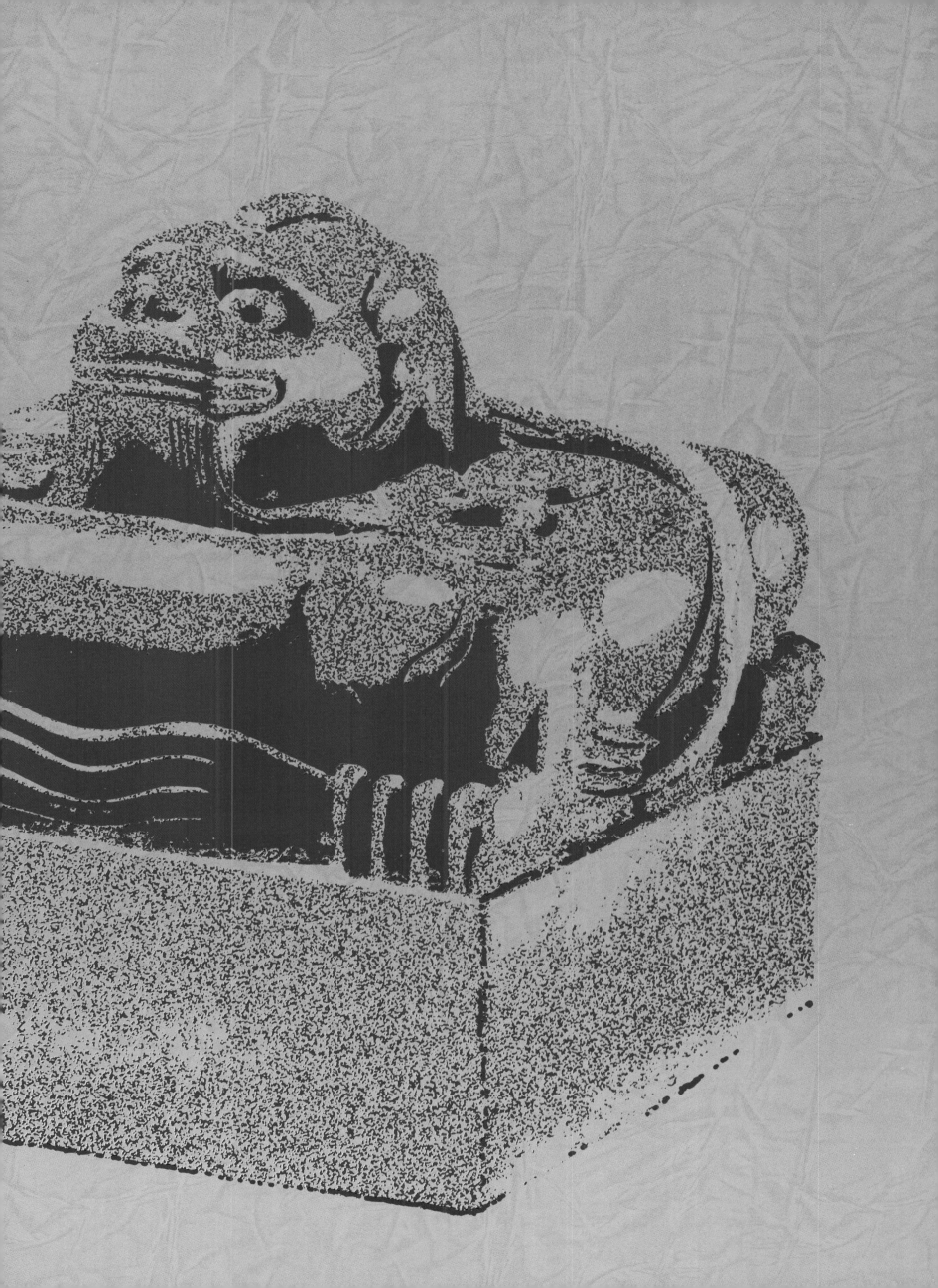

In the Qing period the emperor's handling of routine affairs of state was known as *qin zheng* (diligent government concerning official documents). This included such procedures as *yumen tingzheng* (holding court at the palace gate), *yudian shichao* (granting routine audiences), *yudian chuanlu* (holding court to announce the results of the final imperial examinations), *goudao* (checking judicial verdicts in the Hall of Diligence) and the granting of audiences to foreign envoys. Together these were the main instruments in the management of affairs of government.

The majority of the main administrative institutions of the Qing dynasty had been inherited from the Ming period. Apart from the emperors who were still minors and the Emperor Guang Xu, who failed to consolidate his position, the Qing emperors were autocratic monarchs who personally made the major decisions regarding the government of the empire. The central departments such as the Political Conference, the Grand Secretariat and the Grand Council, whose functions were merely to assist the emperor in handling affairs of state, were not decision-making bodies at an important level. Before the establishment of the Grand Council, the Grand Secretariat could still 'discuss the political affairs of the empire', draft imperial decrees and important official documents and comment on memorials to the throne. It was thus still fairly powerful. At that time reports and memorials (usually known as *tizou benzhang*) addressed to the emperor by domestic and foreign officials were forwarded through the Office of Transmission to the Grand Secretariat. The official readers there opened the communications, read them carefully and revised them, writing their suggested answers for the emperor's consideration. After they had been examined and approved by the Grand Secretaries, these memorials together with the comments were sent to the clerks of the Signature of Documents Office who would make a fair copy of each and at dawn the following morning would send both the originals and the copies through the Memorial Office to be read by the emperor. This complicated procedure of the Grand Secretariat was known as the *piaoni zhidu* (memorial-drafting system). The comments appended were very brief. If the Grand Secretariat felt unable to put forward a positive opinion on a particular matter, it might propose two or three alternatives for the emperor's consideration and decision. After they had received the emperor's written instructions, officials of the Grand Secretariat would transfer them in red ink to the original memorial, which was then known as a 'red book'.

The Grand Council was set up in the seventh year of the reign of Yong Zheng (1729), and thereafter a system for memorials was generally adopted, whereby court and provincial officials reported matters directly to the emperor by presenting the memorials which were opened, read and commented upon by the emperor himself and then immediately returned to those officials to be acted upon. Thus, the 'memorial-drafting system' was reduced to the Grand Secretariat attending to routine matters only, and its powers were gradually taken over by the Grand Council.

The Grand Council was established because of the speed of transmission and confidentiality required by the military reports and directives that flew back and forth during the Qing dynasty's almost incessant military operations in the north-west. Emperor Yong Zheng therefore ordered a Grand Chamber to be provisionally set up inside the Gate of Imperial Prosperity. Shortly afterwards the Grand Chamber was renamed the Grand Council. Following the death of Yong Zheng, the Emperor Qian Long abolished it for a time but restored it in 1738.

In point of fact, the Grand Council handled not only military affairs, but also important internal affairs, and as a consequence its power steadily increased. The Grand Council operated for some 180 years, until April 1911, the Grand Council and the Grand Secretariat were then replaced by the Executive Cabinet.

In order to prevent imperial power from being usurped, the Qing rulers adopted a series of measures to restrict the Grand Council. For example, the seal of the Grand Council was kept in the Inner Court. When it was needed for use, the Secretary on duty was required to go through the Inner Memorial Office to ask for the seal, and return it again after use. It was also stipulated that no one should be allowed to divulge the contents of their memorials to the Grand Ministers of the Grand Council before their presentation to the emperor. Within the Grand Council, the Grand Ministers were only allowed to handle the affairs entrusted to them by the emperor on that particular day. The affairs of the various Boards and Departments were not to be handled by the Grand Council, nor were board officials allowed to enter the Grand Council to seek instructions from their Presidents. The Grand Council itself was closely watched and no one was allowed even to peep into the Secretaries' office. A censor was assigned every day to see that these rules were strictly adhered to.

The emperor attended to routine administrative affairs in the Palace of Heavenly Purity and the Hall of Mental Cultivation. Both Shun Zhi and Kang Xi held court, granted audiences to ministers and read memorials in the Palace of Heavenly Purity. Directly over the throne in that palace hangs an inscription which translates as 'Honesty and Open-mindedness'. Behind the board was a box containing the emperor's highly secret choice of his successor. The practice of secretly naming the heir apparent was initiated by the Emperor Yong Zheng, no doubt mindful of conflict among the princes when he deposed the crown prince and ascended the throne. The four emperors who followed Yong Zheng all came to the throne via this system. It was, however, redundant thereafter since Xian Feng had only one son and the two following emperors, Tong Zhi and Guang Xu, had no offspring at all.

The Gate of Heavenly Purity was where the Qing emperors held court. When emperors went to the palace gate to direct the civil and military officers in administering affairs of state it was known as *yumen tingzheng*. It was the Emperor Shun Zhi (the first emperor after the Manchus crossed the Great Wall) who in the Qing dynasty instigated the practice of holding court at the palace gate and, during the reign of Kang Xi, this became an even more frequent occurrence. Many important policy issues were decided upon during the *yumen tingzheng* which was adopted by Yong Zheng and succeeding emperors. It was discontinued after the beginning of Xian Feng's reign because of political corruption and later, during the reigns of Tong Zhi and Guang Xu, the autocratic rule of the Empress Dowager Ci Xi and the increased aggression of foreign powers precluded its reintroduction.

The routine work of the Qing emperors mainly consisted of reading and writing comments on memorials, summoning ministers for consultation and calling high and low officials to see them. Within the Forbidden City there were two institutions with special responsibility for the transmission and delivery of official documents, and these were the Outer and Inner Memorial Offices. Both of these offices were supervised by the Grand Chamberlain. The Inner Memorial Office was made up of eunuchs with various titles, such as Usher Eunuch, Attendant Eunuch, Record-keeping Eunuch and Errand Eunuch. Officials of the Outer Memorial Office were chosen from the secretaries of the Six Boards and the Imperial Household Department – the most important being the Chief Aide, the Mongolian Aide, secretaries and memorial translators.

According to late Qing records, the following was the procedure whereby memorial officials received memorials and transmitted imperial edicts. At midnight each of the Boards would send a secretary with a memorial box to the East Flowery Gate. The gate would be opened and the secretary would follow the memorial officer and hand over the memorial box to the Outer Memorial Office. When the Gate of Heavenly Purity was opened, the box was taken from the Outer Memorial Office to the Inner Memorial Office and the eunuch who presented memorials to the throne would take it to the emperor for his perusal. At about two a.m. the memorial officer would go out of the gate and return the memorials already commented upon by the emperor to the messengers of the various government offices.

In addition to the above, the memorial offices were also responsible for the presenting of the *shanpai* (meal slip). During the Qing period it was required that when an official presented memorials to the throne, or a minister wanted an audience with the emperor, then a eunuch of the Inner Memorial Office should first present the *shanpai* to the emperor. The emperor, however, could summon any of the princes, dukes or ministers in service in the Inner Court to his presence at any time without

requiring the presentation of *shanpai*. Interviews were habitually conducted after a meal, but the venue was not fixed – generally wherever the emperor happened to be having his meal.

From the reign of Kang Xi, the Hall of Mental Cultivation was used by the emperors for routine administrative affairs. It is divided into two sections – the front and rear – connected by a hallway. The five-chamber rear section provided the emperor's living-quarters and the front section was used for conducting administrative affairs. The emperor granted interviews to his officials in the central room of the front section where a throne, screen and desk were situated. The Western Warm Chamber was where he frequently read memorials and discussed political affairs with his ministers.

After the palace coup in 1861 in the eleventh year of the reign of Xian Feng, the Eastern Warm Chamber in the Hall of Mental Cultivation became the place where the two empresses dowager, Ci An and Ci Xi, 'held court behind the screen'. Empress Dowager Ci An, who could hardly read, was 'amiable and carefree without thinking deeply' and was 'cautious in her speech in the presence of ministers'. This left the way open for the Empress Dowager Ci Xi to exercise her own power in the decision-making processes.

The summoning of someone to an interview usually involved only a single person and the rules of etiquette were less demanding. In the twelfth year of the reign of Guang Xu (1886), when Ci Xi summoned the Mongolian Living Buddha to her presence, she bade him approach near to her throne and held his hand in greeting – which the Living Buddha deemed an unusual honour to himself. There were, however, special circumstances which necessitated many people being summoned at the same time. The Emperor Tong Zhi died on the second day of the twelfth lunar month in the thirteenth year of his reign (9 January 1874). Two days later the Empresses Dowager Ci Xi and Ci An summoned to the Western Warm Chamber in the Hall of Mental Cultivation twenty-nine nobles and officials. When they were all assembled the two empresses dowager announced to the packed chamber their decision that Zaitian, son of Prince Chun, should be adopted as Emperor Xian Feng's son, that as such he should start to rule as Emperor Guang Xu immediately, and that his son, should he have one, should inherit the Emperor Tong Zhi's mantle in his turn. During this audience the Western Warm Chamber was almost full of kneeling persons.

In addition to the Forbidden City, the Qing emperors also conducted their routine government activities in the imperial gardens, and in the imperial palaces used for temporary stays, such as the Hall of Diligent Government in the Garden of Perfection and Brightness and the Hall of Tranquillity and Sincerity and the Hall of Refreshing Mists and Waves in the Summer Palace at Chengde.

The tradition of presenting officials at court went back to the Han dynasty, and during the Qing period it was stipulated that officials below the fifth grade from the capital and officials below the fourth grade from the provinces, who were appointed for the first time, or were recommended by others to fill a particular post, or were promoted after examinations, must all be presented to the emperor. These group presentations were held at various times, usually in the Hall of Mental Cultivation. After the Yong Zheng era, the civil officials were ushered into the presence of the emperor by the President of the Board of Civil Office, and the military officers were led in by the President of the Board of War. When the presentation began, the President of the appropriate Board went into the hall and approached the throne to make obeisance to the emperor, while the officials kneeling under the eaves outside the hall reported their names and previous responsibilities. After that they kowtowed and withdrew.

The *yudian chuanlu* was a ceremony held once every three years. It was then that the list of the *jinshi* (successful candidates in the highest imperial examinations chosen by the emperor after grading their examination papers) was announced in front of the Hall of Supreme Harmony. The *jinshi* were then given an audience with the emperor. As part of the examination of the *wulu* (military officers who had passed the imperial examination successfully at provincial level), the emperor personally tested them in archery (both on horseback and on foot),

swordsmanship and weight-lifting and then decided on the eighteen most successful candidates. These were led by guards into the imperial presence where they knelt down and reported their name and place of birth. Having decided their placement on the list, the emperor would return to the hall the following day and announce the final results.

The *goudao* at the Hall of Diligence was a practice inherited from the Ming emperors. Every year at the end of autumn, the emperor personally examined and approved judicial decisions of death sentences. The judicial system of the Qing dynasty provided for the following procedures in the case of a death sentence: the case would be tried first by the authorities in the prefecture or county, it would then be referred to the provincial viceroy or governor for his decision and finally submitted to the Three Judiciary Organs (the Board of Punishments, the Court of Censors and the Grand Court of Appeal) for a joint hearing. During the joint hearing full discussion was expected between medium-ranking officials. The sentence was then submitted to a conference of the Nine Ministers for approval. Finally the case, together with its transcripts, was referred to the emperor for consideration. If the decision of the court for a certain man was capital punishment by decapitation or hanging, the emperor would indicate his agreement by checking the name of the criminal in the records with red ink. This was known as *goudao* or *goujue*. In some cases he might withhold the check, pending re-examination the following year. If the emperor's judgements were conducted indoors, they were then assessed at the west door of the Hall of Diligence in the Palace of Heavenly Purity; if the judgement took place in the Garden of Perfection and Brightness, then it was held in the Hall of Discernment to the east of the Hall of Honesty and Open-mindedness; if the judgement took place in the Summer Palace at Chengde, it was held in the Hall of Clarity and Openness.

This kind of prudent procedure for the consideration of a death sentence was also applied to less serious charges, such as accidentally killing another person while protecting one's own father. The procedure was not, however, adhered to in extreme cases such as that of the rebel Lin Qing, leader of the Religion of Divine Justice. The emperor personally presided over his trial; he and his accomplices were all put to death by *lingchi* (a slow process of dismembering the body before decapitation) that same day. During the reign of Kang Xi political contacts gradually spread to encompass European countries and a few European missionaries were invited to serve on the Board of Astronomy. After taking control of affairs of state Kang Xi began to take advantage of the missionaries' command of the Chinese language together with their technical knowledge in order to develop China's relations with European nations. On a number of occasions he sent missionaries in service in the Forbidden City as his envoys to Russia and France to propound the Qing government's standpoint on issues regarding foreign affairs and to participate in the international boundary and trade negotiations with Russia. He also dispatched them to enlist France's technical aid in developing China's astronomical and geographical sciences. Not long after this, however, the pope was seen to interfere in China's internal affairs and relations deteriorated. The Qing government consequently placed certain restrictions on the missionaries' activities, but trading relations at an unofficial level continued.

Qian Long and Jia Qing were not able to deal effectively with the increasingly complex international situation. Following the Opium War of 1840, China was gradually reduced to a position of semi-feudal, semi-colonial weakness. Nevertheless, normal trading relations were still not broken off.

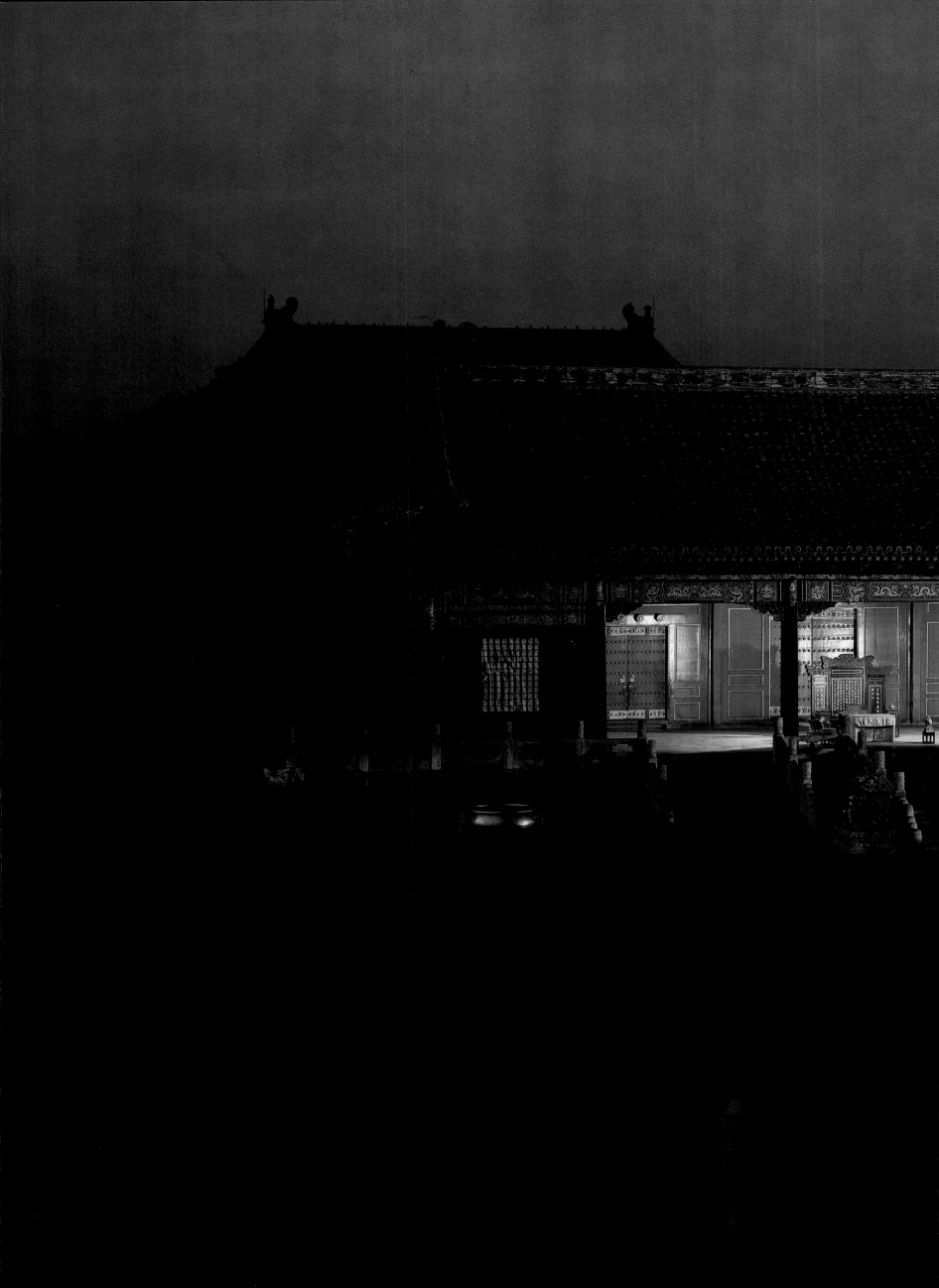

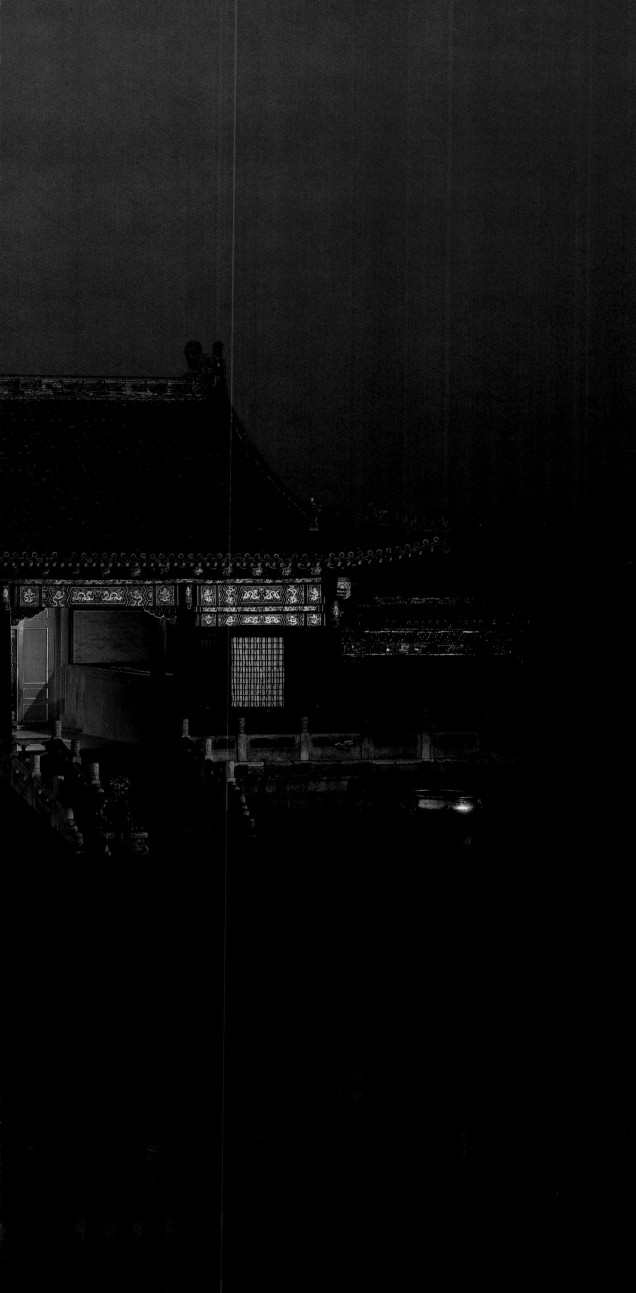

62. The Gate of Heavenly Purity at night.

The Gate of Heavenly Purity, built in the Yong Le reign of the Ming dynasty, is the main entrance to the Inner Court. The low outer buildings to the east and west were the Outer Memorial Office and the Grand Chamber. The inner buildings facing the Palace of Heavenly Purity on the left and right had important functions as the guard-rooms, the Palace Superintendent's Office, the Inner Memorial Office, etc. The Southern Study and the Upper Study, built during the reigns of Kang Xi and Yong Zheng, were also located here. The most important political use of the Gate of Heavenly Purity during the Qing period was as the venue at certain times for the *yumen tingzheng*; the Qing emperors regularly held court at the Gate of Heavenly Purity.

When *yumen tingzheng* took place, the emperor informed the Grand Secretariat who then informed the capital's government offices, and its officials placed the memorials in a box to be presented to the emperor.

Before the *yumen tingzheng* started, the chief eunuch of the Gate of Heavenly Purity had to place the throne and the screen at the centre of the gate. A yellow table was put before the throne and in front of that was a felt mat for those presenting memorials to the throne and making obeisances to kneel on. The guards of the Gate of Heavenly Purity stood on either side of the throne. Beneath the steps, in two rows to the right and the left, facing each other, stood the Commander and Chamberlain of the Imperial Guard, the Guard of Honour and the emperor's imperial bodyguard. Those who had memorials to present would wait in the antechambers. When the emperor was announced, the officials walked to the bottom of the stairs of the Gate of Heavenly Purity and stood in two rows, east and west, facing each other. The secretaries, members of the Hanlin Academy and provincial officials all stood in their designated positions. After the emperor had seated himself on the throne, those officials presenting memorials to him each placed a memorial box on the yellow table in turn. Then, one by one, on their knees, they reported their matters to the emperor, who would give his instructions after each official had finished his report. If the report involved confidential matters, the provincial officials and bodyguards would be instructed to withdraw while the Grand Secretaries and Sub-Chancellors of the Grand Secretariat would move up the steps. Then a Manchu member of the Grand Secretariat would kneel and report the confidential matter to the emperor who, at the end of the report, would give his instructions.

63. *Notes on the Emperor's Daily Life.*

This is a documentary record of the emperor's daily life – what he said and what duties he undertook. As early as the Wu Di period of the Han dynasty, the practice of keeping a record of the emperor's daily life began. The *Notes on the Palace Life* continued to be kept in the succeeding dynasties. The records of the Tang and Song periods were the most detailed, and provide important source material for historians. In the Qing dynasty there was a special department responsible for editing the records, supervised by a specially appointed official. The *Notes on the Emperor's Daily Life* of the Qing dynasty mainly recorded governmental affairs, including the emperor's daily life, his edicts, memorials with his written comments, and all the officials received by him. In addition, during the Qing period there were *Notes on the Inner Palace Life*, or *Lesser Notes on the Emperor's Daily Life*, which specifically kept track of the emperor's activities, his routine sacrifices and worship, in the rear palace.

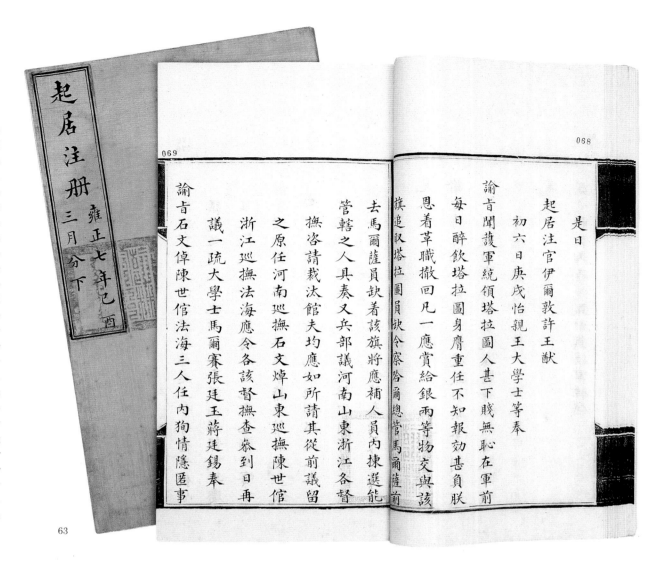

63

65

64

64. Impression from the 'Seal of Imperial Order'.

The left is in Manchu script and the right in Han-Chinese.

65. The 'Seal of Imperial Order'. (11.2 cm square)

One of the twenty-five imperial seals designated by Emperor Qian Long. Made of green jade with an entwined dragon knob, it was used when the emperor issued a document.

54

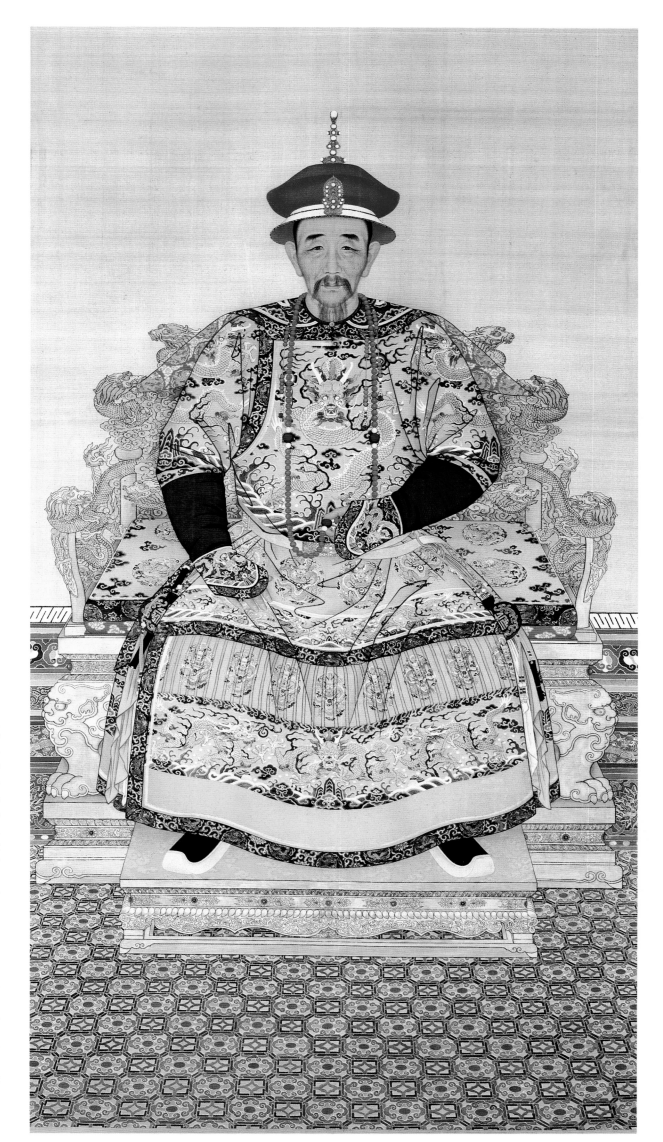

66. A portrait of Emperor Kang Xi in court dress. (306 cm × 220 cm)

Emperor Kang Xi (whose personal name was Xuanye) was the third son of Shun Zhi and the second Qing emperor after the Manchu conquest of north China. He was born to the Empress Xiao Kang Zhang in the Palace of Great Benevolence in the eleventh year of the reign of Shun Zhi (1654). He succeeded to the throne at the age of eight with a regency of four ministers, and was married at twelve. He started to administer affairs of state personally in the seventh lunar month of the sixth year of his reign (1667) and died in the sixty-first year of his reign (1722) at the age of sixty-nine in the Garden of Joyous Spring. Kang Xi was a very capable emperor, and during his reign China made great progress politically, economically and culturally, as well as further consolidating its frontier regions. Emperor Kang Xi was the first emperor of the Qing dynasty's famous 'Flourishing Kang Xi, Yong Zheng, Qian Long Era'.

66

67. The box which contained the emperor's choice of the crown prince and a succession edict.

The emperors who ascended the throne after Yong Zheng followed the practice of secretly naming an imperial successor. To do this the emperor wrote in his own hand a secret edict naming a successor from amongst his sons, and two copies were made. One was kept by the emperor on his person and the other was sealed in a box at the back of an inscribed horizontal board hung above the throne at the centre of the Palace of Heavenly Purity. On the death of the emperor, the regent ministers jointly opened the two copies of the secret edict and verified them with other courtiers before the designated crown prince succeeded to the throne.

68. A front view of the Palace of Heavenly Purity.

The Palace of Heavenly Purity was first built in the Ming dynasty and was refurbished after the Manchus established Beijing as their national capital. During the Shun Zhi and Kang Xi periods, it was the place where the emperors lived and conducted their daily government activities. After the Yong Zheng period, the centre of these

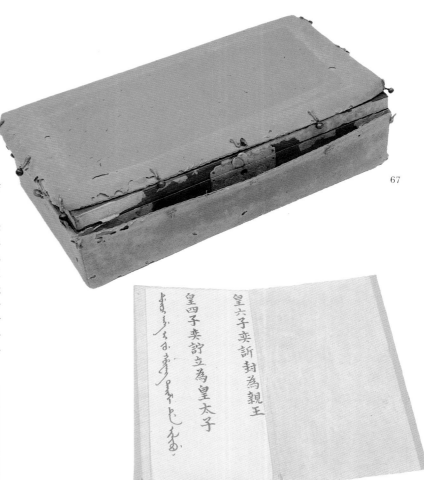

67

activities moved to the Hall of Mental Cultivation. From then on the Palace of Heavenly Purity witnessed fewer government activities and more Inner Court ceremonies or banquets. On the New Year's Day, Winter Solstice and New Year's Eve festivals, and on imperial birthdays, the emperor would usually hold Inner Court ceremonies or family banquets here. Sometimes he would entertain some of his courtiers, and on these occasions the emperor and his ministers would write or recite poems for each other. A 'banquet for greybeards' was held here twice, first in the sixty-first year of Kang Xi's reign and later in the fiftieth year of Qian Long's reign.

69. An interior view of the Palace of Heavenly Purity.

The central room was where the emperor attended to routine governmental affairs, met with ministers and received foreign envoys. The Eastern and Western Warm Chambers were places where the emperor read and commented on memorials and received officials he had called in.

70. A sketch-map of the locations of the gates of the Palace of Heavenly Purity, the Grand Chamber and the Hall of Mental Cultivation.

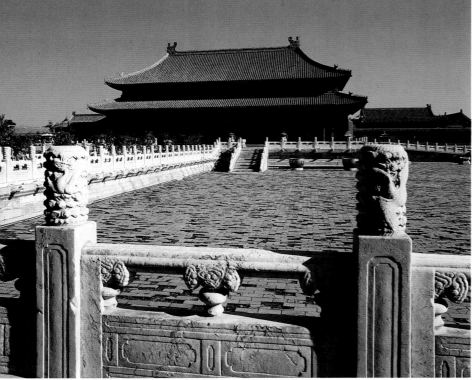

68

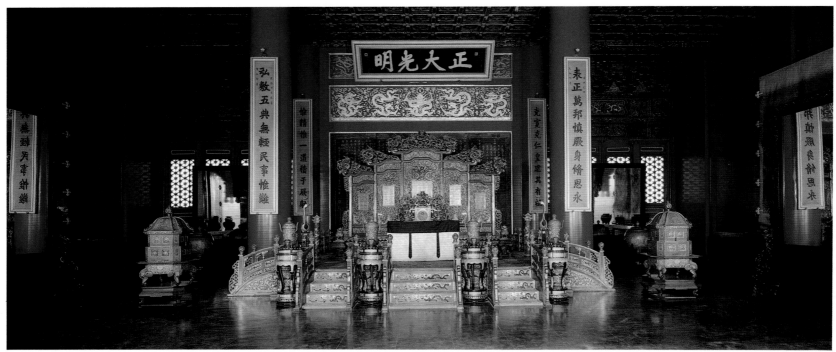

56

69

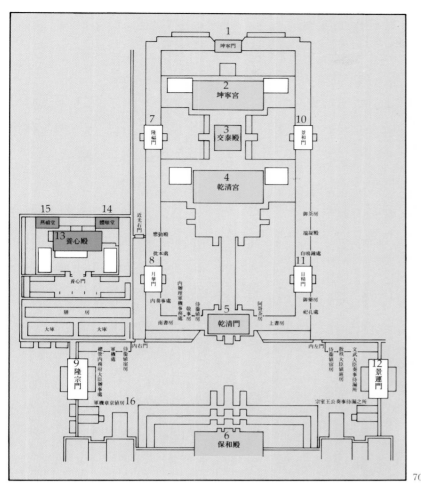

70

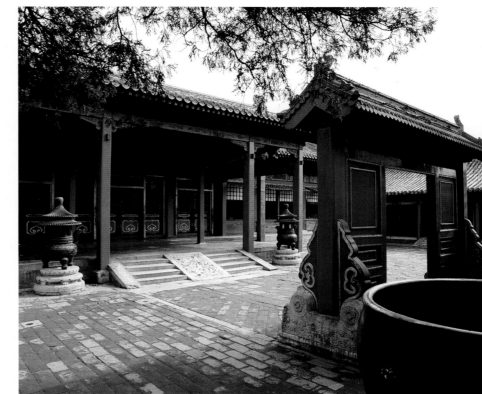

71

72

1 Gate of Earthly Peace
2 Hall of Earthly Peace
3 Hall of Union
4 Palace of Heavenly Purity
5 Gate of Heavenly Purity
6 Hall of Preserving Harmony
7 Gate of Intense Happiness
8 Gate of Lunar Glory
9 Gate of Imperial Prosperity
10 Gate of Beautiful Harmony
11 Gate of Solar Perfection
12 Gate of Flourishing Fortune
13 Hall of Mental Cultivation
14 Hall of Manifest Compliance
15 Hall of Festive Joy
16 Grand Chamber

71. The Hall of Mental Cultivation.

Built in the Ming dynasty, the Hall of Mental Cultivation housed the palace workshops in the Kang Xi period. After Yong Zheng's accession he had the hall rebuilt and moved the imperial living-quarters there from the Palace of Heavenly Purity. From that time, the Hall of Mental Cultivation was an important centre for the emperor's daily activities. Three Qing emperors died there, and on 12 February 1912, the Empress Dowager Long Yu signed the abdication edict of Puyi, the last Qing emperor.

72. The central chamber of the above.

The throne, desk and screen are centred at the back of the chamber. After the Yong Zheng period, the central chamber of this hall was the place where the emperor granted audiences to officials.

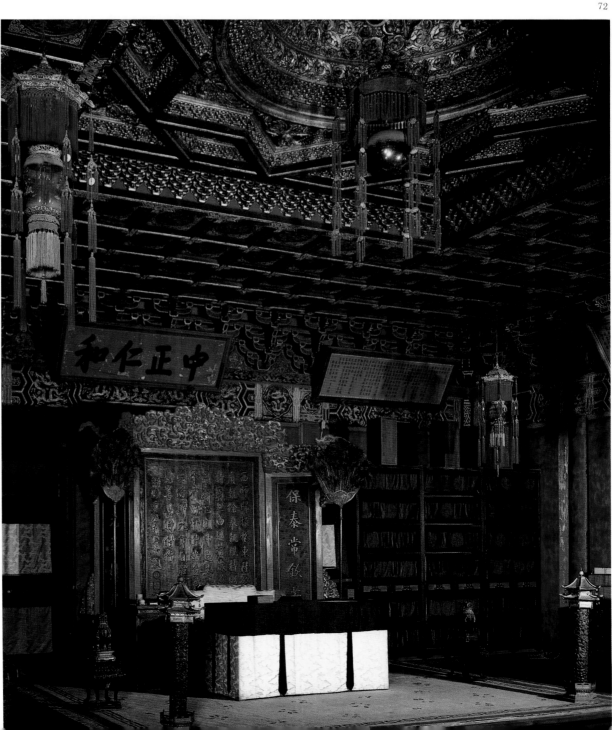

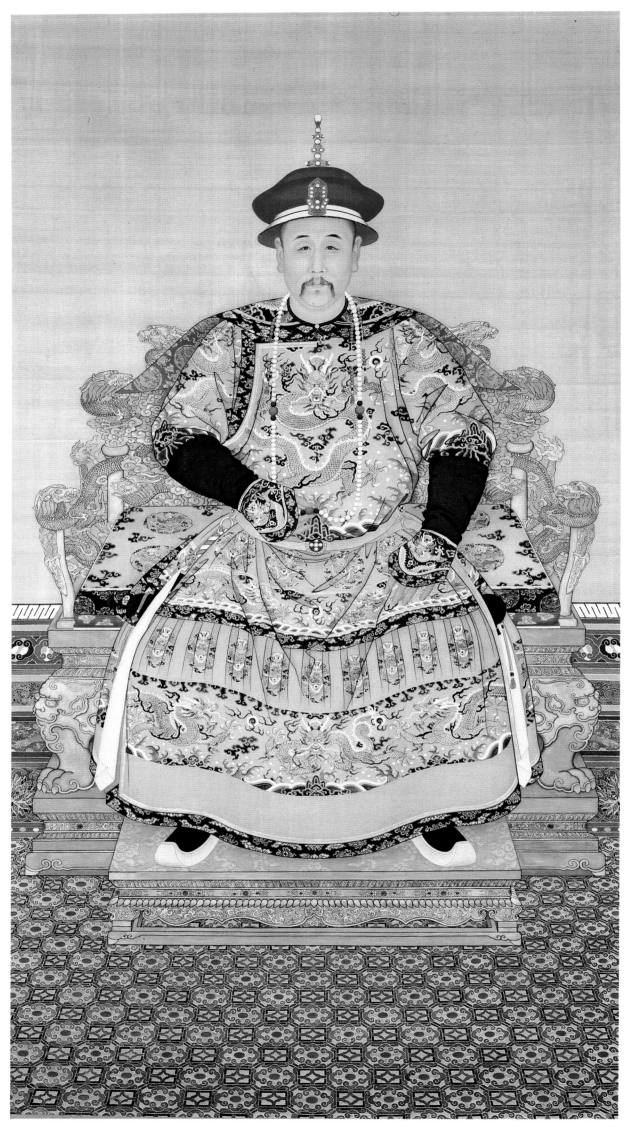

73. A portrait of Emperor Yong Zheng in court dress.

Yong Zheng (whose personal name was Yinzhen) was the fourth son of Kang Xi and the third Qing emperor after the Manchus had crossed the Great Wall. Born to Empress Xiao Gong Ren in the Forbidden City in the seventeenth year of the Kang Xi period (1678), he was enthroned at the age of forty-five and died in the Garden of Perfection and Brightness in the thirteenth year of his reign (1735), aged fifty-eight. Yong Zheng, like Kang Xi, was a capable emperor, and although his reign was short, the policies he implemented in his part of the 'Flourishing Kang Xi, Yong Zheng, Qian Long Era' served as a useful link between the eras of Kang Xi and Qian Long.

74. A *junjidian* mat and the emperor's 'Four Treasures of the Study'.

The mat on which an official knelt when paying respects to the emperor was popularly known as the *junjidian* in the Qing palaces. Such mats were usually piled up in the right-hand corner at the entrance to the Hall of Mental Cultivation. Whenever a minister had an audience with the emperor, he knelt on one of these mats to make his obeisances and then to hear the emperor's decisions.

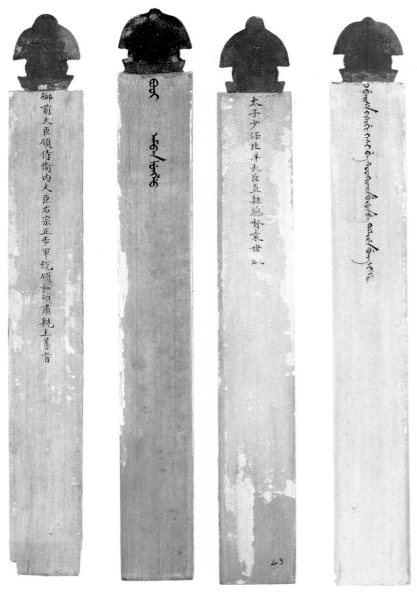

御前大臣領侍衛內大臣右宗正步軍統領和碩莊親王蘊普

太子少保北洋大臣直隸總督京世凱

75. The red- and green-capped bamboo slips.

When an official wanted an audience with the emperor, he had first to present a red- or green-capped bamboo slip bearing his name and official title. This was presented to the emperor before he began his meal, hence its other name, *shanpai* or 'meal slip'. The emperor would look at the slip after his meal and decide whether or not to grant an interview to the official. The red-capped slips were used by princes, dukes and other nobles and the green-capped ones by all other officials.

76. A presentation list.

When an official was promoted, transferred to another post, appointed to fill a vacancy or had completed his term of office, a representative of the appropriate government office had to take him to the Hall of Mental Cultivation or the Palace of Heavenly Purity to have an audience with the emperor – a ceremony known as *yinjian*, or presentation. Prior to the presentation, a list of names, or *yinjiandan* (presentation list), had to be handed in. After the presentation, the emperor's comments on the officials would be written on the list in red ink.

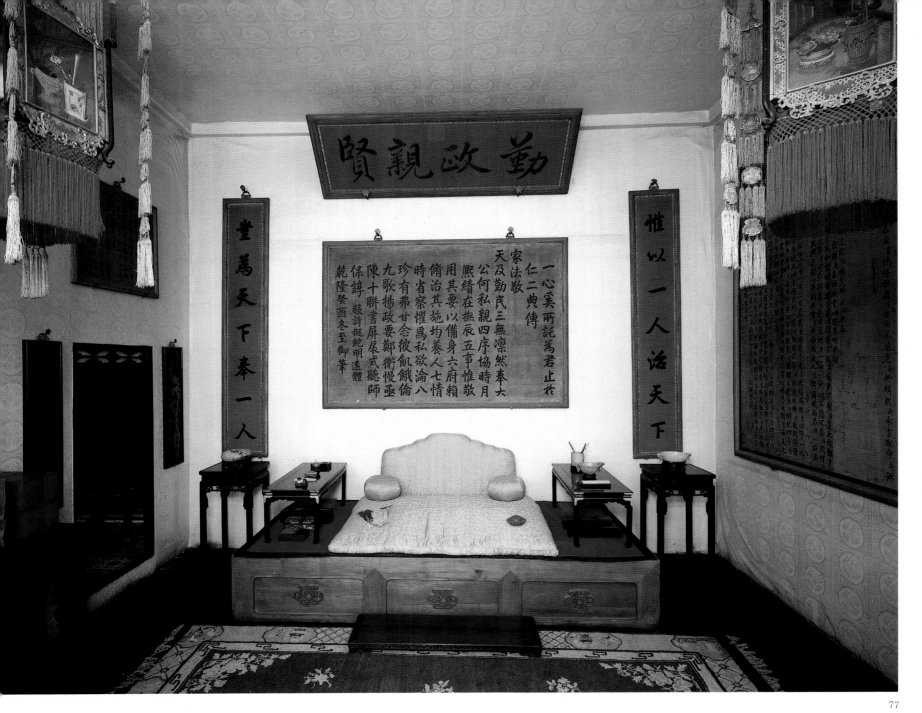

77. The Western Warm Chamber in the Hall of Mental Cultivation.

It was to this room that the emperors from Yong Zheng to Xian Feng summoned their Grand Ministers for consultation to discuss confidential matters. The emperor's yellow-silk couch was placed on a low platform under which hot coals could be placed in winter. The low tables and the 'Four Treasures of the Study' (writing brush, ink-stick, ink-slab and paper) were for the use of the emperors when reading and writing comments on the memorials.

78. The Hall of Refreshing Mists and Waves at the Summer Palace.

The Qing emperors had offices at all their imperial gardens and *ligong* (palaces for temporary residence while on tour). The Hall of Refreshing Mists and Waves in the Summer Palace at Chengde served as both living-quarters and offices. It was in this hall that the critically ill Emperor Xian Feng died after summoning Grand Chamberlain Zai Yuan and Grand Minister Mu Yin and giving them his last will and testament.

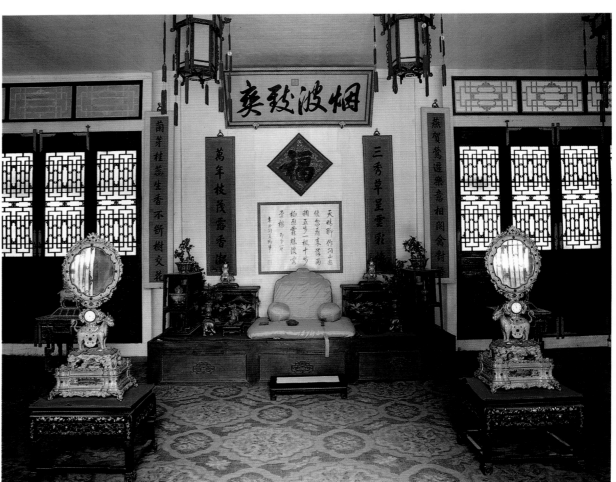

79

80

81

79. A *tiben* memorial.

This was a memorial reporting government affairs to the emperor. According to regulations, a *tiben* memorial must bear the official seal of the government department to which the presenter of the memorial belonged.

80. A *zouzhe* memorial and memorial box.

A *zouzhe* was a memorial in which an official reported confidential or private matters to the emperor. According to the regulations, no seal needed to be affixed to this document. Its transmission was not subjected to the 'memorial-drafting system' of the Grand Secretariat. A *zouzhe* was usually presented to the emperor in a box, and after reading it and commenting on it, he would return the memorial to the presenter to be acted on according to the emperor's instructions.

81. A *zhupi zouzhe*.

A *zhupi zouzhe* was a memorial on which the emperor had written his comments in red ink. This shows a memorial of the Yong Zheng period.

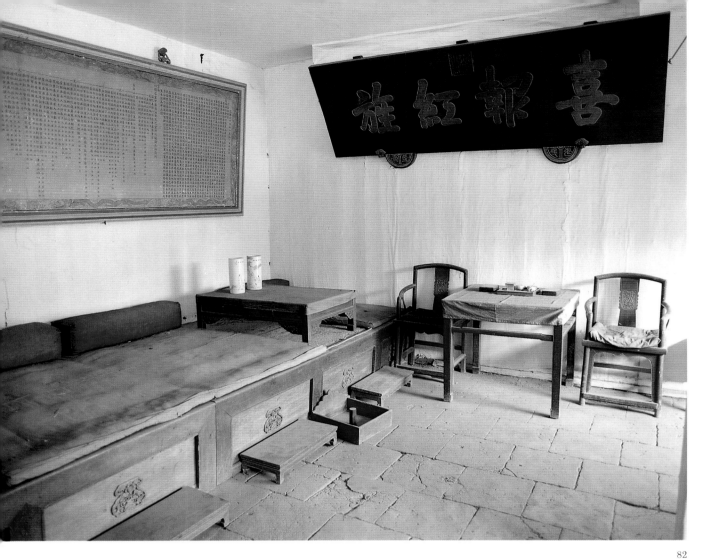

82. The Grand Chamber.

The Grand Council of the Qing dynasty had no office but a chamber within the Gate of Imperial Prosperity for Grand Ministers on duty. The Grand Ministers worked in two shifts, always ready to attend to the emperor's commands. Since it was used in shifts and was basically a duty-room, the chamber was simply furnished, with only a bed and the items necessary for carrying out their work.

82

83. A view of the exterior of the Grand Council Secretaries' duty-chamber.

As assistants to the Grand Ministers, these secretaries were also called Lesser Ministers of the Grand Council. Their duty-chamber was located to the south within the Gate of Imperial Prosperity, just opposite the Grand Chamber.

83

乾隆十八年三月二十一日奉

旨考績古制也前因部院大臣及各省督撫屆期循

例自陳近於故套且皆朕所深知量其材具隨時

黜陟何待三年四降旨傳止其四五品堂官特派

王大臣驗看察核惟三品京堂已列大僚既不可仍

滿自陳蕭葛蒿竟交部通行考核勢必無所殿最

即儻有察議亦不過拘拘成例僅就一二字義分

別等差縱不至徇情舞弊而詞義輕重之間或藉

以高下共手究未必能確披各員事蹟秉公覈實

於黜陟明之義何禪焉夫以各京堂雖非尚書

侍郎可比顧其居心行事俱在朕燭照之中令該

部開其事實親察核逐加詳定庶得其宜此次

更部所進各官事寔清招內如李世倬文保不過

旅進旅退即姑容延待數年未始不可但使京庸者

久居班列有妨後進遷次之階亦非澄叙官方之

道李世倬文保俱著以原品休致餘著照舊供職

欽此

84. A confidential letter in Chinese.

85. A confidential letter in Manchu.

Previously, the emperor's edicts had all been dispatched from the Grand Secretariat, but following the establishment of the Grand Council in the seventh year of Yong Zheng's reign (1729), many of these edicts were drafted by the Grand Ministers and, after being checked by the emperor, were sealed by the Grand Council and forwarded directly through the courier station. Such edicts, called *tingji* or *junjidachen zhiji* (confidential letters dispatched by the Grand Ministers), were generally addressed to a commandant, field marshal, imperial commissioner, military assistant, governor, general, field commander, deputy field commander, high commissioner, viceroy, provincial governor or provincial director, etc. In the Qing period, the *tingji* was an important measure to enable the emperor to ensure his personal control over affairs of state.

86. The Eastern Warm Chamber in the Hall of Mental Cultivation.

This was where Empress Dowager Ci Xi summoned ministers to audiences during the reigns of Tong Zhi and Guang Xu in the later period of the Qing dynasty. The Chamber is shown furnished exactly as it was in Ci Xi's time, with the gauze curtain and throne that Ci Xi used when 'holding court from behind the screen'.

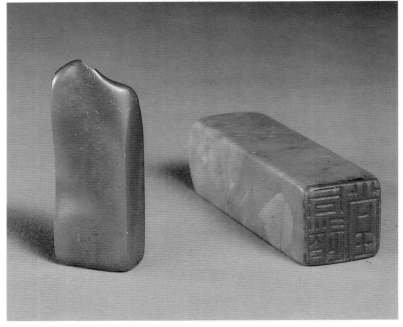

87

87. The *yushang* (5.1 cm high, 1.9 cm long, 1 cm wide) and *tongdaotang* seals (7.8 cm high, 2 cm long, 2 cm wide).

The *yushang* and *tongdaotang* seals were two private seals Emperor Xian Feng always carried at his belt. The *yushang* seal is of *tianhuang* stone, with the characters cut in relief, while the *tongdaotang* seal is of *shoushan* stone, with the characters carved out in intaglio. On his deathbed, Emperor Xian Feng bestowed the *yushang* seal on Empress Niuhuru (later known as Empress Dowager Ci An) and the *tongdaotang* seal on his only son, who soon became Emperor Tong Zhi. As Tong Zhi was under age, the *tongdaotang* seal fell into the hands of his mother, Yehonala, better known as Empress Dowager Ci Xi. After the palace coup of 1861, Ci Xi and Ci An, the two empresses dowager, seized from Su Shun and the other Ministers Regent the power to sign and issue the emperor's edicts. From then on an imperial edict was only considered valid if it bore the *yushang* seal of Ci An at the beginning, and the *tongdaotang* seal of Ci Xi at the end.

88. The impressions of the *yushang* and the *tongdaotang* seals.

89. An imperial edict stamped with the *yushang* and *tongdaotang* seals.

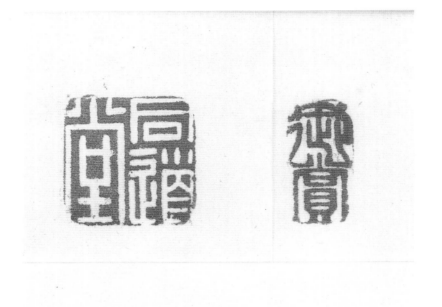

88

89

90. An inner page of a final imperial examination paper.

91. The cover of a final imperial examination paper.

Selection of officials in the Qing dynasty was through the civil-service examination system, and the highest level examination, called *dianshi* (palace examination), was held in the Hall of Preserving Harmony. The topic for the *dianshi* composition was assigned by the emperor and the papers were marked by specially appointed officials. The successful candidates were classified into three categories according to their examination performance. The first category consisted of three successful candidates called *jinshi jidi*; the second category consisted of an indefinite number of successful candidates called *jinshi chushen*, and the third category also consisted of an indefinite number of successful candidates called *tong jinshi chushen*. The first place in the first category was called *zhuangyuan*, the second place *bangyan* and the third place *tanhua*. The results of these classifications were first announced in the courtyard in front of the Hall of Supreme Harmony and then were announced publicly by the Board of Rites on a golden list posted outside the left-hand Gate of Eternal Peace.

90

91

92

92. The small golden list.

There were large and small lists of names of successful candidates. After the names had been announced, the large list was hung outside the Gate of Eternal Peace. The small one was the master-copy used during the announcement of the names.

93. The Qing emperor's abdication edict.

The Wuchang Uprising in the eighth lunar month of the third year of Xuan Tong's reign (October 1911) was followed by the eruption of the Revolution of 1911. On New Year's Day 1912, the Provisional Government of the Republic of China was proclaimed and set up its administrative headquarters in Nanjing, and on the twenty-fifth day of the twelfth lunar month in the third year of the reign of Xuan Tong (12 February 1912) the emperor Puyi announced his abdication, and brought to an end 2,000 years of monarchy in China.

93

94. A gilt-bronze astronomical telescope.

Made in the late Qing period for use in the Forbidden City, this was different from its predecessors in design, installation and regulatory mechanism, an innovation in the technology of astronomical instruments.

95. The equatorial armillary at the observatory.

The revision of the calendar caused a sensation at the Qing court during the Shun Zhi and Kang Xi periods, when two Board of Astronomy officials, the German missionary Johann Adam Schall von Bell (1591–1666) and the Belgian missionary Ferdinand Verbiest (1623–88) were thrown into prison on trumped-up charges. Kang Xi re-examined the case, acknowledged the achievements of the two and re-instated them to the Board of Astronomy. In gratitude, in 1673, Verbiest made a revolving sidereal globe and five other large astronomical instruments for the emperor, who placed them at the observatory in south-east Beijing. This equatorial armillary is on a two-dragon bronze stand. With four rings in three layers, it was used mainly to calculate the position of the stars.

94

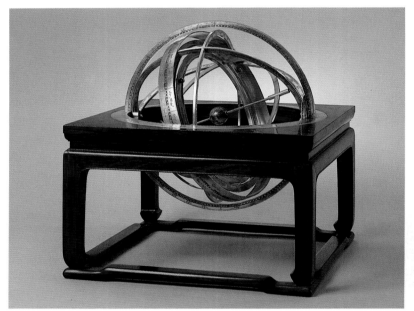

96

96. A silver-gilt armillary sphere.

Made for Kang Xi 1669 under the supervision of Verbiest, this was one of the earliest astronomical instruments made by the palace workshops. The armillary sphere was the same as its ancient Chinese counterpart in structure, except that the graduation on the rings followed the western system after the model of Tycho Brahe's instruments, whereby all the circles were divided into 360° rather than $365\frac{1}{4}$° and each degree into six parts. One side was inscribed with the words: 'Made by His Majesty's Subjects Ferdinand Verbiest and others in midsummer in the eighth year of the Kang Xi period.'

97. *A Comprehensive Map of the Empire.*

In order to facilitate military expeditions and inspection tours, Emperor Kang Xi ordered Joachim Bouvet (1656–1730), a French missionary holding a post in the Forbidden City, He Guodong and other Chinese mathematicians and astronomers to undertake a surveying expedition. They took well over twenty years to survey the vast land of China and drew an unprecedentedly large map, *A Comprehensive Map of the Empire.* This clearly drawn map not only accurately indicates positions and directions, but it also gives the height of Mount Everest. It was the most precise map in Asia at that time.

95

當呼天主之名方是為敬甚悖於中國敬天
可乎中國敬天亦是此意若依閩當之論必
然若以陛下為階下座位為工匠所造急急
御座無不趨踏起敬總是敬君之心隨處皆
皇帝陛下又如過
即大本通之論譽如上表章肉稱
講借中國理義即如以天為物不可敬天此
輕論之是非文學道
為可恕伊不但不知文理即字亦不識如何
關涉圖因多羅來時誤聽教下閒當不通文
理妄誕妄言假如閒曾慶通中國變理亦
行教與中國毫無損益即爾等去留亦毫無
庭曲賜優容亦寓中外一家之意至於爾等所
國之木何甞不容使爾等各獻微長出入禁
傳獲之人朕因軫念遠人俯盃玲恤以示中華
等自西洋航海九萬里投来情願効力華非
餘年並無祖亂乎安無事而犯中國法度爾

98. Emperor Kang Xi's letter to Rome.

In Kang Xi's reign, a controversy arose among foreign missionaries in China over whether or not Chinese Christians could follow the traditional Confucian teaching of ancestor worship. On learning of this, the pope sent a special envoy to China to announce a papal proscription against ancestor worship. Upholding Chinese traditional values, Emperor Kang Xi sent letters to Rome on several occasions to protest at the intervention in China's internal affairs.

98

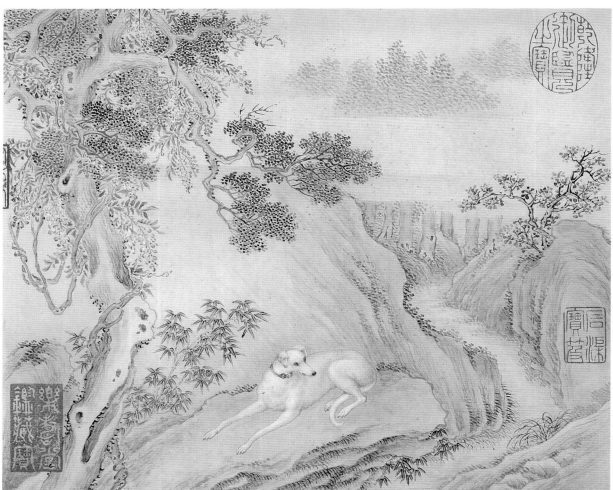

99. The 'Ten Hounds' by Ignatius Sickeltant. (25.2 cm × 30 cm)

During the Kang Xi and Qian Long periods a greater number of European missionaries were serving at the Qing court than at any other time. They included officials of the Board of Astronomy, court-artists, physicians, musicians and translators. Ignatius Sickeltant (1708–80), a Bohemian from what is now western Czechoslovakia, started work as a court-painter in the tenth year of the Qian Long reign (1745). The western dogs depicted in this painting were the dogs the emperor took with him on hunting expeditions.

99

100. The Japanese 'Seven Treasure Vase'. (120 cm high)

This vase was brought to the Forbidden City in the late Qing period.

101. An English mantel clock.

European clocks and watches had found favour with the Chinese emperors and empresses ever since they were brought into the Imperial Palace by the Italian missionary Matteo Ricci (1552–1610) in the Wan Li period of the Ming dynasty. During the Qing dynasty, European envoys often presented clocks and watches as gifts to the Chinese emperors.

100

101

MILITARY AFFAIRS

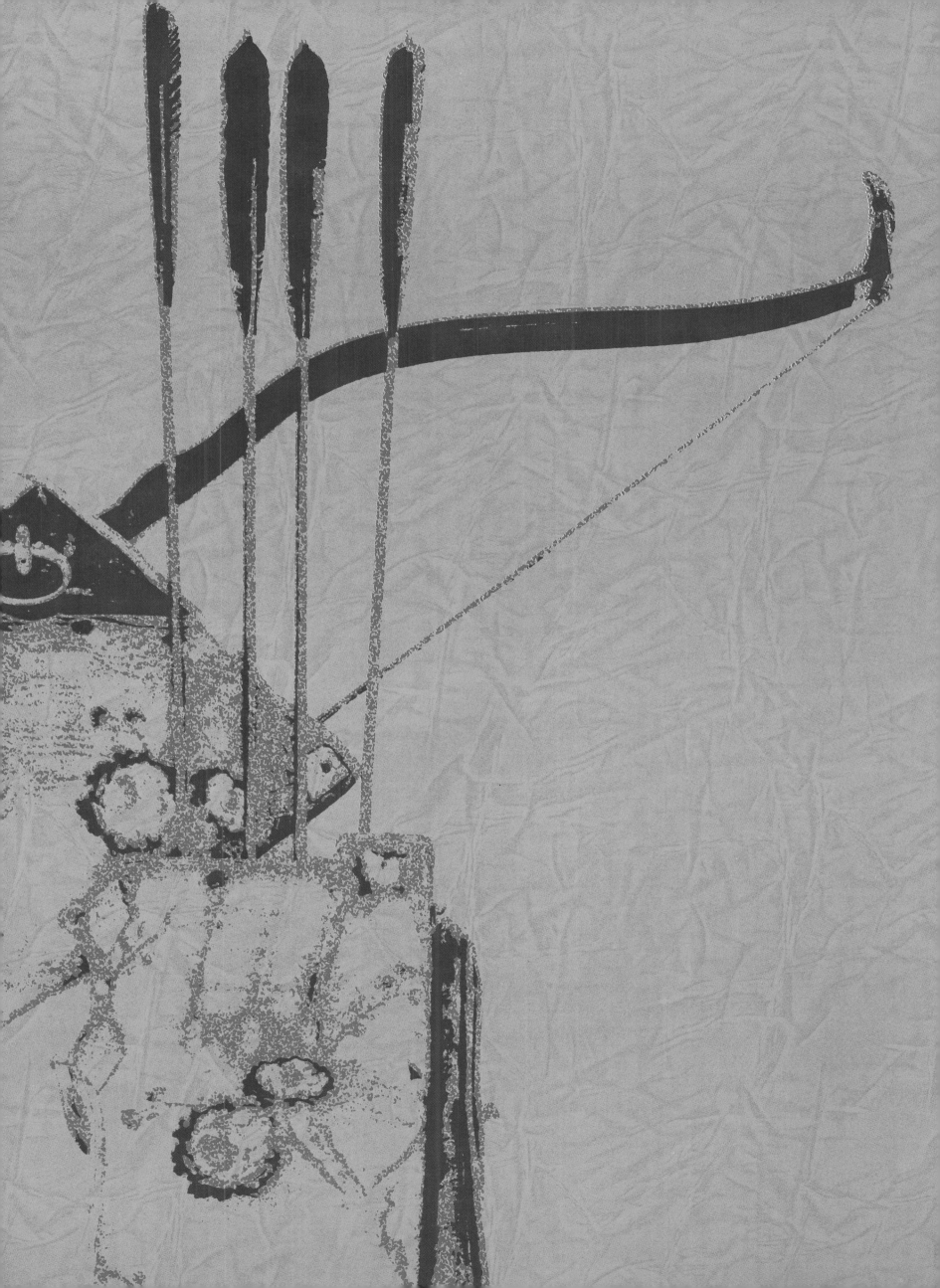

Before their conquest of China the Manchus were a tribe who existed by herding and hunting, and thus the two skills of primary importance to almost every adult male were those of archery and horsemanship. This basic principle was reinforced after Nurhachi's establishment of the Eight Banner system – which in effect integrated the army and the people – when it was stipulated that every Bannerman was obliged to master these two skills. It was this system that proved a major factor in the successful establishment of the Qing dynasty under the leadership of Nurhachi and Abahai. It is not surprising therefore that the Qing emperors who came after should attach great importance to these two skills, and regard their warrior tradition as 'the foundation of the Manchu people' and 'the spirit handed down by their forebears'.

The descendants of Abahai, the Emperors Shun Zhi, Kang Xi, Yong Zheng and Qian Long all agreed with the wisdom of this approach, and they adopted various measures to keep up these Manchu traditions. Firstly, they intensified the education of the imperial family and the Eight Banners, exhorting them not to be less than whole-hearted in their practice of riding and shooting. Emperor Shun Zhi made it a rule that all male members of the imperial clan should, as soon as they reached the age of ten, attend riding and shooting sessions on the drill-ground every ten days. Even greater demands were made on those members of the imperial family who held official rank and were over twenty years of age. They were required to put on armour and join in the archery examinations held by the Court of the Imperial Clan in the spring and autumn of every year. Shun Zhi authorized the Court of the Imperial Clan to punish severely those who failed to do well through idleness. The emperor was equally strict with his own sons, and his extremely skilled bodyguard, Mo'ergen, was specially detailed to teach the emperor's young son, Xuanye (later Emperor Kang Xi), to ride and shoot. In later life Xuanye recalled with gratitude: 'My proficiency in all kinds of skills was due entirely to Mo'ergen. I have been particularly impressed by his loyalty and honesty, and while I can never repay him, I will always remember him.'

This early arduous training in archery and horsemanship was to prove of great advantage to the Emperor Kang Xi when he took on the responsibility for the government of the country. He believed that the mastery of archery and other military skills was essential to the maintenance of the superior status of the Manchu aristocrats. However, the princes brought up in the luxury of the Imperial Palace, lacking this kind of strict training, gradually began to forget their own language and neglect the martial skills, finding them a burden. In order to uphold the warrior traditions of the past, Kang Xi devoted a good deal of time and energy to training the princes, personally supervising them in their lessons and commanding them to go to the court at dawn to recite the classics and practise horsemanship and archery.

Kang Xi also took appropriate steps to train the children of the Eight Banner families. After the foundation of the Qing dynasty, many Bannermen found that promotion could be achieved more quickly through sitting for imperial civil-service examinations, so gradually more and more of them abandoned the study of military in favour of literary skills. There appeared, therefore, a real danger of their forgetting their warrior traditions. In order to counteract this trend, the Emperor Kang Xi encouraged the children of the Eight Banner families to sign up for the imperial examinations, but ordered the Board of War first to examine the candidates in the Manchu language as well as horsemanship and archery. Only those who had reached the required standard in shooting and riding were allowed to sit for the imperial examinations. In addition, Emperor Kang Xi greatly enhanced the position of the military candidates. From the twenty-ninth year of Kang Xi's reign (1690), whenever the candidates had their highest imperial military examinations in horsemanship, archery, sword-play and weight-lifting in front of the Purple Light Hall, the emperor would personally choose the best to be his bodyguards and promote them to the ranks of the Upper Three Banners. During the Yong Zheng period this was extended so that it was explicitly stipulated that 'The first successful military candidate (*zhuangyuan*) in the highest imperial examination is to be given the title Bodyguard of the First Rank; the second and third successful military candidates are to be given the title Bodyguards of the Second Rank.' Among the military it was regarded as a great honour to be bodyguard to the emperor.

Another important measure to promote military accomplishments and the practice of martial skills during the Qing dynasty was the establishment of the review and hunting systems. A major dress-parade was held once every three years, at which the emperor would review the arms and military skills of his troops. The Eight Banner Troops would form into lines according to the order of their Banners and each in succession would demonstrate before the emperor their skills with cannon, gun and bow, as well as in riding, deployment of battle formations, scaling ladders, etc. The Qing emperors regarded these reviews as useful, not only in the training of the Eight Banner Troops, but also as an opportunity to display the strength of their forces to the leaders of other nations.

From the twenty-first year of Kang Xi's reign (1682) onwards, the emperor organized several large-scale military manoeuvres each year, ostensibly as hunting trips, so as to raise the combat potential of the Eight Banner groups. Many court officials could not understand why the emperor should expend such effort and submitted memorials to the throne expressing their opposition to such activities. Manifesting as they did principles counter to his own militaristic commitments, these memorials were naturally rejected by the Emperor Kang Xi, who not only continued his large-scale manoeuvres, but personally led his troops to Ningxia and Inner Mongolia several times, to put down disturbances in the regions of Mongolia and Tibet. Events proved him right regarding his concern with preparedness for war and constant military training, for his Eight Banner Troops were thus ready to win the battles they fought in the border areas and to recapture Taiwan. In his later years, when the Emperor Kang Xi recalled those events, he said with satisfaction: 'If I had believed what was said in the memorials, avoiding fatigue and hardship, and not continuing with the training of the troops, how could they have undertaken expeditions ten thousand *li* away from home to wipe out the bandits and win such victories?'

In order to upgrade the combat efficiency of the Eight Banner Troops further, the early Qing emperors all established special troops like the Wrestling Battalion, the Tiger-killing Battalion and the Firearms Battalion, with the aim of training soldiers in specialist skills. It was through the deployment of a group of court guards who were skilled in wrestling that the Emperor Kang Xi was able to rid himself of the despotic minister Oboi, and thereafter the Wrestling Battalion was formally established. So whenever the emperor gave a banquet for Mongolian princes or watched the military candidates demonstrate their prowess in archery, horsemanship, sword-play and weight-lifting for the imperial examinations, the fighters of the Wrestling Battalion would display their skills.

The Firearms Battalion was established in line with the increasing use of cannon and other firearms in the Eight Banner army. The Eight Banner Troops began to use firearms even before they crossed the Great Wall; indeed, most of the cannon, which they called 'red-coated cannon', were captured from the Ming troops. Several decades later, when they came to put down the rebellions in the border regions, they found that the firearms they had were inadequate. At that time the emperor had no specialist in such weapons, and Kang Xi therefore had to appoint Ferdinand Verbiest of the Board of Astronomy to be in charge of the manufacture of new cannon. So, drawing on all his knowledge of physics, chemistry and engineering, he finally designed and made 320 cannon. Emperor Kang Xi always took the greatest interest in Verbiest's work, believing that modern weapons would be an important factor in deciding the outcome of any future war. When the new cannon were tested at Lugouqiao, the emperor himself went there to observe. The tests were a great success. Kang Xi gave one of the new cannon an awe-inspiring title on the spot: 'Unconquerable, Invincible General', and gave a banquet for the officers of the Eight Banners at the shooting range. In recognition of Verbiest's considerable achievements, the Emperor Kang Xi took off his own marten coat and gave it to Verbiest as a reward. He also took the unprecedented step of promoting him to the rank of Vice-President of the Board of Works (an official of the Second Rank).

With the advent of war there was an increasing demand for arms and a greater proportion of the soldiers began to use firearms. Kang Xi therefore organized these soldiers into a Firearms Battalion of eight thousand officers and men.

Although the emperors of the early Qing period attached great importance to teaching their offspring the traditional skills of riding and shooting, the extravagant and dissolute lifestyle and peaceful atmosphere of the court made the princes and dukes less and less inclined to keep up their martial skills. By the Qian Long period many princes, dukes and other aristocrats could no longer speak Manchu, and their skill at archery had become mediocre. Incensed by this, the Emperor Qian Long ordered the Court of the Imperial Clan to give the younger members of the ruling house tests once a month. 'If there is anyone who cannot speak Manchu, punishment should be given to the princes, dukes and tutors if the boy studies at school; to his father and elder brother if he studies at home.' In the case of the princes and dukes of the imperial clan themselves, Emperor Qian Long personally commanded one of his sons or the Grand Chamberlain to examine them in the Manchu language, horsemanship and archery several times a year. Emperor Qian Long also ordered the Archery Pavilion to be built in the Forbidden City for them to practise their horsemanship and archery. In addition, he ordered the erection of carved stone steles at the drill-grounds of the Archery Pavilion, the Purple Light Pavilion and the imperial guards' barracks, so as to remind his descendants always to be aware of their martial heritage and the need for proficiency in the Manchu language.

Attention was also given to palace security. The imperial court guards of the Qing dynasty were made up of the Department of Bodyguards, the Guards Battalion and the Vanguards Battalion. Because the Department of Bodyguards was directly responsible for the security of the emperor, it was particularly highly regarded, and held a higher rank. All the bodyguards were chosen from the Upper Three Banners, which were controlled by the emperor himself. Those who were of particularly good appearance and were proficient at martial arts were singled out to become the emperor's bodyguards, while the others were divided into the inner and outer groups. The inner group guarded the Gate of Heavenly Purity, the Inner Right Gate, the Gate of Divine Prowess and the Gate of Peaceful Old Age. The outer group guarded the Gate of Supreme Harmony. Although the Eight Banner Troops were the main armed forces of the Qing dynasty, they were subdivided into the Upper Three Banners, commanded by the emperor himself, and the Lower Five Banners, led by the princes. Of the gates of the Forbidden City, the most important were guarded by the Department of Bodyguards. All the other gates were guarded by Upper Three Banners officers and men from the Guards Battalion and the Vanguards Battalion. The gates outside the Forbidden City were guarded by the Lower Five Banner Troops. The responsibility for the security of the Imperial Palace was the primary function of the Department of Bodyguards, the Guards Battalion and the Vanguards Battalion. There were 525 officers and men on each watch of the Guards Battalion. Those on sentry duty at the various gates inside and outside the Forbidden City were armed with a full complement of weapons. These had to be maintained in first-class order, and their bows had to be drawn every day.

The Forbidden City was important not only as the place where the emperor, empress and imperial concubines lived, but also as the place which housed the largest administrative complex. Although there were deep city moats and high walls, it was difficult to avoid the occasional incident. In order to consolidate the security of the court, the Qing emperors initiated a number of precautionary measures. A horse-dismounting stele was erected outside the Forbidden City, where all officials had to dismount and leave their horses and bodyguards behind. The only exceptions were for princes and their sons, who were allowed to take two bodyguards into the court with them. The ministers and officials who entered the court on business were required to enter through the gate appropriate to their rank. The emperor would go through the centre of the Meridian Gate. Princes, dukes and royal clansmen would use the entrance to the right of the Meridian Gate, while other officials went through the entrance to the left. Palace officials, eunuchs and artisans entered through side-doors of the East Flowery Gate, the West Flowery Gate and the Gate of Divine Prowess. Those working in the emperor's Southern Study – because they were very close to the emperor – could come and go through the Gate of Heavenly Purity. The Grand Chamberlain and members of the Grand Council entered through the Inner Right Gate. At each of the gates around the Forbidden City two guards were posted holding red wooden staffs. They would use the staffs to beat anyone who dared to try and enter without giving their name. Specially appointed officers would check the names of the officials who passed by. Labourers, artisans and cooks who worked in the court were strictly examined. They were given a Waist Card, on which was written the name, Banner and features of the holder. It was the authorization for them to pass through the gates, and at the gates were kept bound copies of the documents on file so that checks could be made.

At night the security of the Forbidden City was even tighter. Those who entered or left the palace had to have a tally with the characters for 'Imperial Edict' carved in relief and were allowed to pass only when their tally was found to match another tally with which it formed a pair. The other half had the characters carved intaglio and was kept at the gate. There was also a night patrol system – the guards on patrol passed to one another a foot-long wooden baton around the Forbidden City, non-stop, all through the night. The wooden baton was passed from hand to hand through the main gates and passages to keep a check on the patrols.

Although the Imperial Palace was heavily guarded, many incidents still took place which disquieted the emperors. In 1758, when a lone monk armed with a short sword broke through the East Flowery Gate, several dozen guards in the vicinity were apparently rendered immobile by his aggressive manner. It was only when the monk reached the Gate of Harmony that several guards were finally able to apprehend him. Qian Long was extremely angry with the slackness of the security system and the incompetence and cowardly behaviour of the guards. He rebuked them, saying, 'You had plenty of men there, yet you could not even stop a single monk. If you met the enemy on the battlefield, I expect that you would run away and be defeated.' He ordered that these comments of his should be written on wooden placards and hung at every gate to admonish the guards.

In the Jia Qing period there were two further major incidents. In 1803, Chen De, who had worked in the imperial kitchen as a cook and who could no longer bear his poverty, slipped into the Imperial Palace with his son. When Emperor Jia Qing reached the Gate of Divine Prowess on his way back to the palace, Chen De and his son rushed out with daggers to assassinate him. More than one hundred guards at the scene of the attack did not know what to do. Only six of the emperor's bodyguards had the courage to struggle with the would-be assassins. This caused the emperor considerable panic, and he immediately ordered an examination of the guarding procedures for the palace. He also ordered admonitory wooden placards erected again. On the boards were written his own rebuke as well as that of Qian Long, and they were hung at all the entrances. Ten years later an even more serious incident took place. A small detachment of troops of a peasant uprising, with the help of eunuchs operating within the palace, rushed through the East Flowery Gate and West Flowery Gate, and even reached the Hall of Mental Cultivation. Although the emperor was not there, and the rebellious peasant troops were quickly defeated, nevertheless, the event greatly shocked the emperor, who declared, 'Such an incident never happened in the Han, Tang, Song or Ming dynasties,' and felt compelled to issue a 'self-condemnation edict' on his way back to the palace. With the decline of the Qing dynasty, the defence of the Forbidden City deteriorated still further. In the periods of the Emperors Tong Zhi and Guang Xu more incidents took place, such as the theft of weapons and bronze chains. Pedlars came and went as they pleased. The Empress Dowager Ci Xi and the Emperor Guang Xu could only bemoan the fact that, 'The established laws are no longer respected,' and command the guards to 'order stricter patrols'. They were not, however, able to strengthen the discipline within their troops.

102. The Purple Light Pavilion.

This is on the western bank of the Great Liquid Pool – today the North, Central and South Lakes in the Western Park in Beijing. It was called the Level Terrace in the Ming dynasty. It was the main venue for martial activities during the Qing period. In mid-autumn the emperor gathered officers from the Upper Three Banners in front of the pavilion to demonstrate their skill at riding and archery. When military candidates took their final imperial examinations, the emperor would sit in front of the hall to watch them shooting both from horseback and on foot.

103. *A Banquet at the Purple Light Pavilion.* (45.8 cm × 486.5 cm)

Emperor Qian Long ordered the hall to be reconstructed to commemorate several great victories. In 1761, after reconstruction, the emperor gave a banquet to celebrate the event, and ordered painters like Yao Wenhan to paint portraits of the officials and army commanders who had rendered meritorious service. He wrote a laudatory poem and had it and the portraits hung inside the hall.

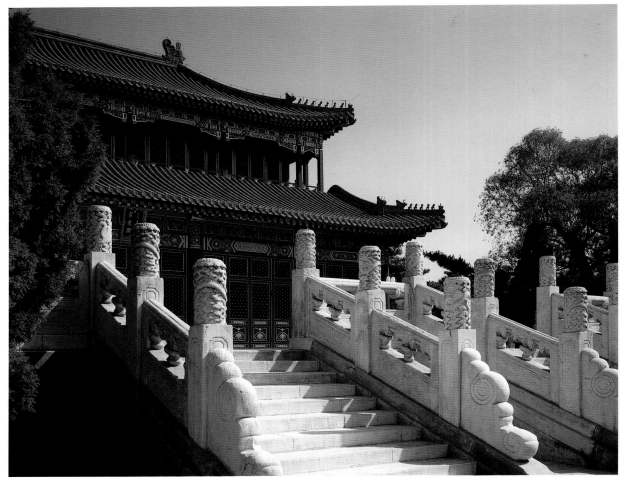

102

103

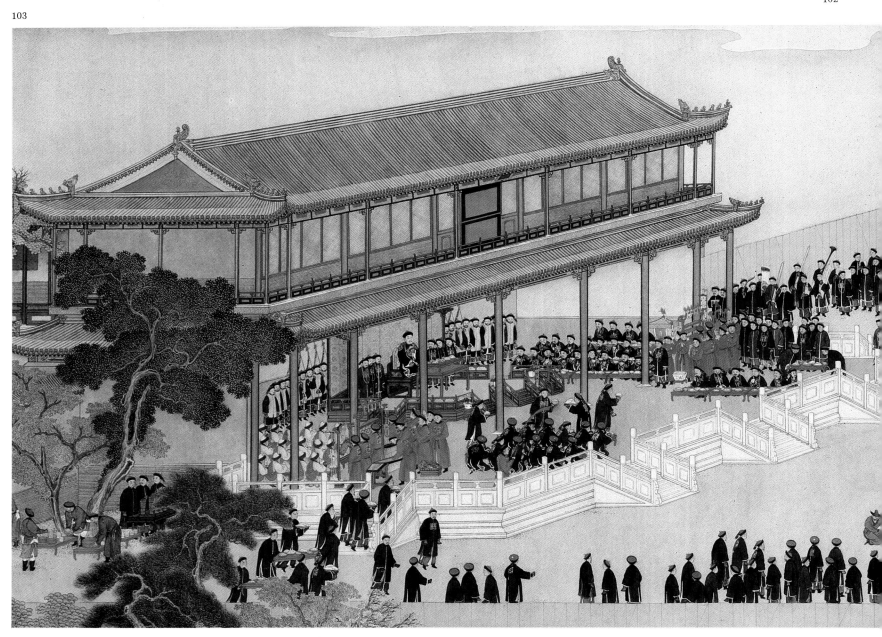

104. The stele at the Purple Light Pavilion.

The Qing dynasty was established through military proficiency, and the Qing rulers regarded horsemanship and archery as 'the foundation of the Manchus'. In order to keep to 'the spirit of the former emperors', to consolidate and strengthen the rule of the Qing dynasty, Emperor Qian Long promulgated decrees in the seventeenth year (1752) and twenty-fourth year (1759) of his reign which told the officials of the Eight Banners to be diligent in riding and shooting practice and to strive for proficiency in the Manchu language. Later, the decree issued in the seventeenth year of the Qian Long reign was inscribed as an admonition on several steles which were put in the Archery Pavilion inside the Forbidden City, at the Purple Light Pavilion in the Western Park, as well as at the drill-grounds of the Imperial Guards and the Eight Banner Troops.

105. A rubbing of one of the stele inscriptions in the Purple Light Pavilion.

104

105

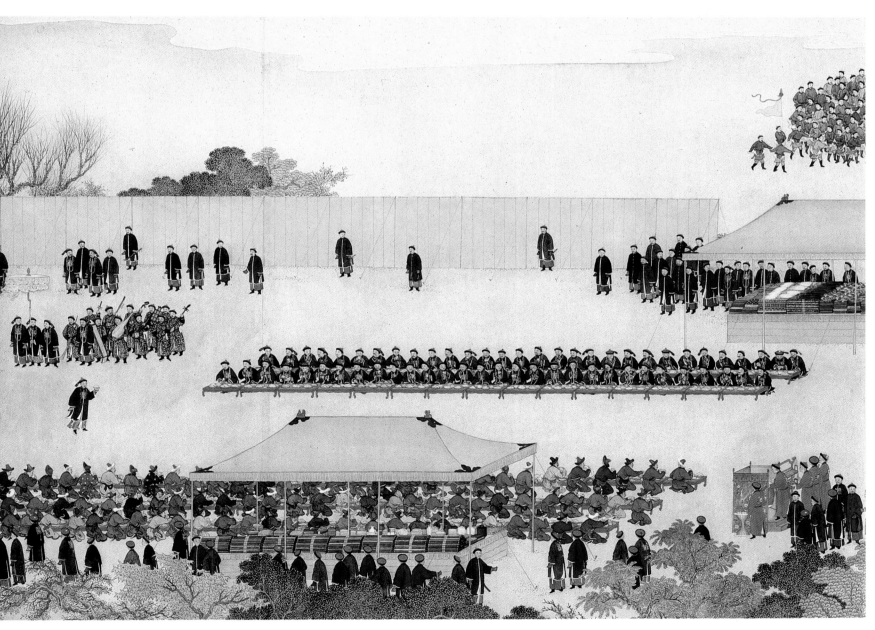

77

106. Qing dynasty weapons.

From left: *ahu* spear, lance, two halberds with crescent-shaped blades, *shu* spear, three long-handled swords (two with flanged crescent-shaped blades), two *tang* spears.

106

阿虎槍

矛

戟

戟

殳

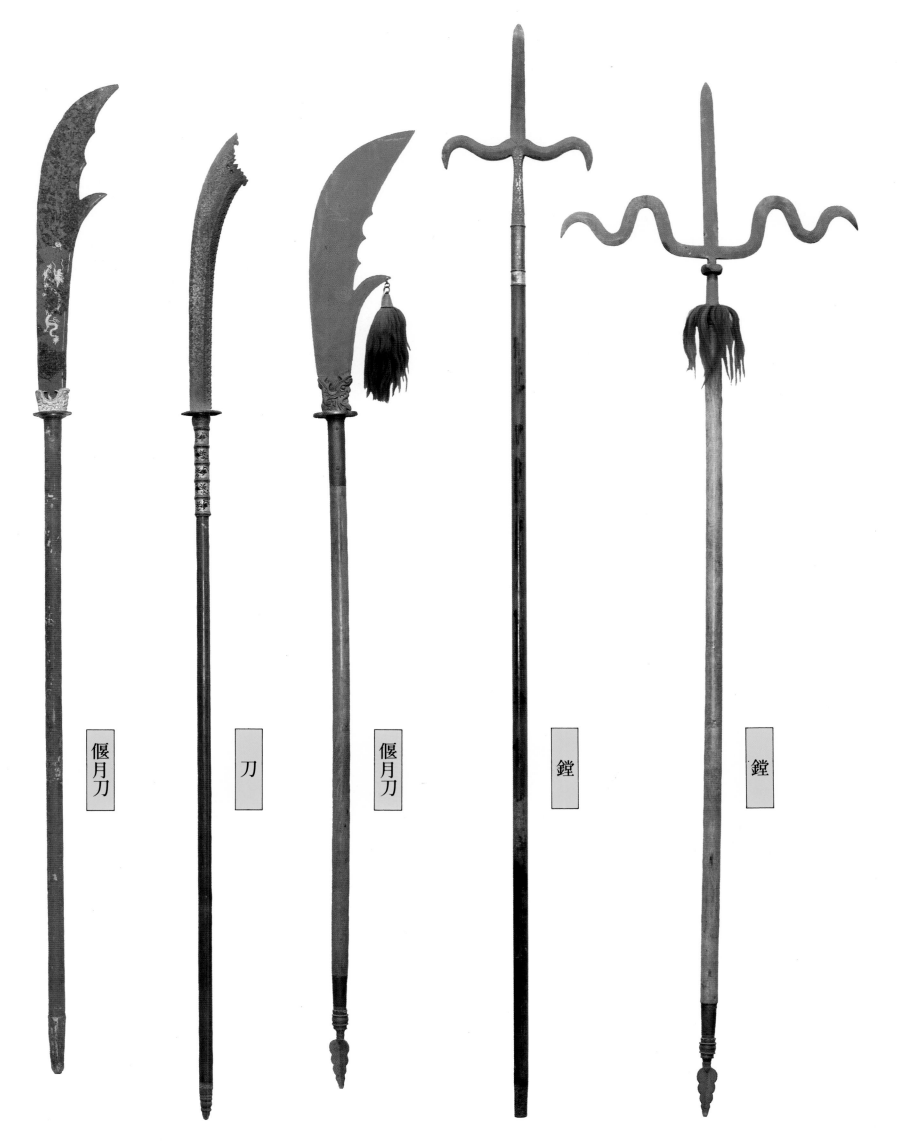

偃月刀　　刀　　偃月刀　　鎲　　鎲

107

108

107. A rattan shield.

Rattan shields – the example shown is from Fujian – being light, solid and strong, were widely used for defence in ancient military encounters. In the Qing dynasty the Green Battalion Troops all had rattan shields, and the Valiant Cavalry Battalion of the Eight Banner Han Troops, which was regarded as a special troop, was a Rattan Shield Battalion, playing a part in the battle to resist the Russian invasion at Yacsa in the Kang Xi period. The soldiers brandishing their rattan shields defeated the enemy and won the day.

108. A long-handled sword and crossbow, illustrated in *Weapons of the Imperial Palace*.

The book *Weapons of the Imperial Palace* was compiled in the twenty-fourth year of the Qian Long reign (1759). It includes all kinds of weapons used in the Qing dynasty. It may be noted that the crossbow was in use in China in the Bronze Age, many centuries before its appearance in Europe.

109. The 'mighty long-range general' cannon, made for the Emperor Kang Xi.

Firearms were in use in the Abahai period, before the Qing troops moved south of the Great Wall. During the reign of Kang Xi, because of the need to suppress the rebellions on the borders, cannon began to be manufactured in large numbers. This cannon, weighing 280 kg, is made of bronze. Its shells each weigh 15 kg. Engraved on it in Manchu and Chinese is: 'Mighty long-range general, made at Coal Hill in the twenty-ninth year of the reign of Kang Xi of the Great Qing Dynasty. General Supervisor: Hai Qing, imperial guard of the First Rank. Supervisor: Le Li, Board secretary. Designer: Ba Ge. Workmen: Yi Hangzheng and Li Wende.'

109

110

110. *A Catalogue of Weapons.*

This catalogue, compiled during the Qing Long period and revised in the Jia Qing period, records all kinds of weapons and the sums of money spent by the troops of the Green Battalions and the Eight Banner Battalions garrisoned in the provinces and in the capital.

111. The Archery Pavilion.

To encourage the children of the royal family and the Eight Banner Troops to carry on the martial tradition of the Manchus, Emperor Qian Long ordered that an Archery Pavilion be built outside the Gate of Flourishing Fortune in the Forbidden City for daily military training. When military candidates took their imperial examinations, the emperor would sit here to assess the skill of military candidates in archery, sword-play and weight-lifting.

111

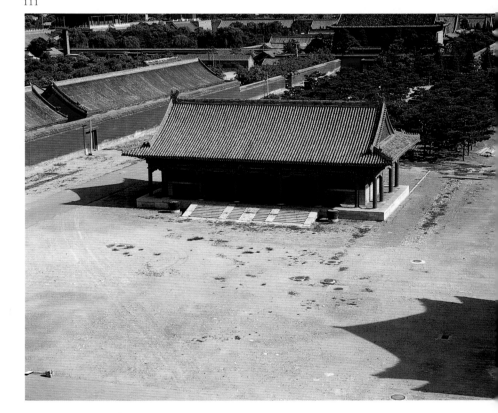

112. The blockhouse used for military training.

During the Qian Long period, disturbances broke out in the Greater and Lesser Jinchuan areas in the southwest. Several times Emperor Qian Long sent troops to suppress the rebellions, but they failed on each occasion because the blockhouse walls were too formidable. Later Emperor Qian Long ordered a blockhouse built at the foot of the Fragrant Hills, where special troops practised scaling the walls using ladders by day and night. They began to employ military strategy and were finally able to defeat the rebels. A special battalion was then stationed at the blockhouse.

113. The Drilling Tower in the Round City.

At the same time as Emperor Qian Long ordered a special battalion to be established, the Round City was built near by, where he could review the soldiers of the special battalion during their military training.

112

113

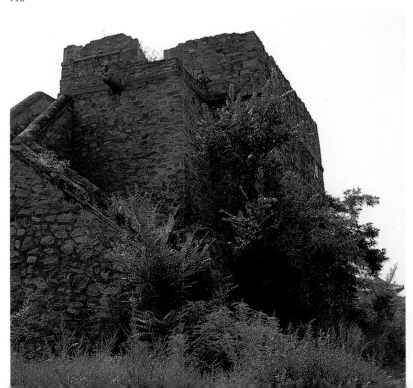

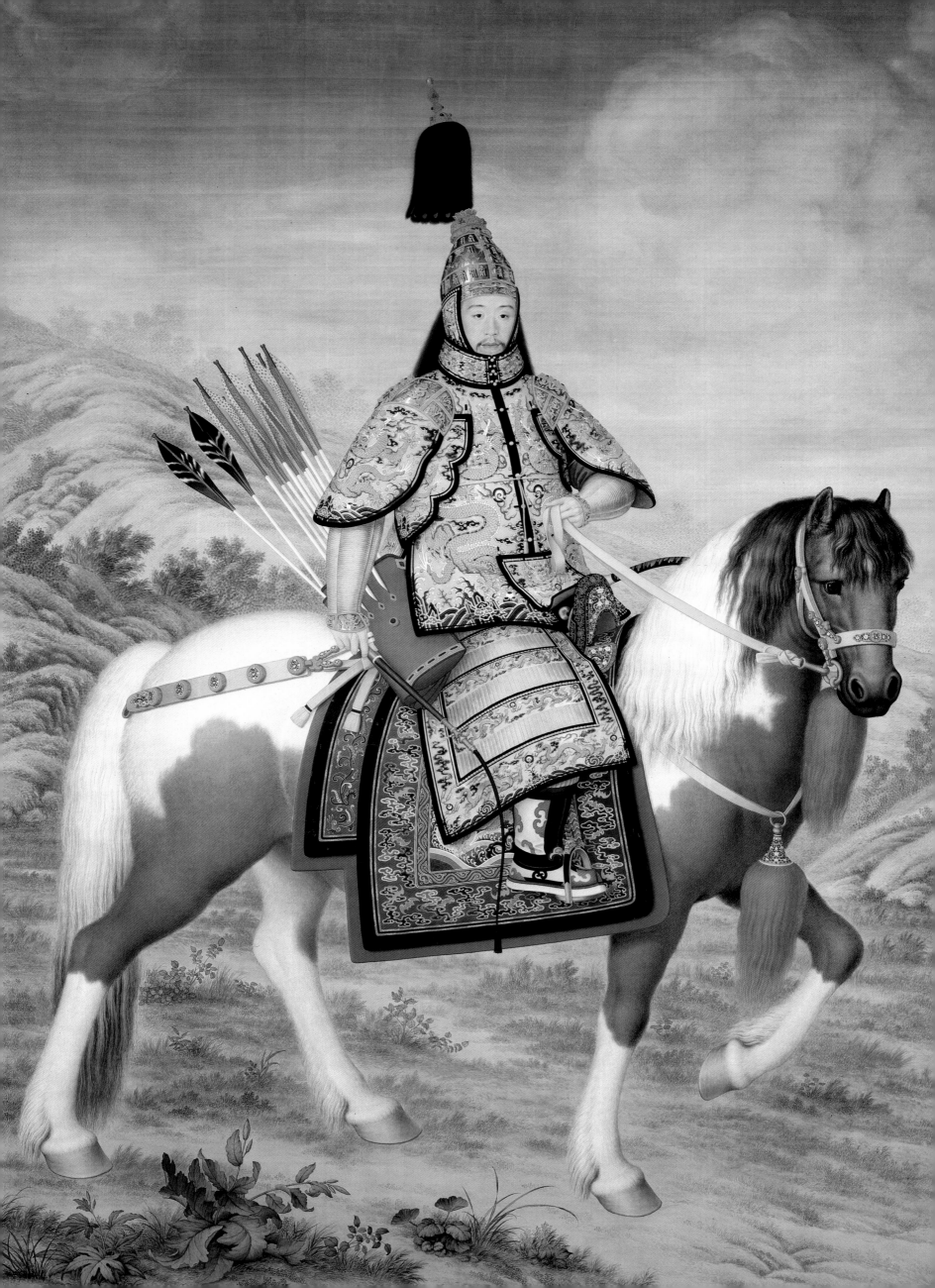

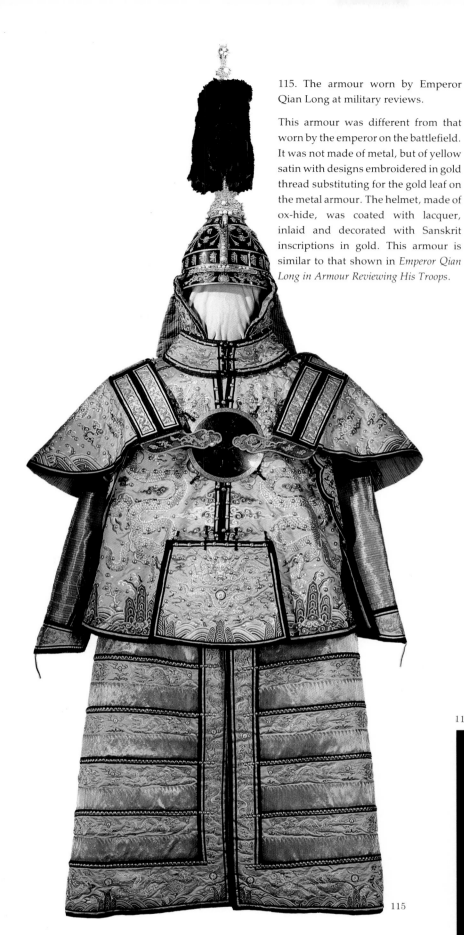

115

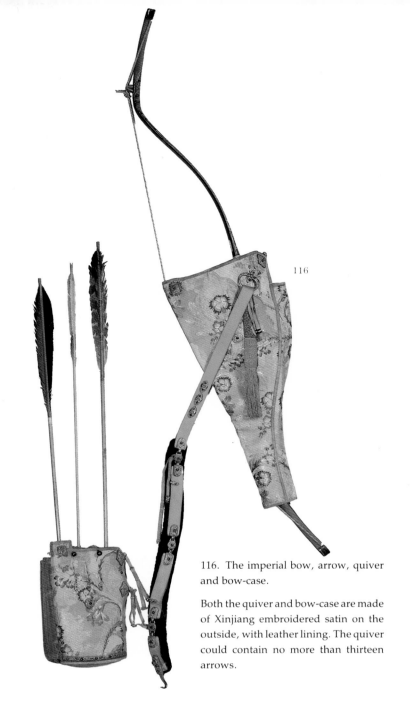

116

117

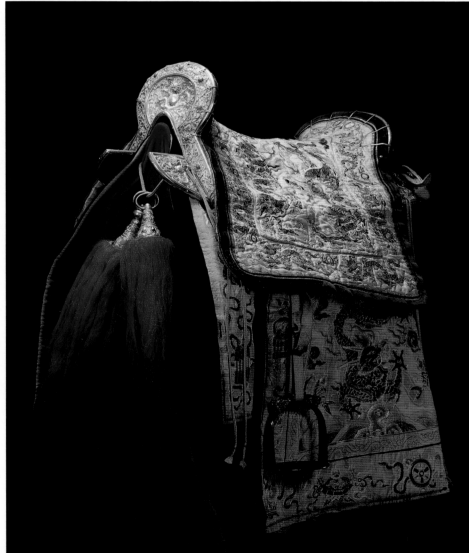

115. The armour worn by Emperor Qian Long at military reviews.

This armour was different from that worn by the emperor on the battlefield. It was not made of metal, but of yellow satin with designs embroidered in gold thread substituting for the gold leaf on the metal armour. The helmet, made of ox-hide, was coated with lacquer, inlaid and decorated with Sanskrit inscriptions in gold. This armour is similar to that shown in *Emperor Qian Long in Armour Reviewing His Troops*.

116. The imperial bow, arrow, quiver and bow-case.

Both the quiver and bow-case are made of Xinjiang embroidered satin on the outside, with leather lining. The quiver could contain no more than thirteen arrows.

114. *Emperor Qian Long in Armour Reviewing His Troops*. (322.5 cm × 232 cm) A coloured silk scroll by Giuseppe Castiglione (1688–1766), Lan Shining in Chinese.

Qing dynasty military reviews began with the Emperor Tai Zong (Abahai), and in the Shun Zhi period a review was held every three years. The emperor, in full armour, would review the Eight Banner Cannon Battalion, Firearms Battalion, Vanguards and Guards Battalions, etc. In the Qian Long period most of the reviews took

place in the Southern Park. This picture was originally hung in the temporary palace in the Southern Park and was moved to the Palace Museum in 1922.

117. Emperor Shun Zhi's imperial saddle.

Inlaid with gold and pearls, the saddle has a saddle cloth embroidered in coloured silks with designs of clouds, dragons and waves. It is typical of early Qing dynasty embroidery.

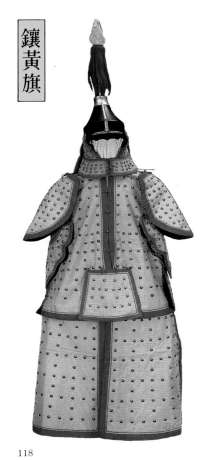

鑲黃旗

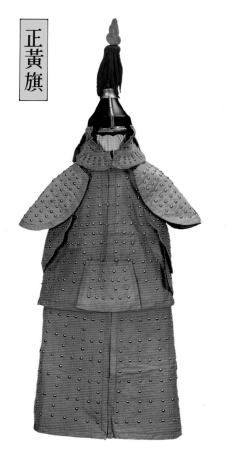

正黃旗

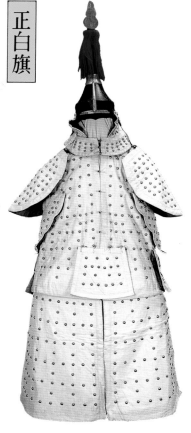

正白旗

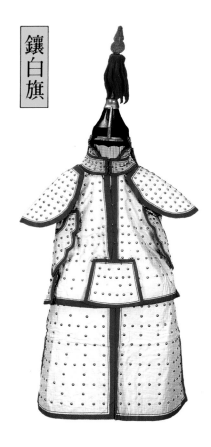

鑲白旗

118

118. Suits of armour of the Eight Banner Troops.

The armour of the Eight Banner Troops was divided into the bordered yellow, the yellow, the white (these three are for the Upper Three Banners), the bordered white, the red, the bordered red, the blue and the bordered blue (these five are for the Lower Five Banners). This armour was formal attire for the grand review, not for use on the battlefield. It was lined with cotton cloth, with silk on top and a decoration of bronze nail-heads. The helmets were made of ox-hide. In the Qian

Long period tens of thousands of such suits of armour were made by the Hangzhou Imperial Silk Workshop, but they were only worn during the grand review. When not in use they were stored in the tower over the West Flowery Gate of the Forbidden City.

119

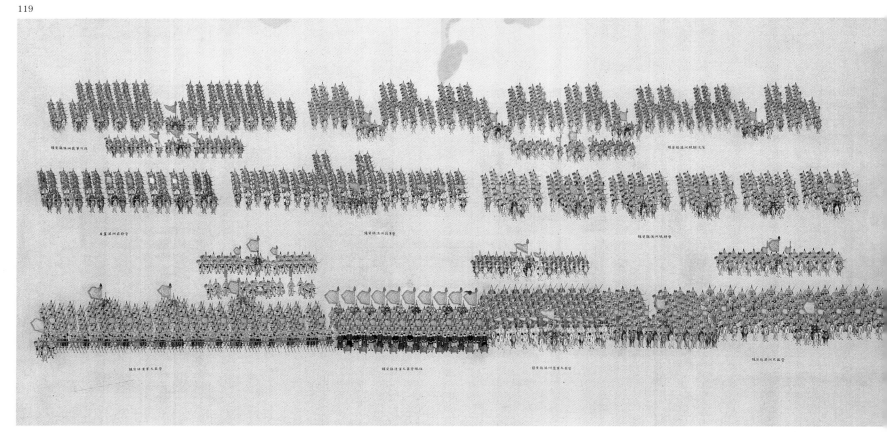

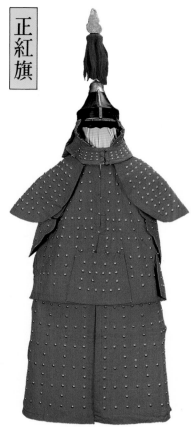

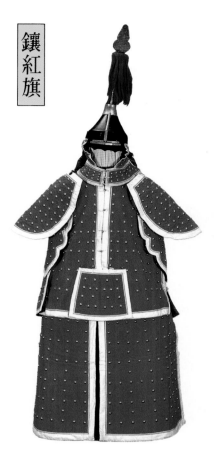
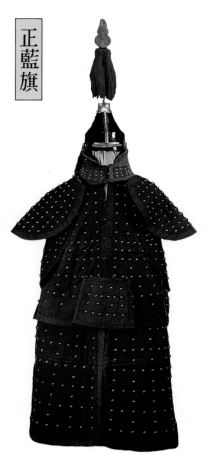
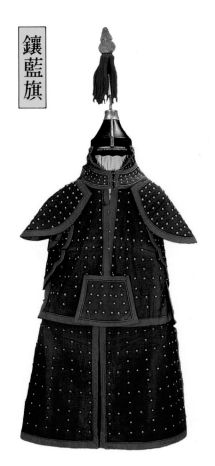

正紅旗　鑲紅旗　正藍旗　鑲藍旗

119. *Emperor Qian Long Reviewing Troops.* (detail, 68 cm × 1761 cm)

This painting was done by court-artist Jin Kun and others in the twelfth year of the Qian Long reign (1747). During the Qing dynasty, the Eight Banner system was introduced not only among the Manchus but later among the Mongolians and the Han-Chinese for the purpose of enlarging the Qing rulers' military forces and winning the support of the people. Thus, there were also the Mongolian Eight Banners and the Han Eight Banners. The Eight Banner officers and men who took part in the grand review were in fact from twenty-four banners including the Manchu, the Mongolian and the Han, totalling tens of thousands for each review. The illustration depicts the Manchu Valiant Cavalry Battalion under the bordered yellow banner, the Manchu Cavalry Battalion under the white banner, the Han Firearms Battalion under the bordered yellow banner and the Manchu Guards Battalion under the bordered yellow banner, indicating the proper order of the Eight Banner Troops of the Manchu, Mongolian and Han during the military review.

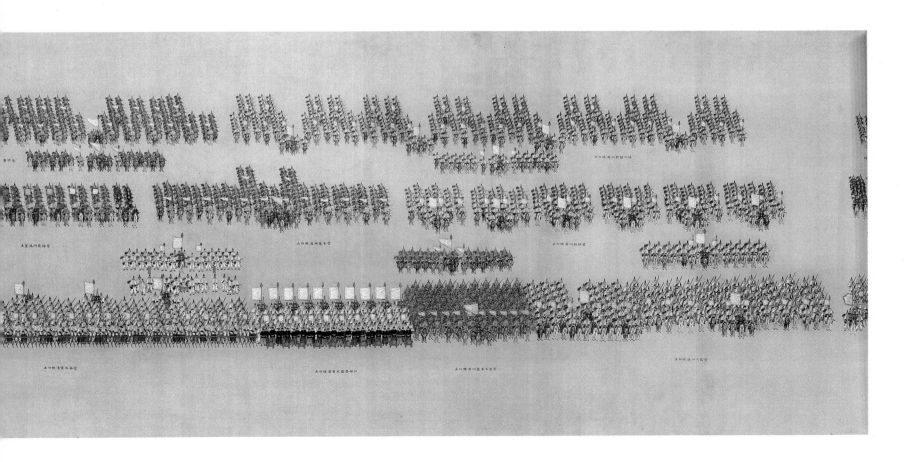

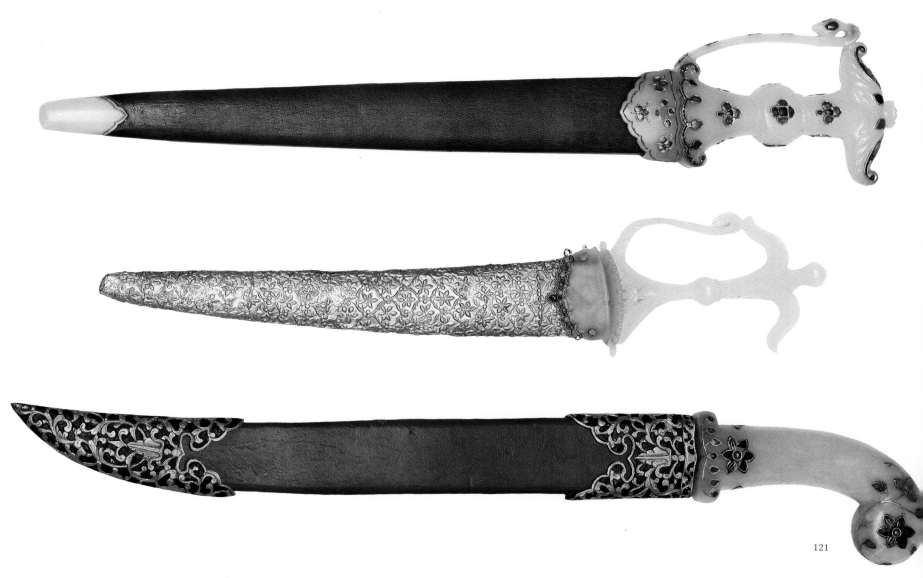

120. The Southern Turret over the West Flowery Gate.

It was stipulated in the early Qing dynasty that the Upper Three Banner guards were responsible for the defence of the four gates of the Forbidden City and the Left Imperial Gate, Right Imperial Gate, Gate of Correct Demeanour, Gate of Heavenly Peace and the Great Qing Gate. The West Flowery Gate was manned by one guard officer, two guards in charge of checking passes and twenty sentries. The other three gates had the same number of guards. During the day they kept watch at the gates, and at night they patrolled the Forbidden City.

Outside the Forbidden City, their fixed route was as follows: they set off from the Left Imperial Gate, turned westward and walked through the Meridian Gate, exited from the Right Imperial Gate, walked westward and then turned north, passed through the West Flowery Gate, walked around the Forbidden City walls and then turned back to the Left Imperial Gate. There were many enclosures and twenty-two sentry-posts on the way.

121. The emperor's daggers.

These sharp daggers, about a foot in length, were usually hidden under the emperor's throne to enable him to defend himself if necessary.

122. Emperor Qian Long's sword.

The hilt is inlaid with blue jade and gems and the sheath is made of the bark of a species of peach tree grown in Xinjiang.

123. A Waist Card.

The Waist Card was the authorization which allowed the artisans and labourers working at the court to enter and leave the Forbidden City during the Qing dynasty. It was tied to the waist and could not be transferred or lent; those who did not obey this rule were liable to punishment. Made of wood, the Waist Card was inscribed with the title of the reign and the stamp of a *yamen* as well as the name, age and features of the holder, and the card's number.

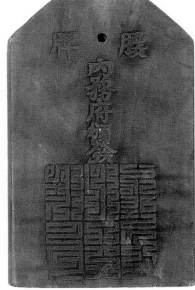
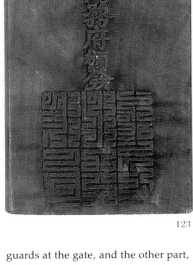

123

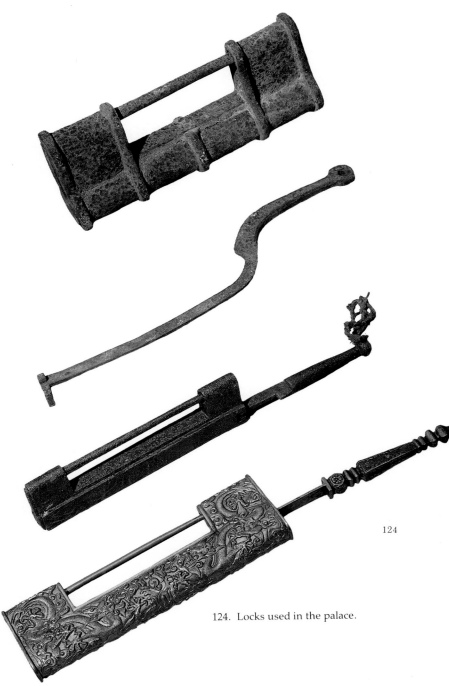

124

125. Tallies.

The tally was a special pass used in the Imperial Palace and the capital at night. Made of bronze, it consisted of two parts: on the inside were inscribed the two words, 'Imperial Edict', carved intaglio on one half and in relief on the other. The part with words carved intaglio was kept by the senior of the guards at the gate, and the other part, with the words carved in relief, was allowed into the palace. Anyone who entered or left the Forbidden City at night had to show the tally with the words carved in relief. They were allowed to pass only when the two parts fitted together. Otherwise, no one was allowed to pass, even if they had an imperial edict.

124. Locks used in the palace.

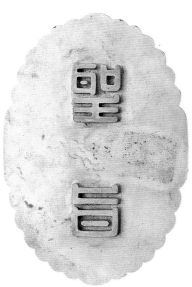

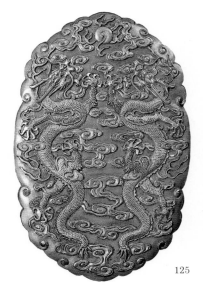

125

126

126. Wooden tallies.

Wooden tallies with many characters on them were also used as part of palace security.

127. The ancient battlefield at Ulan-butung.

Several dozen kilometres north of the Mulan Hunting Ground is a huge grassland. Under the blue vastness stands a red-hued mountain which looks like a jar, called Ulan-butung in Mongolian (meaning 'red jar'). In the twenty-ninth year of the reign of Kang Xi (1690), the emperor personally commanded his troops to make an expedition to the north to put down the rebellion launched by Galdan, head of the Eleut Mongol aristocracy. With abundant supplies and high morale, the Qing troops won an overwhelming victory over Galdan at Ulan-butung. Unfortunately, however, the chief Qing commander, Tong Guogang, Emperor Kang Xi's uncle, was killed in the battle. Legend has it that, after Tong Guogang was hit, the cannon he used sank into the marsh below the red mountain and spring-water instantly gushed out and formed a lake. To commemorate this able general, the local herdsmen called the lake 'The General's Lake'.

巡狩編

IMPERIAL TOURS OF INSPECTION AND HUNTING EXPEDITIONS

Among the varied activities of the Qing emperors, inspection tours (*xunxing*) and hunting expeditions (*da shou*) were regarded as fairly major undertakings.

Inspection tours, which were known as *xunshou* in former times, had been an important aspect of court tradition since the time of the three ancient dynasties (Xia, Shang and Zhou, *c.* twenty-first century to 221 BC). In those days such tours involved the king or emperor leaving the capital and making tours of the states administered by the dukes and princes. The emperors of succeeding dynasties continued this practice and the Qing emperors also followed the tradition of having inspection tours. Among the many large-scale inspection tours undertaken by the Qing emperors, the ones made by Kang Xi and Qian Long, extending south of the Yangtze River, were the most significant.

During the early years of his reign, the Emperor Kang Xi regarded three issues as being of major importance. These were the rebellions of three enfeoffed princes, the control of the capricious Yellow River and other rivers, and the transportation by water of tribute goods. In the twenty-first year of his reign (1682) the three rebellions which had disturbed the previous eight years were put down, and during the following year Taiwan was recaptured from factions still loyal to the Ming dynasty. Control of the rivers and their transportation potential thus became the major issues affecting the prosperity of the Qing administration. Many of his ministers and other high court officials, therefore, presented memorials to the throne exhorting the emperor to follow ancient traditions and make tours of inspection in order to gain firsthand knowledge of the conditions under which his subjects lived. Emperor Kang Xi agreed to the suggestion and decided to make a tour to inspect the rivers in the south. Within about a hundred years, Emperors Kang Xi and Qian Long undertook twelve tours of inspection: an unusually large number.

The average length of these tours – leaving the capital, travelling south and then returning to Beijing – was four to five months. The distance was covered either by boat along the Grand Canal, embarking at Tongzhou, or travelling by land as far as Jiangsu before boarding the boats. In contrast to the short tours undertaken to other areas, these long-distance travels to the south required elaborate preparations, and the emperor appointed a minister to oversee the travel arrangements. This minister was thus in command of the tour and was responsible for all the arrangements. In addition to members of the imperial family, a certain number of trusted ministers and high-ranking officials, a large number of labourers, security guards and soldiers also accompanied the emperor on these trips. Six to seven hundred secretaries and security officials usually accompanied Emperor Qian Long, as well as two or three thousand guards and troops. The preparations for the supply of carts, boats, horses, camels and other means of transport were extremely complex. It was stipulated that each minister could have five horses and two boats; every security official could have three horses and every two or three of them could have one boat between them; every bodyguard or senior secretary could have two horses; while the rest of the entourage could have three horses between two and one boat between ten. A retinue of 3,000 persons thus required 6,000 to 7,000 horses and 1,000 boats.

At important towns along the way, such as Suzhou, Hangzhou, Jiangning (nowadays called Nanjing) and Yangzhou, it was usual for the emperors to stay at imperial travelling lodges. On the rest of the journey, however, they stayed on board the barges or were put up in temporary camps. These were known respectively as water camps or land camps, or more generally were simply called imperial camps. Although these camps were just temporary lodging sites, nevertheless, there were strict rules governing them. The emperor's encampment was at the centre and was encircled by yellow wooden walls with flags, or by yellow cloth walls. Outside this was another circle of so-called 'net walls'. The Imperial Guards set up guard posts about one hundred paces outside the net walls. Between one and two *li* away from the net walls outposts were set up by the Vanguards Battalion's officers and men, and patrols continued through the night. Anyone walking within the outposts was punishable under military law. When the emperor stayed in one of these land camps, his retinue had to put up with all manner of inconveniences. According to the regulations, with the exception of those on guard duty, no officials or soldiers were allowed to stay near the emperor's encampment. If this was within ten *li* of the river, everyone else in the retinue had to stay on board their vessels. If, however, his encampment was far away from the river, then the retinue were allowed to set up their camps a few *li* from the imperial camp, or could stay in near-by temples or villages.

The intense preparations for the emperor's tours to the south involved not only the Imperial Household Department and the various yamens of the court, but also high-ranking provincial officials, the local gentry and other persons of consequence in the regions. In order to avoid the possibility of the emperor's progress being impeded by other boats, the grain and salt boats set out earlier than usual – in the winter of the preceding year. To prevent local grain prices in Jiangsu and Zhejiang soaring when the emperor's large retinue converged on the district, the viceroy of the two provinces applied in advance to the emperor for permission to keep back part of the grain and copper that should be shipped to the capital. This he hoped could be used for minting coins and stabilizing the price of grain. In order to feed such large numbers of horses and camels, which were accustomed to being fed on black soya beans and grain, the Governor of Shandong Province was instructed to collect and transport black beans from other areas and store them along the route of the emperor's tour. During his journey the emperor required silver to give as rewards to his retinue and local officials. In order to win favour with the emperor, the salt merchants and imperial merchants all donated money. On one occasion the salt merchants of Huaibei and Huainan donated one million taels of silver.

Although the Emperor Qian Long gave orders that money was not to be wasted on vainglorious excess, nevertheless, the actual expenditure on his southern tours was immense. Lu Jianzeng, Transportation Commissioner for Huaibei and Huainan, for example, built the Temple of Heavenly Peace Imperial Travelling Lodge beside the Chang River at Yangzhou and an imperial garden to the west of Level Hill Hall. The Emperor Qian Long absolved himself of the responsibility for draining the state treasury by his extravagance on his southern tours by finally executing the devoted and hard-working Lu Jianzeng.

Another important part of the preparations made by local officials for the visit of the emperor was the creation of an atmosphere of peace and prosperity. At those towns where the emperor's boats or carriages passed through, all the men and women over the age of eighty had to kneel, wearing yellow clothes and holding incense to welcome the emperor. By the roadside or on the banks of the Grand Canal outside the cities of Jiangning, Suzhou, Yangzhou and Hangzhou, stages were set up for the performance of dramas and acrobatics such as pole-climbing, walking on stilts and tight-rope walking. In the cities themselves, colourful awnings and pavilions were erected along the streets. Every house had to be decorated with lanterns, and decorations and incense-tables were set out to create a festive atmosphere, 'dancing in the lanes and singing in the streets', to make a favourable impression on the emperor.

The reason that the Emperors Kang Xi and Qian Long mobilized vast forces to tour the south, was not merely to enjoy the beautiful scenery south of the Yangtze River. The most important objective was to inspect water-conservancy projects such as those on the Yellow and Huai Rivers and the sea-walls in Zhejiang Province. During each of his southern tours, Kang Xi went to examine the walls of the Gaojiyan Dam by the Hongze Lake. At the site of the river-control project he used levels to measure the depth of water in Hongze Lake and sat on the dam wall with various officials, correcting the errors on the map of the river and discussing the plans for controlling the river. Water-conservancy provision was improved year after year, with the beneficial result that there were no floods for twenty years along the Yellow and Huai Rivers.

After the Emperor Qian Long had been four times on his southern tours to inspect the sea-wall projects, debates still continued regarding the method of construction of the sea-walls. Some advisers suggested the use of wood and earth while others believed that rocks should be

used. Qian Long went to the sea-walls and conducted experiments, which showed that rocks would not stay in place because of the shifting sand beneath them. Following these investigations he therefore suggested a compromise whereby the existing wood and earth sea-walls would be improved for the time being, and the building of rock walls was officially postponed. He also ordered fish-scale rock walls to be built inside the wood and earth walls, combining the two types into a stronger whole. After a few dozen years the improved constructions gradually succeeded in producing calm water.

A further aim of the Qing emperors' southern tours was to win the support of the Han scholars and men of business. Shandong, Jiangsu and Zhejiang were three provinces that had always flourished both economically and culturally in feudal China, and traditional feudal concepts were deeply rooted among the people who lived there. They mourned the passing of the previous Ming dynasty, and continued to feel that the Ming was still the legitimate dynasty of China. During their southern tours, both Kang Xi and Qian Long held many memorial ceremonies for Confucius and paid homage at the Ming Mausoleum. They received scholars everywhere and encouraged and rewarded literary merit, doing their utmost to display a proper interest in culture.

When the Emperor Kang Xi arrived at Jiangning on the first of his southern tours, his primary undertaking was to pay homage at the mausoleum of the Ming Emperor Tai Zu. He then went to offer sacrifice at the tomb. Afterwards he rewarded the officials guarding the mausoleum and ordered the local officials to be diligent in their care of the mausoleum and to forbid the gathering of firewood in the area. These acts won wide support from the people, and it was said at the time that the emperor was 'followed by tens of thousands of people who were moved to tears'.

Qian Long followed his grandfather's example and pursued a policy of winning the support of the Han literati. During his last tour he ordered the building of three libraries – the Pavilion of Literary Corpus at Yangzhou, the Pavilion of Literary Collection at Zhejiang and the Pavilion of Flourishing Literature at Hangzhou – to store copies of the *Complete Library in Four Branches of Literature* (*Si Ku Quan Shu*). He emphasized that the books in the three libraries were to be read and were 'not for display on the shelves'. He gave permission for the literati and other scholars to borrow the books and to make extensive copies.

Although in general very similar in terms of purpose, route and other aspects, nevertheless, there were still some differences in the southern tours undertaken by the two emperors. When the Emperor Kang Xi was making his tours to the south, the nation was just recovering from the dynastic war and building up its economic strength. The national treasury was not, therefore, very full. Thus, during his journey he usually commandeered government offices for his lodgings and 'all the palaces the emperor lodged in were not painted in bright colours and the expenditure at each place was only about ten to twenty thousand taels of silver'. By the time the Emperor Qian Long undertook his southern tours, however, the society was prosperous and the economy was buoyant. It was known as a 'peaceful age of prosperity'. Qian Long spent extravagantly and enjoyed considerable luxury. Not only did he build imperial travelling lodges everywhere, but he also sought out famous gardens and beautiful scenery wherever he went, seeking 'pleasure in the hills and streams'. Following his southern tours, he built replicas of the famous gardens he saw south of the Yangtze River. Qian Long's tours were thus less beneficial than those made by Kang Xi because of his extravagance. In his later years Qian Long himself realized that 'the six southern tours had tired the people and drained the treasury'.

The ancient text, *Zuo Zhuan* (Zuo Qiuming's commentary on *The Spring and Autumn Annals*), stated that hunting in periods of reduced farming activity were a form of military training. Every spring the Qing emperors went hunting with their generals and soldiers in the woods south of Beijing. During this hunt a tiger-killing ceremony was held at the Liangying Terrace. A few days before the ceremony, the Tiger-killing Department caged a fierce tiger which had been kept at the Tiger Zoo in western Beijing. The cage was locked and chained and put in front of the Liangying Terrace. For the ceremony, when the emperor had seated himself on the terrace, the Tiger-killing Department sent a soldier on horseback to undo the chains and release the tiger. The tiger, having been caged for many days, had usually lost its former ferocity and when the cage was opened would lie down and show no interest in moving. The emperor's bodyguards would then release hunting dogs to bark at the tiger and would fire at it until the tiger became enraged and rushed out. The participants would then attack it in a group and vie with each other in their attempts to kill it. When the cornered tiger was finally killed, the ceremony was declared at an end.

The hunts conducted on the largest scale by the Qing emperors were those held in autumn at the Mulan Hunting Ground outside the Great Wall. (The name Mulan is derived from a Manchu word meaning to hunt deer by imitating their cry.) Mulan was an ideal place for hunting and military training, being situated at Yakou in Jehol (today's Chengde), south of the Saihan Dam, where the rolling hills, clear winding streams and luxuriant forests were the home of many animals. Every autumn the Qing emperors led tens of thousands of troops there to hunt with guns, bows and arrows, falcons and hounds.

For autumn hunting at Mulan there were two programmes: deer hunting and encirclement hunting. Deer hunting began at dawn, when the hunters would don false deer heads and imitate the male deer's cry to entice the does. After a doe had been thus lured and captured alive, it was ready for the emperor to kill. Deer hunting involved only a few participants. Encirclement hunting, on the other hand, was to all intents and purposes a large-scale military manoeuvre. The participants were not only the emperor's accompanying troops, but also 1,500 cavalry, 100 guides and 300 marksmen sent by the Mongolian tribes every year, who all co-operated in the hunt.

Encirclement hunting usually took twenty days. Each day, at the first light of dawn the troops, commanded by the officials in charge of the hunt, went on horseback to form the encirclement in two detachments, one to the left and one to the right. Those on the left flank held plain white banners and those on the right flank held plain red ones. Each detachment had a blue banner at its head. They would surround the area that had been previously selected by the guide officials and then close in. Regardless of thorny undergrowth or precipitous cliffs the soldiers were expected to forge their way ahead without demur. The emperor, from a screened watch-tower on high ground outside the encirclement, commanded the fights with the animals encountered. About ten thousand cavalry and infantry formed a circle of a few dozen li. With gun-shots and shouts they drove the animals inside the surrounded area nearer to the emperor's watch-tower. The emperor then led the princes to hunt within the encirclement, and under his order the generals and soldiers, mounted and on foot, started to attack the animals with swords and bows and arrows. Hunting horns, the cries of the animals, gun-shots, the neighing of the horses and the sound of their hoofbeats rang through the air. The animals fled in all directions, but even those that managed to break out of the encirclement could not escape the marksmen who awaited them in ambush outside. After the emperor had selected those he wanted, the rest were prepared to feed the troops for the banquet that evening.

Although all the Qing emperors insisted that the tradition of military training through encirclement hunting could not be abandoned, only Kang Xi and Qian Long were conscientious about undertaking it. From 1681 until his death, Kang Xi seldom missed a year hunting. His hunting achievements were considerable. The Emperor Qian Long often took delight in telling the story of his shooting a black bear at the age of twelve when he went with his grandfather to Mulan. After the Qian Long period, in the time of the Emperor Jia Qing, the tradition of hunting was maintained only with difficulty and later, as the Qing dynasty declined, the autumn hunts at Mulan were held less and less often.

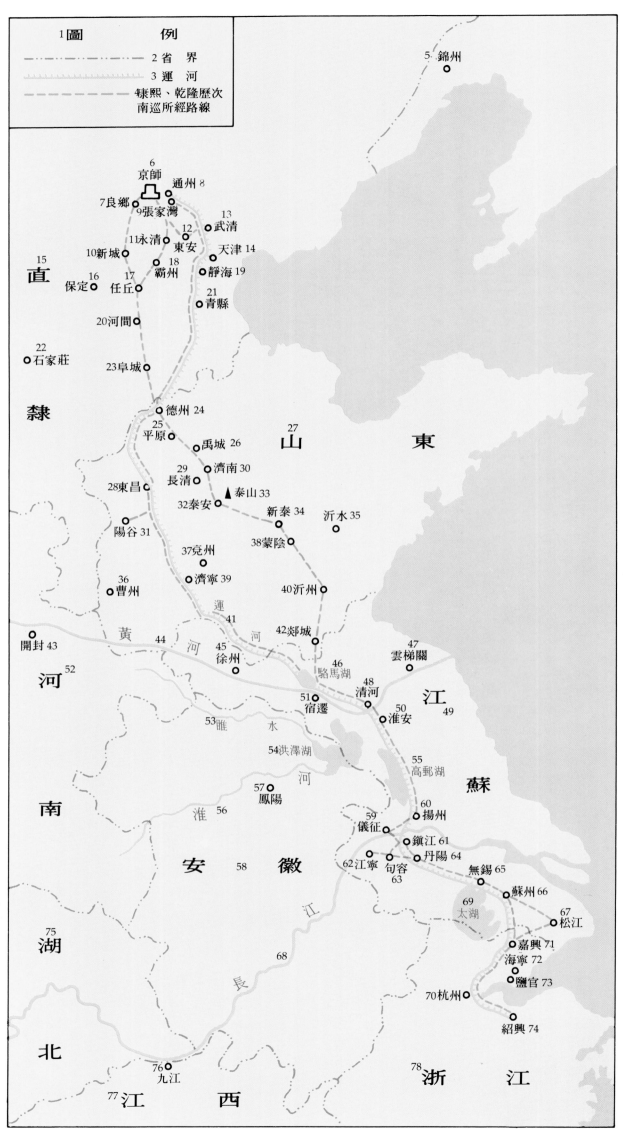

圖　例
2 省　界
3 運　河
康熙、乾隆歷次
南巡所經路線

京師　通州
良鄉
張家灣
武清
永清　東安
新城　天津
霸州　靜海
保定　任丘
青縣
河間
石家莊
阜城
德州
平原
禹城
濟南
長清　泰山
東昌　泰安
陽谷
新泰　沂水
蒙陰
兗州
濟寧
曹州
沂州
運河
黃河
郯城
開封
徐州　駱馬湖
清河
宿遷　雲梯關
淮安
睢　水
洪澤湖
鳳陽　高郵湖
淮　儀征
揚州
鎮江
丹陽
江寧　句容
無錫
蘇州
太湖　松江
嘉興
海寧
鹽官
杭州
紹興
九江
江　西
浙　江
直　隸
山　東
河　南
江　蘇
安　徽
湖　北
江　西
浙　江
長江

1 legend
2 boundaries of provinces
3 Grand Canal
4 route of the southern tours
 by Emperors Kang Xi and
 Qian Long
5 Jinzhou
6 Beijing
7 Liangxiang
8 Tongzhou
9 Zhangjiawan
10 Xincheng
11 Yongqing
12 Dong'an
13 Wuqing
14 Tianjin
15 Zhili Province
16 Baoding
17 Renqiu
18 Bazhou
19 Jinghai
20 Hejian
21 Qingxian
22 Shijiazhuang
23 Fucheng
24 Dezhou
25 Pingyuan
26 Yucheng
27 Shandong Province
28 Dongchang
29 Changqing
30 Jinan
31 Yanggu
32 Tai'an
33 Mount Tai
34 Xintai
35 Yishui
36 Caozhou
37 Yanzhou
38 Mengyin
39 Jining
40 Yizhou
41 Grand Canal
42 Tancheng
43 Kaifeng
44 Yellow River (Huang He)
45 Xuzhou
46 Luoma Lake
47 Yuntiguan
48 Qinghe
49 Jiangsu Province
50 Huai'an
51 Suqian
52 Henan Province
53 Sui River
54 Hongze Lake
55 Gaoyou Lake
56 Huai River
57 Fengyang
58 Anhui Province
59 Yizheng
60 Yangzhou
61 Zhenjiang
62 Jiangning
63 Jurong
64 Danyang
65 Wuxi
66 Suzhou
67 Songjiang
68 Yangtze River (Chang Jiang)
69 Tai Lake
70 Hangzhou
71 Jiaxing
72 Haining
73 Yanguan
74 Shaoxing
75 Hubei Province
76 Jiujiang
77 Jiangxi Province
78 Zhejiang Province

128. A map of the southern inspection tours by Emperors Kang Xi and Qian Long.

129. The imperial wharf in front of the Temple of Heavenly Peace imperial travelling lodge in Yangzhou.

The Temple of Heavenly Peace is situated north-west of Yangzhou. During one of his southern tours, Kang Xi ordered Cao Yin, Superintendent of the Imperial Silk Workshops in Jiangning, to set up a publishing house at the Temple of Heavenly Peace to compile and publish the *Complete Collection of the Tang Dynasty Poetry* (*Quan Tang Shi*) in order to win the support of the Han literati. During Qian Long's tours, Lu Jianzeng, the Transportation Commissioner of Huaibei and Huainan, built a travelling lodge at the temple. When Emperor Qian Long boarded his boat from the imperial wharf in front of the travelling lodge and set off upstream, he could enjoy the spectacular sites built by rich merchants and local gentry along the Chang River.

129

130. The Spring Willow Long Causeway by the Chang River of Yangzhou.

Now known as Shouxi Lake, it was constructed by Lu Jianzeng for the emperor.

130

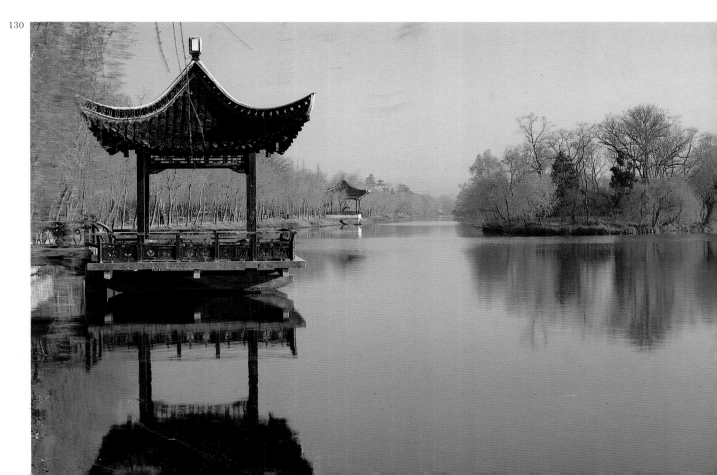

131. The Four Bridges in Rain and Mist on Shouxi Lake.

The Four Bridges in Rain and Mist is one of the most famous views of Shouxi Lake in Yangzhou. The four bridges are the Spring Wave Bridge in the south, the Everlasting Spring Bridge in the north, the Jade Plate Bridge in the west and the Lotus Flower Bridge in the east. Watching the four bridges appearing like rainbows from among waves in the rain and mist, Emperor Qian Long was delighted by the beauty of the scene and wrote the text of a tablet, 'Garden of Delight', especially to commemorate it.

132. The High Autumn Temple at Yangzhou.

Before Qian Long's fifth southern tour, Cao Yin and Li Xu, Superintendents of the Jiangning and Suzhou Imperial Silk Workshops, and Li Can, a new Superintendent of Transport, took the lead in donating money to build the sumptuous High Autumn Temple imperial travelling lodge at Zhuyuwan in Yangzhou. To show his appreciation, Qian Long awarded Cao Yin the title of Director of the Imperial Information Administration, Li Xu the title of President of the Grand Court of Appeal and Li Can the title of Assistant to the Political Council.

133. The Level Hill Hall of Yangzhou.

The Level Hill Hall, one of the scenic features of Yangzhou, was built by Ouyang Xiu (1007–72), a well-known writer and historian of the Song dynasty. Every time Emperor Qian Long went to Yangzhou, he insisted on visiting this place. Lu Jianzeng built the imperial garden, Fifth Spring under Heaven, to the west of Level Hill Hall.

134. Crossing the Yangtze River – a detail from the painting *Emperor Kang Xi's Tour of the South*. (67.5 cm × 2227.5 cm)

Emperor Kang Xi's Tour of the South, painted by Wang Hui and other Qing-dynasty artists, is a collection of twelve scrolls painted in colours on silk. The twelve scrolls are all 67.5 cm high but vary in length, with the longest being 2,600 cm and the shortest 1,500 cm. The first nine scrolls record the entire southward journey of Kang Xi's tour, from leaving Beijing to arriving at Shaoxing in Zhejiang. The last three describe his return journey starting in Zhejiang, passing through Nanjing and back to Beijing. This part shows Kang Xi crossing the Yangtze River. On his last tour, at the age of fifty-six, he felt a slight reluctance to cross the river due to old age and poor health, but on the other five tours he calmly sat in the boat showing no fear while crossing the turbulent river (as shown in the painting). At several river crossings, he watched closely and studied the boatmen's skill in handling the vessel. Later he wrote an article entitled *On Boat Sailing*, in which he likened government administration to sailing a boat. Only by conforming to the nature of the water (aspirations of the common people), he said, could a boat sail smoothly and safely.

132

133

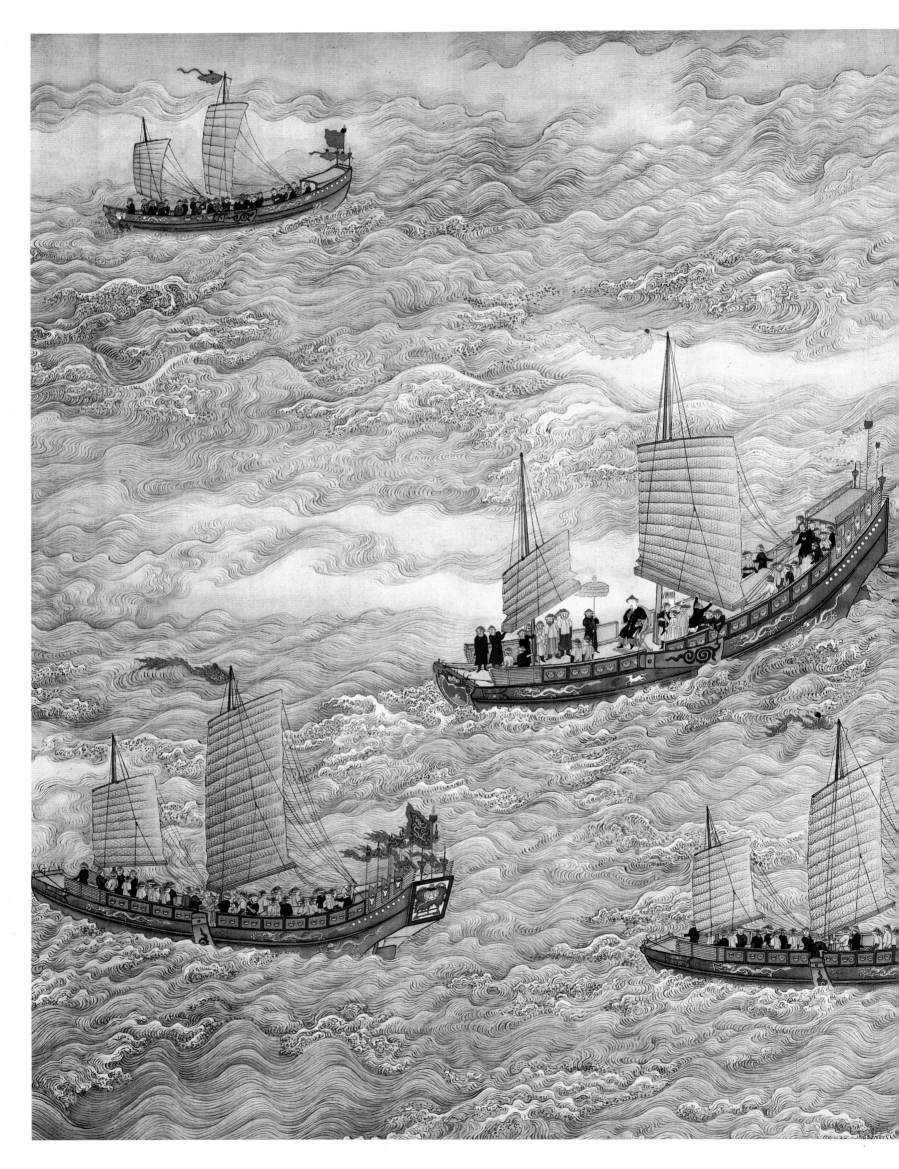

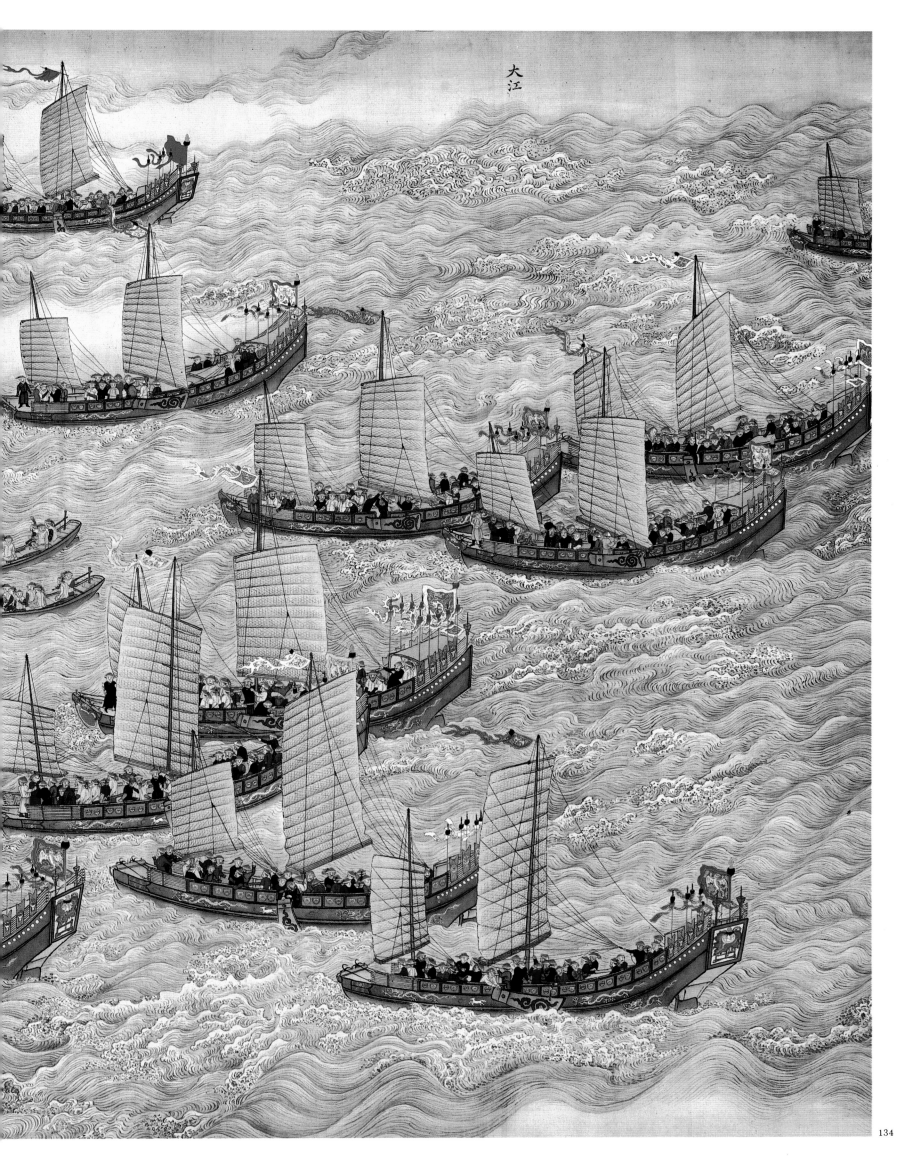

大江

135. The Gold Hill Temple in Zhejiang.

The Gold Hill Temple in Zhejiang, a Buddhist temple, was first built in the Eastern Jin dynasty (317–420). Emperor Kang Xi wrote the text of a tablet, 'River and Heaven Temple', in praise of the temple when he visited it. During Qian Long's reign an imperial travelling lodge was built nearby.

136. A distant view of Gold Hill.

137. A view of the Yangtze River from Jiao Island in Zhejiang.

Facing Gold Hill, Jiao Island rises from the middle of the Yangtze River. At its foot lies an old temple built in the Eastern Han dynasty (25–220), to which the Emperor Kang Xi gave the name Dinghui Temple during one of his southern tours. The famous stone carvings dating from the Southern dynasties (420–589) are known as the *Crane Burial Inscriptions* and have been held in high regard for centuries. Having at one time fallen into the river, they were rescued from the water during the Emperor Kang Xi's reign by River Superintendent Chen Pengnian and set at the foot of Jiao Island. When the Emperor Qian Long saw these stone carvings at the foot of the hill, he also had a stone tablet erected there with an inscription in his own calligraphy.

135

136

138. Tai Lake.

On their southern tours, the Qing emperors usually travelled first by land when they left Beijing and then changed to boats after they reached Suqian in Jiangsu Province. The vast expanse of the misty Tai Lake was a view not to be missed on the southern tours.

138

139. The Pleasure Garden of Wuxi.

The Pleasure Garden of Wuxi was the private garden of Qin Dejin, an official of the Ming dynasty. Originally called Phoenix Pavilion Halting Place, it got its present name in the Qing dynasty. In the garden, surrounded by halls, towers, pavilions, kiosks and artificial hills, is a clear lake which collects water from the two springs of Hui Hill. The Emperor Kang Xi visited the garden several times to enjoy the plum blossom. Fascinated by its fine execution and beautiful design, Qian Long was so entranced that he forgot to return to his own lodgings. The Huishan Garden, a replica of this Wuxi garden, was built on the eastern slope at the foot of Longevity Hill in west Beijing after Qian Long's return to the capital.

139

140. Sky Level Hill in Suzhou.

Sky Level Hill lies in the suburbs of Suzhou. Emperor Qian Long visited it four times and erected a stone tablet with inscriptions and a pavilion at the foot of the hill.

141. The Lion Grove in Suzhou.

The Lion Grove, a famous garden in Suzhou, contains hills shaped like lions. Emperor Qian Long liked this garden so much that every time he went to Suzhou, he felt he had to visit it. He carefully studied the artificial hills, bridges and pavilions in the garden and compared them with the painting *The Lion Grove* by the great painter, Ni Zan (1306–74, one of the Four Masters of the Yuan dynasty). He also ordered the painters in his retinue to paint the scenes in the garden. Later, gardens imitating the Lion Grove were built in the Garden of Eternal Spring within the Garden of Perfection and Brightness and in the Summer Palace at Chengde. The tablet entitled 'True Delight' in Qian Long's own calligraphy still hangs in a pavilion in the Lion Grove.

142. Tiger Hill in Suzhou.

Tiger Hill in the north-east of Suzhou has been given the title of 'The Leading Place of Beauty in the Wu State'. According to legend, the Sword Pond at the foot of the hill was the place where He Lü, the king of the Wu state, tempered his sword. In front of the pond is the Thousand Persons Rock where a monk of the Jin dynasty (265–420) preached the Buddhist doctrines. Once, when Kang Xi visited Tiger Hill with his concubines, he discussed with the abbot 'whether the Thousand Persons Rock could really seat one thousand people'.

142

105

143

144

145

143. The Sea God Temple of Haining in Zhejiang.

In 1729, a double-roofed Sea God Temple in the *xieshan* style (a traditional style of Chinese palace architecture) was built at Yanguanzhen in Haining, Zhejiang.

144. The palace gate of the imperial travelling lodge at Solitary Hill in Hangzhou with the West Lake behind.

For Emperor Kang Xi's southern tours, an imperial travelling lodge was built at the Temple of Holy Cause.

145. The Temple of Soul's Retreat in Hangzhou.

Kang Xi ascended the North Peak of Hangzhou and saw smoke curling up from the temple at the foot of the hill which, shrouded in mist, looked as if it were built in a sea of cloud. When he came down from the mountain, he wrote the text of a plaque for the temple which reads 'Monastery for Meditation in the Cloud Forest'.

146. The Crane Pavilion in Hangzhou.

Standing on the north slope of Solitary Hill in Hangzhou, this pavilion was constructed in the Yuan dynasty (1271–1368) in memory of the Northern Song poet Lin Hejing (967–1028), who lived on the hill for twenty years, cultivating plum trees and rearing a crane. Kang Xi erected a stone tablet with an inscription of the 'Ode to the Dancing Crane', written in the style of the famous calligrapher Dong Qichang (1555–1636).

147. 'The Autumn Moon on Calm Lake'.

'The Autumn Moon on Calm Lake', overlooking the lake from the embankment, is one of the ten famous views of West Lake. On his third tour to Hangzhou, Emperor Kang Xi erected an engraved tablet and built a pavilion and a water-tower there, which added to the attractions of the site. After his southern tour, Qian Long had a similar view added to the Garden of Perfection and Brightness.

146 147

148. 'The Three Pools Mirroring the Moon'.

This is another of the ten views of West Lake. When Su Dongpo (1037–1101), a famous writer, painter, calligrapher and statesman of the Northern Song dynasty, was an official in Hangzhou, he dredged West Lake and erected three small stone pagodas as water-level markers. Planting lotuses and water chestnuts in the lake was forbidden by Su Dongpo to prevent the lake from becoming overgrown. According to tradition, there are three deep pools in the lake. If candles are lit in the pagodas on a night when the moon shines clearly, the lights appearing through the small round holes in the pagodas are reflected in the water as three small moons competing with the moon in the sky. This is how the site got its present name. When Qian Long saw this phenomenon, he wrote the following verses especially for it: 'The water in mid-lake reflects casually the ancient mirror in the sky, Seek not from Flower-Plucking Buddha his teachings on cause and effect.'

148

149

149. The Temple of Great Yu in Shaoxing.

Among the many emperors and kings in Chinese history and mythology, Yu of the Xia dynasty (c. twenty-first century to sixteenth century BC) was particularly famous for controlling the rivers. The most important aim of the southern tours made by Kang Xi and Qian Long was to inspect the water-control projects. To show their respect for the ancient river-taming monarch, they crossed the Qiantang River after arriving at Hangzhou and paid visits to the temple and tomb of Yu in Shaoxing. Emperor Kang Xi wrote a tablet, 'Heaven Accomplishing Peace on Earth', for the temple, and the four characters of this phrase were mounted on the roof of the temple.

150. The Orchid Pavilion in Shaoxing.

At the Orchid Pavilion, Emperor Kang Xi copied the 'Preface to the Orchid Pavilion Collection' by Wang Xizhi (321–79), a great calligrapher of Eastern Jin. A stone tablet with an inscription was later erected at the ruins of the pavilion.

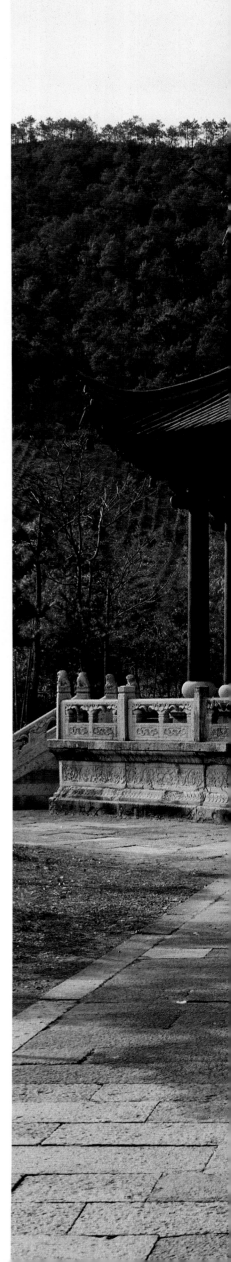

151. 'The Winding Stream for Floating Wine-Goblets'.

An ancient pastime was to float wine cups on the water of a winding stream so that they were carried along to a place where others could pick them up and drink the wine. The practice was thought to avert calamities. This is the place where Wang Xizhi and his friends enjoyed 'floating the goblets in the winding streams'.

151

150

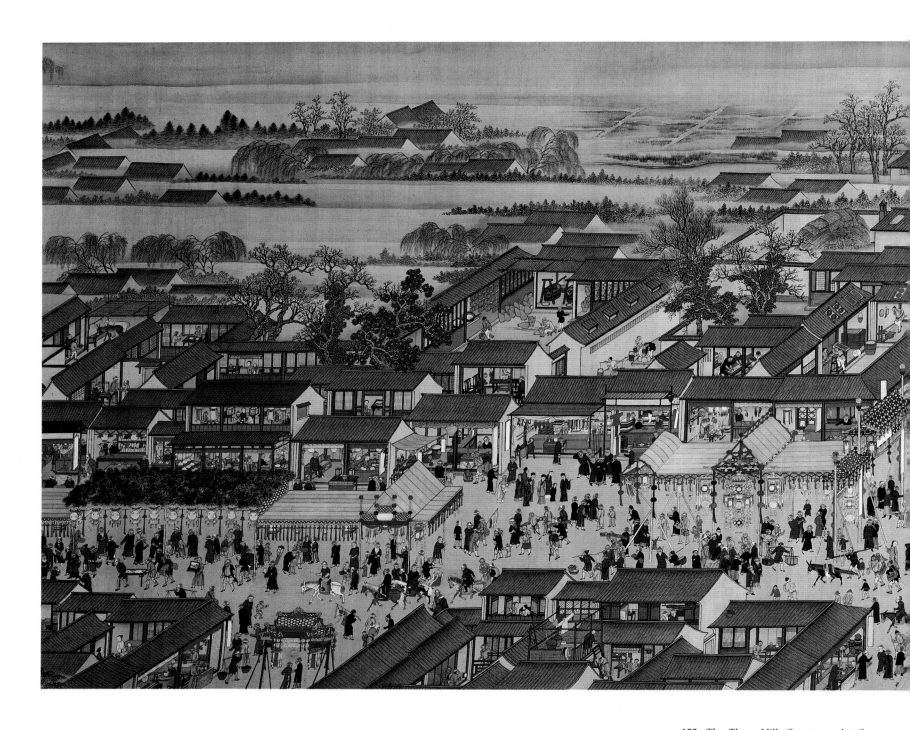

152. The Three Hills Street – a detail from *Emperor Kang Xi's Tour of the South*. (67.5 cm × 1555 cm)

This part of the painting depicts the lively scenes at Three Hills Street, Fanhua District of Jiangning (now called Nanjing), when Emperor Kang Xi arrived there. In front of every house lanterns and festoons were hung, incense tables placed and awnings set up across the street.

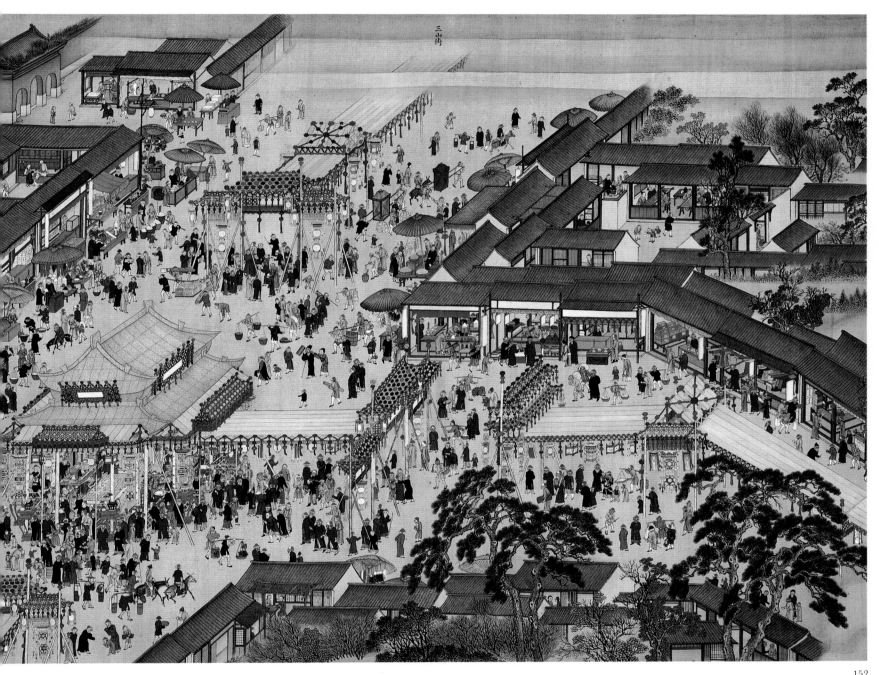

三山街

153. The ruins of the garden at the mansion of the Superintendent of the Jiangning Imperial Silk Workshop.

Emperors Kang Xi and Qian Long both had their travelling lodges at the mansion of the Superintendent of the Jiangning Imperial Silk Workshop when they visited Jiangning. During Qian Long's tours, Yin Jishan, the Viceroy of Jiangsu and Zhejiang, built many exquisite gardens around the mansion.

154. The Temple of Rosy Clouds in Nanjing.

The Temple of Rosy Clouds, in the north-east of Jiangning, was built in the Southern dynasties. During the southern tours of the Qing emperors, a room in the temple was usually set aside for the emperor. Later Yin Jishan, Viceroy of Jiangsu and Zhejiang, built an imperial travelling lodge at the back of the temple for Emperor Qian Long.

155. A tablet inscribed 'Surpass the Tang and Song in Administering the Country' at the Xiaoling Mausoleum of the Ming dynasty in Nanjing.

Every time Emperors Kang Xi and Qian Long went to Jiangning, they either went personally or sent a representative to offer sacrifices at the Xiaoling Mausoleum of the Ming in order to win the support of the people south of the Yangtze River by showing their respect for the previous dynasty. Emperor Kang Xi wrote 'Surpass the Tang and Song in Administering the Country' and ordered Cao Yin to erect a stone tablet with the inscription at the Xiaoling Mausoleum.

155

156. Part of the sketch map of Qian Long's southern-tour route from the *Grand Ceremony of the Southern Tour*.

The map shows the topography around the Grand Canal and the San-cha River at Yangzhou.

157. A list of tribute presented to Emperor Qian Long by Shen Deqian.

On the tours of the Qing emperors, the local officials and gentry all presented to the emperors their collections of valuable paintings and calligraphy.

This is a list of tribute made out by Shen Deqian and presented to Emperor Qian Long on his first southern tour. Shen Deqian was a retired Vice-President of the Board of Rites and a well-known scholar.

156

157

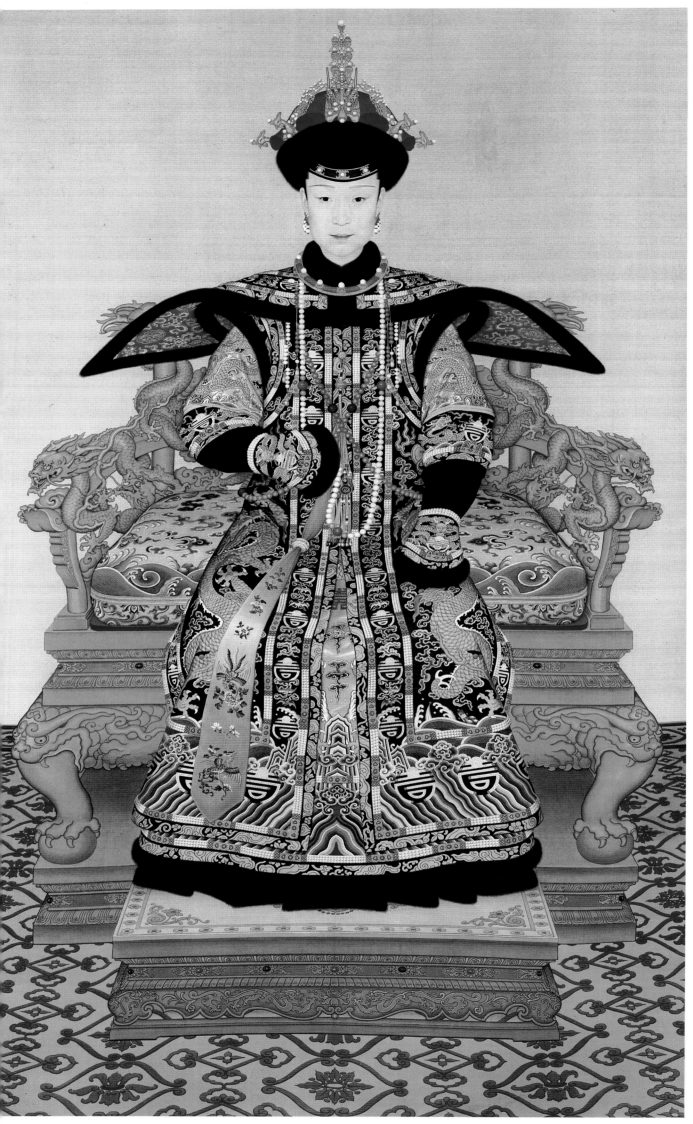

158. A portrait of Empress Xiao Xian Chun in court dress.

Empress Xiao Xian Chun, called Fucha, was the Emperor Qian Long's first wife. It was said that the empress was a kind, virtuous and refined woman who did not adopt a luxurious lifestyle, usually wearing neither pearls nor jade but only wild and velvet flowers. She was very much loved by Emperor Qian Long. While accompanying Qian Long on his tour to Shandong Province in the thirteenth year of his reign (1748), she fell ill at Dezhou on their way back to Beijing and within a few days she died on board the ship. She was then only thirty-seven years old.

159. The Mulan Hunting Ground.

The Mulan Hunting Ground was situated at Weichang County, 200 *li* north of modern-day Chengde. This area is criss-crossed by rivers, has rising peaks, and is fertile with verdant forests. In the twentieth year of his reign (1681), Emperor Kang Xi went hunting outside the Great Wall. During a period of more than two weeks he reconnoitred hills and mountains, plains and ravines over an area of 100 *li*. Then a hunting ground with an area of 300 *li* from north to south and east to west was designated. To safeguard this area for imperial use only, Kang Xi ordered that palings and willow-branch fences be built at each pass around the whole site, and that Manchu and Mongolian Eight Banner Troops be stationed there and sentry-posts set up to keep ordinary people from entering the area.

160. Tiger-Shooting Hill.

In the autumn of the seventeenth year of his reign (1752), Emperor Qian Long went hunting around the Yuedong area of the hunting ground, where huntsmen had reported that a tiger was hiding in a cave on Gegu Hill about 300 paces away. Emperor Qian Long levelled his gun and fired at the cave to frighten the tiger into coming out. Unexpectedly, he hit the tiger, which leapt out of the cave with a roar. The emperor fired again and killed it. Overjoyed, Emperor Qian Long wrote 'A Record of Tiger-Shooting' to describe the event. A stone tablet inscribed with this record was erected on the hill opposite the tiger's cave.

161. Cliff carvings beside the Tiger-Shooting Cave.

After Emperor Qian Long had killed the tiger, he ordered that inscriptions be carved on the cliff beside the tiger's cave in Chinese, Manchu, Mongol and Tibetan. The Chinese reads: 'Qian Long killed a tiger in this cave in the seventeenth year of his reign.'

162. Yakou (cliff entrance).

At the juncture of Poluohetun (today's Longhua County) and the hunting ground, there is a narrow pass with high cliffs on both sides and the Yisun River flowing between them. It was the only pass through which the Qing emperors went to the hunting ground from the Summer Palace in Chengde. It was called 'Yisun Gebuqi'er'. In Mongolian, 'Yisun' is a transliteration of 'nine' and 'Gebuqi'er' means 'cliff entrance'. The two words combine to mean that a river with nine bends within the hunting ground passes the cliff entrance.

162

163. The tablet at Yakou.

On the top of Yakou is a stone tablet erected by Emperor Qian Long. The inscription on the tablet in Manchu, Chinese, Mongolian and Tibetan is the poem 'Entering Yakou', composed by Qian Long in the sixteenth year of his reign (1751). The poem reads: 'The Qing family values military training and has conquered the country. It was practised in the past and is at present, and will be passed on for many generations. Rocks and peaks rise high as screens with the cliff entrance as a pass. A cliff holds back the mountains for the Yisun River to pass. I often pass here for autumn hunting, and each time I find it hard to compose a poem on horseback.'

164. The ruins of the imperial travelling lodge in the hunting ground.

There were two passages through which it was possible to enter the hunting ground from Poluohetun in order to hunt. The eastern one was at Yakou and the western one at Ji'erhalangtu. If the emperor entered the hunting ground through the east passage, then he returned to Beijing through the west passage, and vice versa. The Qing emperors had an imperial lodge built at the entrance of each passage so that they could rest on their way to or from the hunting ground. The red walls behind the pines at the foot of the hill are the ruins of the imperial lodge at the entrance of the eastern passage.

163

116

164

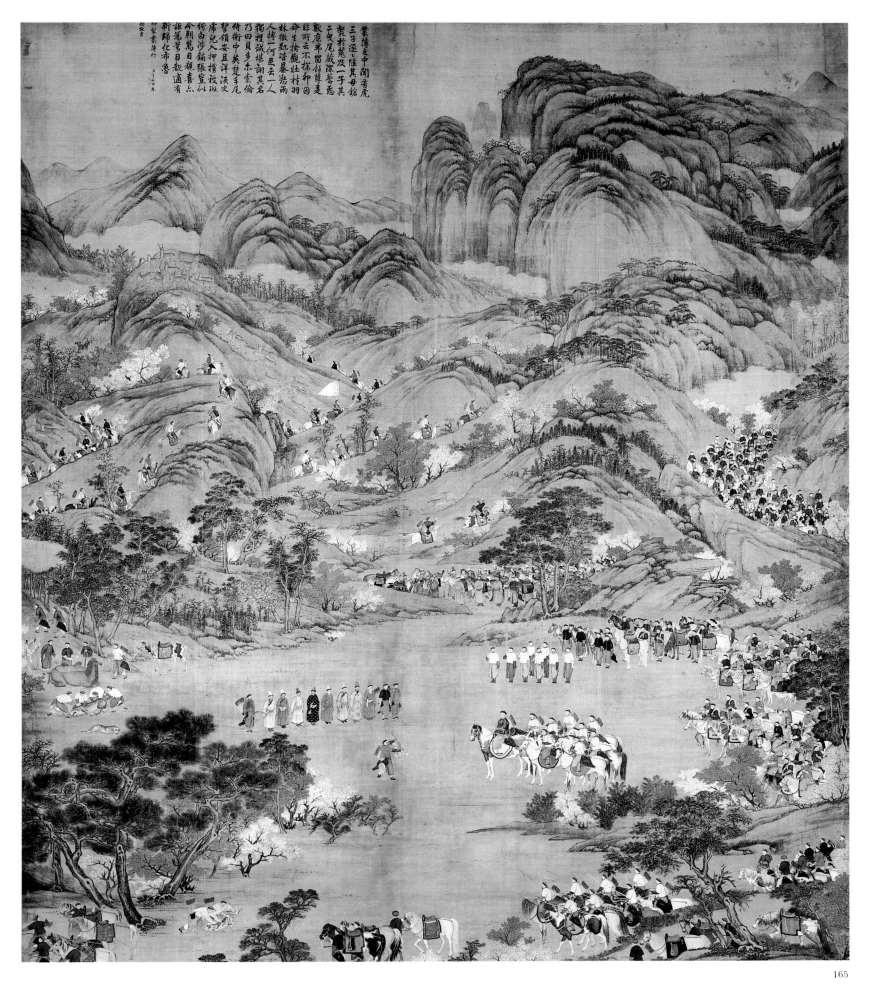

165. *Hunting in Dense Undergrowth.*
(424 cm × 348.5 cm)

In one of the encirclement hunts north of the Great Wall, Emperor Qian Long came across a tigress and three tiger cubs in thick undergrowth. Three were shot by his marksmen and one was caught alive by his bodyguard, Bei Duo'er. It happened that a representative from the Kirghiz tribe was present paying a visit to the emperor. The fact that a bodyguard caught a tiger alive was taken as a demonstration of the superb military accomplishments of the Qing army. Highly delighted, the emperor composed a poem entitled 'Hunting in Dense Undergrowth' to record the event and ordered the court-painters to paint the scene.

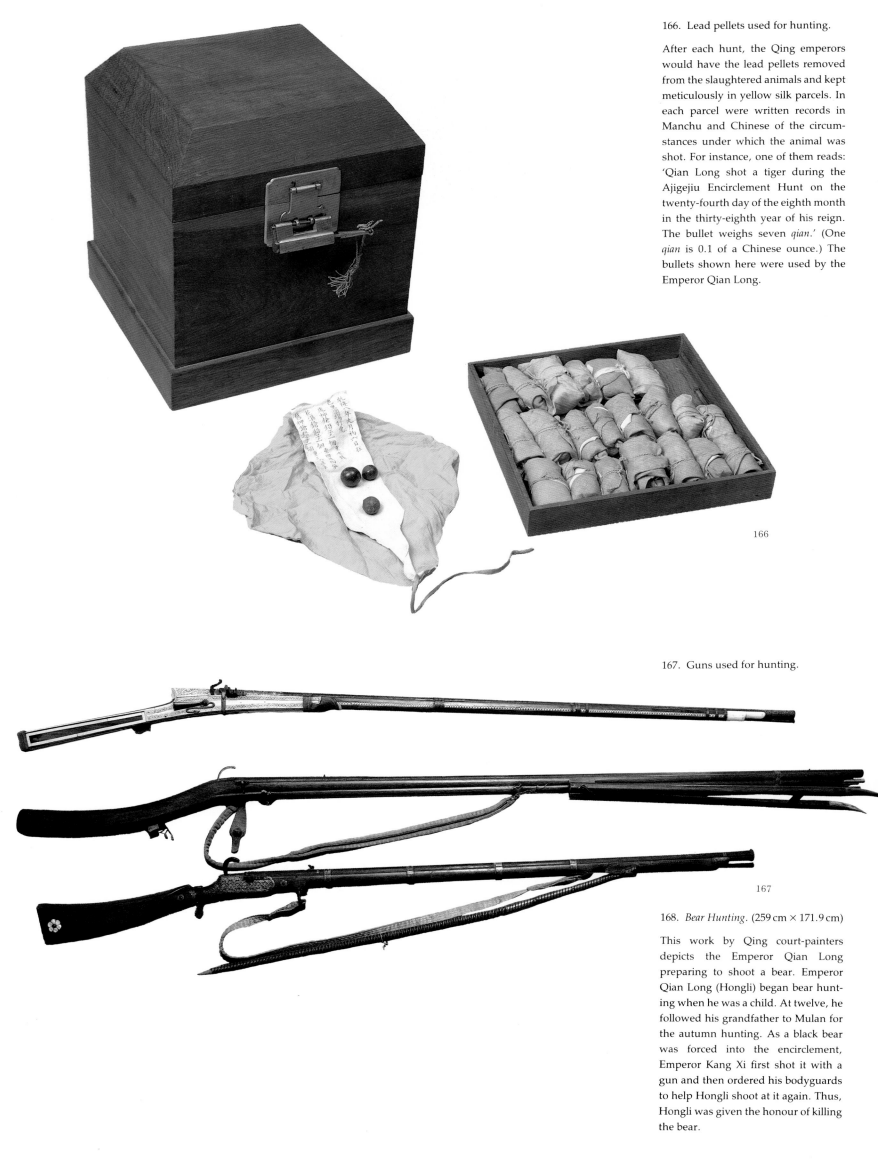

166. Lead pellets used for hunting.

After each hunt, the Qing emperors would have the lead pellets removed from the slaughtered animals and kept meticulously in yellow silk parcels. In each parcel were written records in Manchu and Chinese of the circumstances under which the animal was shot. For instance, one of them reads: 'Qian Long shot a tiger during the Ajigejiu Encirclement Hunt on the twenty-fourth day of the eighth month in the thirty-eighth year of his reign. The bullet weighs seven *qian*.' (One *qian* is 0.1 of a Chinese ounce.) The bullets shown here were used by the Emperor Qian Long.

166

167. Guns used for hunting.

167

168. *Bear Hunting*. (259 cm × 171.9 cm)

This work by Qing court-painters depicts the Emperor Qian Long preparing to shoot a bear. Emperor Qian Long (Hongli) began bear hunting when he was a child. At twelve, he followed his grandfather to Mulan for the autumn hunting. As a black bear was forced into the encirclement, Emperor Kang Xi first shot it with a gun and then ordered his bodyguards to help Hongli shoot at it again. Thus, Hongli was given the honour of killing the bear.

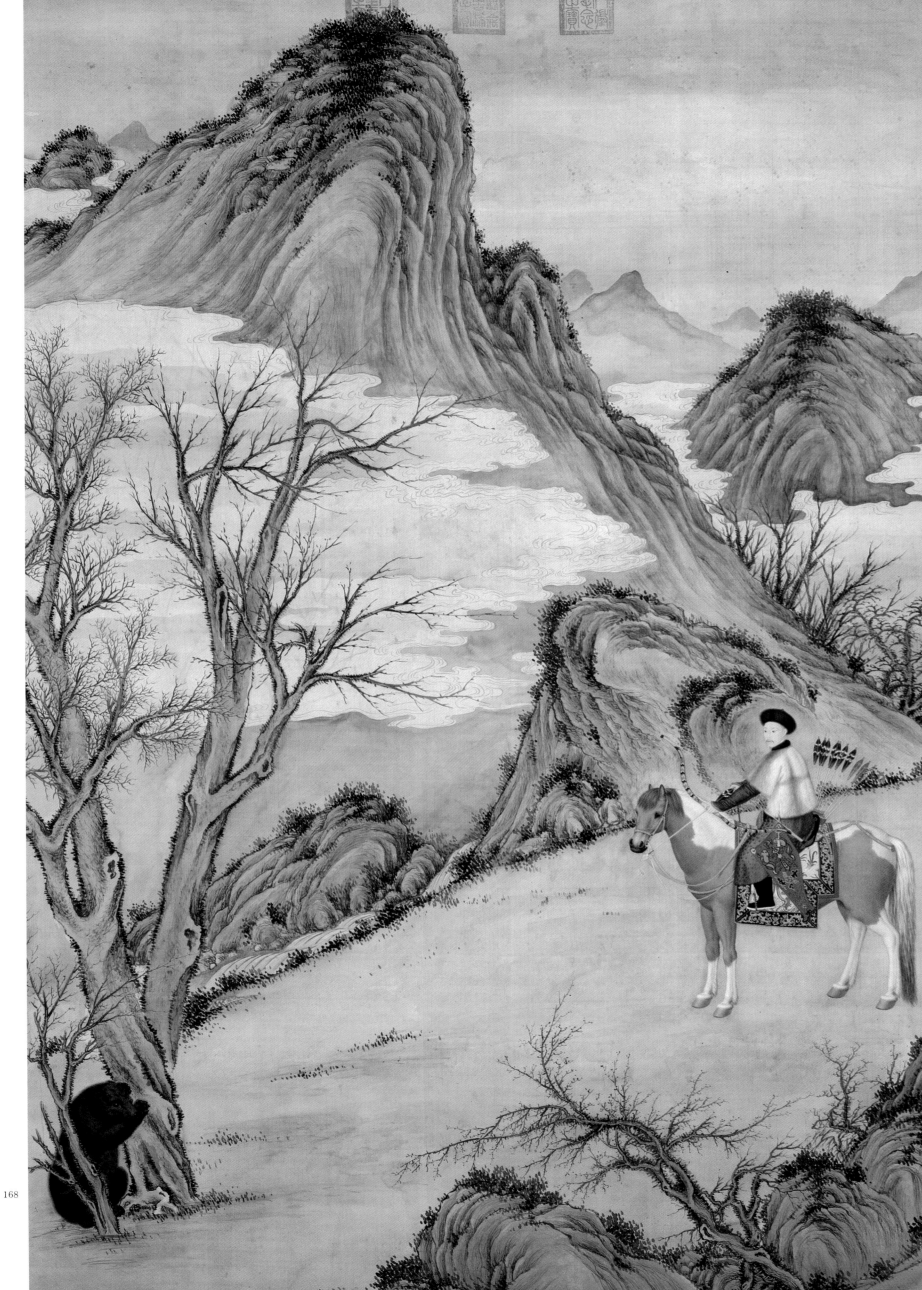

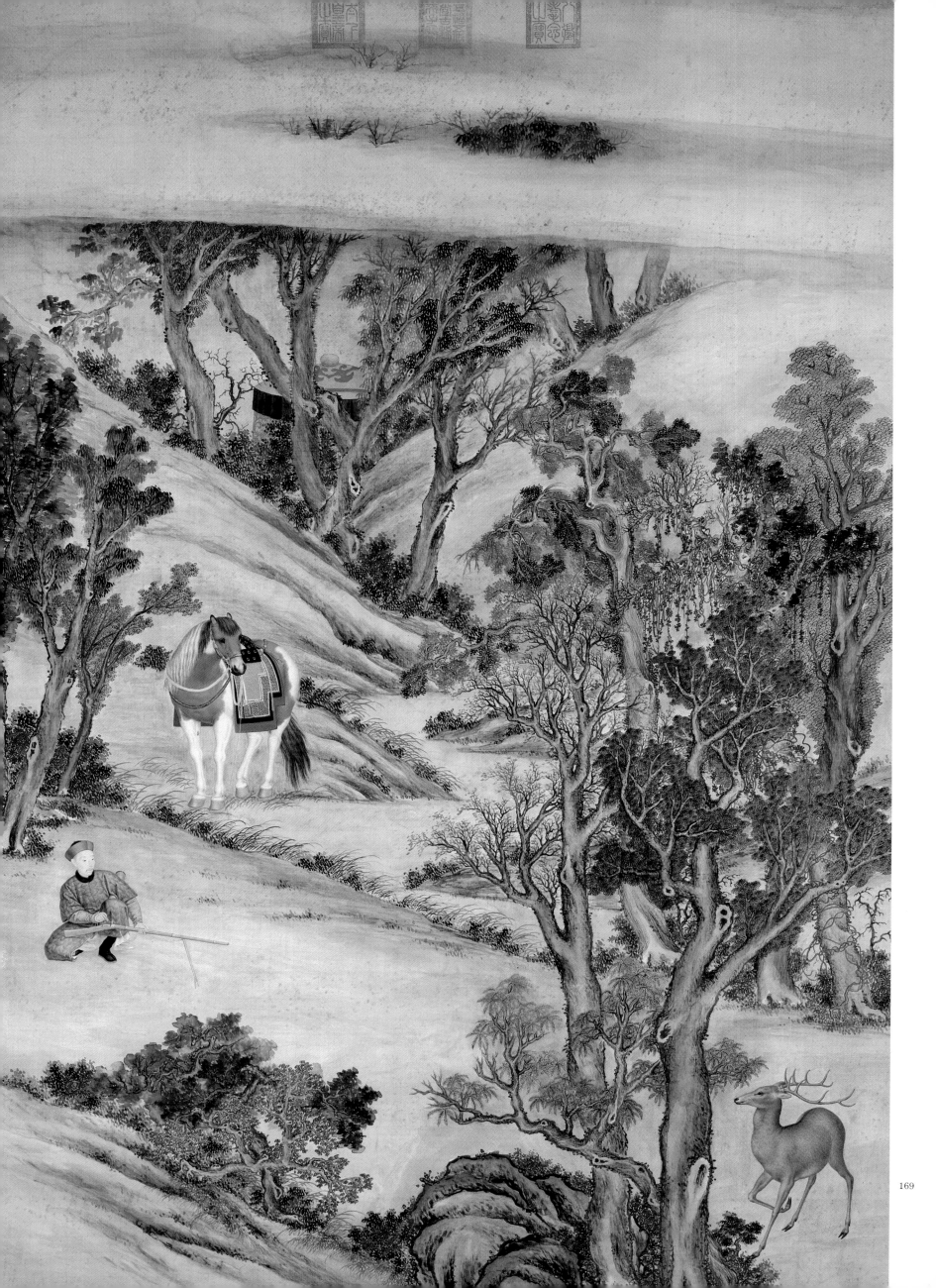

169. *Deer Hunting.* (301.5 cm × 419 cm)

This work by Qing court-painters depicts the Emperor Qian Long shooting a deer with a gun. During deer hunting, the soldiers, wearing antlers, imitated the animals' cry to lure the deer from the trees, when the emperor was able to shoot them.

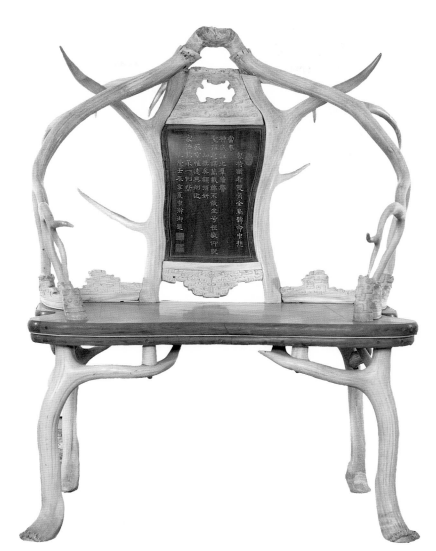

170. A deerhorn chair.

From the time of the Qing Emperor Tai Zong (*c.* 1627–35), the horns of deer captured during hunting expeditions were used to make chairs, and verses were carved on their backs to remind people of the Manchu tradition of horsemanship and archery. Thus, the deerhorn chair was a symbol of the Qing emperors' adherence to their traditional values.

170

171. Deer whistles.

These whistles were used to imitate the deer's cry during the Mulan imperial deer hunts. They are made of red sandalwood and some are gilded and decorated with colourful designs.

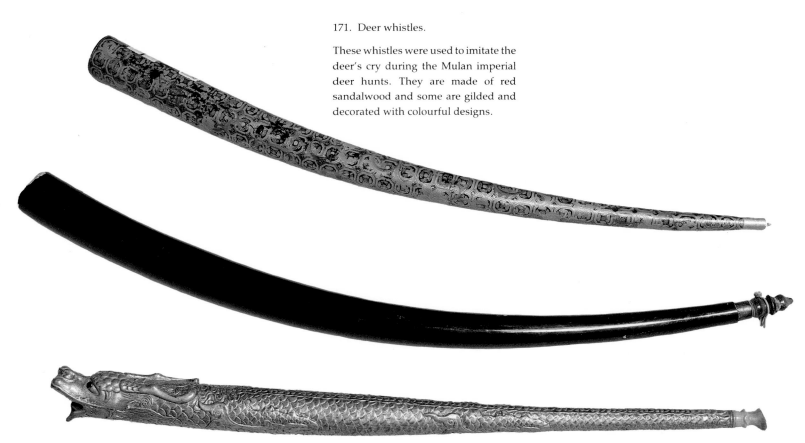

171

起居編

DAILY LIFE

Behind the three great halls that dominate the front section of the Imperial Palace is a rectangular area known as Transverse Way. In the centre of the rear of this area is the Gate of Heavenly Purity flanked by the Inner Left Gate and the Inner Right Gate. Behind these gates are a group of palaces (built next to one another), each enclosed within its own courtyard. These palaces provided the living-quarters of the emperors, empresses and imperial concubines. On the western side through the Gate of Imperial Prosperity are the Palace of Benevolent Peace, the Palace of Longevity and Good Health and the Palace of Peace and Longevity, the apartments of the empresses dowager. Through the Gate of Flourishing Fortune on the eastern side stands the Palace of Blessing, where the crown prince lived, the Palace of Peaceful Old Age, built for the father of the emperor to reside in, and the Hall of Gathering Fragrance, the living-quarters of the young princes. These palaces collectively made up the Inner Court of Sleeping-Quarters.

The Palace of Heavenly Purity was the residence of the emperor during the Ming dynasty, and this tradition was continued by the early Qing emperors. Even after the Emperor Yong Zheng moved his living-quarters to the Hall of Mental Cultivation, the Palace of Heavenly Purity remained the place where the emperor held court and where Inner Court ceremonies were held. The Hall of Luminous Benevolence to the east of the Palace of Heavenly Purity was the emperor's study during the reign of the Emperor Kang Xi. The Hall of Broad Virtue on the western side provided the emperor's dining-room, study and office. In the rooms joined by galleries around the perimeter of the Palace of Heavenly Purity were housed various government departments and offices for the organization of the emperor's daily life. The three rooms at the northern end of the eastern gallery were the duty-rooms of the eunuchs of the Palace of Heavenly Purity, although outside hung a board inscribed 'Imperial Teahouse' in the Emperor Kang Xi's calligraphy. The three rooms due south of these duty-rooms were known as the Hall of Sedateness. Outside these rooms hung another board with the words for 'apparel' inscribed in the Emperor Kang Xi's calligraphy, and these rooms were used for the storage and care of the emperor's headgear, robes, belts and footwear. The three rooms even further south were also considered part of the Hall of Sedateness and were where the chiming clocks were kept, along with incense and head-dresses, robes and jewellery belonging to former emperors. To the south of the Gate of Solar Perfection was the Imperial Dispensary. The three rooms in the middle in the northern part of the western gallery were collectively the Hall of Diligence, where the Emperor Kang Xi studied when he was a boy. The emperor's books, historical documents and writing paraphernalia were kept here. To the south of the Gate of Lunar Glory was the area where the emperor's sedan-chairs were kept. The functions of all these buildings were thus related to the daily life of the emperor.

According to the written records from the early years of Qian Long's reign, the daily routine of the emperor was as follows: after rising, he often enjoyed a bowl of swallow's nest cooked with crystal sugar, before going to the Western Warm Chamber of the Palace of Heavenly Purity, or the Warm Chamber of the Hall of Broad Virtue, or to the Hall of Mental Cultivation to peruse a volume of written accounts of, or imperial instructions pertaining to, the previous dynasties. He breakfasted at about eight o'clock, or perhaps a little earlier, while at the same time he read the list of names of princes, dukes and ministers who were requesting an audience. After breakfast he opened and read the memorials presented by the ministers and other officials, and then began the audiences. He had lunch at about two o'clock in the afternoon, following which he read the memorials from the various departments and regional governors which had been presented by the Grand Secretariat. He ate a very simple supper in the evening. Even when the emperor was staying at the Sea Terrace Island or at one of the other imperial gardens, his routine was more or less the same.

The Hall of Earthly Peace was the principal residential palace of the empress during the Ming dynasty, and according to the Qing regulations it should also have been the principal palace of the empress during the Qing period. However, the empresses of the Qing dynasty did not actually live there. They only stayed in the Hall of Earthly Peace on those occasions when they were to receive congratulations in the Hall of Union. The hall had been rebuilt according to Manchu custom in the early Qing in the style of the Palace of Purity and Tranquillity in Shenyang. The section with windows and the western part were converted into a shrine for the offering of sacrifices to the gods, while the Eastern Warm Chamber was used as the bridal chamber on the occasion of the emperor's marriage.

The Hall of Union, standing between the Palace of Heavenly Purity and the Hall of Earthly Peace, was also used as the living-quarters of the empress during the Ming dynasty. From the period of the Qing Emperor Qian Long onwards, however, the hall was used to house the emperor's twenty-five seals, as well as clepsydras (water-clocks) and chiming clocks. On festival days such as birthdays and the New Year, the empress received congratulatory gifts from the imperial concubines and princesses in this hall. Every year in mid-spring on the day before the empress was due to attend the Altar of the Goddess of Silkworms and take part in the ceremony of plucking mulberrry leaves, she came to the Hall of Union to examine the instruments used for picking the leaves.

The Hall of Mental Cultivation was south of the six western palaces, and it was in the rear section of this hall that the Emperor Shun Zhi and all the emperors following Yong Zheng made their living-quarters. The innermost room of the Eastern Warm Chamber of this 'sleeping-palace' was the emperor's bedroom. The other rooms provided the rest of his living-quarters where all kinds of valuable works of art were displayed. The east wing of the back of this hall provided rest-rooms for the empress, while the west wing and the eastern and western side-rooms were temporary resting-rooms for the imperial concubines. For a short time, when the Emperor Tong Zhi was young, Empress Dowager Ci An lived in the east wing while Empress Dowager Ci Xi lived in the west wing. When Tong Zhi became adult, the two empresses dowager moved into the Palace of Concentrated Purity and the Palace of Eternal Spring, respectively. Tong Zhi's empress and later Guang Xu's empress also lived in the east wing. It was said that the empress and the imperial concubines could only go to the emperor's bedroom when they were summoned by the emperor. The records do not indicate whether the emperor ever went to the palaces of the empress or the imperial concubines.

On the left and right of the three rear halls are the six eastern and six western palaces, where the imperial concubines lived in the Ming dynasty. In the Qing dynasty they were the living-quarters of the empress and imperial concubines, and according to Qing custom the empress commanded the affairs of the rear palaces. Immediately beneath her in status was an imperial consort (huangguifei), then two high consorts (guifei), four consorts (fei) and six imperial concubines (pin), as well as an indefinite number of lesser concubines (guiren, changzai and daying). Some Qing emperors, however, did not limit themselves to so few high-ranking concubines, and at one time or another during his reign the Emperor Kang Xi had in all twenty-five empresses and imperial consorts. If all his lesser concubines were included then the total came to fifty-four. Emperor Qian Long had twenty-four empresses and imperial concubines and sixteen lesser concubines, while the Emperor Guang Xu only had his empress and two concubines. Within the twelve palaces in which the empress and concubines lived, each woman of the rank of imperial concubine or above would be the mistress of her own palace. The lesser concubines lived in the palaces of those of higher rank. Each of the twelve eastern and western palaces occupies about 2,500 square metres of land, with twenty-two principal rooms, including the front hall, which was used for ceremonies, and the rear hall, which was used as sleeping-quarters, in addition to the east and west wings. There were also side-rooms and washing-rooms, which were generally used by the eunuchs and palace maids.

The Emperor Qian Long had a horizontal board with an inscription in his own calligraphy hung in each of the twelve eastern and western palaces. There were also a screen, a throne, incense burners and a perfume-casket placed in the front hall of each palace to enable the empress and imperial concubines to perform ceremonies and receive

respects. He also decreed that pictures of the door gods and New Year couplets written on paper be pasted up in the palaces every twelfth lunar month. On the same day 'pictures of palace admonitions' and 'commendations composed by the emperor' were to be hung on the eastern and western walls of the front hall of each palace. They and the pictures of the door gods were taken down in the second lunar month of the following year and stored. The 'pictures' and 'commendations' extolled the virtues of famous empresses and imperial concubines of past dynasties, with the purpose of teaching the feudal code for women and exhorting the empress and concubines to emulate their excellent example. Although the twelve palaces were inhabited by the empresses and imperial concubines during nine reigns of the Qing dynasty, there are no detailed records of how they actually lived, apart from a small amount of fragmentary material gathered from related historical documents.

The Imperial Household Department was set up in the early Qing period and, following the traditions of previous dynasties, eunuchs were appointed to a number of posts relating to day-to-day life in the palace. The Emperor Shun Zhi, however, bearing in mind the excess of power assumed by the Ming eunuchs, considerably reduced their number. In addition to this, in the sixth lunar month of the twelfth year of his reign (1655) Shun Zhi strictly prohibited eunuchs from intervening in government affairs: anyone who contravened this prohibition was to be put to death by slicing. Iron tablets inscribed with this decree were placed in the Imperial Household Department, the Hall of Union and, later, in the Attendants' Office and other places. In order to strengthen the control over the eunuchs, in the sixteenth year of Kang Xi (1677), the Attendants' Office was set up under the Imperial Household Department with special responsibility for the administration of the eunuchs. During the Emperor Yong Zheng's reign there were further decrees governing the ranks to be granted eunuch officials. The chief palace superintendent was to be an official of the Fourth Rank; the superintendent, the lower Fourth Rank; the assistant superintendent, the Sixth Rank; and the supervisors were to be officials of the Seventh and Eighth Ranks. Later, another decree stated that no distinction should be made between the full and lower ranks for the eunuchs serving as officials in the palace. The duties of the Attendants' Office were to administer the affairs of the palace, following the orders from the emperor. This included examining, transferring, rewarding and punishing eunuchs in the palace, performing rituals, receiving money and grain from the storehouses, inspecting, opening and closing the palace gates, guarding against the danger of fire, keeping watches, guarding the gates and performing sundry duties assigned by the Imperial Household Department and other government offices. In addition, it was responsible for recording the births of princes and princesses, the deaths of emperors, empresses and imperial concubines, and for drawing up the imperial family tree. There were more than 120 officials under the auspices of the Attendants' Office concerned with the administration of the eunuchs.

The number of eunuchs employed at the Qing court varied with the different reigns. In the early periods there were usually about 2,600 employed within the court itself and in the surrounding establishments. In the late Qing, however, this number was reduced to between 1,500 and 1,600. The eunuchs were recruited by the Accounting Office and the Ritual Office of the Imperial Household Department. Most of them came from poor families living in districts all over Hebei Province and, having been brutally mutilated when they were six or seven, they were selected to work in the palace after application through eunuch-recruiting agents. A small number were also assigned work in the houses of princes. Another source of eunuchs was the families of persons who had committed 'treason'. As part of the father's punishment his whole family was sometimes executed, but sons and grandsons who were under sixteen years of age were not eligible for capital punishment. They were put in prison until they were ten, when they would be castrated and become eunuchs. Some of them were tortured to death for some misdemeanour. Only when they were too old or too sick to work any longer were they permitted to leave the palace and live the life of a normal person. This was often impossible, however, and they lived out the end of their days in abject misery, because by the time they returned to their native districts, they had been away so long that they knew no one and were ostracized by the rest of society. Only a very small number of eunuchs who managed to reach the higher ranks were in a position to donate money to monasteries which would in turn allow them to live the closing years of their lives there. A very few even managed to continue to exercise power and retain their prosperity in the monasteries.

When a new eunuch first came to the palace he had to find another established eunuch to whom he could apprentice himself in order to learn the regulations and rules of decorum of the palace. First he would be subjected to enslavement by his eunuch master and later to the enslavement and bullying of the palace mistresses, eunuch superintendents and supervisors. The eunuchs were usually responsible for the care and cleaning of the palaces, and for keeping watch. Some were employed in delivering documents, imperial memorials and edicts to and from the Imperial Household Department and the various government offices; some looked after the imperial seals and the emperor's clothes and ceremonial weapons; others served in the dining-rooms, kitchens and dispensary. Some eunuchs were even assigned to look after the spiritual aspects of daily life, to become lamas and recite the scriptures at Buddhist shrines in the palace or, alternatively, serve as Daoist priests. On the more secular side, others were sent to the theatre in the palace to learn to perform in operas.

Generally, the Qing court had strict regulations regarding eunuchs. Those who were found guilty of minor violations were upbraided and beaten, while those who committed serious offences were handed over to the Office of Punishments of the Imperial Household Department. A number of eunuchs could not stand the maltreatment and ran away. The regulations stipulated that eunuchs who ran away for the first or second time and returned of their own accord were punished relatively lightly – they were beaten and then sent to Wudian (Nanyuan) to cut fodder. Those who were recaptured after they had run away for the third time were first beaten and then handed over to the Office of Punishments. There they were put in a cangue for one or two months and afterwards permanently exiled to Heilongjiang to work as the slaves of the garrison soldiers. Very few of those who ran away managed to retain their freedom. Some eunuchs who were found guilty of stealing were publicly beaten to death. Others committed suicide as the only way to escape the unendurable ill-treatment. However, suicide was considered unlucky in the palace and failed attempts were harshly dealt with.

The maids in the Qing palace were employed from among the daughters of the house-slaves of the Imperial Household Department. Each year the girls who had reached the age of thirteen were taken to the palace to be selected, by arrangement with the Accounting Office of the Imperial Household Department. Those who were recruited were put to work in the various palaces serving the daily needs of the empress and the imperial concubines. The regulations stipulated that the empress dowager was entitled to twelve maids, the empress to ten, the imperial consort and high consort to eight, the consorts and imperial concubines to six, the concubines to four, the *changzai* to three and the *daying* to two. The actual number employed, however, frequently exceeded these numbers.

Once they had been selected to work in the palace, the maids were not permitted to go home to see their families, nor were parents allowed to come to the palace to see their daughters until the maids reached the age of twenty-five, when they left the palace to get married. The maids lived in small rooms in the various palaces, and their behaviour was governed by strict rules. No frivolity, laughter or loud voices were permitted. Occasionally a maid might catch the eye of the emperor and become a concubine, but this was rare. Like the eunuchs, some committed suicide because they could not endure the hardships, and some were beaten to death, while others were so ill-treated that they became physically ill or lost their reason and so had to be sent from the palace.

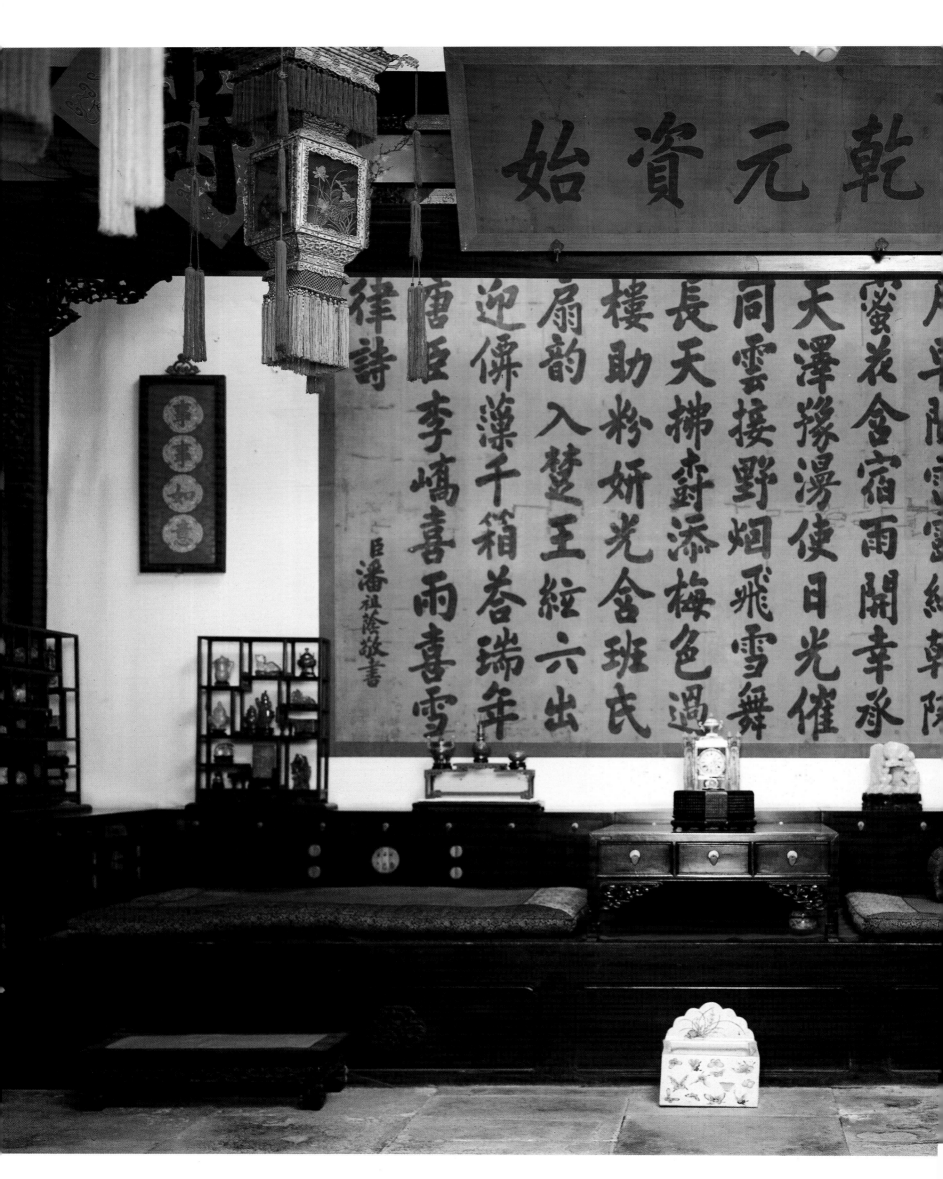

172

173

174

172. The rear section of the Hall of Mental Cultivation.

The front and rear sections are connected by a gallery by which the emperor could return to his sleeping-palace through the doors on the left and right sides behind the throne, which stood in the front section. Apart from the empress, the imperial concubines, the emperor's family and attendant eunuchs who were summoned by the emperor, nobody was allowed to enter the emperor's sleeping-palace. Along one wall in the middle room is a wooden platform bed or couch, known as the throne bed, surrounded on three sides by low cupboards. The display shelves standing on the cupboards allowed the exhibition of many works of art. On the wall behind the bed is a Tang-dynasty poem copied by a minister, which is flanked by a pair of New Year scrolls. The hall is now decorated in the way it would have been during the reigns of the Emperors Tong Zhi and Guang Xu. The interior decoration is not unduly luxurious.

173. A *ruyi* sceptre of green jade.

Ruyi existed as early as the Han and Wei dynasties. Originally instruments for scratching, these gradually developed into auspicious symbols, often presented as gifts.

174. Persimmon-shaped spittoon of red carved lacquer.

'Persimmon-shaped spittoon' and 'ruyi' combine to give a homophone for 'everything as you wish it', implying that the emperor should achieve whatever he desired.

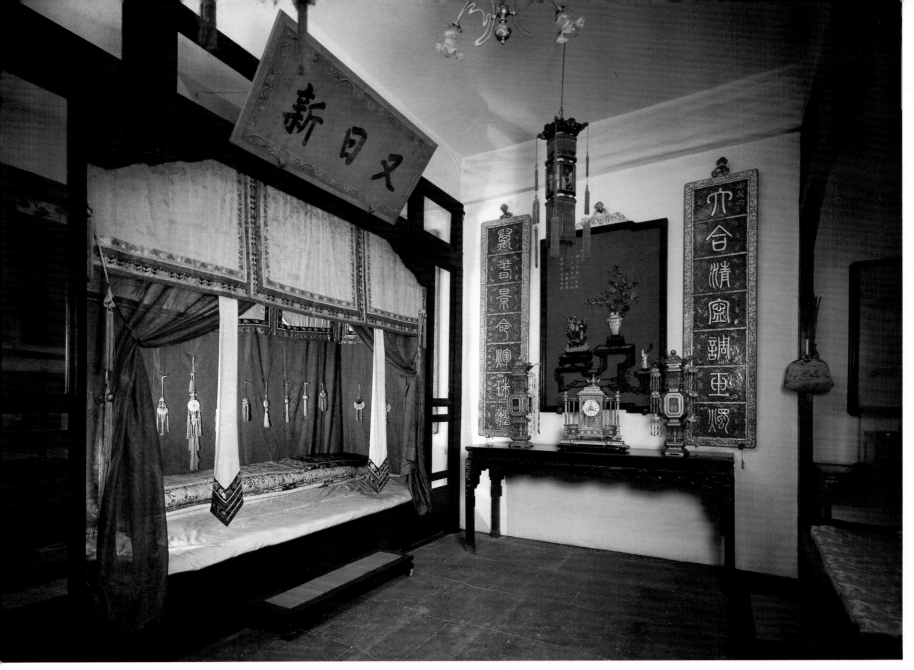

175

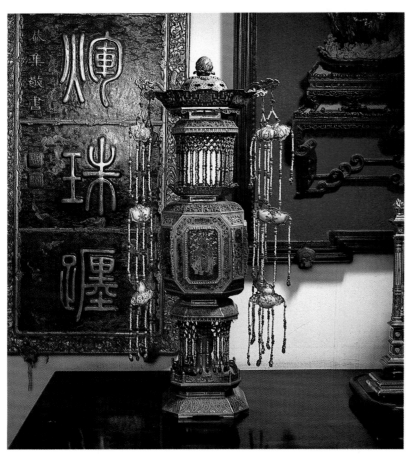

176

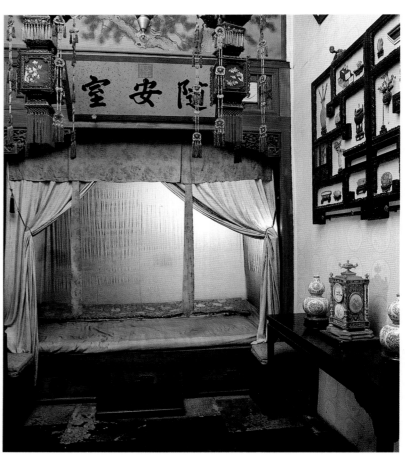

177

175. The emperor's bedroom – the Eastern Warm Chamber in the rear section of the Hall of Mental Cultivation.

The emperor's bed is at one end of the Eastern Warm Chamber. The wooden platform-bed, which is more than three and a half metres long, is hung with a gauze curtain in summer and a lined silk-satin curtain in winter. It is decorated with pennants and the interior curtain is hung with ornamental perfume-sachets. The embroidered quilts are also of silk satin, and there is a rectangular pillow. The room is warm in winter and cool in summer. It was heated from outside by a wood fire through channels under the floor and charcoal burners in the room. The floor was covered in woollen carpets. A reed awning was erected outside in summer. It provided pleasant shade but allowed the cool breezes into the room.

176. A pierced *cloisonné*-enamel table-lamp.

The lamp is in three sections. From each of the four dragon heads on the top are suspended cascades of enamel beads. The section where the flame was lit is enclosed in glass.

177. The quiet room.

The quiet room is in the north-eastern corner of the Eastern Warm Chamber of the Hall of Mental Cultivation. It was the emperor's bedroom during the two- or three-day periods of abstinence before a sacrificial ceremony. During these periods, the emperor was to abstain from six things: drinking, eating meat or fish, dealing out punishments, banqueting, listening to music and indulging in sexual relations, in order to demonstrate a sincere frame of mind.

178. A portrait of Emperor Jia Qing in court robes. (271 cm × 141 cm)

Jia Qing, whose personal name was Yongyan, was the fifth emperor of the Qing dynasty after it assumed control of the whole country. The fifteenth son of Emperor Qian Long, he was born in the twenty-fifth year of Qian Long's reign (1760) and was made the crown prince in the sixtieth year (1795). He succeeded to the throne the following year when Emperor Qian Long abdicated to live as the emperor's father. The Emperor Jia Qing died in the Summer Palace in Chengde in the twenty-fifth year of his reign (1820), when he was sixty-one.

178

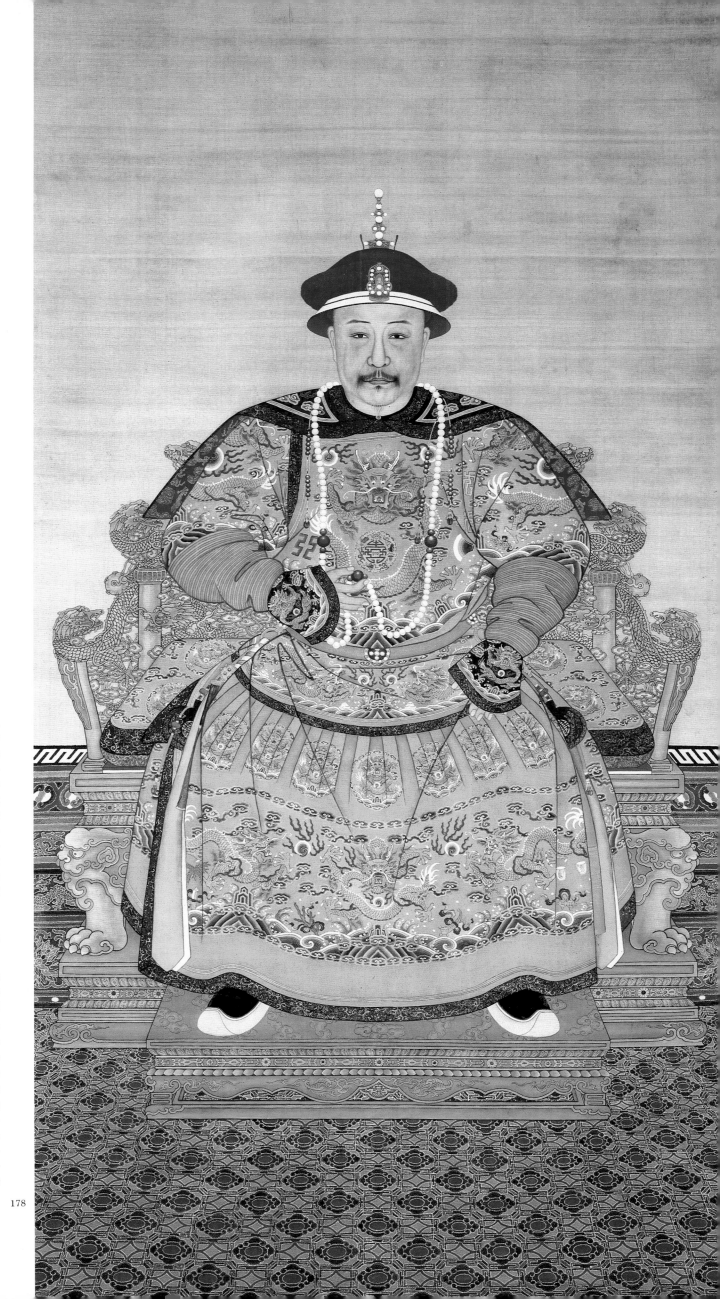

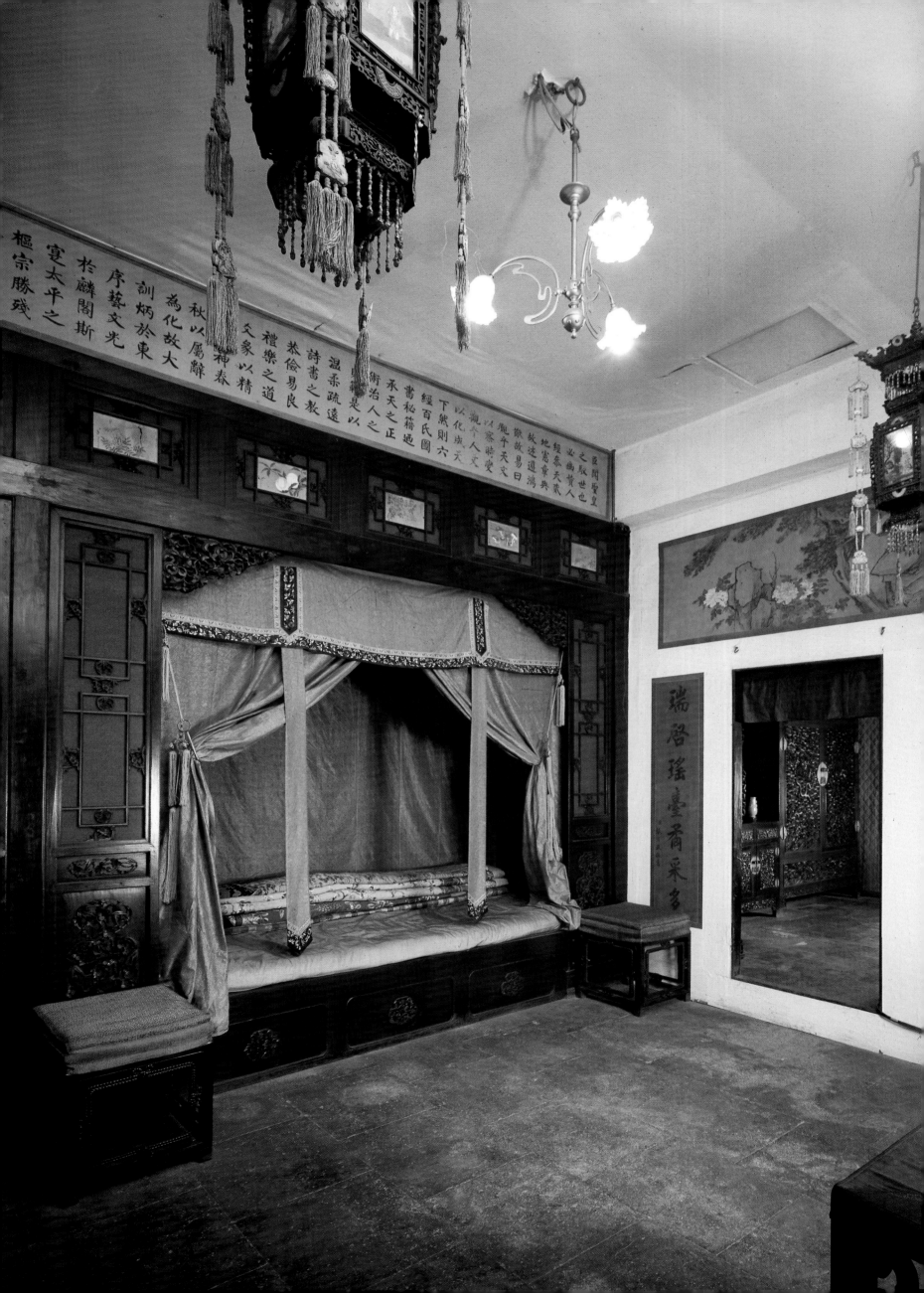

180

180. A bathtub.

This oval, red-lacquer bathtub was made of rattan, lacquered and decorated with gold designs. Even the towels shown here are original objects from the Qing court. The emperor was waited on by the eunuchs in every aspect of his private life. Every day his washing implements and, in summer, his bathtub were brought to his room by eunuchs and removed again after use.

181. A commode.

The emperor's commode bowls were made of pewter or silver. This wooden-framed commode has a silver basin and a removable lid. It was usually kept in a closet next to the emperor's bed. Even when this was used, the emperor was waited on by eunuchs.

181

179. The Western Warm Chamber in the rear section of the Hall of Mental Cultivation.

There is also a curtained bed in this room, but the emperor very rarely spent the night here.

182. A highly decorated gold incense-burner, vase and box, inlaid with jewels.

Scholars in ancient times often placed incense-burners on their desks. The censer, vase and box illustrated here are a set of vessels for burning incense. The lid, handles, feet and base of the censer are inlaid with rubies, sapphires and turquoise. The vase stands on a pedestal in the form of cranes, bamboo and pines. In the vase are a gilded scoop and a pair of chopsticks for removing ashes from the censer and picking up the incense. The incense used at that time was made of sandalwood, garuwood, ambergris, etc.

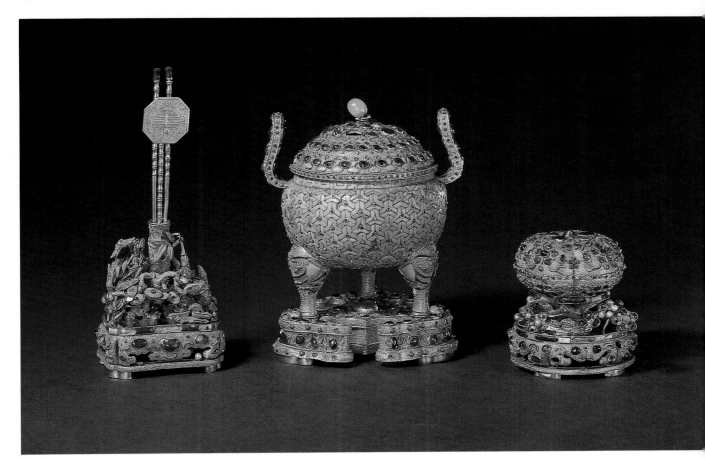

182

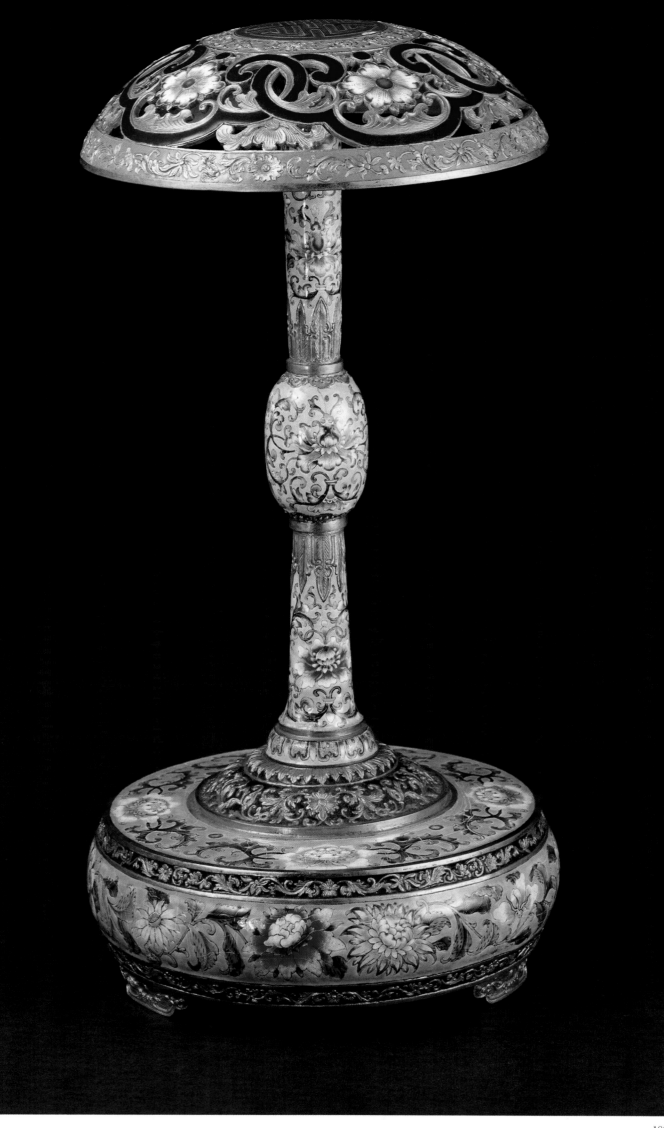

183. A hat-stand. (height, 28.5 cm, diameter, 13 cm)

This enamel hat-stand is painted with plants and flowers and has the character for longevity (*shou*) on the top. It was a useful item that was usually conveniently placed on a bedside-table or desk.

184. Large red sandalwood cupboards carved with dragon and cloud designs. (height, 2.92 m, width, 1.76 m)

In the emperor's living-rooms were large cupboards for storing his clothes, hats, belts and shoes. These two which stand in the rear part of the Hall of Mental Cultivation are made in two sections. The front areas of each cupboard are decorated with beautiful relief carvings of five dragons among elaborate cloud formations.

185. A red sandalwood hat-rest inlaid with silver and jade.

Hat-rests were made of many different materials, such as porcelain, jade, enamel and carved wood. This red sandalwood hat-rest with the emperor's everyday hat on it was one of those made in the palace workshops. It is exquisitely inlaid with silver elements in flower designs and incorporates a type of inlay called *shangsi*.

186. An ivory mat. (120 cm × 132.5 cm)

This ivory mat was woven from ivory strips less than 0.3 cm wide. Its fine texture and smooth surface made it pleasantly cool to sleep on in summer. During the reign of Yong Zheng and the early years of Qian Long, officials in Guangdong often presented ivory mats to the court as tribute. Only two, however, have been preserved in the Qing palace.

183

184

185

186

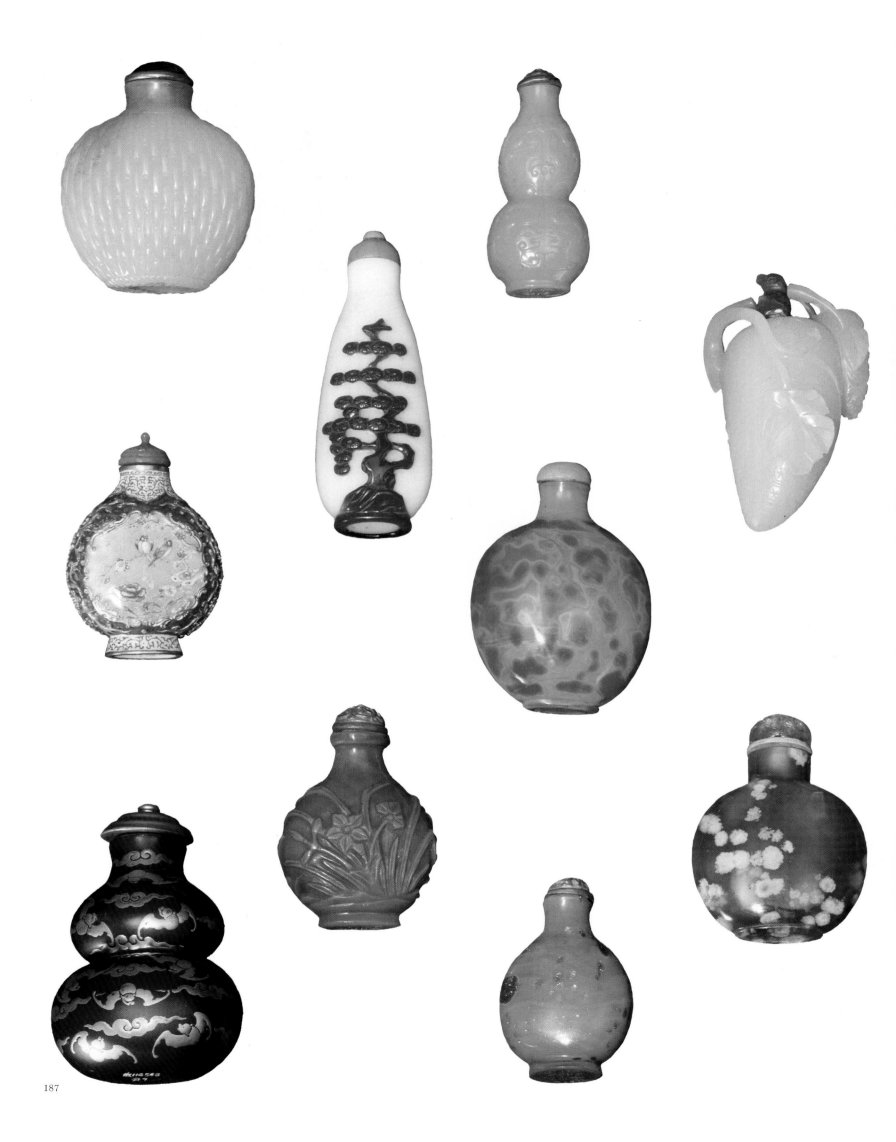

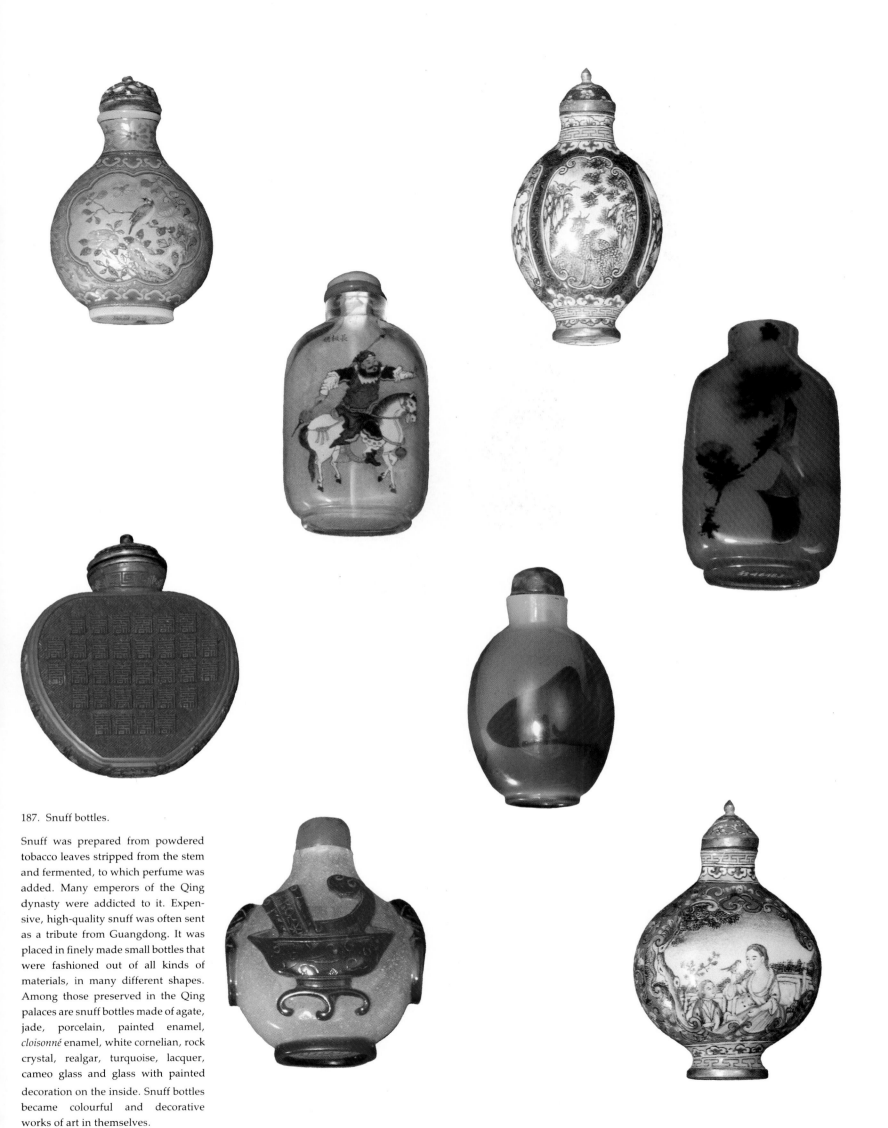

187. Snuff bottles.

Snuff was prepared from powdered tobacco leaves stripped from the stem and fermented, to which perfume was added. Many emperors of the Qing dynasty were addicted to it. Expensive, high-quality snuff was often sent as a tribute from Guangdong. It was placed in finely made small bottles that were fashioned out of all kinds of materials, in many different shapes. Among those preserved in the Qing palaces are snuff bottles made of agate, jade, porcelain, painted enamel, *cloisonné* enamel, white cornelian, rock crystal, realgar, turquoise, lacquer, cameo glass and glass with painted decoration on the inside. Snuff bottles became colourful and decorative works of art in themselves.

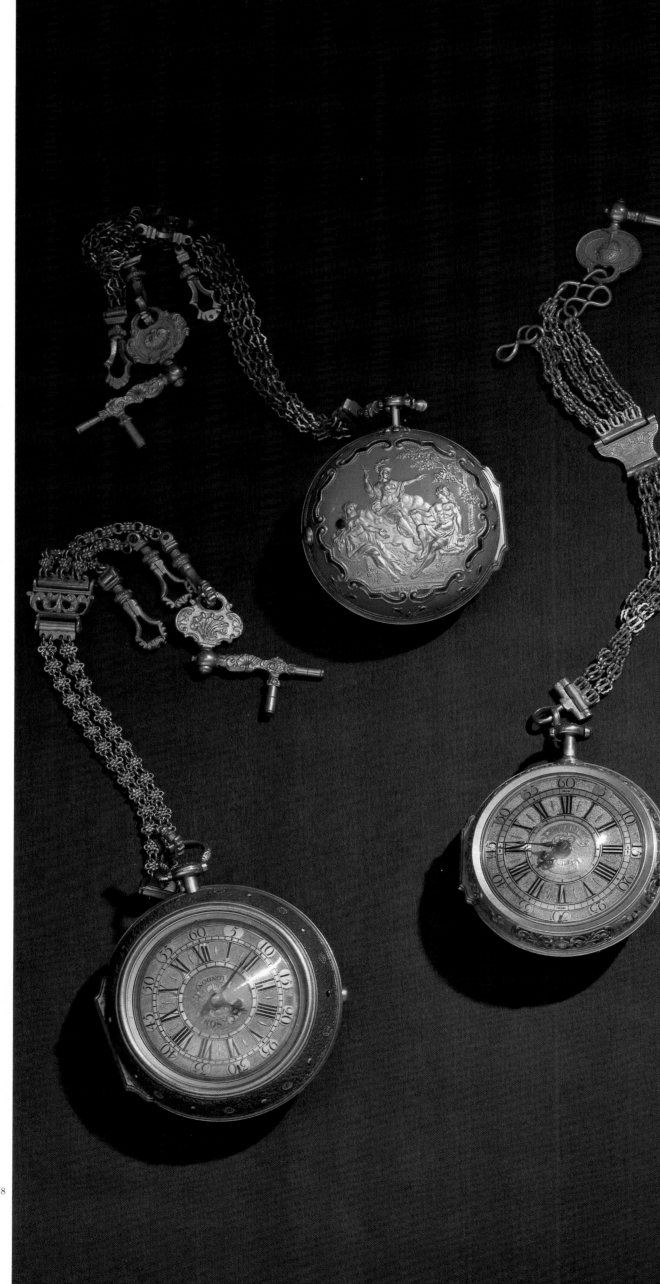

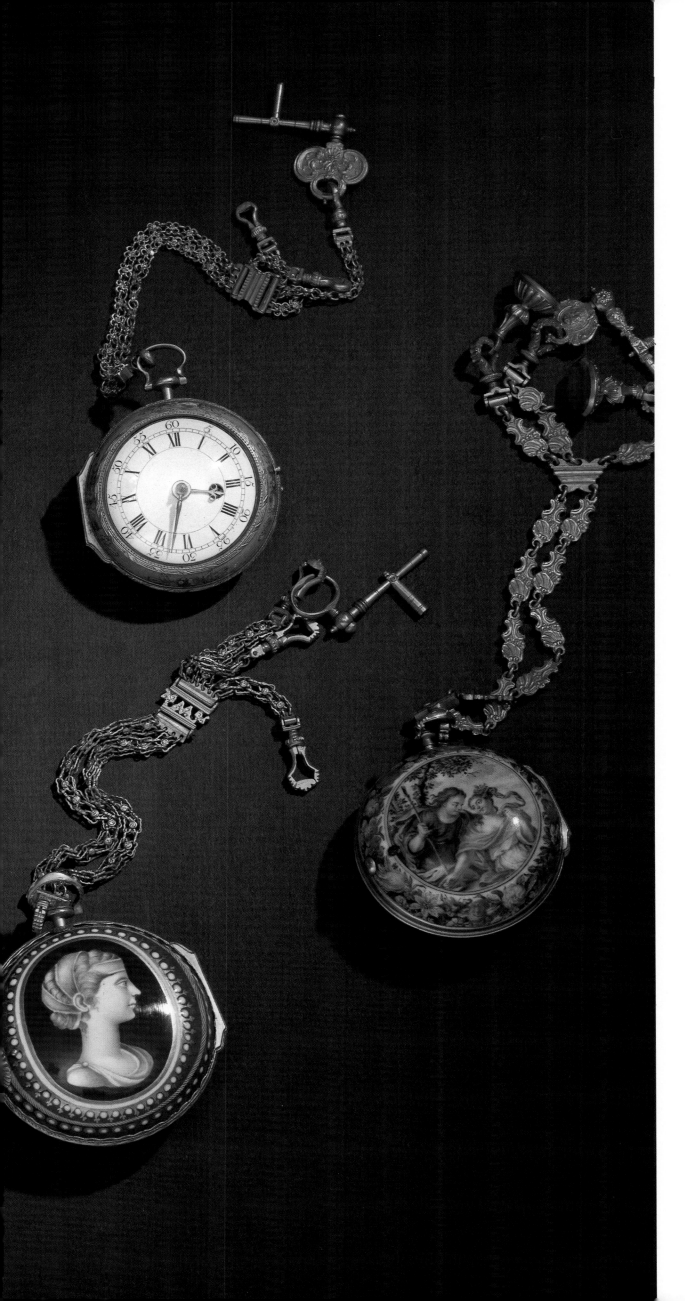

188. Fob-watches.

These fob-watches were made in Britain and France in the eighteenth century.

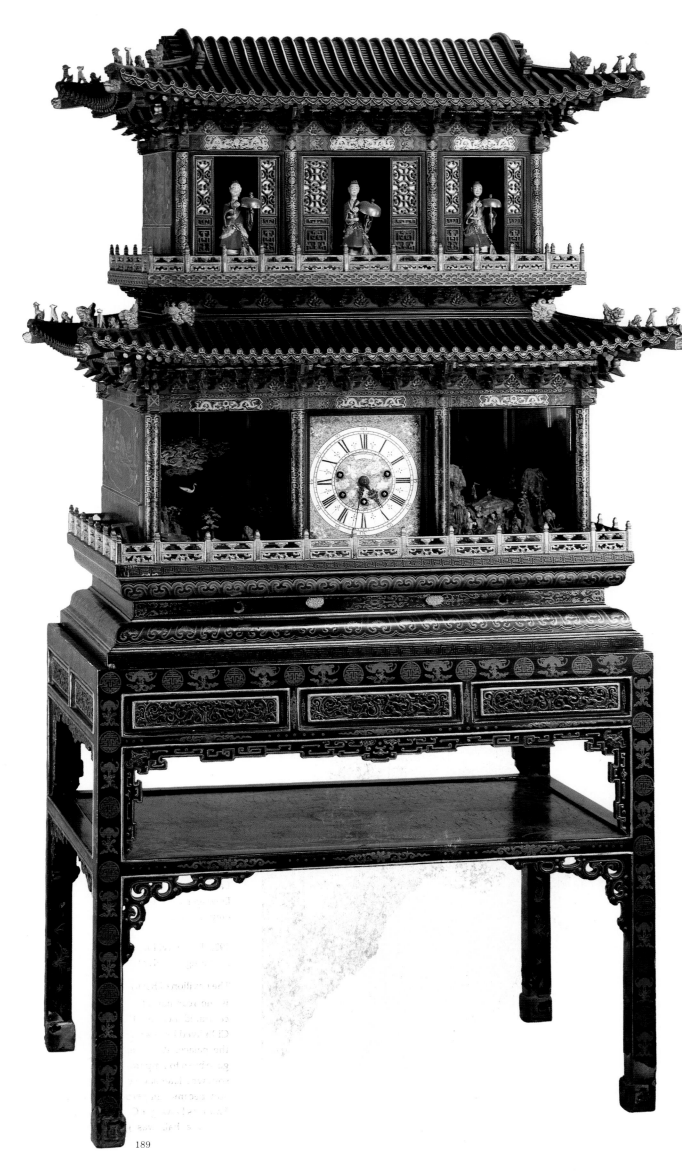

189

189. A clock in the form of a two-storey pavilion, decorated with coloured lacquer and gold designs. The scenes in the lower recesses depict the immortals and Shoulao, the Star God of Longevity.

According to written records, there were more than 3,400 clocks in the various halls of the Qing palaces in the eighth year of Guang Xu's reign (1882). This clock, housed in a two-storey pavilion with gilded decoration, was made by the clock-makers in the palace workshops. At three, six, nine and twelve o'clock, music began to play and the three doors on the upper floor opened automatically to allow three figures, each holding a bell, to appear. The middle figure struck his bell on the hour and the two figures on either side rang the quarter-hours. At the same time, the figures in the lower recesses began to turn. After the chimes and music stopped, the figures retreated and the doors closed behind them.

190. An aerial view of the six western palaces.

The narrow passage in the middle of the picture is the second of the long western alleys with the Multitudinous Progeny Gate at its southern end and the Hundred Sons Gate at its northern end. On the left of the alley are, from south to north: the Palace of Eternal Life, the Queen Consort's Palace and the Palace of Concentrated Beauty. On its right are: the Hall of the Absolute, the Palace of Eternal Spring and the Palace of Complete Happiness, as well as the two palaces added later, the Hall of Manifest Harmony and the Hall of Manifest Origin. All of them were sleeping-quarters for the empress and imperial concubines.

191. An exterior view of the Palace of Concentrated Purity.

The Palace of Concentrated Purity is one of the six eastern palaces. It has in all twenty-two rooms among its front and rear halls and side-halls. First built in the Ming dynasty, it was frequently renovated during the Qing. Its front eaves and the inside structures were built in the late Qing. In the early Ming, it was known as the Xianyang Palace and was the dwelling place of the crown prince. Its front hall was called the Palace of Prosperity and its rear hall the Hall of Wisdom. The name of the palace was changed to the present one during the reign of Long Qing (1567–73) in the second half of the Ming dynasty. In the Qing dynasty it provided living-quarters for the

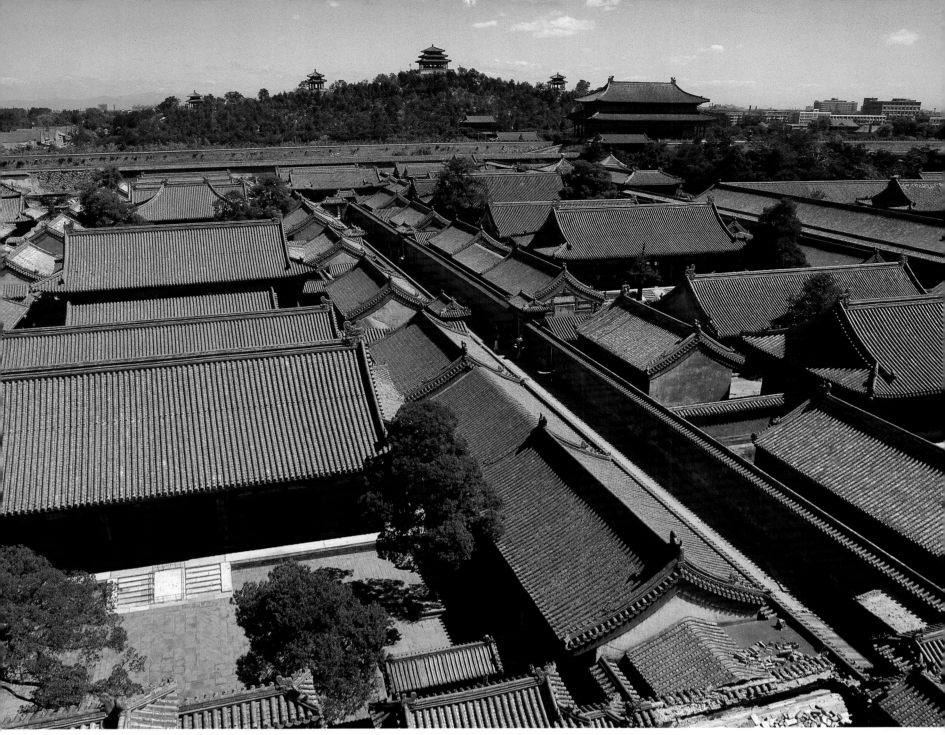

empress or imperial concubines. Qian Long's inscription on the board hung in this palace reads 'Modesty and Gentleness'. The painting, *Empress Xu Serves Food*, and the emperor's commendation were hung on the east and west walls in this palace from the twelfth lunar month until the beginning of the second lunar month the following year. When he was young, Emperor Xian Feng lived in this palace. Later, Empress Xiao Zhen (Empress Dowager Ci An) and then Guang Xu's empress lived here.

192. The Pavilion of Beautiful Surroundings, at night.

The Pavilion of Beautiful Surroundings is the rear hall of the Palace of Concentrated Beauty. Empress Dowager Ci Xi lived here when she first came to the palace. It was also here that she gave birth to Emperor Xian Feng's only son, who later succeeded to the throne and became Emperor Tong Zhi. On Empress Dowager Ci Xi's fiftieth birthday, the hall was given its present name.

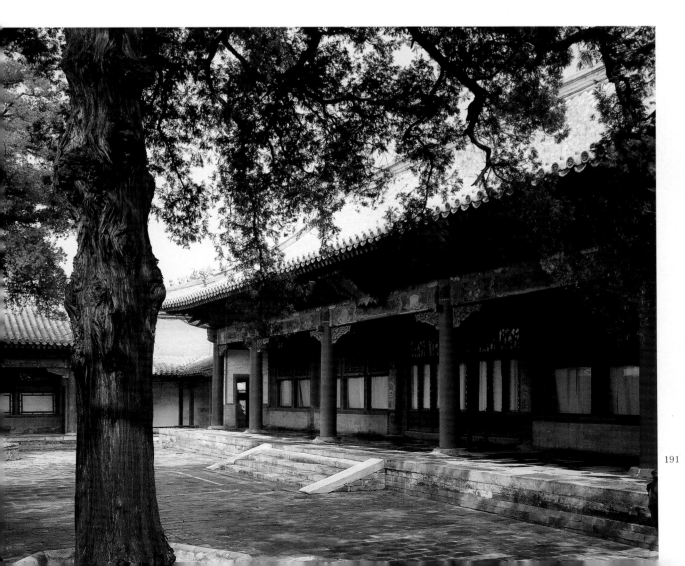

191

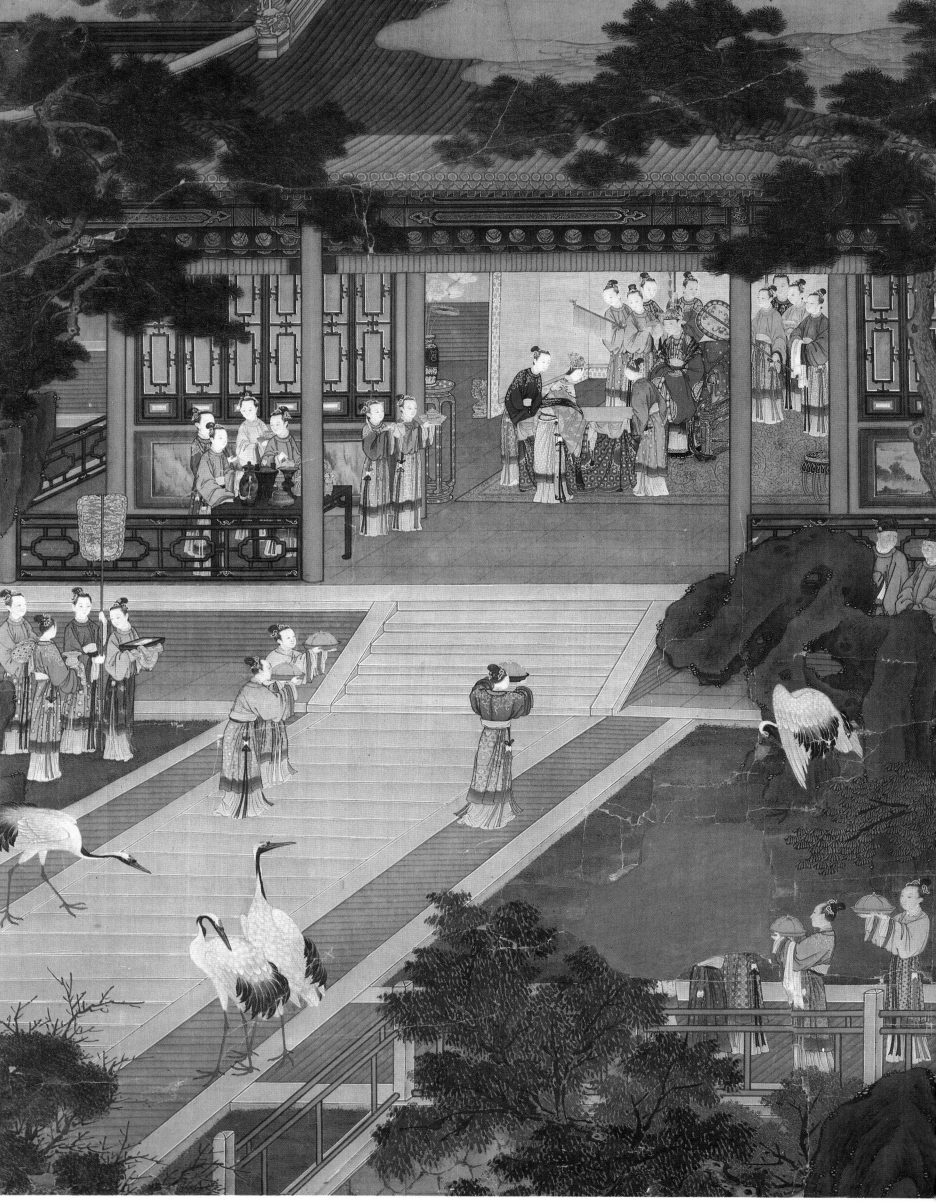

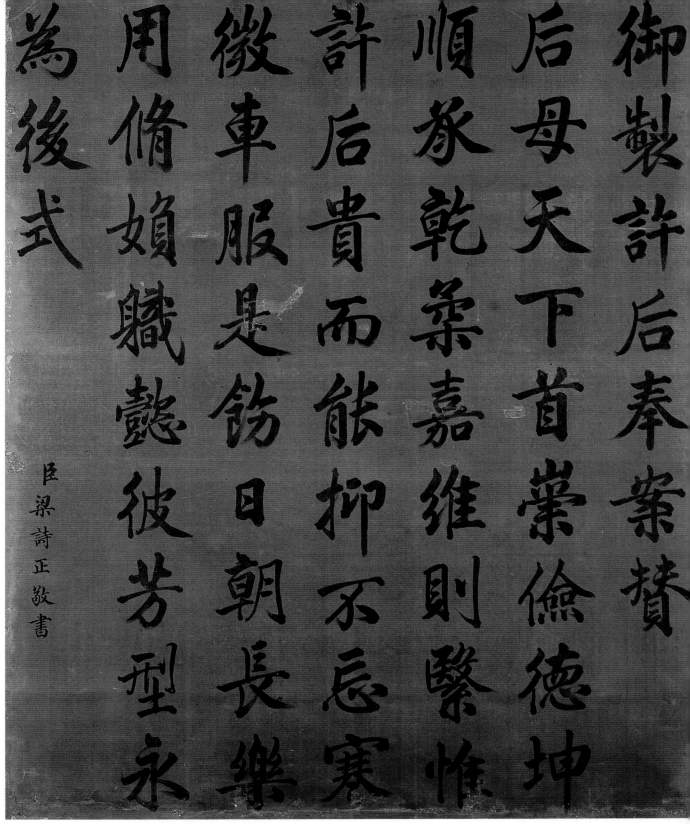

御製許后奉案贊

后母天下首崇倫德御坤

順承乾柔嘉維則繫惟

許后貴而能抑不忝寒

微車服是飭日朝長樂

用脩娖職懿彼芳型永

為後式

臣梁詩正敬書

194

193. *Empress Xu Serves Food.*

Painted by a court-painter in the early years of the Qian Long reign, the picture tells the story of Xu, empress during the reign of Emperor Xuan Di of the Han dynasty, who personally served food to the emperor's mother. During the New Year festival every year, instructive pictures and the emperor's commendations were hung in the six eastern and six western palaces for the inspiration of the empress and concubines. This picture was hung in the Palace of Concentrated Purity during the New Year festival.

194. 'Commendation relating to *Empress Xu Serves Food*'.

This poem was composed by Emperor Qian Long and is written in the calligraphy of the Minister Liang Shizheng. It commends Empress Xu for her filial conduct and exhorts the empress and concubines to follow her example.

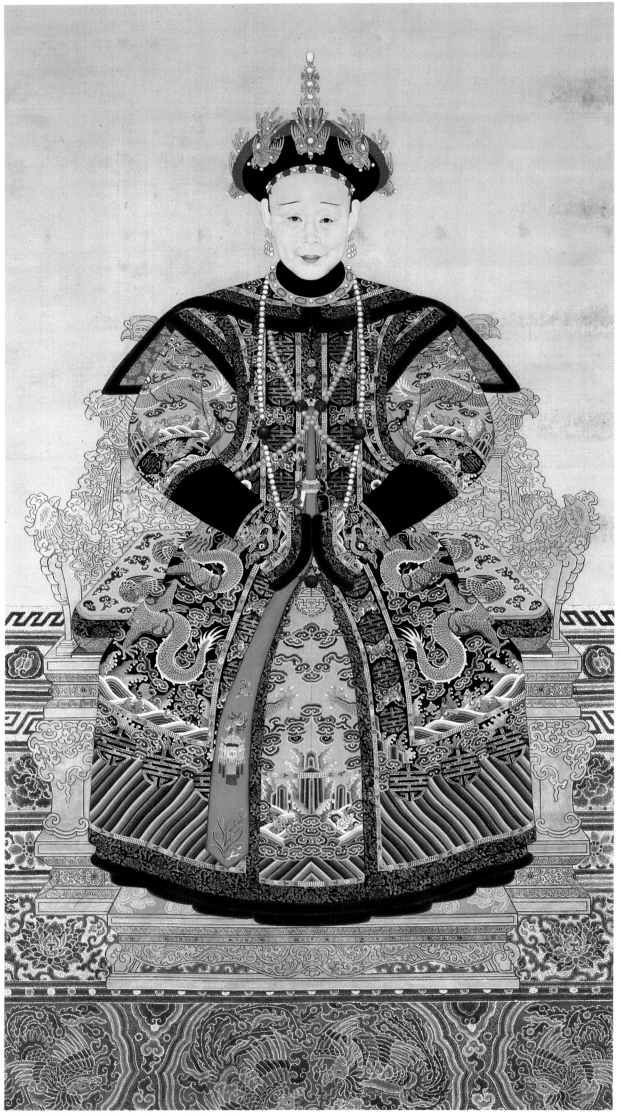

195. A portrait of Empress Xiao He Rui in court robes. (241 cm × 113.2 cm)

Empress Xiao He Rui, originally named Niuhuru, belonged to the Manchu Bordered Yellow Banner. She was made a high consort in the first year of Jia Qing (1796) when she was twenty-one, an imperial consort the following year and empress three years later. She was honoured as the empress dowager in the first year of Dao Guang (1821). She died in the twenty-ninth year of Dao Guang (1849), when she was seventy-four.

196. A screen and throne in the Palace of Eternal Spring.

The Palace of Eternal Spring is one of the six western palaces built in the Ming dynasty. It was renamed the Palace of Eternal Peace in the fourteenth year of Jia Jing in the Ming dynasty (1535). In the forty-third year of Wan Li (1615), however, its original name was restored. It underwent reconstruction in the twenty-second year of Kang Xi (1683) and again during the reign of Guang Xu. The empress or the imperial concubines lived here. When Empress Xiao Xian Chun died while accompanying Emperor Qian Long on an eastern tour in the thirteenth year of his reign (1748), her coffin lay in state in this palace. After her funeral, her head-dress and clothing were enshrined here until the sixtieth year of Qian Long (1795). Empress Dowager Ci Xi lived in this palace during the reign of Tong Zhi.

In the early days of his reign, Emperor Qian Long decreed that a screen and a throne were to be placed in each of the twelve eastern and western palaces. Although it was stated that this arrangement was never to be changed, repeated changes were in fact made in all the succeeding reigns. The screen and throne placed in the middle of the hall were for the empress and imperial concubines to receive congratulations and to have respects paid to them. The arrangement usually included a screen, a throne and a pair of long-handled palace fans, as well as small side-tables, perfume-caskets and incense-burners. The articles illustrated here were all made in the Qian Long period. The screen in this palace is made of red sandalwood, in five sections, with bird and bamboo decoration in coloured ivory. The palace fans made of peacock feathers have red sandalwood stands, and on either side are tables on which stand a pair of pavilion-shaped perfume-caskets. A pair of *cloisonné*-enamel candlesticks in the shape of cranes are placed on either side and slightly forward of the throne.

195

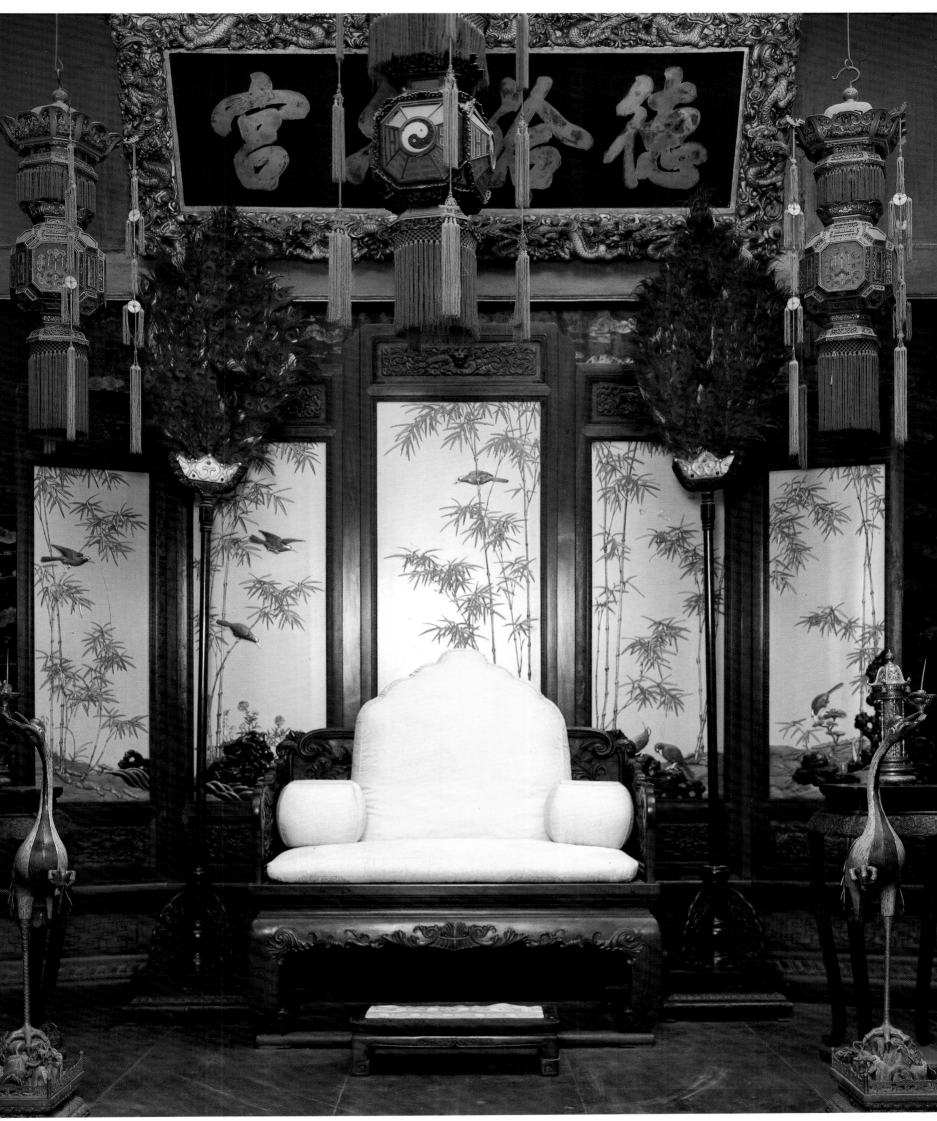

197. A black lacquered dressing-cabinet with gold painted designs.

This dressing-cabinet of black lacquer with painted gold decoration was made in the middle period of the Qing dynasty. It has a circular bronze mirror on a stand on top and, beneath, there are drawers for combs and cosmetics.

198. A vanity-case with gilt mounts.

This vanity-case with gilded decoration and tortoiseshell inlay, enamel miniatures and a mirror, surmounted by a clock, was made in Britain in the eighteenth century. Its feet rest on four rhinoceroses joined together with festoons. The case contained perfumes, scissors, brow-brushes, etc.

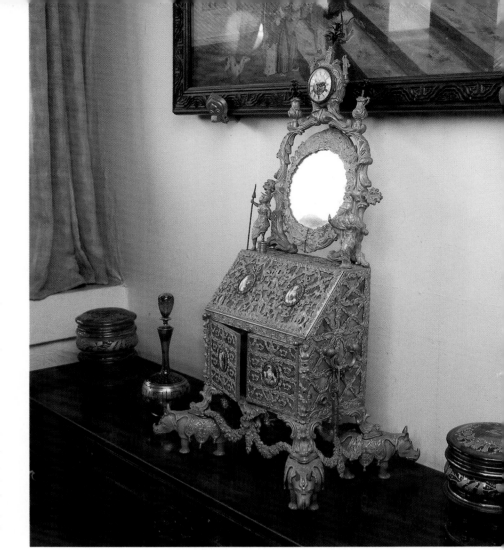

198

199

200

199. A mirror with a gilded and bejewelled handle. (length, 29 cm, diameter, 13.5 cm)

The glass mirror is surrounded with zircons, and there is a small watch mounted in the handle. This was also made in Britain in the eighteenth century.

200. Vanity-case of carved ivory.

The lid of the case is decorated with a dragon and cloud design. The sides of the case are carved with auspicious motifs such as the 'phoenix greeting the sun', 'magpies among plum trees', 'mandarin ducks swimming on the water' and 'crane and deer sharing a spring'. Apart from the drawers for keeping combs and other such items, there are also boxes made of carved ivory to contain face-powder, rouge, etc.

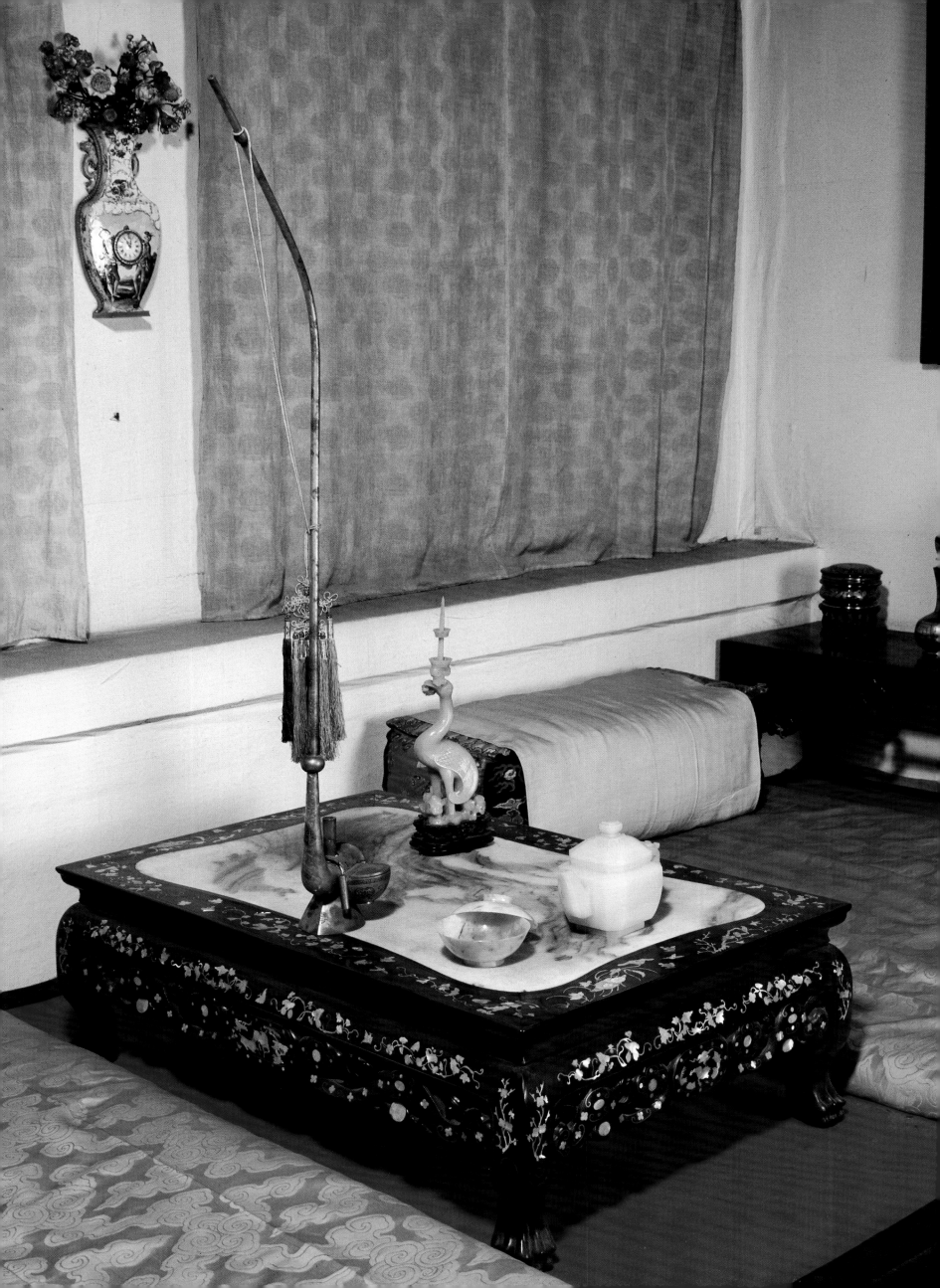

201. A low table of red sandalwood.

This low table is decorated with mother-of-pearl inlays and has a slab set into the top. Dali County in Yunnan Province is famous for its marble, and therefore marble is sometimes known as Dali stone in China. It comes in black, white, grey, yellow or green, with the veins forming the shapes of mountains and clouds. The slab on the top of this table has a design of clouds. On the table are a candlestick in the shape of a long-necked bird, a jade ewer and lidded bowl, as well as a water-pipe. The stem of the pipe is 93 cm long, and when it was smoked it required a second person to light it.

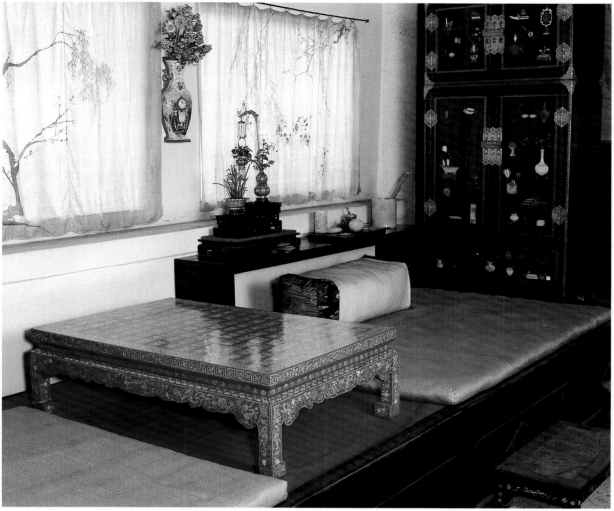

202

202. A low red-lacquer table with mother-of-pearl inlays, including the character for 'longevity'.

In north China a low table is usually placed on the platform bed where people rest during the day. Such tables were to be found in all the sleeping-palaces, and many different types have been preserved in the Qing palaces. Precisely cut inlays of the character for 'longevity' indicate that this table was a gift for the emperor's birthday.

203. A *cloisonné*-enamel wash-basin and inlaid pearwood wash-basin-stand. (height of stand, 2 m, diameter of edge of basin, 63 cm, height of basin, 10 cm)

The basin-stand has an elaborate inlaid decoration of mother-of-pearl *kui*-dragons and phoenixes. The picture set into the upper part of the stand depicts people delivering tribute to the emperor. Palace maids waited on the empress and imperial concubines during their toilet. The maids had to carry water carefully, for any spillage would be punished.

203

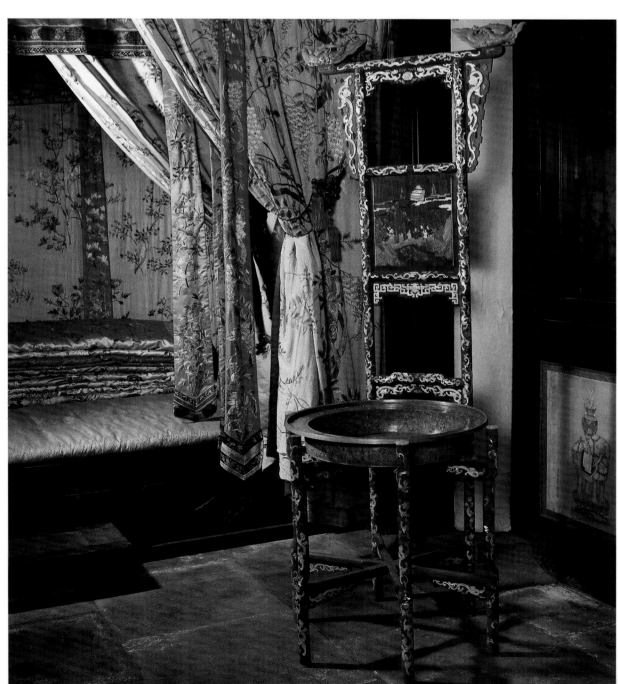

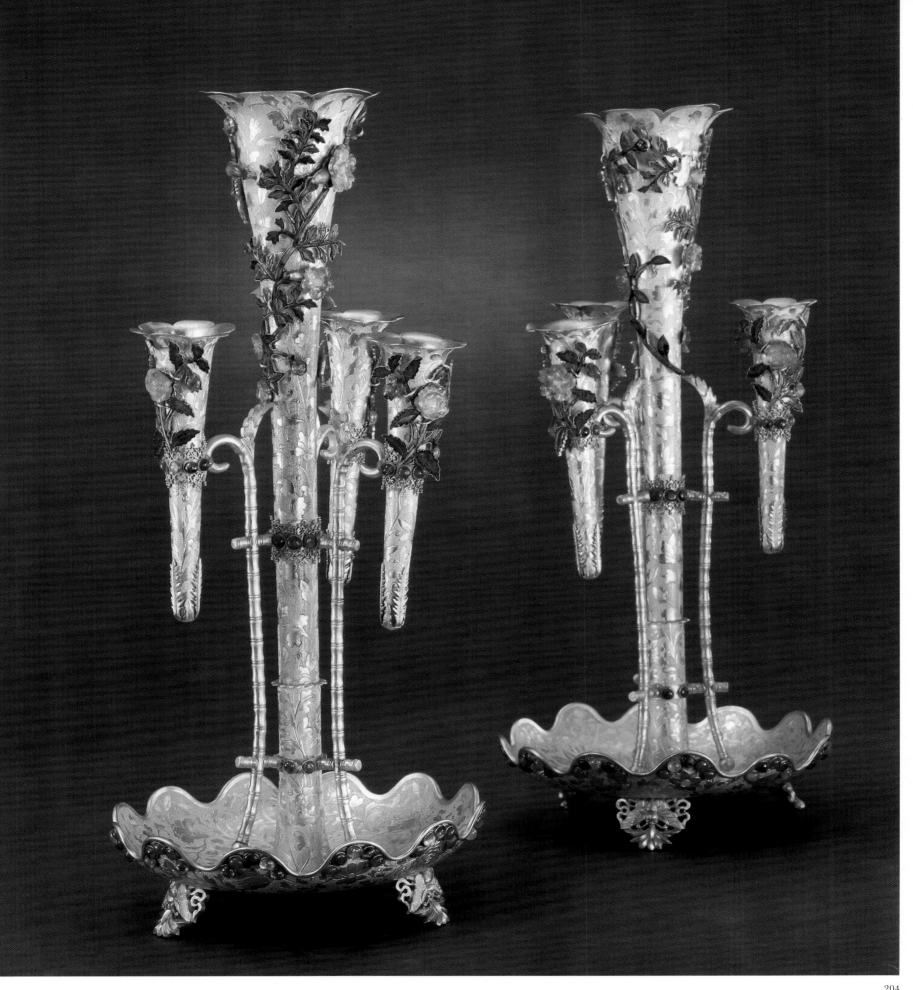

204. Gold candlesticks with engraved and chased design and relief decoration of jewelled flowers. (height, 34.3 cm)

Candles were used for illumination in the palace. The candles were placed in or on candlesticks or in lanterns, depending on the occasion. Low candlesticks like this pair were used on tables.

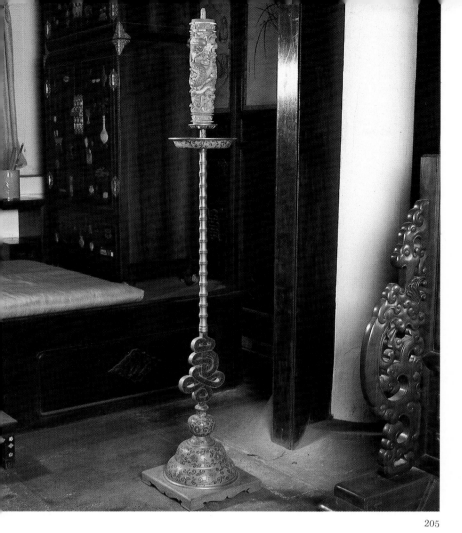

205. A *cloisonné*-enamel candlestick with the character for 'longevity' at the bottom of the stem. (height, 1.24 m)

Above the *cloisonné*-enamel base decorated with a lotus scroll is a section forming the character for 'longevity' and decorated with the character for 'ten thousand'. The gilded-bronze stem is shaped like segmented bamboo. All these things together are homophones for 'Respectfully wishing you a long life of ten thousand years'. The candle on the candlestick is of the kind normally used in the palace. It is 36 cm high and decorated with a coiling dragon in clouds.

206. A hanging lantern in the shape of a double gourd, with a hardwood stand.

Palace lanterns were made of various materials including carved ivory, enamel, carved lacquer, inlaid hardwood and various types of glass. There were even goat-horn lanterns. They were also of a number of different types, such as suspended lanterns, table lanterns and hand-held lanterns, and took many different forms, for instance pavilions, fish, flower-baskets; round, square or polyhedron. The lantern illustrated here was used indoors and the two characters painted on it mean 'great good fortune'.

205

207

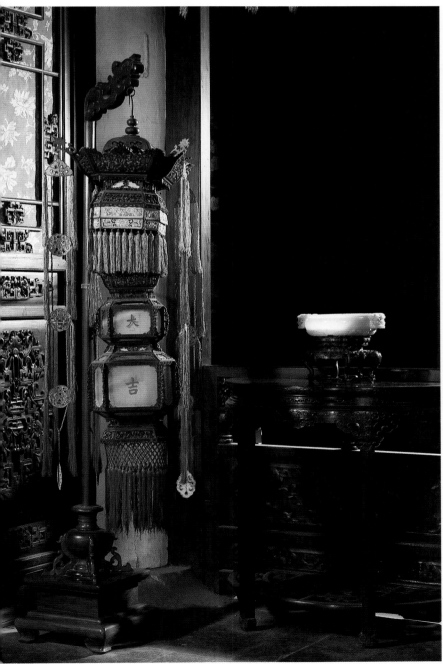

207. A candlestick of green jade.

The base of the candlestick is carved in the shape of a turtle swimming in water. On its back stands a petrel unfolding its wings, with the candlestick rising from its head. This is a type of candlestick often used in the emperor's study.

206

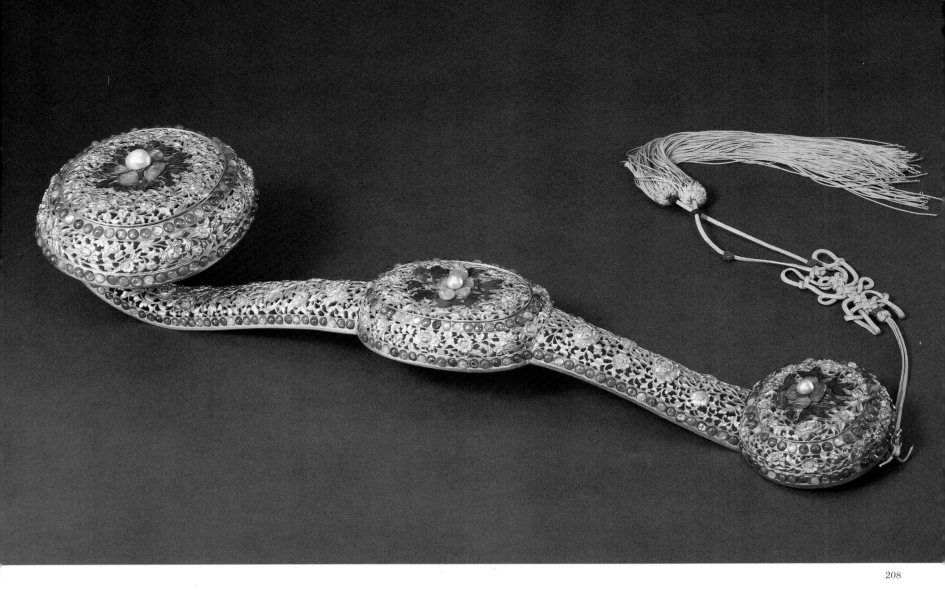

208

208. A gold *ruyi* with pierced decoration, embellished with jewels.

This *ruyi* has three pomander-like compartments, one at each end of the handle and one in the middle. These compartments have removable lids so that sweet-smelling flowers could be placed inside and their fragrance released through the holes of the pierced design.

209. A painted enamel hand-warmer.

Hand-warmers were used for keeping warm in winter. Burning charcoal was placed inside and the heat escaped through the pierced lid. This hand-warmer is shaped like a crab-apple and is decorated with pictures of deer and flower sprays on a yellow ground.

209

152

210

210. An enamel spittoon with a painted decoration of blue dragons on a yellow ground.

211. A porcelain spittoon decorated with butterflies in cobalt blue underglaze.

211

212

212. A screen fan from Chaozhou.

213. Fans used in the Qing palaces.

Many of the fans used in the Qing palaces came as tributes from other areas. There were screen fans of silk tapestry (*kesi*), embroidered silk, painted silk, or feathers. There were also folding fans with painted decoration. The fan shown here came as tribute from Chaozhou in Guangdong Province. Silk was stretched over its bamboo frame and painted with human figures in landscapes.

213

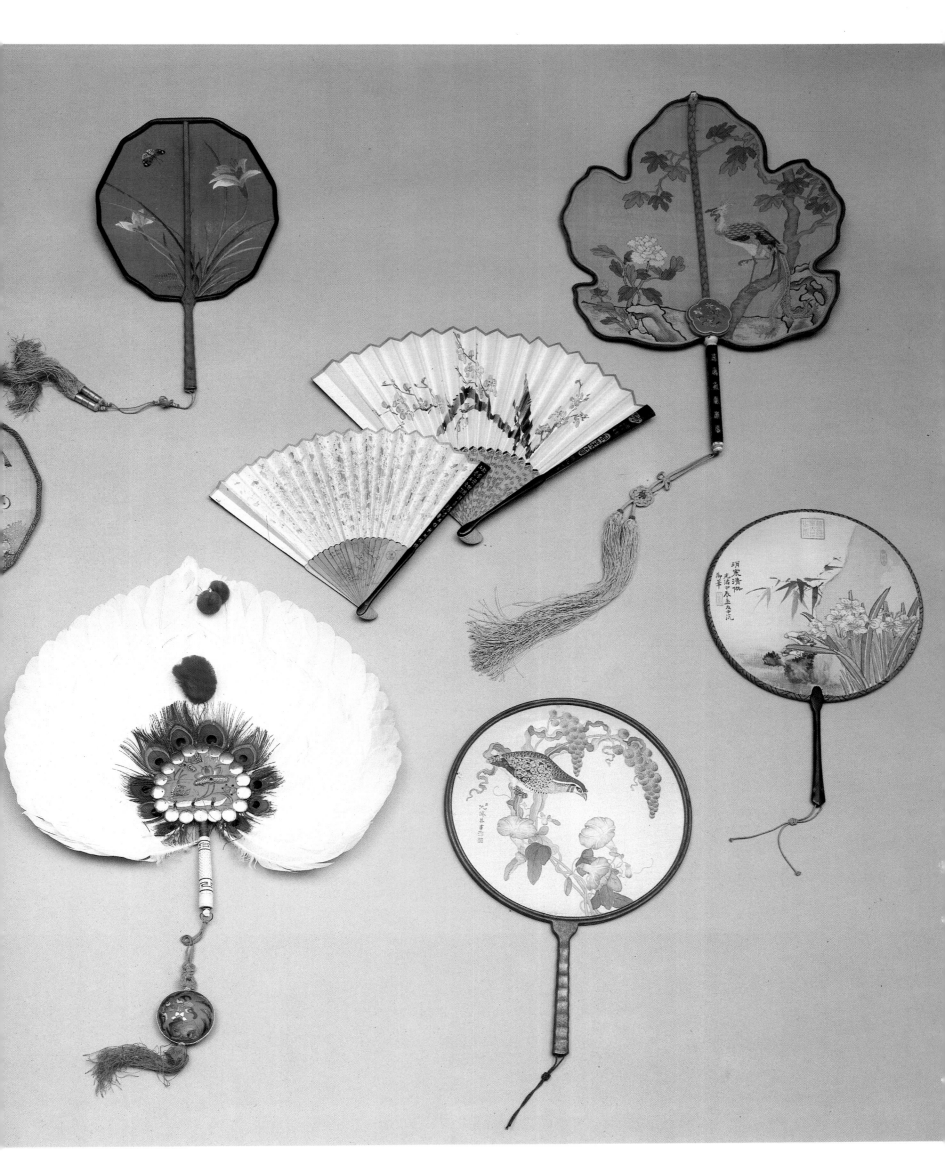

215. Furniture in the Palace of Concentrated Beauty.

The Palace of Concentrated Beauty is one of the six western palaces built in the Ming dynasty. Originally named the Palace of Longevity and Prosperity, it was renamed in the fourteenth year of Jia Jing in the Ming dynasty (1535). It was rebuilt in the twelfth year of Shun Zhi (1655) and later on several other occasions. The present palace was rebuilt in the tenth year of Guang Xu (1884) for the fiftieth birthday of Empress Dowager Ci Xi. The furniture in the palace includes a long red-sandalwood side-table with up-curving scroll ends on which is placed a potted red-coral tree. On either side of this stand celebratory carved-ivory dragon and phoenix boats, both of which were tributes for Empress Dowager Ci Xi's birthday. In front of the long table are a square red-sandalwood table and chairs with inlaid backs.

214

214. A picture of the Haoran Pavilion, made of semi-precious stones.

Inlaid pictures for display on the walls of the palace were made using a number of different materials and methods. This picture on the wall behind an openwork screen has a lacquer ground inlaid with green jade, malachite, lapis lazuli and mother-of-pearl. The scene depicted is the two-storey, multiple-eaved Haoran Pavilion on the banks of the river. There are fishing boats and rocks protruding from the water as well as hills in the background.

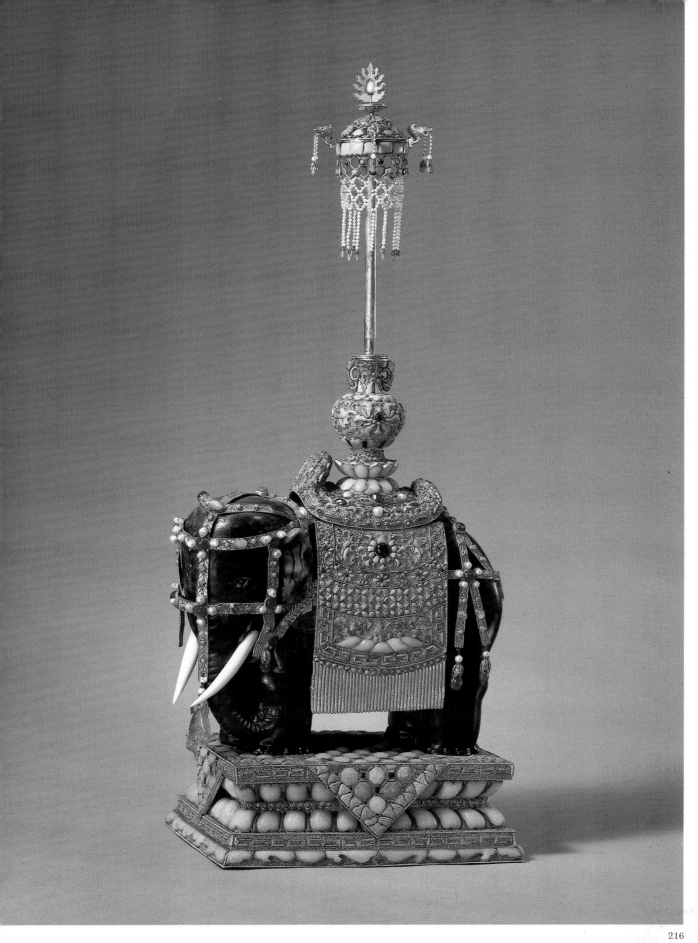

216. Lapis lazuli elephants with gold trappings inlaid with pearls and gemstones.

Objects fashioned in the shape of elephants symbolized peace and stability. This lapis lazuli carving was made during the reign of Qian Long. Lapis lazuli, a semi-precious stone, was mainly imported from Afghanistan. This is one of the few tributes from the minority princes and chieftains in China's north-west during the Qing dynasty that has been preserved. The carved elephant is embellished with gold trappings and

its gold stand is inlaid with pearls, turquoises, jade and other stones. The canopy fringe is formed by stringing together numerous tiny pearls and coral beads.

217. A carved-ivory dragon boat with immortals, given to celebrate a birthday. (length, 91.5 cm, width, 23.5 cm, height, 58 cm)

This finely carved dragon boat has three decks. On the upper deck are dragon and phoenix pennants and two canopies. On the middle deck are the three figures, symbolizing good

fortune, wealth and longevity, with an orchestra playing a variety of instruments. The Eight Immortals – Han Xiangzi, He Xiangu, Lü Dongbin, Zhang Guolao, Cao Guogiu, Lan Caihe, Han Zhongli and Li Tieguai – stand on the lower deck. Inside, musicians beat drums and gongs. There are eight oarsmen on either side and a coxswain at the stern.

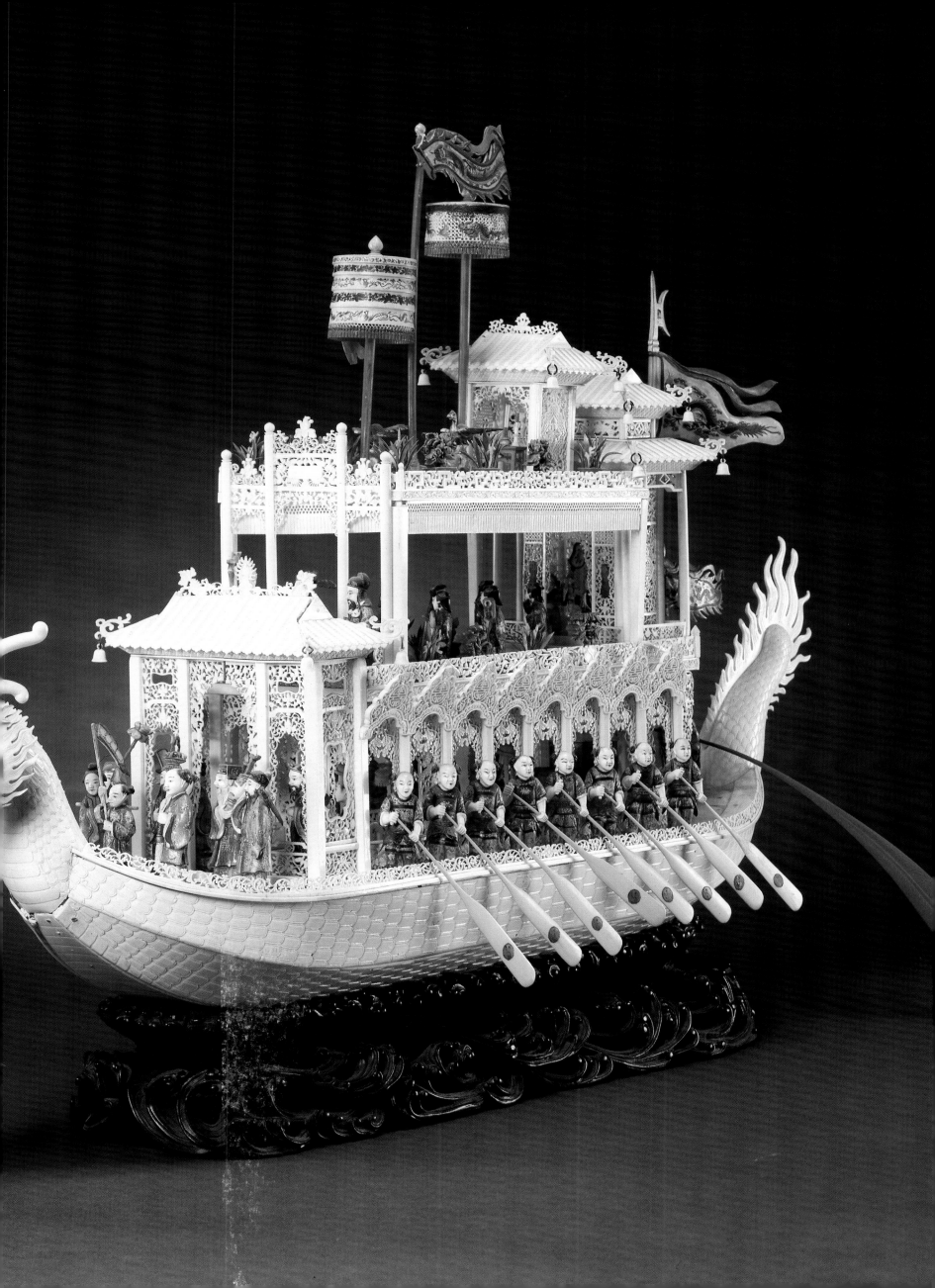

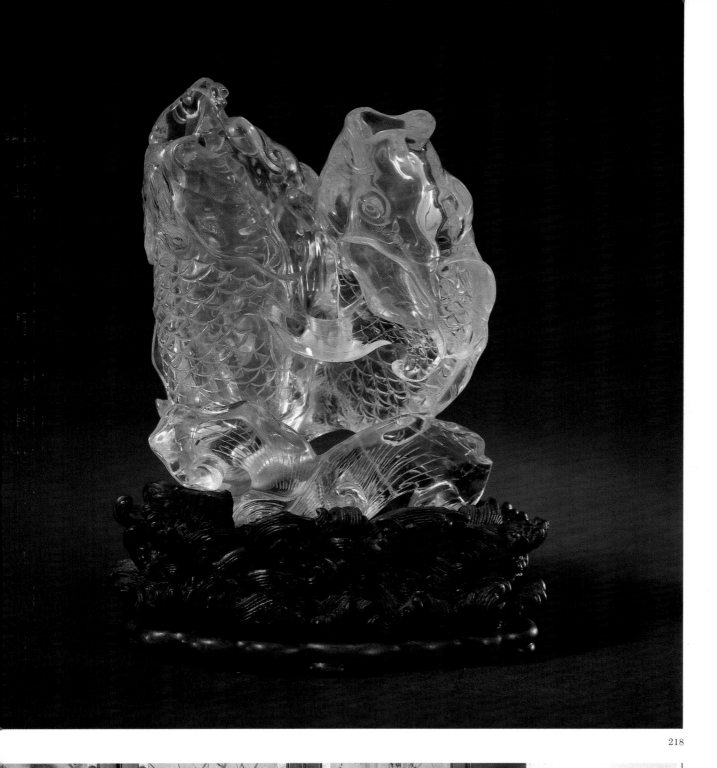

218. A rock crystal twin-fish flower vase.

There are transparent, purple, smoky and tea-coloured rock crystals, as well as horse's-mane and hair crystals. Rock crystal is a difficult material to carve, but transparent rock crystal free from flaws was generally chosen for carving decorative objects. The twin-fish vase symbolizes 'more than enough', for the word 'fish' is a homophone for 'surplus'. The two joyful jumping fish are finely executed and their open mouths were for holding flowers.

218

219. A bamboo cabinet with display shelves. (height, 66 cm, length, 57 cm, depth, 18 cm)

This kind of furniture was produced in the south of China, where there was an abundance of different types of bamboo. This finely carved cabinet is decorated by exploiting the different shades of bamboo.

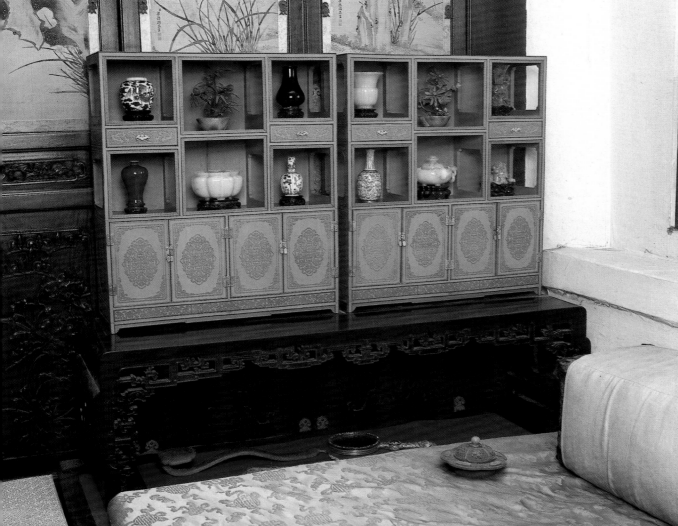

219

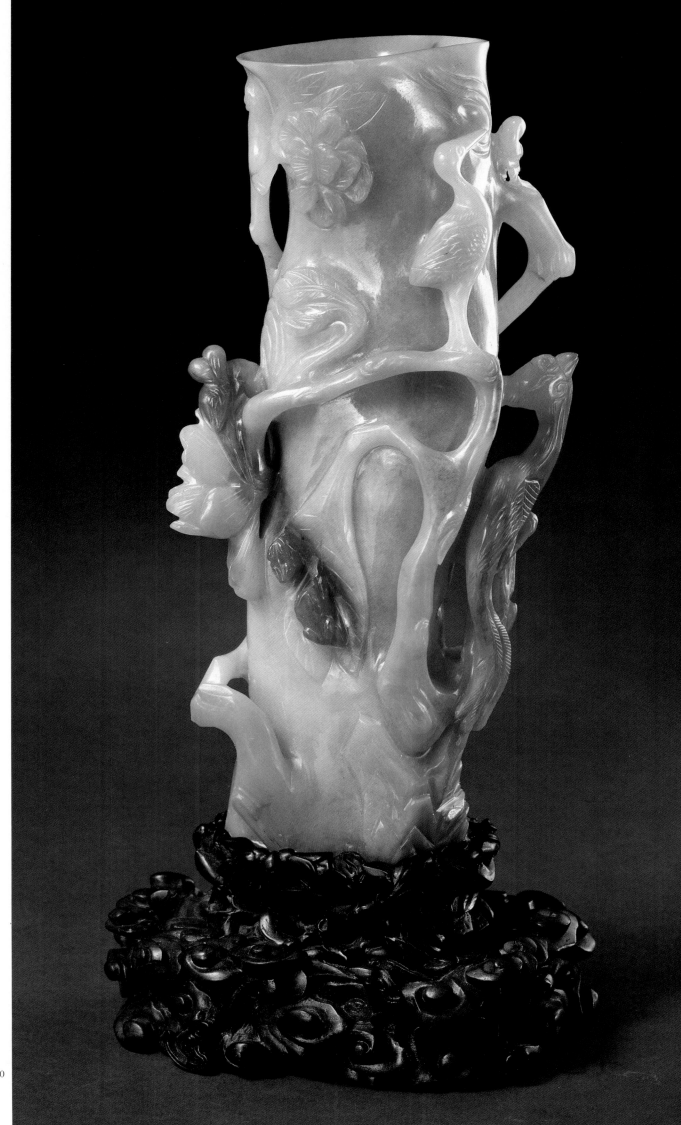

220. A jade vase with phoenix, crane and peony decoration. (height, 30 cm)

Pieces of jade of this size were not common, and this large vase is the only one in existence in the palace. The lapidary has made ingenious use of the yellow and green colour of the original stone for the peonies and birds.

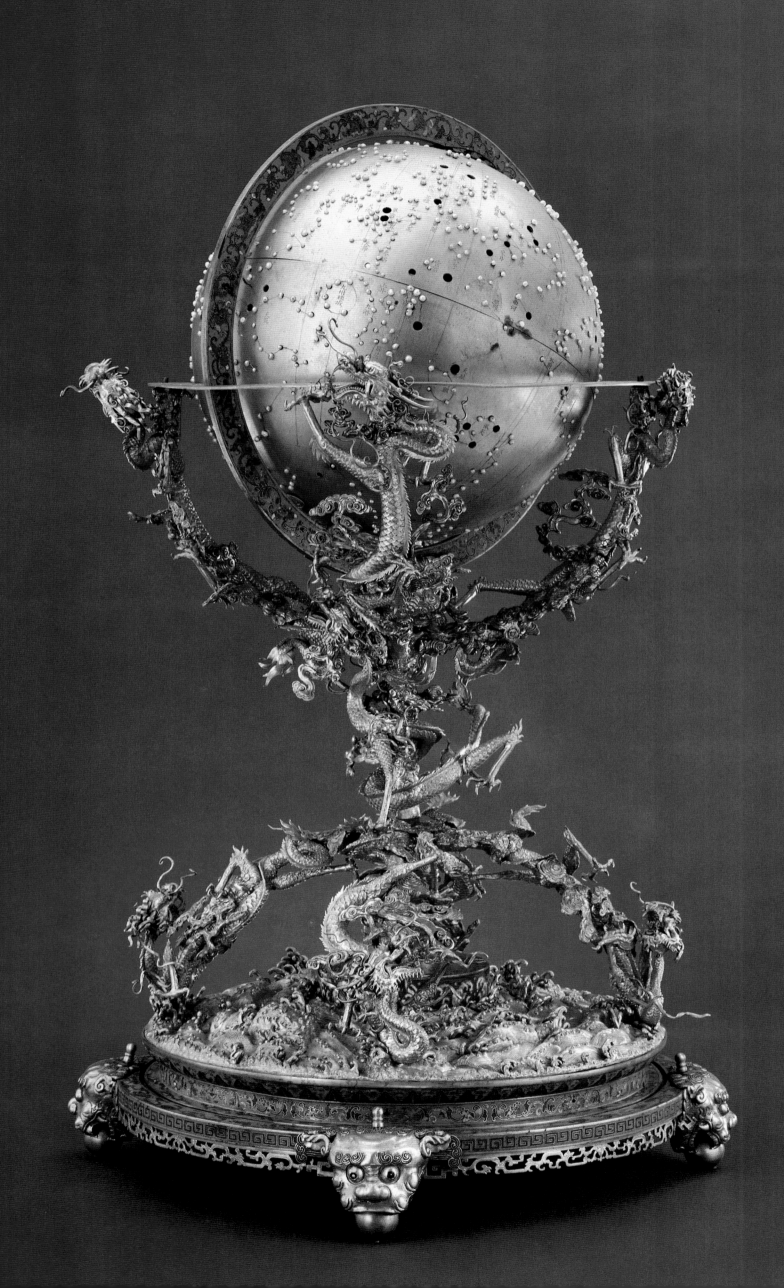

221. A gold armillary sphere.

The armillary sphere was invented by ancient Chinese astronomers some 1,800 years ago to observe the position of the heavenly bodies. This armillary sphere, made of gold and inlaid with pearls for the constellations, was made during the reign of the Qing Emperor Qian Long.

222. A potted miniature garden with ruby prunus blossoms.

Potted miniature scenes were a very popular form of ornament in the palaces, especially on festival days. As well as fresh flowers, miniature landscapes made from precious and semi-precious gems were often placed in the halls. The petals of this prunus blossom are made of rubies and the calyxes of gold. A great many rubies have been used.

223

223. A rose-quartz incense-burner.

Pink rose-quartz is difficult to carve. During the Qing dynasty articles made of rose-quartz were often presented to the emperor as tribute by high officials. However, very few of them are still preserved in the Qing palaces. This censer of particularly fine texture and clear colour is a very rare object.

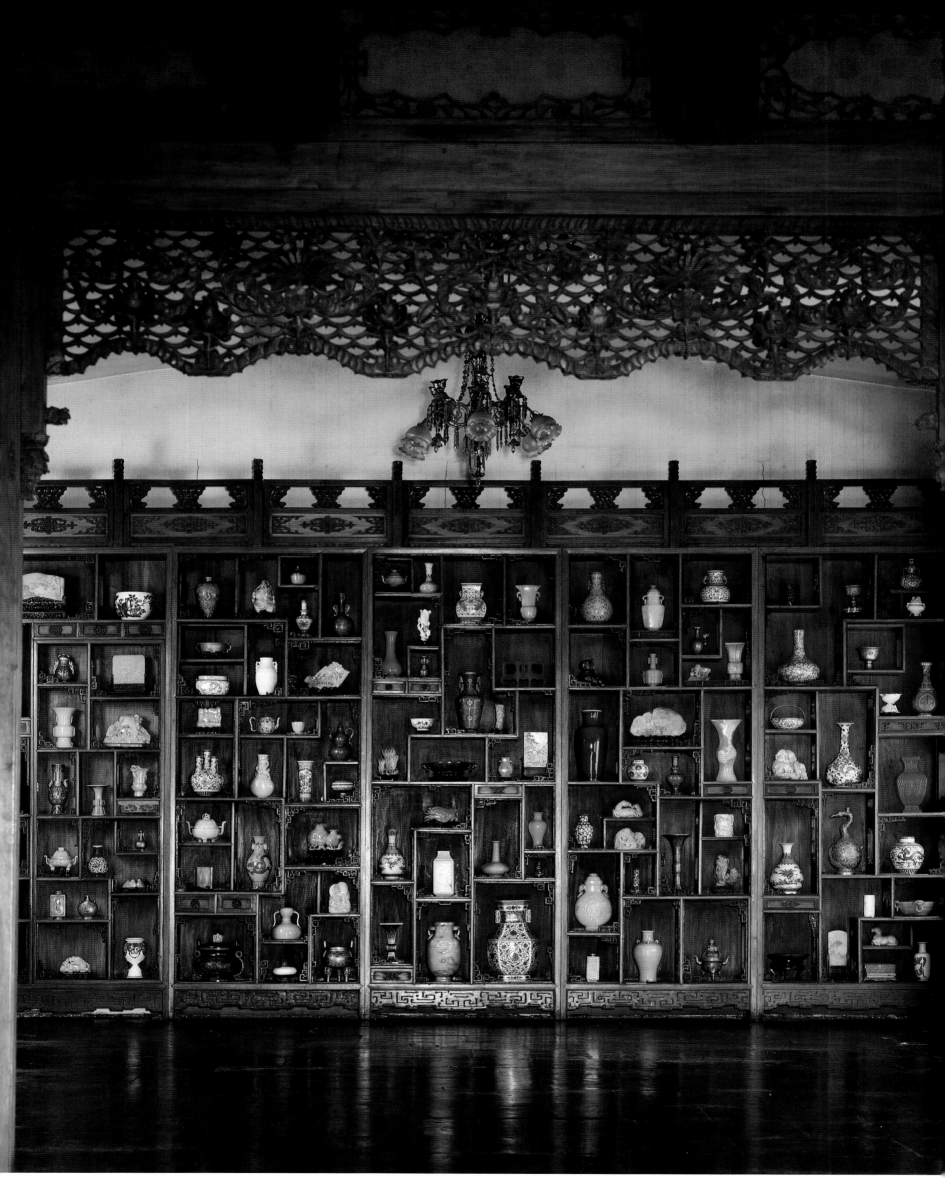

225

226

224. Display shelves along the wall of the Study of Fresh Fragrance.

In the palaces there are many types of shelves for displaying art objects. These are larger than usual and are able to display many quite sizeable items. Emperor Qian Long often came here to eat with Empress Dowager Chong Qing.

225. A list of candidates for selection as palace maids.

Palace maids were servants to the mistresses of the various palaces. These lists are dated the nineteenth year of the reign of Guang Xu (1893).

226. A list of candidates for selection as 'beauties'.

According to Qing regulations, the daughters of Manchu officials between thirteen and sixteen all had to submit themselves for selection as 'beauties'. Those who were above sixteen were considered too old. The selection was arranged by the Board of Revenue. The candidates were listed and taken to the palace in groups of three or five. If selected they became mistresses of the palaces or were married to the emperor's sons or grandsons, or to princes, dukes or their sons or grandsons. Emperor Kang Xi, Emperor Tong Zhi and Emperor Guang Xu succeeded to the throne when they were very young, but when the time came for them to marry, their empresses were

selected from among the 'beauties'. The nearest volume in this photograph is a list of candidates for selection as 'beauties' prepared in the eleventh year of Tong Zhi (1872). Alute, one of the girls named here, the daughter of Chong Qi of the Mongolian Blue Banner Troop, later became the empress of Tong Zhi. The names of those not chosen were indicated on the list by a special character.

227

227. *Notes on Life in the Inner Palace.*

These are records of the emperor's daily life in the palace or the imperial gardens. The opened page notes that the emperor conferred a title of nobility on the empress at the Nine Islet Dining Hall in the Garden of Perfection and Brightness in the third year of Xian Feng (1853).

165

228

228. A board hung in the Attendants' Office.

The Attendants' Office was set up under the Imperial Household Department in the sixteenth year of Kang Xi (1677), to tighten the control over the eunuchs. A nameboard prepared with an inscription by Emperor Kang Xi and the office was located in the southern-corridor rooms of the Palace of Heavenly Purity. The Attendants' Office was headed by the Supervisor (an official of the fourth rank) and Assistant Supervisor (an official of the sixth rank) who managed such affairs of the palace as examining, appointing, rewarding and punishing the eunuchs. The office was moved to the Northern Five Houses after Jia Qing. The board shown here carries an inscription by the Empress Dowager Ci Xi and was made during the reign of Guang Xu.

230

229. The iron tablet made at the command of the Emperor Shun Zhi. (144 cm × 60.18 cm × 3.2 cm)

Emperor Shun Zhi, who had learned of the abuses by the eunuchs in the Ming dynasty – manipulating power for personal ends, acting in a despotic manner – issued the following decree on the twenty-eighth day of the sixth lunar month in the twelfth year of his reign (1655): 'The employment of eunuchs has been a tradition since ancient times. However, their abuses have often led to disastrous disturbances. Recent examples are to be found in Wang Zhen, Wang Zhi, Cao Jixiang, Liu Jin and Wei Zhongxian of the Ming dynasty. They misappropriated power, intervened in government affairs, organized secret agents,

229

murdered the innocent, commanded troops and brought their evil practices to the border regions. They even engaged in conspiratorial activities, framed those who were loyal and good, instigated factional struggles and encouraged fawning and flattery until the affairs of state deteriorated day by day and corruption occurred everywhere. Their example can well serve as a warning. I find that the inner palace offices and their staff are closely abiding by the regulations. But from now on, anyone who is guilty of interfering with government affairs, misappropriating power, accepting bribes, involving himself in internal and external affairs, associating himself with Manchu and Han officials, reporting on things which are not his duty or suggesting whether an official is good

or bad, shall promptly be put to death, by slicing, without mercy. This iron tablet is hereby erected so that it may be observed from generation to generation.' The Board of Works was ordered to have the decree cast in the form of an iron tablet and placed in the Thirteenth Office. (The Imperial Household Department was set up in the early Qing. It was replaced by the Thirteenth Office in the eleventh year of Shun Zhi (1654). In the eighteenth year of Shun Zhi (1661), the Imperial Household Department was restored.) Later, similar iron tablets were placed in all the offices under the Imperial Household Department. There was also one in the Hall of Union.

230. A document recording the punishment of eunuchs.

When a eunuch was employed in the palace, he received a certain amount of silver. On receipt, he in effect forfeited his personal freedom, and could not go home. Only when he was old or seriously ill could he live a normal life. As a servant in the palace, he was constantly ordered about, scolded and maltreated by his masters, and consequently eunuchs often ran away or tried to commit suicide. The Imperial Household Department regulations laid down severe punishments for these eunuchs. Shown is a record from the twentieth year of the reign of Dao Guang (1840). This document is a warrant from the Imperial Household Department's Office of Punishments, exiling Chen Jinfu and three others to Heilongjiang to serve as the slaves of the local garrison soldiers.

231. A statue of a eunuch. (height, 20 cm)

This statue of a eunuch was made in the late Qing and preserved in the Imperial Palace. It portrays an old, hairless eunuch with a pinched mouth and lined face. He is wearing a winter hat of black velvet and red braid, and a long robe with narrow sleeves worn under a dark blue overgown. There is a court necklace hanging round his neck, and on his feet is a pair of black shoes. His arms bend slightly as he bows and smiles. It is a lifelike portrayal of an old, worldly-wise eunuch of some status as he greets his master or mistress.

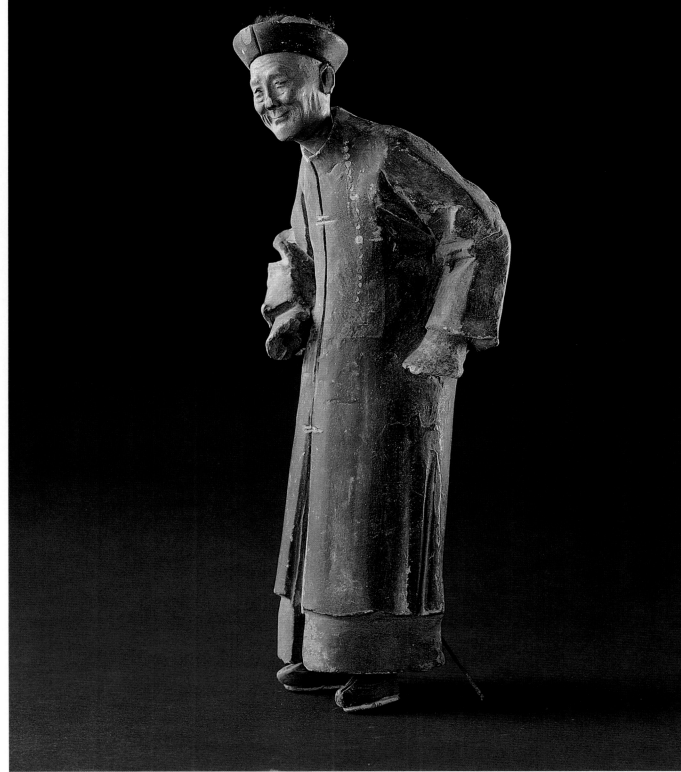

231

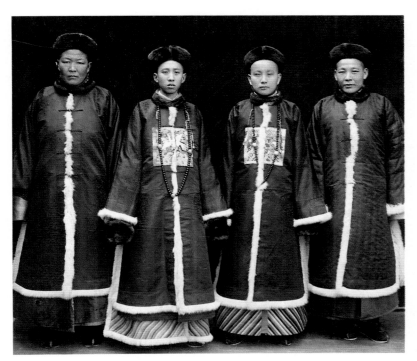

232

232. A photograph of four eunuchs.

233. The eunuchs' duty-rooms.

Each inner palace was often served by more than a dozen eunuchs, who looked after the furnishings, cleaned the palaces and carried out sundry minor duties. They also kept the watches at night on a shift system. The small, low buildings around the palaces were their duty-rooms. The picture shows a row of low buildings outside the Gate of Mental Cultivation, which were the duty-rooms of the eunuchs serving the Hall of Mental Cultivation.

COURT DRESS, EATING HABITS AND MEDICINE

Clothing, food and medicine play an essential part in everyone's daily life, and the Qing emperors were no exception to this. However, even such things as these took on a very different meaning when applied to the inhabitants of the Imperial Palace, for, unlike the clothing, food and medicine of the common people, those of the emperors had hierarchical and even political significance. They were governed by all kinds of rules and regulations which had to be strictly adhered to. One of the purposes of formulating these rules and regulations was in order to follow the Manchu 'ancestral traditions'. In reality, however, the Manchus had associated for so long with the Han people and had been so thoroughly influenced by them, that the Manchu traditions were, in practice, not nearly as strong in the Imperial Palace as those of the Han.

Compared to other areas, however, Qing court dress did retain rather more Manchu characteristics. As early as the Chong De period of his reign (1636–43), Abahai regarded the rules relating to dress as being of fundamental importance to the stability of the country. He said: 'Horsemanship and archery were the two basic skills of our country, and the rules laid down when the Qing was founded should not be altered.' Later this was elaborated on by the Emperor Qian Long, who said that the Liao, Jin and Yuan dynasties had not lasted long because their rulers had not adhered to their own rules for clothing, but had favoured Tang and Han styles of dress. Feeling that this posed a real danger, he not only tried his best to maintain the rules of dress advocated by his ancestors, but also formulated a comprehensive set of rules and regulations governing Qing court dress. Nevertheless, the rules drawn up by the Emperor Qian Long, and the natural development of Qing clothing and personal adornment, were actually closer in many ways to the previous Ming customs. The Twelve Symbols, for instance, were important emblems on the ceremonial dress of the Qing emperors, but were almost exact copies of those on the Ming imperial robes, the only major difference being a change in their placement. The Emperor Qian Long regarded this as following ancestral tradition, but in point of fact it was not the tradition of his Manchu ancestors.

The items that retained Manchu characteristics most distinctly were the red-tasselled, conical summer hats, which looked like inverted bowls, and the winter hats with upturned brims, both of which had a button on the top to indicate official rank. The wide collar and 'arrow' cuffs (popularly known as horse-hoof cuffs) were also uniquely Manchu features of dress.

Within the regulations for dress there were different rules for officials of different ranks. Emperor, emperor's son, prince, son of a prince, grandson of a prince, emperor's son-in-law, duke, marquis, count, viscount, baron, general and officials from the First to the Ninth Rank; each had their own specified headgear, robes, belt and beaded necklaces – the latter only worn by civil officials above the Fifth Rank and military officers above the Fourth Rank. The same applied to the ladies of the court, with different rules relating to the headgear, robes, necklaces and other ornaments worn by the empress dowager, empress, imperial consorts, imperial concubines, princesses, high-ranking officials' wives and ladies who had received honorary titles.

The emperor wore different clothes in summer and winter, and on different occasions: full ceremonial dress including the *duanzhao* and the *gunfu* (royal robe) for grand ceremonies, auspicious robes (also known as 'dragon robes') for festive occasions, informal attire for everyday wear, travelling clothes for hunting and touring and special outer garments for rain. Different headgear, such as ceremonial crowns, auspicious-occasion hats, informal hats and travelling hats, matched the various outfits.

All the emperor's garments and accessories were taken care of by the Clothing Storehouse under the auspices of the Imperial Household Department.

The empress's clothing also included particular outfits for particular occasions, such as ceremonial dress (including inner and outer robes), auspicious robes (also known as dragon robes) and informal dress. Headgear was again appropriate to the occasion and included ceremonial crowns, auspicious-occasion head-dresses and *tianzi* head-dresses.

There were also rules governing other ornaments worn by the empress and the imperial concubines. As part of full ceremonial dress, for instance, the empress had to wear three court necklaces – one of pearls and two of coral. In addition, she was expected to wear coloured scarves, headband, necklet and earrings. Variations of these ornaments were also worn by other court ladies, depending on their rank.

The court robes were all made of the finest fabrics such as silks, satins and gauzes, as well as fabrics woven with peacock feathers, embroidered with gold and silk threads and sewn with seed pearls. All of these were produced by the Imperial Silk Workshops at Jiangning, Suzhou and Hangzhou. The court robes were designed by court designers, examined and approved by the emperor and then sent to be made by the three workshops.

The emperor's daily meals were prepared by the Imperial Kitchen, while the empress and imperial concubines had separate kitchens in their own palaces. The Imperial Banquet Department, the Choice Food Department of the Board of Rites, and the Imperial Teahouse and Imperial Kitchen had more than 370 officials, cooks and assistants. In the Imperial Teahouse and Qing Teahouse over 120 people were employed. There were, additionally, more than 150 eunuchs in these two institutions, while in the Imperial Banquet Department and the Choice Food Department, the officials alone numbered more than 160.

Special high-sounding phrases were used to dignify the emperor's daily meals. Simple 'eating', for example, became 'transmitting viands' or 'consuming viands'. The emperor did not have a specified venue for his meals, but usually ate in his sleeping-quarters or where he happened to be working. It was usual to have two main meals a day, one in the morning, between six and eight o'clock, and the other either around noon or about two o'clock. In addition to these he had wine and light snacks whenever he desired them, frequently in the afternoon and evening. A menu and a list of the cooks responsible for cooking the dishes were drawn up each day by high officials of the Imperial Household Department. Unless the emperor gave special permission, no one was allowed to dine with him, and usually the empress dowager, the empress and the imperial concubines took their meals in their own palaces.

The Qing dynasty archives contain detailed records of some of the emperor's meals. The menu for the Emperor Qian Long's afternoon meal, eaten in the Eastern Warm Chamber on the first day of the tenth month in the twelfth year of his reign (1747), for instance, included:

A dish of swallow's nest, shredded chicken, shredded mushroom, shredded smoked meat and shredded Chinese cabbage, garnished with peace fruits (served in a bowl with a decoration of red waves);
A dish of three delicacies;
A dish of swallow's nest, smoked duck slices and filled sausage, and a dish of Chinese cabbage with chicken wings, tripe and mushrooms (served in two bowls from the Zhang'an Official Kiln);
A dish of fat chicken and Chinese cabbage (served in a big enamel bowl with a decoration symbolizing the Five Blessings);
A dish of stewed *diaozi*, a dish of thoroughly cooked duck with soup, and a dish of shredded pheasant meat with shredded pickled Chinese cabbage (served in four enamelled bronze bowls);
A dish of stir-fried chives with shredded breast of deer (served in a No. 4 yellow bowl);
A dish of pork and lamb for sacrifice (served on two silver plates);
A dish of fried wheat-and-rice cakes (served on a silver plate);
A dish of roast lamb for sacrifice (served on a silver plate);
A dish of buttered beans (served in a silver bowl);
A dish of honey (served in a purple dragon dish);
A dish of mashed bean paste (served in a No. 2 gold bowl);
A dish of pickled vegetables (served in an enamel box with sunflower designs);
A dish of pickles from south China, a dish of spinach and a dish of osmanthus-flavoured turnips (served in three bronze dishes with motifs symbolic of the Five Blessings and Longevity).

The utensils used for the meal were spoons, chopsticks and napkins.

The daily food for the emperor, empress and imperial concubines was prepared according to strict rules by the kitchens of the different palaces. In the case of banquets, these were of many different kinds and each was governed by specific regulations. Every year on New Year's Day and on the emperor's birthday grand banquets were held in the Hall of Supreme Harmony. More than 200 tables were laid out, on and below the throne platform, with one table seating two people. On each table were placed wheaten buns of all kinds, piled to a height of fourteen inches. For this reason the tables were also known as 'bun tables'. The tables were also served with four plates of crisp, filled delicacies; four plates of buns with four-coloured seals; four plates of horse-shaped cakes symbolic of happiness and prosperity; four plates of different types of melon seeds; two bowls of small buns; six plates of steamed bread; three plates of dried dough twists in red and white; twelve plates of dried fruit, six plates of fresh fruit and a small dish of salt. The food for these tables was all prepared by the Imperial Banquet Department, while the food for the large table on the throne platform was prepared especially for the emperor by the Imperial Kitchen and Teahouse.

The utensils used in the palace, which included such items as plates, bowls, spoons and chopsticks, were made in a range of different materials: gold, silver, jade, porcelain, enamel, agate, etc. These materials were not in use among the common people. The porcelain used in the palace came mostly from the official kilns at Jingdezhen in Jiangxi Province. Almost every year the Imperial Palace placed large orders for more porcelain. In addition to porcelain, gold and silver were also in common use in the palace. During the reign of the Emperor Dao Guang, for instance, there were more than 3,000 items of gold and silver in the Imperial Kitchen, of which the gold utensils weighed 140 kg and the silver weighed 1,250 kg. The emperor's daily meals were served in a variety of vessels and in winter vessels heated with charcoal and bowls with double sides warmed with water were also used. At particularly grand banquets the plates and bowls used on the emperor's table were for the most part made of jade. A set of gilded bronze *cloisonné*-enamel bowls and plates with the 'longevity' symbol were made especially for Emperor Qian Long's birthday. At banquets the empress, imperial consorts and concubines used different-coloured bowls, according to their rank: yellow glazed-porcelain bowls and plates for the empress and empress dowager, bowls and plates with green dragon designs on a yellow ground for the consorts, yellow dragon designs on a blue ground for imperial concubines, purple dragons on a green ground for concubines and red dragons on various coloured grounds for the *changzai*. For the less formal daily meals other types of bowls and plates could be used.

The largest banquets ever held in the Imperial Palace were the Greybeards' Banquets held during the reigns of Emperors Kang Xi and Qian Long. The first of these was held to celebrate the Emperor Kang Xi's sixtieth birthday in the fifty-second year of his reign (1713) in the Garden of Joyous Spring, the second in the Palace of Heavenly Purity in the sixty-first year of his reign (1722). On each occasion there were over a thousand guests over the age of sixty-five. During the reign of the Emperor Qian Long, two Greybeards' Banquets were held, one in the fiftieth year of his reign (1785) in the Palace of Heavenly Purity, in which 3,000 men over the age of sixty participated, and the other eleven years later – in the first year of the reign of the Emperor Jia Qing (1796) – in the Hall of Imperial Supremacy of the Palace of Peaceful Old Age, to celebrate the handing over of the reins of government to Jia Qing. This banquet had more than 5,000 guests, including ministers, officials, military officers, civilians, craftsmen and artisans, all over the age of sixty. Over 800 tables were laid, and gifts such as *ruyi* sceptres (auspicious symbols), walking sticks, *objets d'art* and silver tablets were given to the guests.

The Imperial Infirmary, which catered exclusively to the inhabitants of the Forbidden City, was located to the south-east of the Gate of Heavenly Peace. There were doctors on duty day and night to care for the emperor, empress dowager, empress and imperial concubines.

The Imperial Infirmary was headed by a director, with two deputy directors. Its staff included imperial physicians, officials, doctors and assistants, and the total number of staff varied in the different periods. *The Collected Statutes of the Qing Dynasty (Da Qing Hui Dian)*, compiled during the reign of the Emperor Guang Xu, record that the infirmary at that time had a staff of thirteen imperial physicians, twenty-six officials, twenty assistants and thirty doctors. The practice of medicine was divided into nine areas; *dafang* pulse, *xiaofang* pulse, typhoid fever, gynaecology, sores and ulcers, acupuncture and moxibustion, ophthalmology, stomatology and bone-setting. Usually the staff of the infirmary from the director down to the assistants worked in shifts in the palace, depending on their speciality. When an imperial physician was called upon to make a visit, he was always ushered into the palace by a eunuch from the Imperial Dispensary. When treating the emperor for some illness, the physician had first to make a diagnosis and prepare a prescription along with the eunuch from the Imperial Dispensary and an Inner Palace eunuch, then the prescription would be sealed with all their signatures. A memorial would then be written describing the properties of the prescribed medicine and the method of treatment, giving the date of the prescription and again the signatures of the physician and eunuchs, before it was finally submitted to the emperor for approval. The memorial was also registered for record, with the date and signatures, and kept by the Inner Palace eunuch for later reference.

After the memorial was approved by the emperor, the prescription was sent to the Imperial Dispensary to be prepared according to the regulations. The prescribed medicinal herbs were divided into two parts and decocted separately under the joint supervision of an official of the Imperial Infirmary and the Inner Palace eunuch. When ready, the two parts of the medicine were mixed and poured into two bowls. One bowl was first tasted by the physician, the infirmary's deputy director and the Inner Palace eunuch to check if there was anything wrong with it, and the other bowl was sent to the emperor. If the decoction had an unpleasant smell or was not prepared according to the prescription, or if there was any mistake in the sealing-up, the Imperial Dispensary would be punished for being 'greatly disrespectful'. If the medicine was ineffective or caused the emperor's death, the officials and physicians of the Imperial Infirmary would have to bear the consequences.

When treating the empress dowager, empress or imperial concubines, the Imperial Infirmary had to keep a detailed file, recording the patient's name, official position, the doctor's name and his diagnosis and prescription. This also applied to the treatment of the palace servants, such as wet-nurses, maidservants and eunuchs, when they fell ill. The medical files compiled by the Imperial Infirmary are still kept today in the Palace Museum.

If a prince, princess or princess's husband or high-ranking military or civil official living outside the palace was sick, an imperial physician could be requested. At an edict from the emperor, the Imperial Infirmary would send doctors to see the patient, and they would be expected to report to the emperor on the treatment. If the patients rewarded the doctors with gifts, this also had to be reported to the emperor, who then decided whether or not they should be accepted. Officials and doctors of the Imperial Infirmary always accompanied the emperor when he visited the imperial gardens or went on inspection tours or hunting.

The Imperial Dispensary in the Imperial Palace was administered by officials. The medicinal herbs needed by the dispensary came from the Imperial Infirmary, and the Imperial Palace set the prices of the medicinal herbs, which had to be procured by herbal merchants. The collected medicinal herbs had to be checked and examined by officials of the Imperial Infirmary and the ones of sufficiently high quality were given to the Imperial Dispensary to prepare for later use. The Imperial Dispensary was also responsible for making up medicinal pills and powders under the supervision of the Imperial Infirmary. Rare and precious medicinal herbs, which were presented to the Imperial Palace by officials from different regions, were immediately given to the Imperial Dispensary accompanied by an edict from the emperor. In addition to the Imperial Dispensary, a Longevity Dispensary was set up in the empress dowager's palace, where a statue of the God of Medicine was enshrined.

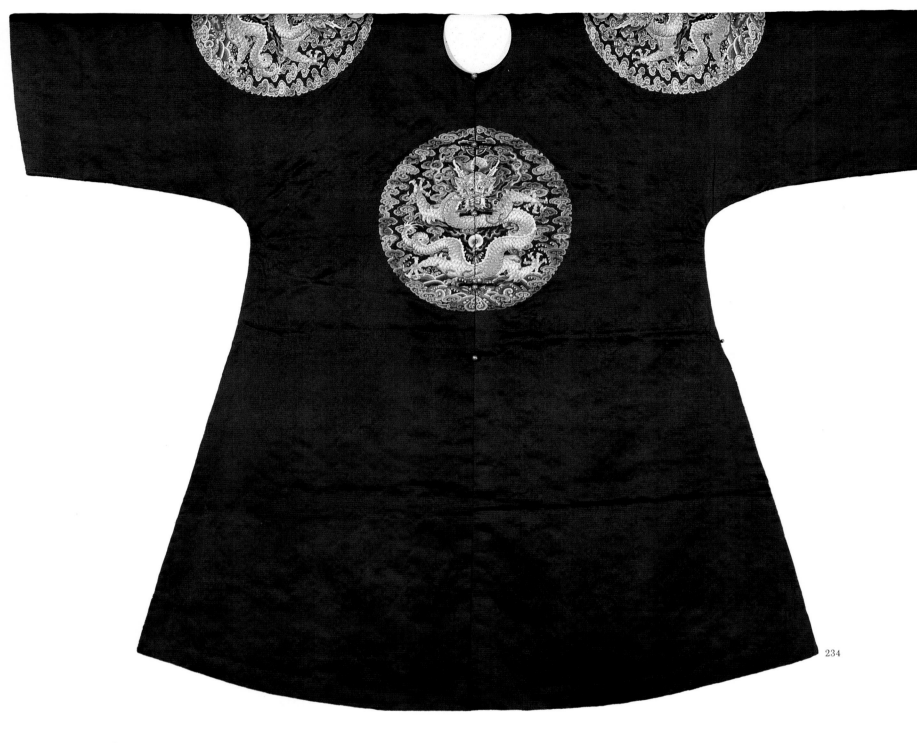

234

234. One of the emperor's outer coats of the 'royal robe' (*gunfu*) type.

At grand ceremonies, the emperor wore the *gunfu* over his dragon robe. Slightly shorter than the dragon robe, the *gunfu* fastens down the front and has flat sleeves. It is made of dark blue twill-weave silk and has four round medallions depicting golden five-clawed dragons amid multi-coloured clouds. The one on the left shoulder incorporates the sun, the one on the right, the moon. The medallions on the chest and back incorporate the character for 'longevity' written in seal script. This garment was worn by Emperor Qian Long.

235. The emperor's winter court robe.

This is one of the emperor's full-ceremonial robes, which differed in summer and winter. In the cold of winter the emperor wore the *duanzhao* over his other garments. It was an outer robe lined with black fox or sable. This winter robe is yellow silk on the outside, fastens down the right side and has dyed horse-hoof cuffs. Its decorative design includes four five-clawed dragons, one on each shoulder and one on both the chest and back, and four horizontal dragons on the lower sections in the front and on the back. The folds of the skirt have six more horizontal dragons and the 'Twelve Symbols'. They are, the sun, moon, constellations, mountains, dragons, pheasants, tiger and monkey, water and grass, fire, flour and rice, axe, and bows. The 'Twelve Symbols' were used to decorate the king's or emperor's clothing in ancient times. It is said that each image has a meaning: a gold cock in the sun, a jade hare in the moon, the Big Dipper or three stars for the constellations symbolizing illumination, mountains symbolizing power (these four symbolize the four annual sacrifices made by the emperor), paired dragons symbolizing change, pheasants symbolizing culture and painting (together symbolizing dominion over the world of nature), the tiger and monkey libation-cups symbolizing filial piety, water-weed symbolizing purity, flames symbolizing brightness, a plate of millet symbolizing nurture (these with the addition of the mountain represent the five elements: water, metal, fire, wood and earth), the axe, half-black and half-white, symbolizing judgement, two bows, half-black and half-blue, symbolizing differentiation (together depicting temporal power). This robe was worn by Emperor Kang Xi.

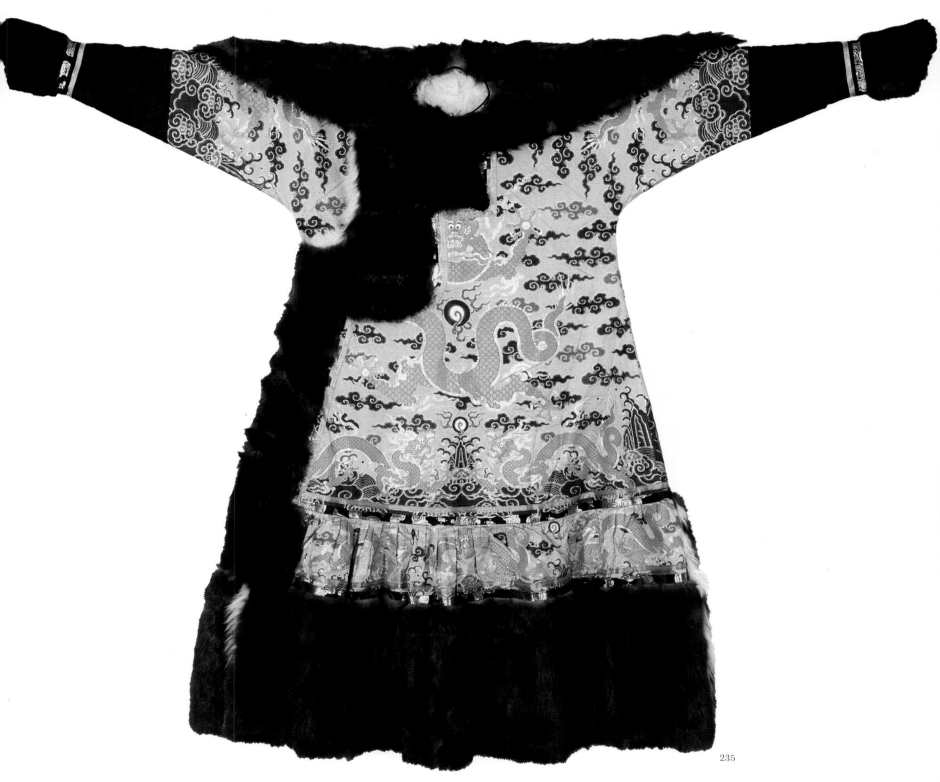

235

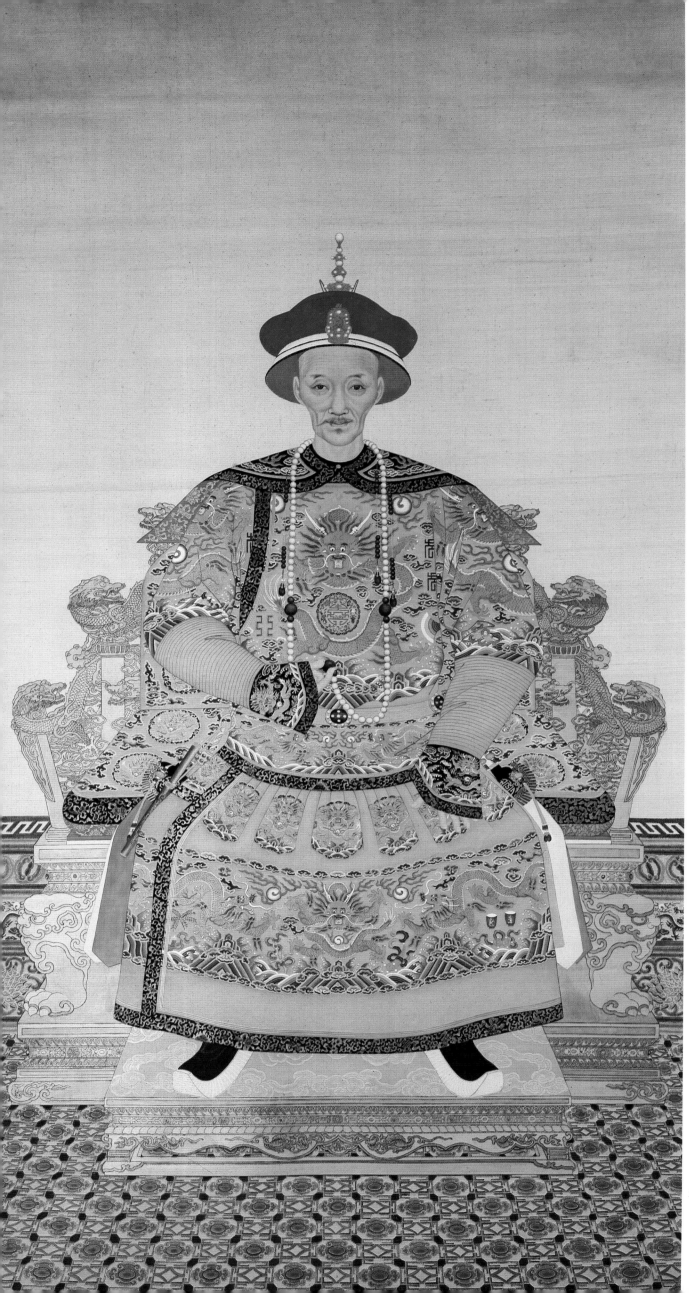

236. A portrait of Emperor Dao Guang in court robes. (257.5 cm × 138.7 cm)

Emperor Dao Guang, whose personal name was Minning, was the sixth emperor of the Qing dynasty after the Manchu troops had crossed the Great Wall. He was the second son of Emperor Jia Qing and his mother was Empress Xiao Shu Rui. He was born in the forty-sixth year of the reign of the Emperor Qian Long (1782) in the Hall of Gathering Fragrance in the Imperial Palace. He ascended the throne in 1821 at the age of thirty-eight. In the twentieth year of his reign (1840), when China was defeated in the Opium War and the imperialist powers invaded, one after another, China was progressively reduced from being an independent feudal state to a semi-colonial, semi-feudal country. The emperor died in the thirtieth year of his reign (1850) in the Hall of Care and Virtue in the Garden of Perfection and Brightness, when he was sixty-nine years old.

237. The emperor's summer court robe.

Imperial court robes could be made of fur, silk, cotton or gauze, lined or unlined, depending on which of the four seasons they were for, and were in four colours: bright yellow – the most prestigious colour, worn at grand ceremonies such as those on New Year's Day, Winter Solstice, birthdays and the days when sacrifices were offered to ancestors at the Imperial Ancestral Temple; blue – worn at ceremonies offering sacrifices to heaven to pray for good harvest and rain; red – worn at ceremonies offering sacrifices to the sun; and bluish-white – worn at ceremonies offering sacrifices to the moon.

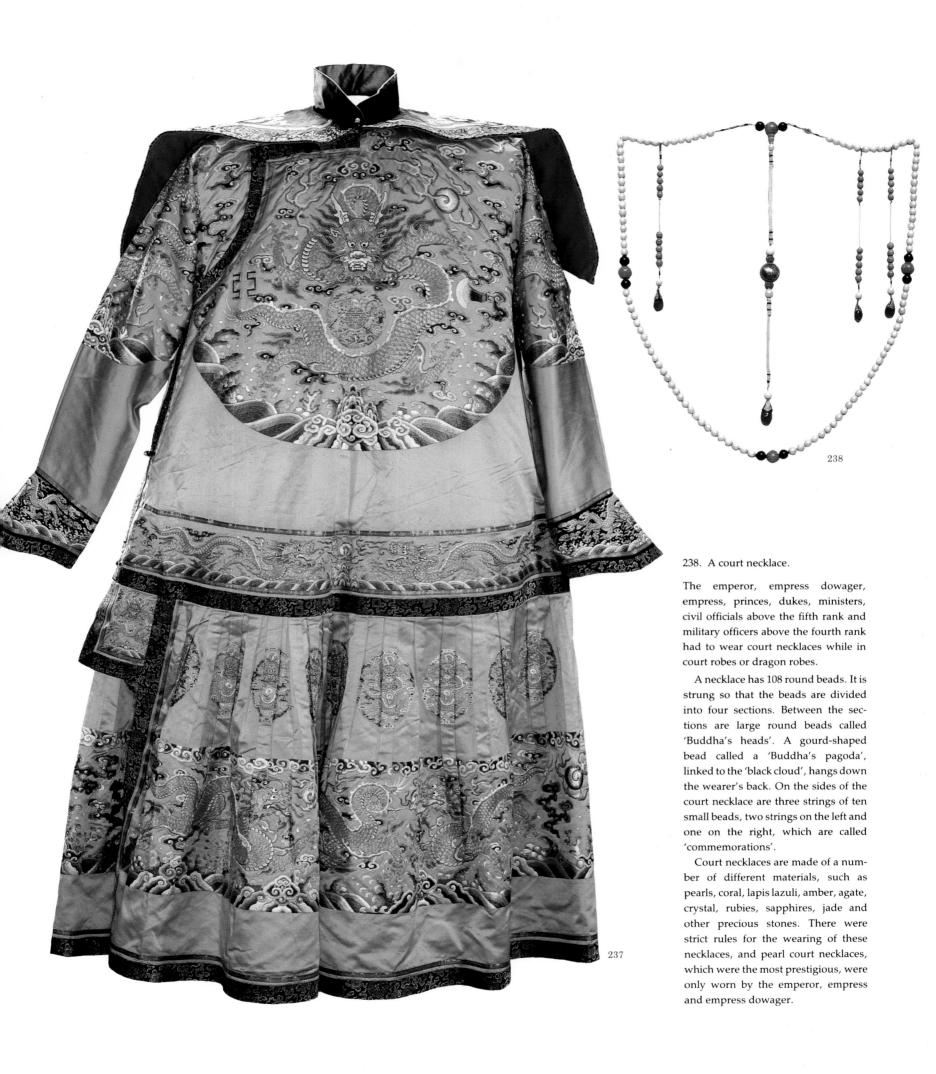

238. A court necklace.

The emperor, empress dowager, empress, princes, dukes, ministers, civil officials above the fifth rank and military officers above the fourth rank had to wear court necklaces while in court robes or dragon robes.

A necklace has 108 round beads. It is strung so that the beads are divided into four sections. Between the sections are large round beads called 'Buddha's heads'. A gourd-shaped bead called a 'Buddha's pagoda', linked to the 'black cloud', hangs down the wearer's back. On the sides of the court necklace are three strings of ten small beads, two strings on the left and one on the right, which are called 'commemorations'.

Court necklaces are made of a number of different materials, such as pearls, coral, lapis lazuli, amber, agate, crystal, rubies, sapphires, jade and other precious stones. There were strict rules for the wearing of these necklaces, and pearl court necklaces, which were the most prestigious, were only worn by the emperor, empress and empress dowager.

237

238

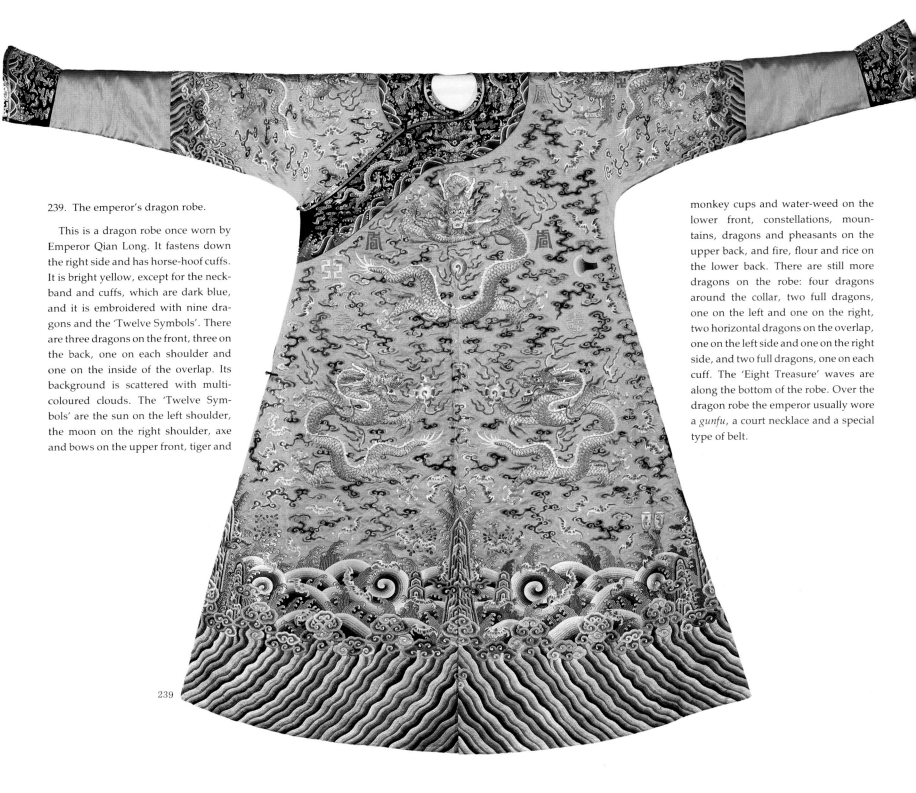

239. The emperor's dragon robe.

This is a dragon robe once worn by Emperor Qian Long. It fastens down the right side and has horse-hoof cuffs. It is bright yellow, except for the neck-band and cuffs, which are dark blue, and it is embroidered with nine dragons and the 'Twelve Symbols'. There are three dragons on the front, three on the back, one on each shoulder and one on the inside of the overlap. Its background is scattered with multi-coloured clouds. The 'Twelve Symbols' are the sun on the left shoulder, the moon on the right shoulder, axe and bows on the upper front, tiger and monkey cups and water-weed on the lower front, constellations, mountains, dragons and pheasants on the upper back, and fire, flour and rice on the lower back. There are still more dragons on the robe: four dragons around the collar, two full dragons, one on the left and one on the right, two horizontal dragons on the overlap, one on the left side and one on the right side, and two full dragons, one on each cuff. The 'Eight Treasure' waves are along the bottom of the robe. Over the dragon robe the emperor usually wore a *gunfu*, a court necklace and a special type of belt.

239

240. The emperor's dragon-robe belt.

When the emperor wore court robes he used a particular type of belt: with a dragon robe he wore the appropriate belt. There are two types of court-robe belts: one is made of bright yellow silk with four oval gold plates decorated with dragons and inlaid with precious stones and pearls – this was worn at grand ceremonies; the other, with four square gold plates inlaid with pearls and jade of various colours, was worn at sacrificial ceremonies. The court-robe belt has ornaments hung from both sides, such as the *fen* (silk ribbon), *nang* (bag), *sui* (flint), *xi* (awl) and *dao* (knife). The dragon-robe belt is the same colour as the court-robe belt and similar in appearance. Its gold plates are inlaid with precious stones of various kinds. The plate at the end of the belt serves as a clasp. The two plates on the left and right have rings for hanging silk ribbons, bags and a flint. On the left ring there was usually an awl for untying knots, and on the right ring there was a knife in a sheath. Later on, a watch and a thumb ring were added to these. Because the Qing had conquered China on horseback, the bags had originally been used to store food for a journey; the ribbon was a substitute for horse reins, which had been taken along as spares in case the reins broke. The ribbon was at first made of ordinary cloth but later of silk, to match the court robes, when the belt became purely decorative.

This auspicious robe belt was once used by Emperor Jia Qing. It has oval gold plates inlaid with coral, bluish-white silk ribbons, bags embroidered with gold thread, an awl with a gold sheath inlaid with turquoises, a knife with an enamel sheath and a flint.

240

241

242

241. A black satin hat.

Embroidered with the character for longevity, the hat also has a red silk knot and tassel. It was made in the reign of Emperor Guang Xu.

242. The emperor's informal hat.

The emperor's headgear included hats for full-ceremonial robes, dragon robes, informal dress and travelling robes. There are also summer and winter crowns for full-ceremonial dress. Ceremonial winter crowns have upturned brims and are made of sea-otter, dyed marten fur or black fox. Ceremonial summer crowns are conical and woven of white straw, cane or fine bamboo strips. The top of the crown is cylindrical, in three sections, each section decorated with four gold dragons. On each dragon and between each section are pearls. The crown is topped with a large pearl. In the front, an image of the Buddha is inlaid with fifteen pearls and the back of the crown is embroidered with two characters, *she lin*, and decorated with seven pearls. On a dragon-robe hat, the upper part is elaborately embroidered in gold with a large pearl on top. Winter-travel dress-hats are made of black fox or black sheepskin and black velvet, with a red silk knob. Summer-travel dress-hats are yellow with a pearl at the front. The hat shown here is an informal-robe hat made of black velvet with a red silk-cord knot and red silk-cord fringe.

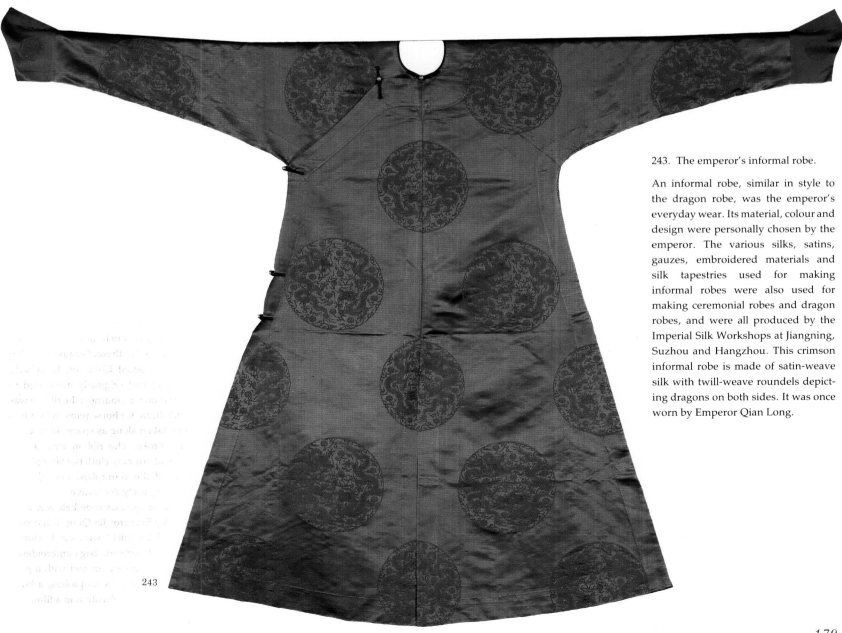

243

243. The emperor's informal robe.

An informal robe, similar in style to the dragon robe, was the emperor's everyday wear. Its material, colour and design were personally chosen by the emperor. The various silks, satins, gauzes, embroidered materials and silk tapestries used for making informal robes were also used for making ceremonial robes and dragon robes, and were all produced by the Imperial Silk Workshops at Jiangning, Suzhou and Hangzhou. This crimson informal robe is made of satin-weave silk with twill-weave roundels depicting dragons on both sides. It was once worn by Emperor Qian Long.

244. Jade thumb rings.

At first, thumb rings were used to protect the thumb in archery, but by the time of Emperors Qian Long and Jia Qing, they had become purely ornamental. They were usually made of jade, agate, coral, crystal, gold, silver, copper, iron or porcelain. These jade thumb rings, dating from the reign of Emperor Qian Long, are carved with a cockerel decoration and an inscription. Although they could have been worn, they were in fact ornamental.

245. The emperor's travelling robe.

This travelling robe, one of the light robes, was worn by the emperor during his inspection tours and hunting expeditions. Similar in style to the informal robe, it is one-tenth shorter than the latter. For convenience in horse-riding, the travel robe's left overlap was made one foot shorter than the rest of the robe. This grey-lined silk travel robe with round dragon medallions on both sides was made during the reign of Emperor Qian Long.

246. These court-dress boots of yellow silk, embroidered with small pearls and coral, were made in the reign of Emperor Kang Xi.

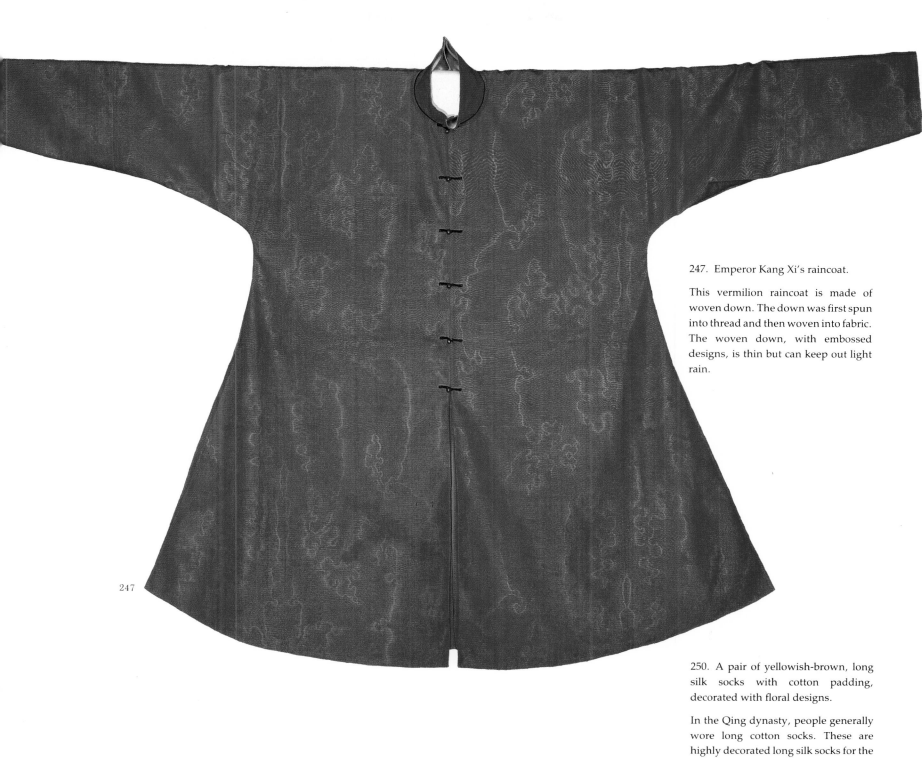

247. Emperor Kang Xi's raincoat.

This vermilion raincoat is made of woven down. The down was first spun into thread and then woven into fabric. The woven down, with embossed designs, is thin but can keep out light rain.

250. A pair of yellowish-brown, long silk socks with cotton padding, decorated with floral designs.

In the Qing dynasty, people generally wore long cotton socks. These are highly decorated long silk socks for the emperor to wear in autumn and winter. He had a wide choice of materials and designs.

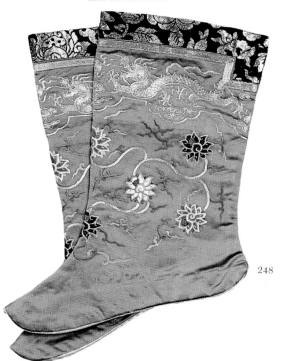

248. A pair of lined, blue silk, long socks embroidered with gold dragons and floral scrolls.

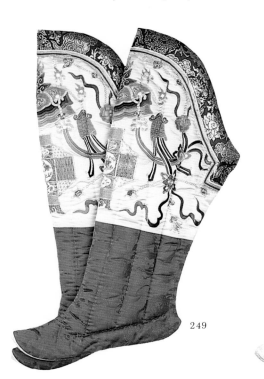

249. A pair of long, white satin socks with cotton padding, embroidered with the symbols of plenty.

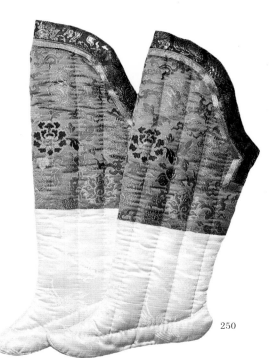

181

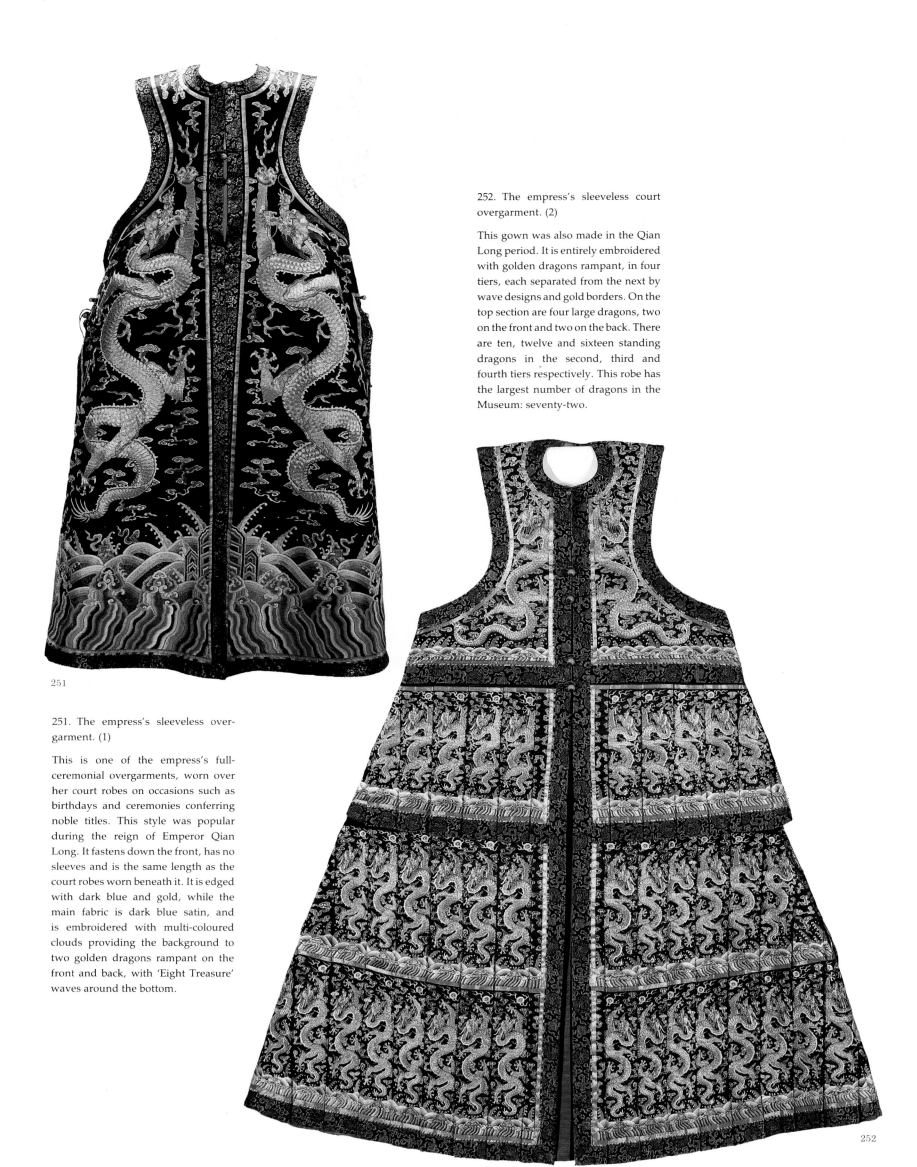

251

252. The empress's sleeveless court overgarment. (2)

This gown was also made in the Qian Long period. It is entirely embroidered with golden dragons rampant, in four tiers, each separated from the next by wave designs and gold borders. On the top section are four large dragons, two on the front and two on the back. There are ten, twelve and sixteen standing dragons in the second, third and fourth tiers respectively. This robe has the largest number of dragons in the Museum: seventy-two.

251. The empress's sleeveless overgarment. (1)

This is one of the empress's full-ceremonial overgarments, worn over her court robes on occasions such as birthdays and ceremonies conferring noble titles. This style was popular during the reign of Emperor Qian Long. It fastens down the front, has no sleeves and is the same length as the court robes worn beneath it. It is edged with dark blue and gold, while the main fabric is dark blue satin, and is embroidered with multi-coloured clouds providing the background to two golden dragons rampant on the front and back, with 'Eight Treasure' waves around the bottom.

252

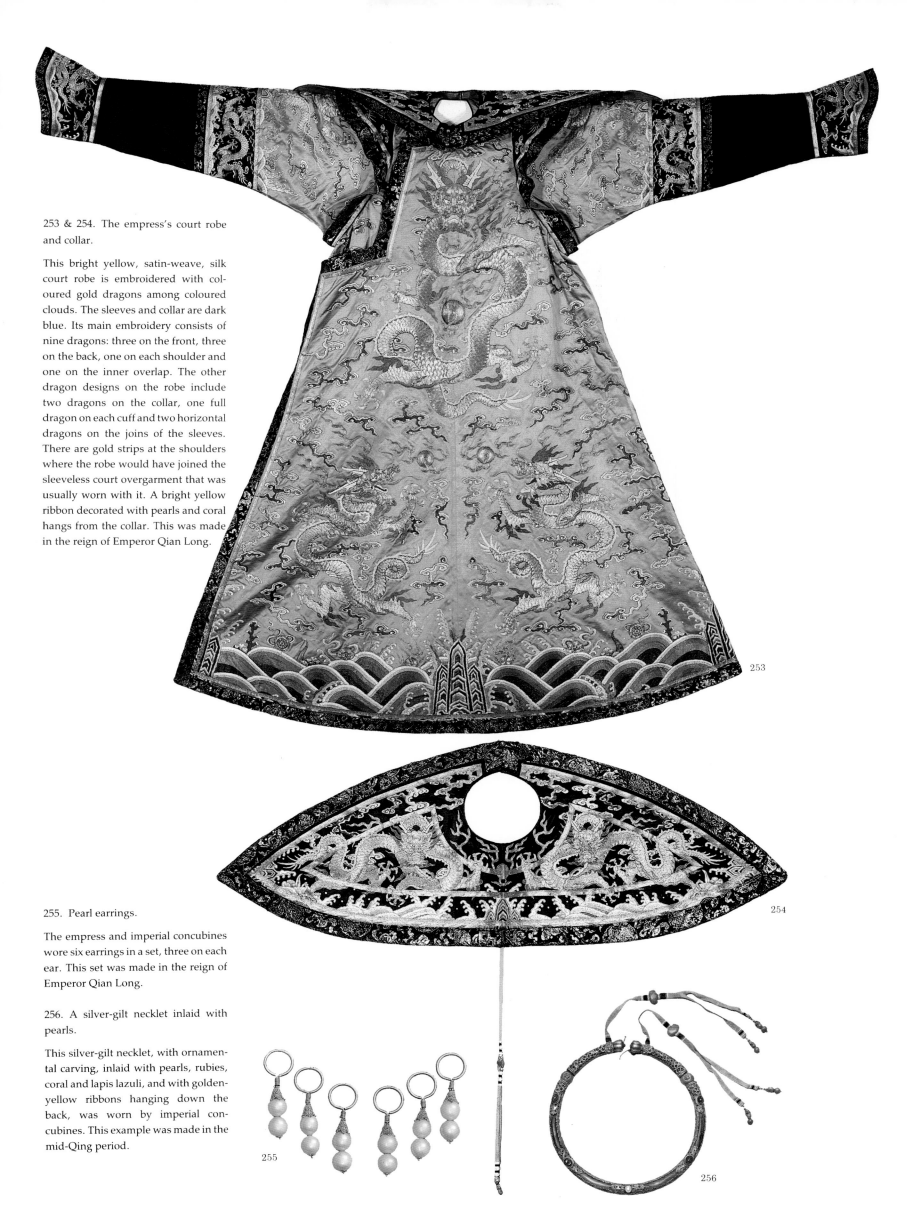

253 & 254. The empress's court robe and collar.

This bright yellow, satin-weave, silk court robe is embroidered with coloured gold dragons among coloured clouds. The sleeves and collar are dark blue. Its main embroidery consists of nine dragons: three on the front, three on the back, one on each shoulder and one on the inner overlap. The other dragon designs on the robe include two dragons on the collar, one full dragon on each cuff and two horizontal dragons on the joins of the sleeves. There are gold strips at the shoulders where the robe would have joined the sleeveless court overgarment that was usually worn with it. A bright yellow ribbon decorated with pearls and coral hangs from the collar. This was made in the reign of Emperor Qian Long.

255. Pearl earrings.

The empress and imperial concubines wore six earrings in a set, three on each ear. This set was made in the reign of Emperor Qian Long.

256. A silver-gilt necklet inlaid with pearls.

This silver-gilt necklet, with ornamental carving, inlaid with pearls, rubies, coral and lapis lazuli, and with golden-yellow ribbons hanging down the back, was worn by imperial concubines. This example was made in the mid-Qing period.

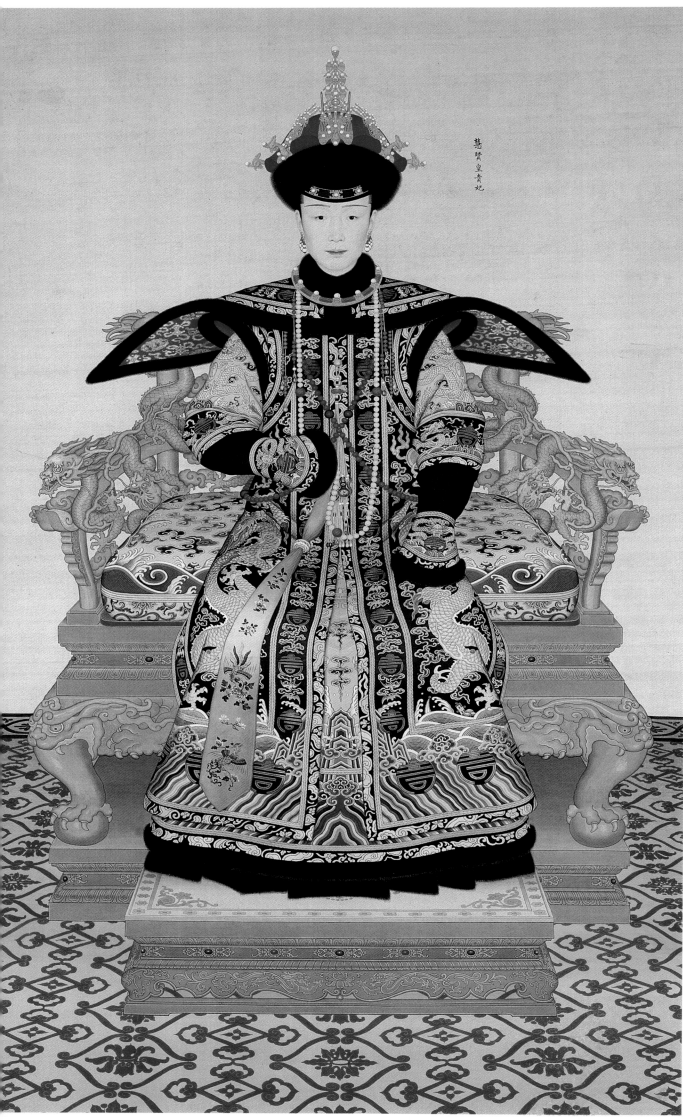

慧賢皇貴妃

257. A portrait of Imperial Consort Hui Xian in court robes.

Imperial Consort Hui Xian, originally named Gaojia, was a Manchu from the Bordered Yellow Banner. She became a high consort in the second year of Qian Long's reign (1737), later rose to become an imperial consort in the tenth year of the reign (1745) and died in the same year. She was posthumously honoured with the title of Hui Xian and buried at the Eastern Tombs. In the portrait, Imperial Consort Hui Xian wears a gold filigree winter court crown with three phoenixes on the top, a gold headband, a necklet, a winter court robe, a sleeveless court overgown, a pearl court necklace, two coral court necklaces, a pink scarf with bird and flower designs and pearl earrings.

258. A portrait of Emperor Dao Guang's empress, Xiao Quan Cheng, in court robes. (241 cm × 113.4 cm)

Emperor Dao Guang's empress, Xiao Quan Cheng, originally named Niu-huru, became imperial concubine in the second year of Dao Guang's reign (1822), consort in the third year, imperial consort in the fifth year and empress in the fourteenth year (1834). She gave birth to Yizhu (Emperor Xian Feng) in the eleventh year in the Hall of Clear Tranquillity in the Garden of Perfection and Brightness. She died in the twentieth year (1840) at the age of thirty-three.

According to the regulations, the empress's winter ceremonial crown was made of dyed marten fur and the summer ceremonial crown of black velvet. On top of the court crown are three gold filigree phoenixes, each decorated with seventeen small pearls. Between each layer is a pearl, and on top of the three phoenixes is a large pearl. Around the crown are seven phoenixes, each embellished with nine pearls, one cat's-eye and twenty-one small pearls. There is also a red ribbon. On the back is a golden pheasant embellished with a cat's-eye and sixteen small pearls. Hanging from the bird's tail are five strings of pearls, 302 in all, with coral at the end. Behind the crown is a protective collar with two bright yellow ribbons decorated at the ends with precious stones.

In the portrait, Empress Xiao Quan Cheng is in summer court robes. Her summer crown has three gold filigree phoenixes on the top. She also wears a gold headband, a necklet, a pearl court necklace, two coral court necklaces, a scarf with auspicious symbols hanging from a fastening on her breast and pearl earrings. This is a typical court robe for an empress.

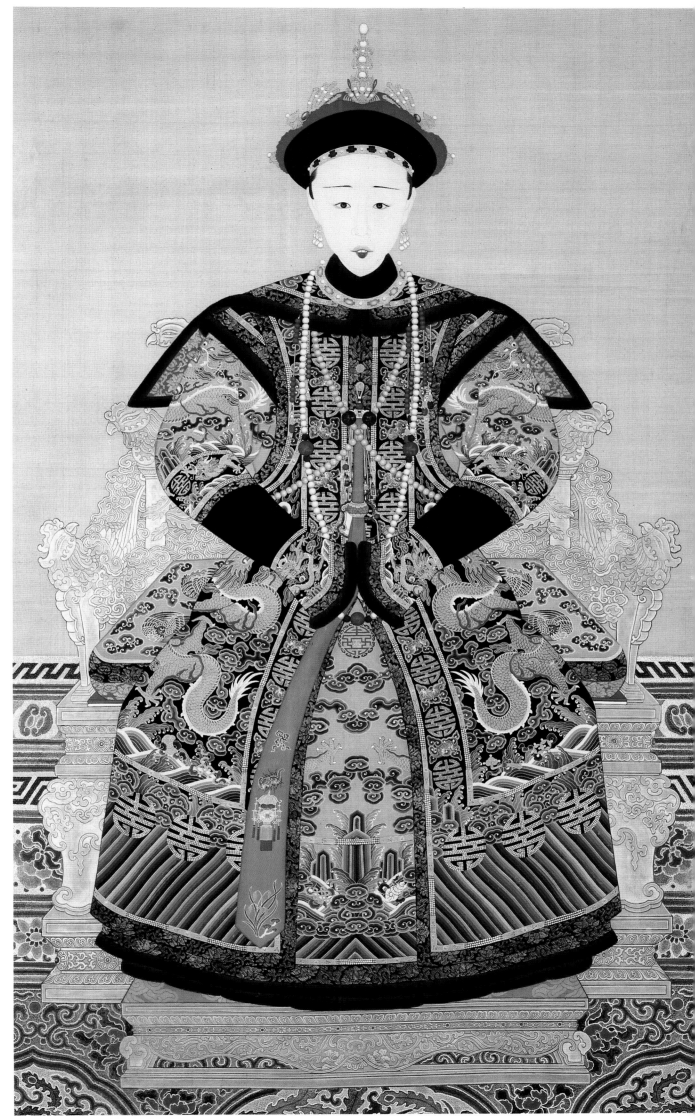

258

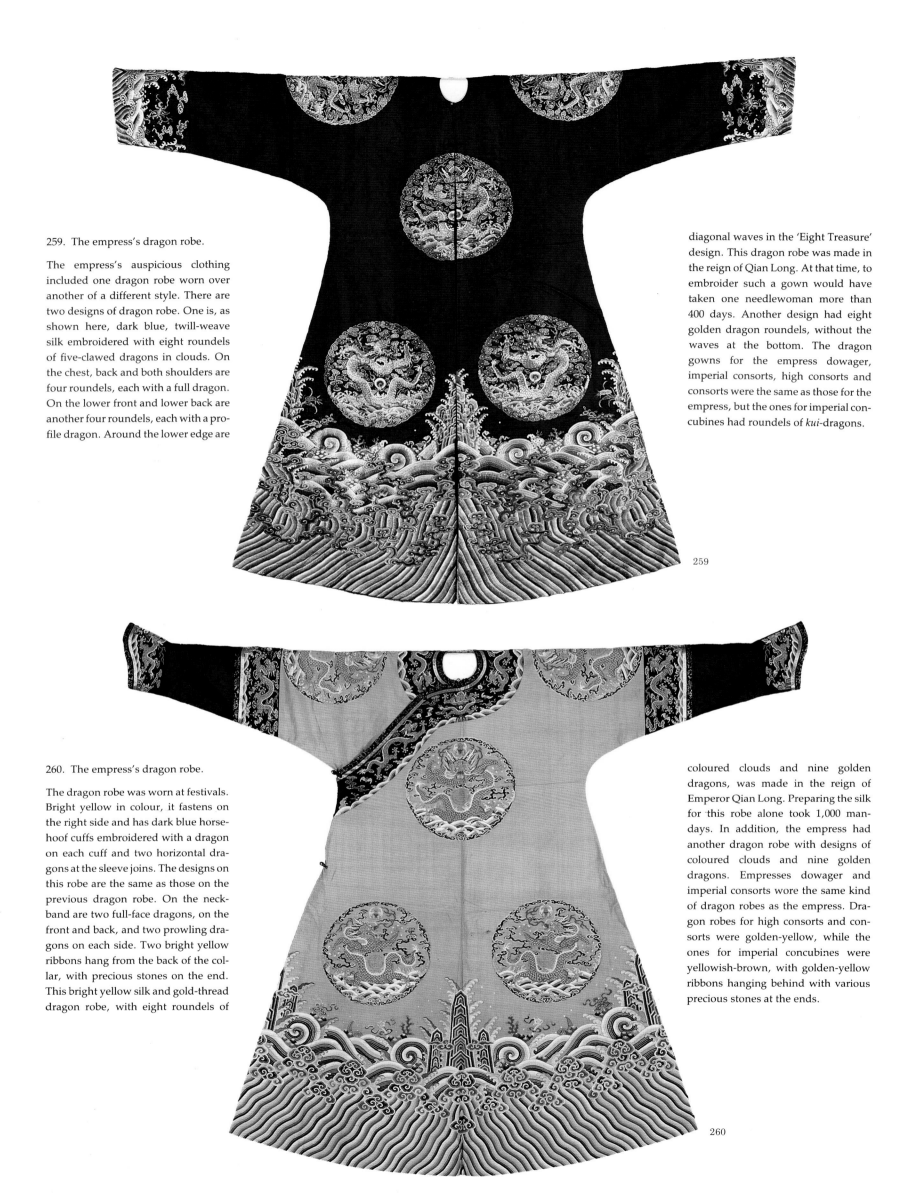

259. The empress's dragon robe.

The empress's auspicious clothing included one dragon robe worn over another of a different style. There are two designs of dragon robe. One is, as shown here, dark blue, twill-weave silk embroidered with eight roundels of five-clawed dragons in clouds. On the chest, back and both shoulders are four roundels, each with a full dragon. On the lower front and lower back are another four roundels, each with a profile dragon. Around the lower edge are diagonal waves in the 'Eight Treasure' design. This dragon robe was made in the reign of Qian Long. At that time, to embroider such a gown would have taken one needlewoman more than 400 days. Another design had eight golden dragon roundels, without the waves at the bottom. The dragon gowns for the empress dowager, imperial consorts, high consorts and consorts were the same as those for the empress, but the ones for imperial concubines had roundels of *kui*-dragons.

259

260. The empress's dragon robe.

The dragon robe was worn at festivals. Bright yellow in colour, it fastens on the right side and has dark blue horse-hoof cuffs embroidered with a dragon on each cuff and two horizontal dragons at the sleeve joins. The designs on this robe are the same as those on the previous dragon robe. On the neck-band are two full-face dragons, on the front and back, and two prowling dragons on each side. Two bright yellow ribbons hang from the back of the collar, with precious stones on the end. This bright yellow silk and gold-thread dragon robe, with eight roundels of coloured clouds and nine golden dragons, was made in the reign of Emperor Qian Long. Preparing the silk for this robe alone took 1,000 man-days. In addition, the empress had another dragon robe with designs of coloured clouds and nine golden dragons. Empresses dowager and imperial consorts wore the same kind of dragon robes as the empress. Dragon robes for high consorts and consorts were golden-yellow, while the ones for imperial concubines were yellowish-brown, with golden-yellow ribbons hanging behind with various precious stones at the ends.

260

261. The front view of a hat decorated with garnets and pearls in flower designs.

262. The back view of the same hat.

The empress and imperial concubines wore the court crown while in court dress and another style of crown while in dragon robes. In addition, there was a hat called the *tianzi* worn by the ladies of the Manchu Eight Banners on the days regarded as appropriate for wearing colourful clothes. The *tianzi* can include the phoenix hat, the Manchu hat and the half-hat. From the front the

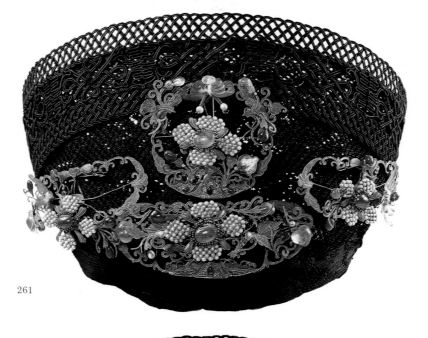

261

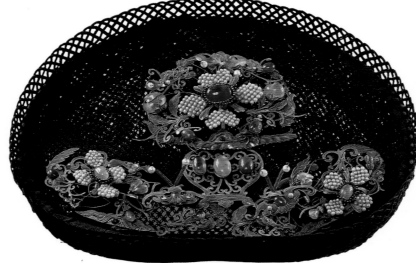

262

tianzi looks like the phoenix crown and from the back it looks like an upturned winnowing basket. It is made on a frame of either wire or cane and covered with black gauze, or it is made of black velvet and satin strips with jade, pearls and precious stones decorating the front and back. The phoenix hat is decorated with nine pearls, the Manchu hat with eight and the half-hat with five. The hat shown here, decorated in flower designs of jade, pearls and precious stones, is the Manchu hat, dating from the late Qing period.

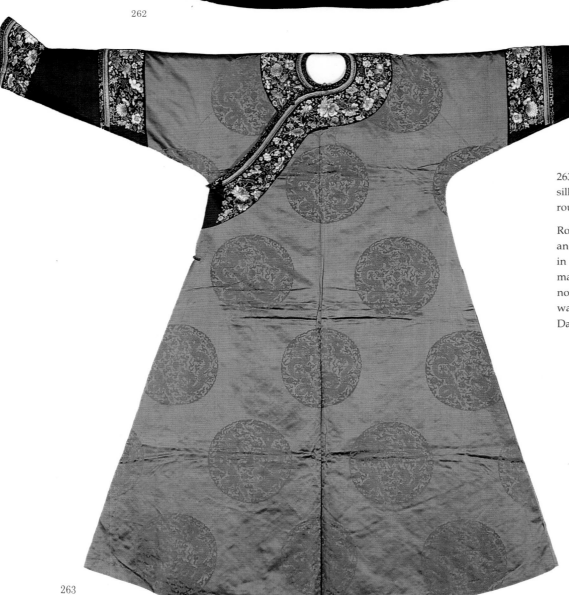

263

263. A woman's green satin-weave silk robe with twill-weave dragon roundels.

Robes worn daily by Qing empresses and imperial concubines were similar in style to dragon robes, but the materials, colours and designs were not subject to regulations. This robe was made during the reign of Emperor Dao Guang.

文化編

CULTURAL
ACTIVITIES

Before the Manchus crossed the Great Wall, Manchu society had in many ways not reached a particularly high point in its development and, indeed, was still in the process of transition from a slave-owning to a feudal society. On the literary side, the Manchu script had only recently been created and its vocabulary was still far from rich. The *Essential Dictionary of the Qing Dynasty* (*Wu Ti Qing Wen Jian*), which was compiled in the Qian Long period, contained only 18,000 entries, against the 480,000 entries in the Han-Chinese equivalent, *The Great Treasury* (*Pei Wen Yun Fu*), compiled in the Kang Xi period. Although the Manchus had conquered the Han people and thus become the ruling ethnic group, nevertheless, they could not avoid being influenced in the areas of politics, economics and culture by the more advanced Han society. Cultural life in the Forbidden City was to a great extent Sinicized as a result of the large numbers of officials and eunuchs remaining from the Han-Chinese Ming dynasty who were employed in the Qing palaces. The 'civilizing' influence of the Ming court was evident in every aspect, from the emperors' and their sons' studies, to court cultural activities such as poetry and prose composition, calligraphy, painting, collecting works of art, the compilation and printing of books, music and theatre. Some Manchu features were retained, but they were remarkably few in number.

The first emperors of the Qing dynasty all attached great importance to studying Han culture, both for their own education and that of their offspring. The Emperors Shun Zhi and Kang Xi both worked very hard studying Han-Chinese literature from their childhood onwards. Not only did he exert himself in the study of traditional Chinese culture, but he also invited European missionaries to teach him astronomy, geography, mathematics and music. *An Illustrated Primer for the Imperial House* (*Di Jian Tu Shuo*), edited in the Ming period especially for the child emperor, Wan Li, was also adopted as a textbook for the child emperors of the Qing dynasty.

Emperor Kang Xi was also keenly aware of the importance of educating his successors, and so concerned himself with his sons' studies. He even personally instructed the Crown Prince Yunreng (later deposed), and when the latter reached the age of six, the emperor chose the Grand Secretary Zhang Ying and other learned persons to be his tutors. In order to supervise the studies of his sons, Yong Zheng had an Upper Study set up in the south chamber on the east side of the Gate of Heavenly Purity and another in the Garden of Perfection and Brightness. He stipulated that his sons should start their education at six, and appointed the most learned imperial academicians as tutors to teach them the Chinese language, the Four Books (*The Great Learning*, *The Doctrine of the Mean*, *The Analects of Confucius* and *Mencius*) and the Five Classics (*The Book of Songs*, *The Book of History*, *The Book of Changes* and *The Spring and Autumn Annals*). Several *anda* (Mongolian word for companion, but in this context meaning someone accompanying the emperor's sons in study) were also appointed to teach the princes the Manchu and Mongolian languages as well as archery before their other classes began.

The Emperor Qian Long was also very demanding of his sons. He worried that the princes would become effeminate scholars unable to take decisive action when necessary. In point of fact, Han-Chinese culture had become so much a part of life in the Imperial Palace that it would have been very difficult to reverse this trend away from Manchu values. Among Qian Long's adult sons, only the fifth, Prince Rong (Yongqi), was proficient in the national language and had also successfully learned archery and horsemanship. Unfortunately, he died at the age of only twenty-six. The other sons were good only at composing prose and poetry, calligraphy and painting, and not at archery and horsemanship. This tendency to forsake the martial skills in favour of literary pursuits could not easily have been checked since, having been born into the highest rank to lead a life of ease and comfort in which they had few tasks to keep them occupied, the princes needed diversions. Even more significantly, the emperors themselves participated in the cultural life of the Han-Chinese, and this inevitably influenced the attitudes within the palace and among high officials and nobles. The Upper Study continued to exist as a school for the princes during the Jia Qing and Dao Guang periods.

In the first half of the Qing dynasty, the literary and artistic life within the Imperial Palace was very dynamic. The Emperor Shun Zhi was a calligrapher and painter. Emperor Kang Xi was a great admirer of the works of the three famous calligraphers, Mi Fei, Zhao Mengfu and Dong Qichang, and his own calligraphy was based on the style of Dong Qichang. The Emperor Yong Zheng also did calligraphy in the style of his father and Dong Qichang.

In the Qian Long period the arts of calligraphy and painting reached a high-point. Woodblock printing of copybooks for calligraphy began in the Qing palace in 1690. In this year a large format reprint of a collection of specimens from famous calligraphers called *Copybook of the Hall of Diligence* (*Maoqin Dian Fatie*) was brought out and a Calligraphy Office (later renamed the Imperial Calligraphy Office) was set up especially to supervise the engraving and rubbing of imperial calligraphy, and that of famous calligraphers. Following this was the publication of the *Copybook of the Yuanjian Studio* (*Yuanjian Zhai Fatie*) and the *Copybook of the Siyi Hall* (*Siyi Tang Fatie*). More such publications came out in the Qian Long period, such as the *Copybook of the Jingsheng Studio* (*Jingsheng Zhai Fatie*), *Copybook of Momiao Hall* (*Momiao Xuan Fatie*), *Copybook of the Lan Pavilion* (*Lan Ting Ba Zhu Tie*) and the reprinting of *Copybook of the Chunhua Pavilion* (*Chongke Chunhua Ge Tie*). These publications numbered seventy or more by the end of the Qian Long period.

Qian Long was much given to showing off his literary talent and calligraphic skills. Examples of his calligraphy can be found inscribed or engraved wherever he went: in the palaces, parks, gardens and temples. Although many of these were actually the work of his courtiers, it is nevertheless true that Qian Long's calligraphy was of a good standard. Most of the emperors who succeeded him were also good calligraphers, although none of them could really be compared with Qian Long.

The ruling houses of the various Chinese dynasties had always attached considerable importance to painting. Since the Han dynasty, special officials or offices had been appointed in the imperial palaces with responsibility for painting. The Qing court established the Ruyi Studio. During the Kang Xi period, those working in this studio included several European painters, the best known amongst them being the Italian missionary Giuseppe Castiglione (Chinese name, Lan Shining), who served both the Kang Xi and the Qian Long emperors. He was particularly skilful in combining the techniques of Western and Chinese painting, and completed a considerable number of very fine works, which, with their use of shading and perspective, had quite an influence on the Ruyi Studio. *Emperor Qian Long in Armour Reviewing His Troops* (see Plate 114) is a famous work of his. Qian Long even bestowed official posts on those who were particularly talented. Fine paintings from the Ruyi Studio were listed in the catalogues of the collection of the imperial family. At that time many high-ranking officials were well-known painters and painted for the imperial family.

The Ruyi Studio flourished during the Kang Xi, Yong Zheng and Qian Long eras, but by the Jia Qing period it had already started to decline. However, according to historical records, even in the Jia Qing period there were over eighty Chinese and Western artists who had made names for themselves working in the Ruyi Studio, and it is certain that the record of artists was not complete. Although the studio was re-established during the period when Ci Xi was in power in the later Qing, it did not regain its former size or standards.

All the emperors who followed Shun Zhi were accomplished at writing poetry and prose, and each of them left an anthology of his poetry and prose for posterity. The most prolific poet was the Emperor Qian Long, who was said to have written 43,000 poems during his lifetime, which would almost have equalled the total works of the 2,000 or more poets of the Tang dynasty. The poems attributed to him are of markedly higher quality than those attributed to other emperors. Qian Long did admit that the poems were half his own work and half the work of others, although to claim even half of such a prodigious output seems dubious. Nevertheless, these poems did have at least some connection with the emperor. Every year during the Spring Festival, he hosted a tea party at the Palace of Heavenly Purity or at the Palace of Doubled Glory at which the guests were asked to compose *bailiang*-style poems (poems

with seven characters to a line), one person composing a line and another supplying the antithesis to it.

The Qing emperors were keen collectors of a wide variety of objects: paintings and calligraphy, rare books, ceramics, bronzes, jade and inkstones, to mention but a few. In the early part of the reign of Qian Long the Imperial Household Department had laid up in store more than 10,000 examples of painting and calligraphy from previous dynasties. In the ninth year of his reign (1744), therefore, Emperor Qian Long instructed palace officials to take an inventory of this collection and compile a book recording the best of them. It was called *The Treasury of Shiqu* (*Shiqu Baoji*) and ran to forty-four volumes. This immense catalogue was compiled and classified by place of origin. It contained extremely detailed records of aspects such as size, inscriptions, seal impressions and colophons, as well as recording those with imperial inscriptions and official seals. The records indicate that most of the paintings and calligraphy were stored in the Palace of Heavenly Purity, Hall of Mental Cultivation, Hall of the Three Rarities, Palace of Doubled Glory, the Imperial Study, the Poetry Learning Study and the Painting Studio – all in the Forbidden City – as well as at the Garden of Perfection and Brightness and the Summer Palace at Chengde. By 1793 the imperial collection of paintings and calligraphy had increased to such an extent that Qian Long ordered a sequel to the catalogue. These two catalogues and another, compiled in the Jia Qing period, listed a total of 12,500 items in the collection.

After *The Treasury of Shiqu* had been completed, Emperor Qian Long instructed Liang Shizheng, President of the Board of War, and some other officials to produce precise drawings of ancient bronze vessels stored by the Imperial Household Department, and to take rubbings of the inscriptions on them and compile the *Xi Qing Collection of Ancient Bronzes* (*Xi Qing Gu Jian*) in the style of the Song dynasty *Illustrated Catalogue of Antiques of the Xuan He Period* (*Xuan He Bo Gu Tu*). In the fortieth year of Qian Long's reign (1775), once again on the emperor's instructions, they made drawings of the ceramics, stone, *songhua* stone and imitation *cheng* clay ink-stones in the Imperial Household Department and compiled the *Xi Qing Collection of Ink-stones* (*Xi Qing Yan Pu*). Unfortunately, these catalogues include a number of fakes alongside the genuine pieces. Emperor Qian Long also ordered officials to sort out the rare Song, Yuan and Ming books in the palace. After these had been examined and approved by himself, they were put in a special repository in the Hall of Luminous Benevolence. He named the repository *Tianlu Linlang* (The Heavenly Brilliant Collection) after the imperial book repository of the Han dynasty, the *Tianlu Ge*, which had been renowned as a place for 'collecting secret books and cultivating men of virtue'. However, the books in the Qing repository were reduced to ashes in 1797. A fire extensively damaged the Palace of Heavenly Purity, the Hall of Union and the Hall of Luminous Benevolence. After this catastrophe the emperor assigned to President Peng Yuanrui and other officials the task of re-forming the collection of Song, Yuan and Ming books. This eventually contained 659 rare books, some 237 more than were in the first Heavenly Brilliant Collection repository. The emperor attached his seal to and inscribed his favourites among these books, as an indication of his high regard for them. There were in addition many other imperial repositories of books.

From the Kang Xi period onwards a considerable number of men were brought together to compile, cut the blocks for and print books. Apart from the documentary records of the various dynasties, imperial admonitions and the emperors' prose and poetry compositions, they compiled books on a wide range of subjects. Among the compilations of the Kang Xi period were the *Kang Xi Dictionary* (*Kang Xi Zidian*) and *The Great Treasury* (*Pei Wen Yun Fu*), both of which are still widely used today, as well as the many-volumed reference work, *Collection of Books of Ancient and Modern Times* (*Gujin Tushu Jicheng*), consisting of 10,000 *juan*. During the Qian Long period the world-famous *Complete Library of the Four Treasures* (*Si Ku Quan Shu*) was compiled. It consisted of over 78,730 *juan*. Seven fair copies of this work were made and stored separately, in four libraries in the north and three in the south. However, in the course of compiling *The Complete Library of the Four Treasures*, Emperor Qian Long

burned, banned and tampered with a great many books as well as indiscriminately killing innocent people during what amounted to a literary inquisition.

In the Kang Xi period, institutions such as the Book Editing Office in the Hall of Military Prowess, a store of movable copper type, and a printing house were set up in the palace to compile and print books. The *Collection of Books of Ancient and Modern Times* was printed using movable copper type. By the Qian Long period, however, these had become so badly damaged that they were finally destroyed and replaced by wooden type, which was known as the 'Treasure-Collecting Plates of the Hall of Military Prowess'. They were of exquisite quality in terms of their paper, ink, engraving, printing and binding. They are known as the Hall of Military Prowess editions and are now avidly collected as rare books.

Dramas had been staged in the Imperial Palace long before the Manchus crossed the Great Wall and, after they established their capital at Beijing, the Qing imperial family continued the tradition of the Performing Artists' Department of the Ming period to encourage drama to exist as before. In the Kang Xi period, the Nanfu Theatre was responsible for music and dramatic performances in the Inner Court. Emperor Kang Xi had a great interest in the study of temperament and harmony, and he learned about Western music from European missionaries, as well as supervising the compilation of a book on music theory called *Orthodox Interpretations of Temperament* (*Lülü Zheng Yi*).

The Emperor Qian Long also loved drama and music. In the early part of his reign he ordered that the palace music be re-evaluated and a sequel to the *Orthodox Interpretations of Temperament* was compiled with many music scores appended to it. He assigned to Zhang Zhao, a literary figure, the task of writing a number of plays, and these were often staged in the palace. Plays were also staged which specifically related to particular occasions or festivals. Theatrical performances were proscribed on certain occasions such as solar eclipses, lunar eclipses, *Jichen* (an anniversary of the death of an imperial parent, ancestor or anyone held in esteem by the ruling house) and fast days.

Whenever Emperor Qian Long travelled outside the palace, eunuch performers from the Nanfu Theatre would accompany him.

As the political situation deteriorated in the Dao Guang period, however, the Imperial Palace found itself in increasingly straitened circumstances and, in the seventh year of his reign (1827), the emperor was forced to cut the number of performers employed by the Nanfu Theatre from 500 to 240 and changed the name from Nanfu to Peace Troupe. Emperor Dao Guang and his son, Emperor Xian Feng, not only attended theatrical performances regularly but sometimes summoned the Peace Troupe artists to perform in front of the imperial living-quarters. When the Anglo-French forces invaded Beijing in 1860, Emperor Xian Feng fled to the Summer Palace at Chengde, and soon summoned the Peace Troupe to join him there. On his sickbed, and even two days before his death, in 1861, he attended the theatre on Ruyi Islet in the Summer Palace.

The Empress Dowager Ci Xi was also an enthusiast of the theatre. During the fifty years she held power, she went almost daily to theatrical performances in the Forbidden City, at Zhongnanhai and the Summer Palace (Yiheyuan). The only exceptions were when the palace observed mourning for Emperors Xian Feng and Tong Zhi, and when the allied forces of the Eight Powers occupied Beijing and she was forced to flee to Xi'an in Shaanxi Province. She was not content to be entertained by the Peace Troupe alone, but frequently had private troupes brought into the Forbidden City to perform for her. The variety of performances also increased to include not only the *Kunqu* and *Yiyang* Operas but also many other local operas. In Ci Xi's time, a new type of opera, the *Pihuang*, or Peking Opera as it is known today, also made its appearance. In addition, acrobatic and other fairground-type performances were also put on in the Forbidden City.

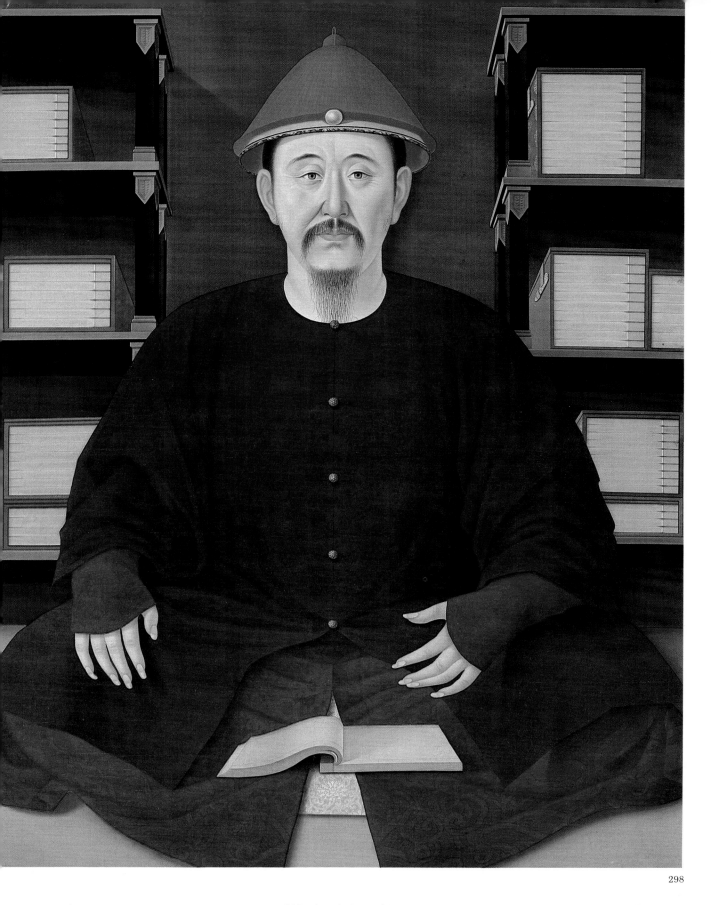

299. A portrait of Emperor Kang Xi about to wield his writing brush. (507 cm × 32 cm)

Emperor Kang Xi had a great love of calligraphy. He said, 'I learnt calligraphy from childhood. I kept my writing brush and paper always at my elbow, never slackening my efforts even in extremely cold or hot weather.' To judge from what remains of his handwriting, he was indeed a proficient calligrapher.

298

298. A painting of Kang Xi at his studies. (126 cm × 95 cm)

Emperor Kang Xi read extensively, but he liked to think things out for himself, saying that you could not believe everything you read in books. When he read about a poor but diligent scholar in ancient China who had studied at night by the light of the fireflies in a transparent container, he tested the veracity of this by putting a hundred fireflies in a glass bottle, finding, however, that he could not read at all by the light they produced. He believed that certain descriptions might sound absurd but were actually true to the facts. Once, he explained, 'I had thought it ridiculous when Dong Fangshuo of the Western Han dynasty

stated that the ice in the north was one thousand *chi* thick [1 *chi* was 0.23 m in Western Han times] and would not melt even in summer. But then I found out from Russians I met that his description was all too true.' On one of his tours of the south, when someone presented him with a book called *Alchemy – a Secret Guide to Healing* (*Lianjin Yangshen Mi Shu*), Emperor Kang Xi said, 'I have never believed in such stuff. Let it be returned to the person who gave it to you!'

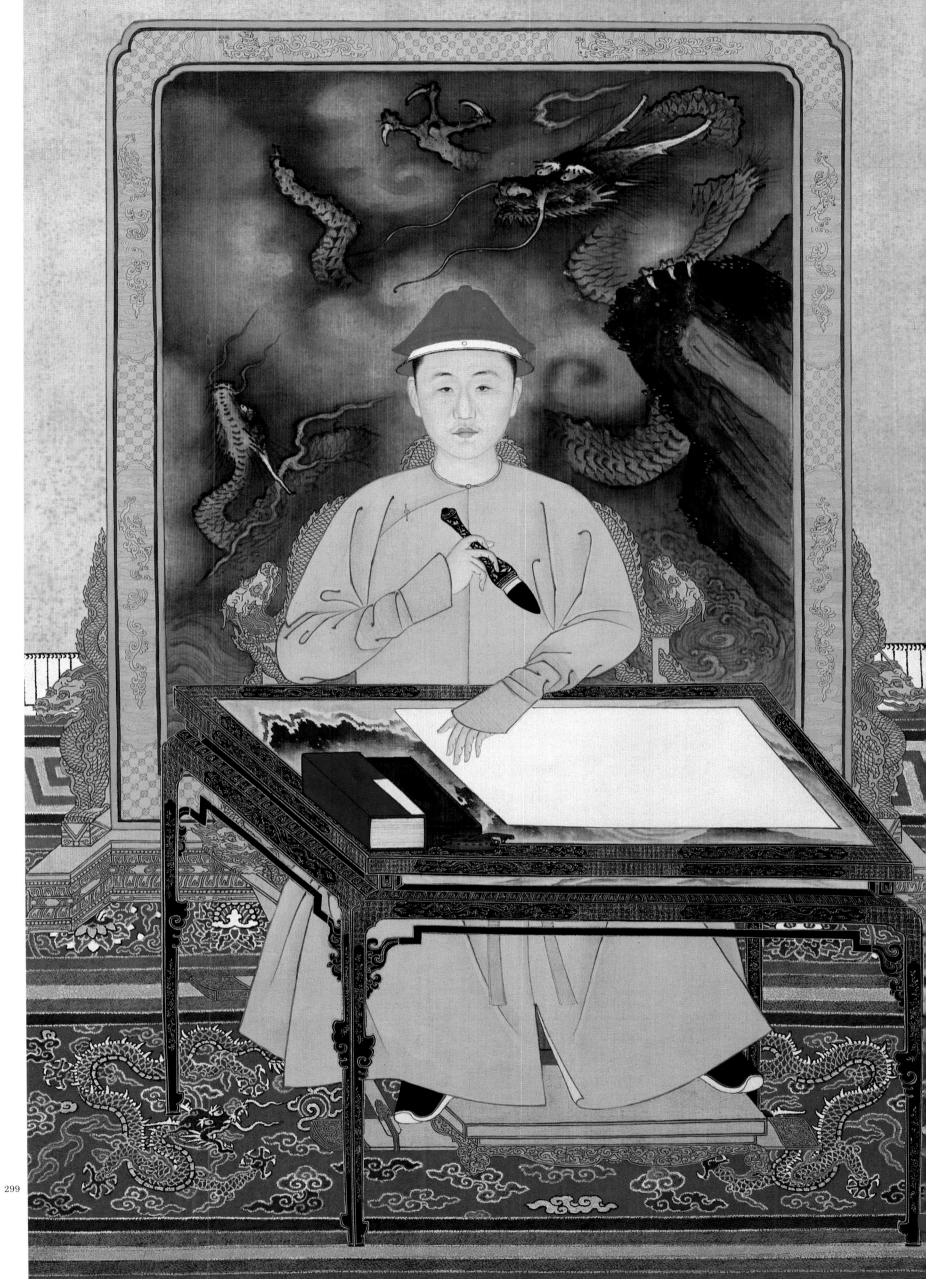

陶令籬邊菊秋来色轉佳翠攅千
片葉金剪一枝花藍逐蜂鬖嶺搖英
隨嶸翹斜帶香飄綠綺和影上窗
紗散漫搖霜彩鮮妍漏日華芳菲
彭澤見稱更在誰家

唐公秉億咏菊
傲米芾

300. A calligraphic scroll written by Kang Xi in the style of Mi Fei.

Emperor Kang Xi greatly enjoyed imitating the handwriting of the Song calligrapher Mi Fei and the Ming calligrapher Dong Qichang. Although the emperor claimed that this calligraphic scroll was in the style of Mi Fei, in composition and structure it is actually more like that of Dong Qichang.

301. A couplet written by Emperor Yong Zheng.

Yong Zheng was one of the best calligraphers among the Qing emperors.

301

302

302. Butong Study.

Located to the east of Sea Terrace Island on South Lake, it was the place where Qian Long studied when he was Crown Prince. Two old *tong* trees stood outside the windows. After one of them had withered, another was planted, but then the remaining original tree also died. In the tenth year of his reign (1745), Emperor Qian Long had four lutes made out of the *tong* wood from the withered trees. He named the four lutes 'Celestial Music of Yingtai', 'Azure Autumn on the River Xiang', 'Singing Fowl and Crying Crane' and 'Sea of Clouds Stirring the Emotions'. Each was then made the subject of a poem and the poems were displayed in the study.

303. *Three Friends of Winter* by Emperor Qian Long.

Emperor Qian Long attained quite a high standard in his study of Han-Chinese culture, being well versed in poetry, creative writing, calligraphy and painting. His calligraphic inscriptions can still be found in many places, but few of his paintings have survived. This scroll painting of bamboo, pine and plum (the 'three friends of winter') is charming, despite certain flaws.

303

304. A block-printed edition of *First Anthology of Emperor Qian Long's Poetry*.

Emperor Qian Long's numerous poems cover a wide range of subjects, from descriptions of landscapes to narrations, odes, inscriptions on paintings and reflections on past eras. In terms of quantity, his landscape poems come first, accounting for more than half the total, narrative poems second, with inscriptions on paintings, and odes third. His poems on other topics are relatively few in number. The shorter poems which Emperor Qian Long wrote in his youth have about them a freshness and charm. However, many of the poems attributed to him after his accession (some of them written by others, in his name) were somewhat pedestrian and frequently had political overtones. Later generations have tended to regard them as historical documents rather than as works of art.

305. *Selected Writings of His Majesty Qian Long*.

The selection contains well over 1,000 pieces on a wide range of subjects, such as astronomy, geography, politics, history, Confucianism, characters, the arts and economics. He used many kinds of literary forms including narrative, rhyming composition, inscription and eulogy. Quite a few of these examples were actually written by others in his name.

306. *The Copybook of the Hall of the Three Rarities.*

Emperor Qian Long treasured the copybooks of the three famous Jin dynasty (265–420) calligraphers – *Clearing Skies After Snow* by Wang Xizhi, *Mid-Autumn* by Wang Xianzhi and the *Letter to Bo Yuan* by Wang Xun. He looked upon them as 'three rarities' and kept them in the conservatory in the Western Warm Chamber of the Hall of Mental Cultivation, calling it the Hall of the Three Rarities. In the twelfth year of his reign (1747) he instructed Minister Liang Shizheng and others to compile and print a large-format collection of calligraphy called *Copybook of the Hall of the Three Rarities* from among the calligraphic works kept in the Imperial Household Department. This book, in redwood covers, with the characters in inlaid mother-of-pearl, presents 350 pieces of calligraphy of all styles, dating from the Wei and Jin periods to the end of the Ming dynasty, as well as 210 annotations and inscriptions. It was an enormous undertaking. The original lithographic stones are kept in the Tower of Reviewing the Old in North Lake.

307. A rubbing from Wang Xizhi's *Clearing Skies After Snow*, which was kept in the Hall of the Three Rarities.

308. A rubbing from Wang Xianzhi's *Mid-Autumn*.

309. A rubbing from Wang Xun's *Letter to Bo Yuan* (1).

310. A rubbing from Wang Xun's *Letter to Bo Yuan*. (2)

306

307

308

310

309

311

312

311. The wooden covers of the reprinted Song-dynasty *Copybook of the Chunhua Pavilion* ordered by Emperor Qian Long and produced from the master-copy using the *goumo* process and rubbing.

312. Rubbings from the reprinted *Copybook of the Chunhua Pavilion*.

313. The *goumo* master-copy of the reprinted *Copybook of the Chunhua Pavilion*.

The process of *goumo* is as follows: first, thin oilpaper is used to make a tracing of the original in outline, which is then traced in red ink on the back of the sheet, before being transferred to the stone so that the engraving may be done. Shown here is a master-copy of the drawings in outline only. The drawings were filled in with black ink and mounted on the instructions of Qian Long. This copy is almost identical to the original, and indicates the high levels attained at the time in tracing, engraving and rubbing.

313

314. *The Imperially-Approved Illustrations Added to Wang Yun's Historical Anecdotes.*

Printed by the Book Editing Office in the Hall of Military Prowess in the Qian Long period, this book was compiled for the crown prince by Wang Yun, a Deputy Judge of Hebei Circuit, in the eighteenth year of the Zhi Yuan period of the Yuan dynasty (1281). It concentrates on the methods of administering state affairs through the narration of historical stories. The original edition contained an illustration for every story. As the illustrations had been lost by the Qing period, new ones were added when the book was reprinted. The new illustrations, exquisitely engraved and printed, are typical of traditional Chinese block prints.

314

315. Emperor Kang Xi's table for mathematical studies. (96 cm long, 64 cm wide and 32 cm high)

This exquisitely designed cedar *kang* table has a silver top engraved with a dozen or so arithmetical and scientific charts and tables. Inside the table are various square frames for storing calculating and charting instruments. The emperor used this table for his studies during his later years. It reflected his strong interest in science and mathematics and his spirit of conscientious inquiry and study.

316. The top of Emperor Kang Xi's table for mathematical studies.

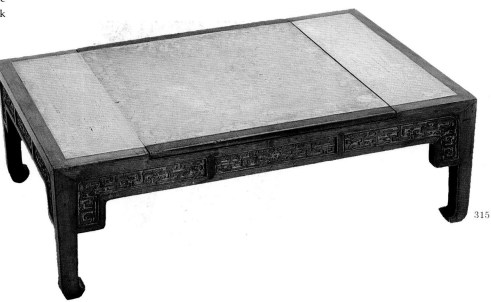

315

316

317

317. *An Illustrated Primer for the Imperial House.*

This was an illustrated-textbook series compiled by Grand Secretaries Zhang Juzheng and Lü Diaoyang at the end of the sixth year of the Long Qing reign of the Ming dynasty (1572) for the newly enthroned ten-year-old Emperor Wan Li. It contained eighty-one good deeds and thirty-six evil deeds done by rulers ranging from the legendary Kings Yao and Shun to emperors of the Tang and Song periods, and was produced as a collection of didactic tales for the young sovereign. The book was also read by emperors of the Qing dynasty.

318. The crown prince's own compositions.

These exercises in writing poetry were produced by Emperor Jia Qing when he was crown prince. The characters in red ink are corrections made by his tutor.

318

319. An exterior view of the Upper Study.

Located on the meandering corridor on the east side of the Gate of Heavenly Purity, the Upper Study was set up in the early period of Yong Zheng's reign as a school for the imperial sons and grandsons.

320. The Pavilion of the Wind in the Pines of the Ten Thousand River Valleys at the Summer Palace at Chengde.

This pavilion, situated at the northern end of the eastern courtyard of the Summer Palace, was where Qian Long studied when he was an imperial grandson.

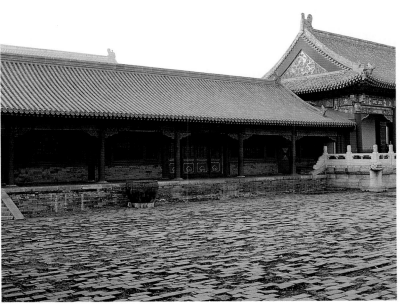

319

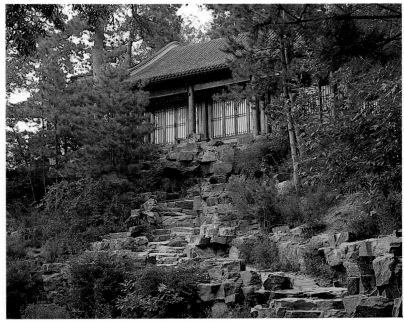

320

321. An aerial view of the Hall of Literary Glory.

The Hall of Literary Glory was where the crown prince studied and where the emperor attended the *jing yan* (expositions of the Confucian classics by official interpreters) in the Ming dynasty. The emperors of the Qing dynasty also attended the *jing yan* here. It was held on auspicious days in mid-spring and autumn every year, and at the end the emperor would give a tea party or banquet for the officials attending the lecture.

322. The Biyong Hall of the Imperial College.

Once every year the emperor went to the Biyong Hall to attend the 'lecture-giving ceremony' in order to indicate his high regard for education. This was called *lin yong* (meaning 'gracing Biyong Hall with his imperial presence') and was a ceremony similar to but somewhat more solemn than the *ying yan*. On the occasion of *lin yong*, the emperor first went to the Confucian temple to pay his respects to the sage, then to the Hall of Ethics to change into his imperial robe. The bell

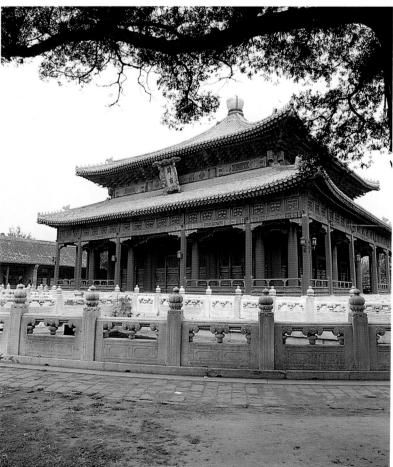

was tolled and the drum beaten, and he mounted his seat in the Biyong Hall to the strains of the Zhongheshaoyue orchestra. The Danbidayue orchestra struck up as the emperor accepted the obeisances of the Holy Duke (a title conferred on the lineal descendant of Confucius), and of the officials giving lectures, the Confucian scholars, and the descendants of sages and saints as well as the president, tutors and students of the Imperial College. When this part of the ceremony was over the lecture-giving officials took it in turns to expound a passage from the Four Books or the Five Classics. These were followed by a conclusive exposition by the emperor himself. Finally the officials, scholars and students kowtowed again and presented tea to the emperor, who then also invited them to drink tea.

322

216

323. *Xi Qing Collection of Ancient Bronzes.*

Influenced by Han-Chinese culture, the Qing imperial house took a great interest in collecting calligraphy, paintings and antiques. This was particularly evident in the Qian Long period. The emperor instructed officials to make drawings of the shapes and copy the inscriptions on the bronzes of the Shang, Zhou and later dynasties and to compile the *Xi Qing Collection of Ancient Bronzes* and its sequel. The *Zhouzhuji zun* wine container (also called a *xuya* rectangular *zun*) shown here is still in the collection of the Palace Museum.

323

324

324. Ancient coins in the Qing palace collection.

These ancient coins provide important material for the study of the monetary systems of the various dynasties in Chinese history.

325. A *yu* basin from the Qing palace collection of bronzes. (height, 39.9 cm, diameter at mouth, 53.5 cm)

This *yu* basin of the Zhou dynasty is one of the largest Zhou bronze vessels of its kind extant in China and bears a sixteen-character inscription reading: 'Treasured *yu* basin made by Bo for use by descendants for ten thousand years'. It is listed in the sequel to the *Xi Qing Collection of Ancient Bronzes* compiled in the fifty-eighth year of Qian Long's reign (1793).

325

217

326

327

326. Seals made of golden stone and chicken-blood stone (pyrophyllite).

The Qing palace boasted a large selection of seals of the precious golden (*tianhuang*) and chicken-blood stones. Some of the seals are by famous engravers like Wen Peng.

327. A Ming *cloisonné*-enamel vase, in the palace collection.

328. A Song dynasty *jun*-ware flowerpot. (15.8 cm high)

This blue and purple glazed stoneware flowerpot in the collection of the Qing palace was made at the famous Jun kilns of the Song dynasty.

328

329. A Ming dynasty *doucai* porcelain jar.

This Ming, lidded jar in the palace collection is in *doucai* (dove-tail colours) style, where overglaze enamel colours are used to fill underglaze blue outlines.

329

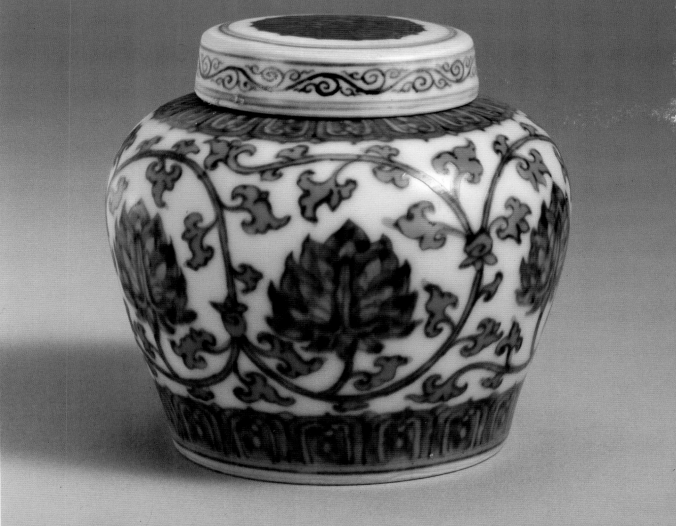

330

331

332

333

330. A hand-copied third edition of *The Treasury of Shiqu*.

This third edition, compiled in much the same style as the first two editions, provides a very detailed record of the calligraphy and paintings in the palace collection at the time.

331. The Song edition of the *Collected Works of Chang Li* (*Chang Li Xiansheng Ji*), from the Emperor Qian Long's collection.

This book is stamped with the emperor's five seals: the *Qianlong Yulan Zhibao* ('Seal for Qian Long's Imperial Reading'), the *Tianlu Linlang* ('Seal of the Heavenly Brilliant Collection'), the *Wufuwudaitang Guxi Tianzi Zhibao* ('Seal of the Seventy-Year-Old Son of Heaven of the Five-Happinesses-Five-Generations Hall'), the *Bazheng Maonian Zhibao* ('Seal for the Eighty-Year-Old Man's Reading') and the *Taishang Huangdi Zhibao* ('Seal of the Emperor's Father').

332. *A Collection of Books of Ancient and Modern Times*.

This work was compiled on the orders of Emperor Kang Xi. The whole undertaking of 10,000 *juan* is a comprehensive survey of the classics, history and the various schools of philosophy, and is one of China's great reference books. The abundant contents are carefully arranged as in an encyclopedia. The original plates used movable copper type for its printing. In the Guang Xu era, another edition was printed.

333. *The Complete Library of the Four Treasures*.

Classified under the four categories of classics, history, philosophical schools and collections of literature, which were bound in yellow, red, blue and brown covers, respectively, it consisted of 36,000 or more volumes, and is the largest series of books in the world. Compilation of the work was started in the thirty-seventh year of the Qian

Long period (1772) and was completed in ten years – a remarkable project. The preservation and classification of the historical documents relating to the various dynasties alone was a significant achievement. There were seven hand-written copies of the book, stored separately in the Four Pavilions of the North (the Pavilion of Literary Profundity in the Forbidden City, the Pavilion of Literary Origin in the Imperial Palace in Shenyang, the Pavilion of Literary Inspiration in the Summer Palace in Chengde and the Source of Culture Pavilion in the Garden of Perfection and Brightness, and the Three Pavilions of the South (the Pavilion of Literary Collection in Zhenjiang, the Pavilion of Literary Corpus in Yangzhou and the Pavilion of Flourishing Literature in Hangzhou). Of the seven copies, only four, those in the Pavilions of Literary Profundity, Literary Origin, Literary Inspiration and Flourishing Literature, survived.

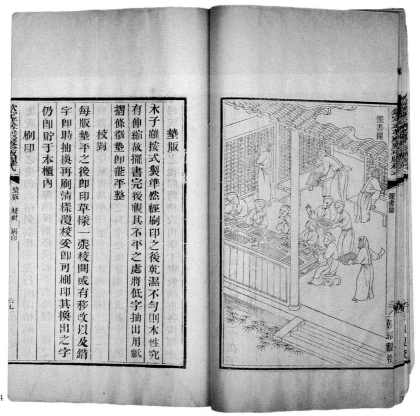

334

永子雖按式製準然經刷印之後乾濕不勻則木性究
有伸縮故擺書完後視其不平之處將低字抽出用紙
摺條微墊卽能平整

摺條微墊卽能平整

校對

每版墊平之後卽印草樣一張校閱或有移改以及錯
字卽時抽換再刷清樣覆校妥卽可刷印其換出之字
仍削貯于本櫃內

刷印

334. *Formulae for the Treasure-Collecting Plates of the Hall of Military Prowess.*

The movable-type wood blocks cut in the mid-Qian Long period, otherwise known as the *juzhenban* ('treasure-collecting plates', similar to letterpress printing), were responsible for the printing of more than a hundred books. The processes and formulae for printing from the blocks were recorded in the form of the manual shown here. It thus provides important material for the study of the history of Chinese printing.

335. The Pavilion of Flourishing Literature in Hangzhou.

This is the only one of the Three Pavilions of the South still extant, and is now restored to its former splendour.

335

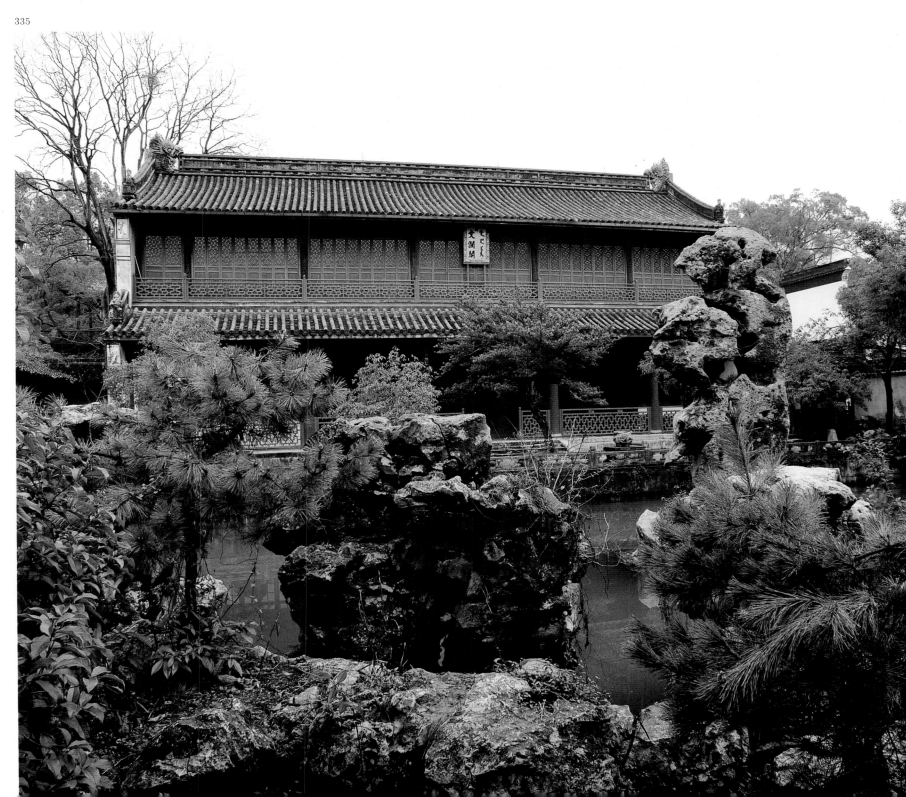

336

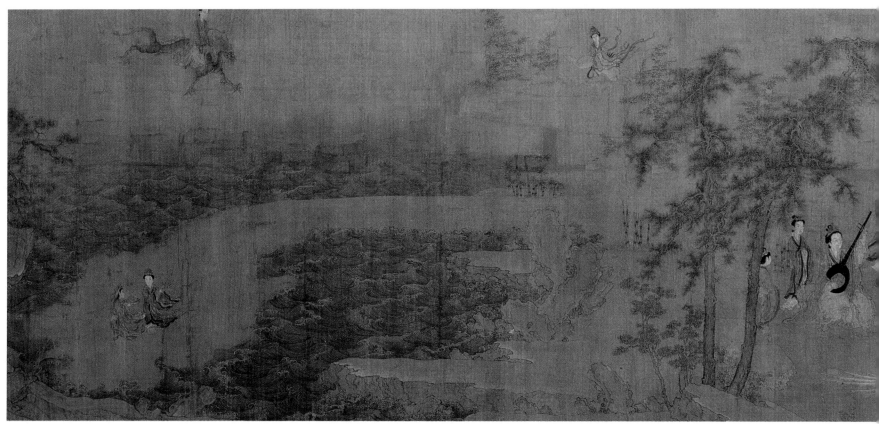

337

336. The Palace Library.

There were a number of libraries in the Imperial Palace. Camphor was placed among the books to deter moths, and the whole library was aired every year.

337. *The Fairies in the Land of Immortals,* from the Qing palace collection. (42.7 cm × 177.2 cm)

This painting on silk by Ruan Gao of the Five dynasties depicts a scene of fairies reading or playing musical instruments among mountains, streams, trees and rocks. Some are seen on the water or flying through the air, accompanied by maidservants and disciples. It represents a scene in the celestial mountains in the land of the immortals of Chinese mythology. Inscribed on the painting is a poem in Qian Long's calligraphy and there are impressions of the seals of Qian Long and Jia Qing.

338. The Heavenly Brilliant Collection in the Hall of Luminous Benevolence.

The Hall of Luminous Benevolence was set aside during the Qian Long period as a library for rare books belonging to the Song, Jin, Yuan and Ming dynasties which was named the Heavenly Brilliant Collection by Emperor Qian Long. Seen here is the hall following restoration to its original condition after a fire in the Jia Qing period.

338

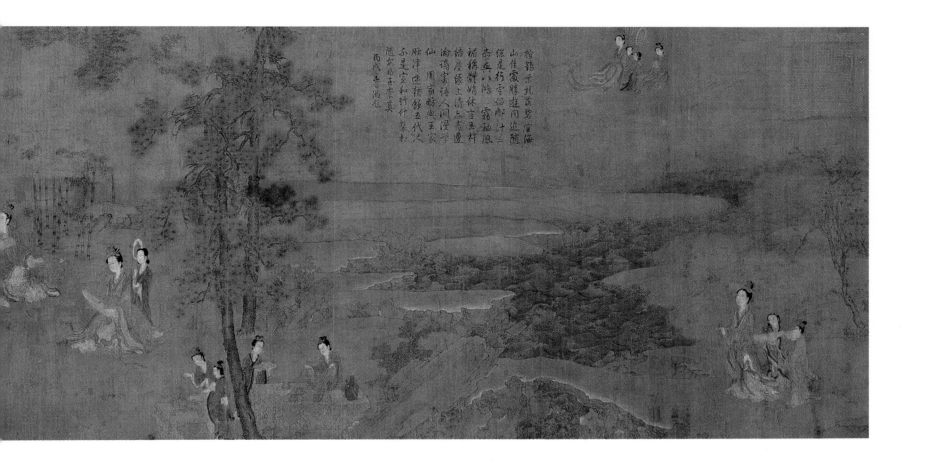

晉內史吳郡陸機士衡書

339

339. *The Copybook of Pingfu*, in the Qing palace collection. (23.8 cm × 20.6 cm)

This copybook is said to be in the calligraphy of the famous Western Jin (317–420) writer Lu Ji, and offers material which sheds light on the development of the running-hand style from the *zhangcao* to the *jincao* style of calligraphy. One of the earliest examples by a famous calligrapher, it was brought into the palace in the Qian Long era and placed in the custody of his mother. After her death, it was bestowed on Yongxing, or Prince Cheng. After that it passed from the palace into private hands. In 1949 Zhang Boju, a collector, donated it to the Palace Museum.

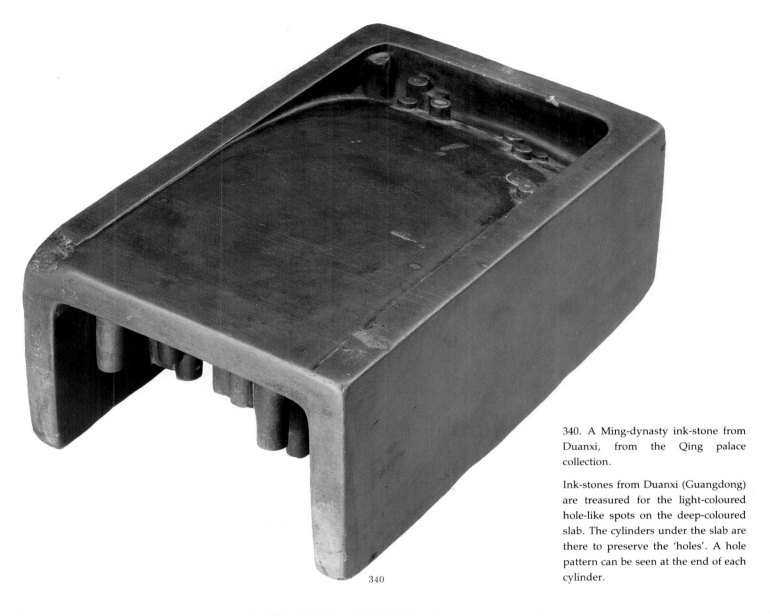

340. A Ming-dynasty ink-stone from Duanxi, from the Qing palace collection.

Ink-stones from Duanxi (Guangdong) are treasured for the light-coloured hole-like spots on the deep-coloured slab. The cylinders under the slab are there to preserve the 'holes'. A hole pattern can be seen at the end of each cylinder.

340

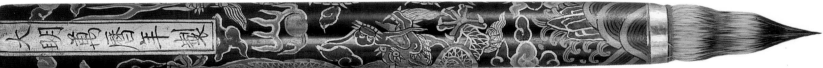

341

341. A writing brush dating from the Wan Li period of the Ming dynasty.

342. The jade *go* pieces in the palace collection set out on a board.

342

225

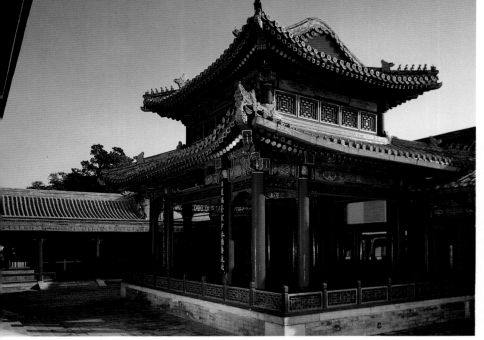

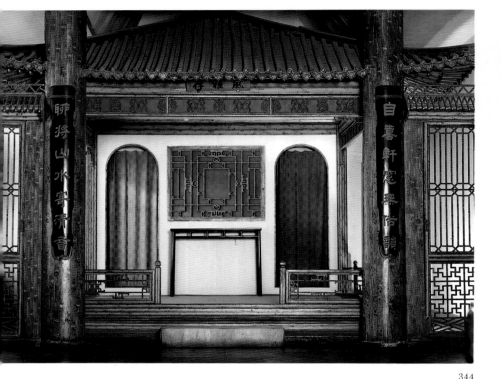

343

345

343. The stage in the Palace of Doubled Glory.

Located in the courtyard of the Study of Fresh Fragrance, it is a medium-sized stage by the standards of the Imperial Palace. Operas were shown here on such festivals as New Year's Day and the emperor's birthday. Sometimes an opera was staged first on the large stage in the Pavilion of Pleasant Sounds and then continued here.

344. The small Preservation of Culture stage.

Located in the rear part of the Study of Fresh Fragrance this stage, measuring only a few square metres, was used during minor banquets when plays appropriate to such occasions were performed. These plays were mainly highlights from particular operas. Each lasted about ten minutes and eulogized the virtues of kings and emperors and the times of peace and prosperity.

344

346

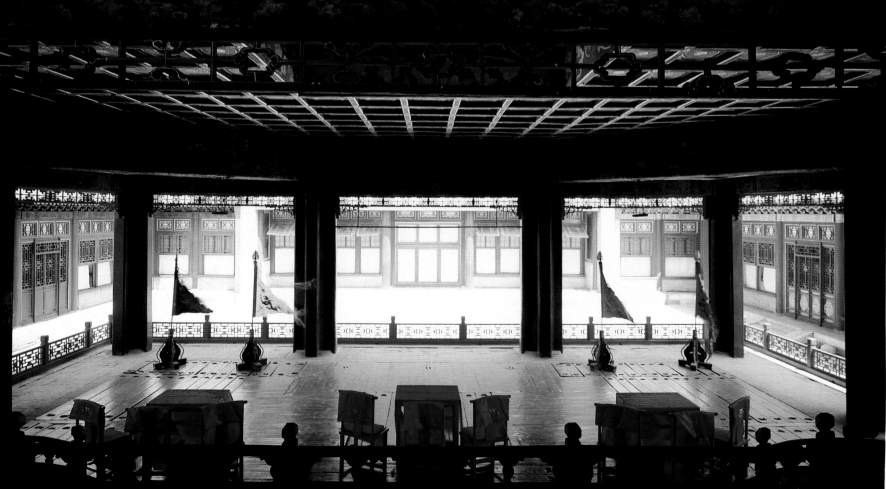

345. The Pavilion of Pleasant Sounds.

This stage, the largest in the Imperial Palace, has three tiers. Sometimes all three functioned simultaneously, but usually only the lowest tier was used. Each tier had mechanical devices, whereby in plays including spirits or ghosts the actors could drop from an upper to a lower tier or be elevated from the basement to the stage above. This stage was completed in the forty-first year of the Qian Long period (1776), as were buildings in the Palace of Peaceful Old Age. Thereafter, operas were staged here on the emperors' and empresses dowager's birthdays.

346. The lowest-level stage in the Pavilion of Pleasant Sounds.

The stage, surrounded by twelve columns on four sides, stands above a basement, which incorporates pits in the centre and on four sides to increase the resonance and thus improve acoustic effects.

347. Stage costumes and theatrical props backstage.

The stage costumes in the early Qing period were mainly adapted from the embroidered fabrics of the Ming period. The texture of the fabric is fine and the workmanship exquisite.

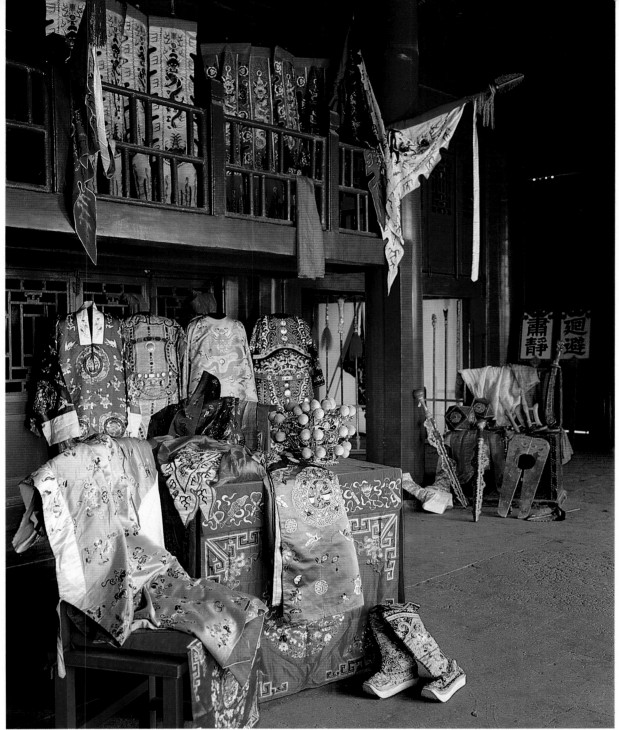

347

348. The Yueshi Tower opposite the Pavilion of Pleasant Sounds.

This was the place from which the emperor and his courtiers watched theatrical performances. The nobility and ministers who were especially invited to watch these performances sat in the east and west wings. The performances generally started at six or seven in the morning and ended at around two or four in the afternoon. Sometimes, however, they went on as late as five or six.

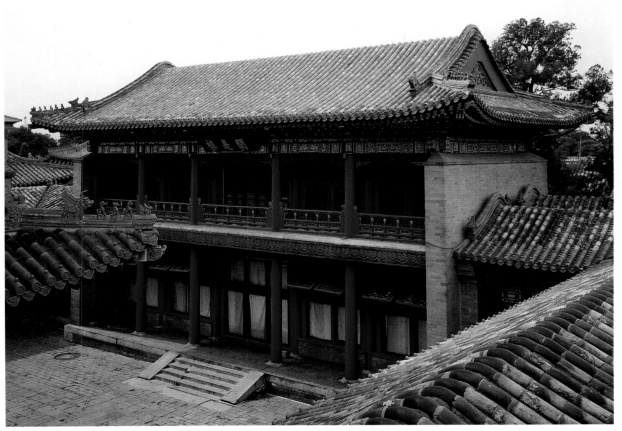

348

349

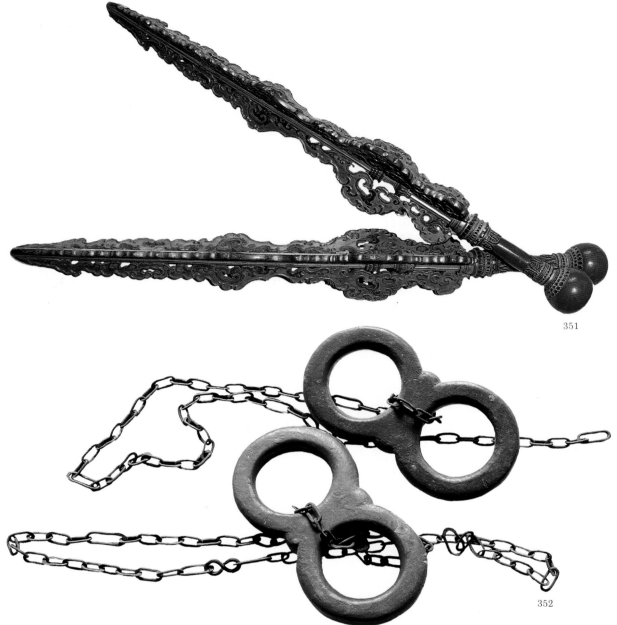

351

350

349. A stage costume for a general.

350. A stage costume with pennants for a woman warrior.

351. Stage props: batons.

352. Stage props: handcuffs.

352

353. A script with traditional musical notation.

This is a legacy of the Peace Troupe. *Kunqu* and *Yiyang* operas were the most popular in the Imperial Palace in the early Qing period. *Luantan* and other operas began to gain popularity by the Tong Zhi and Guang Xu periods, when private troupes were often called into the Forbidden City to perform. Peace Troupe scripts extant today are mostly those of *Kunqu* and *Yiyang* operas. These include *Annals of the Rival Kingdoms, Song of the Enlightened Reign, The Magic Raft, Guide to Virtue, The Iron Flag Formation* and total a thousand or more acts. Scripts for occasional plays and one-act plays were even more numerous. These scripts were mostly hand-copied, some especially for the use of the emperor at the performances and some for the actors at rehearsals.

353

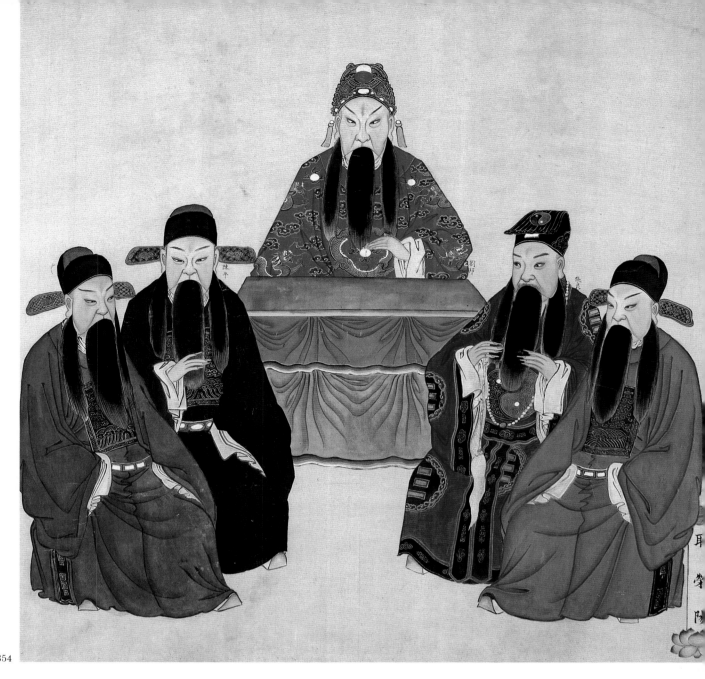

354. A painting of a scene in *The Capture of Yingyang*, in the palace collection.

The Qing emperors not only enjoyed theatrical performances, but they also loved paintings of scenes from the plays.

354

355. A painting of a scene from *Chaisangkou*, in the palace collection.

355

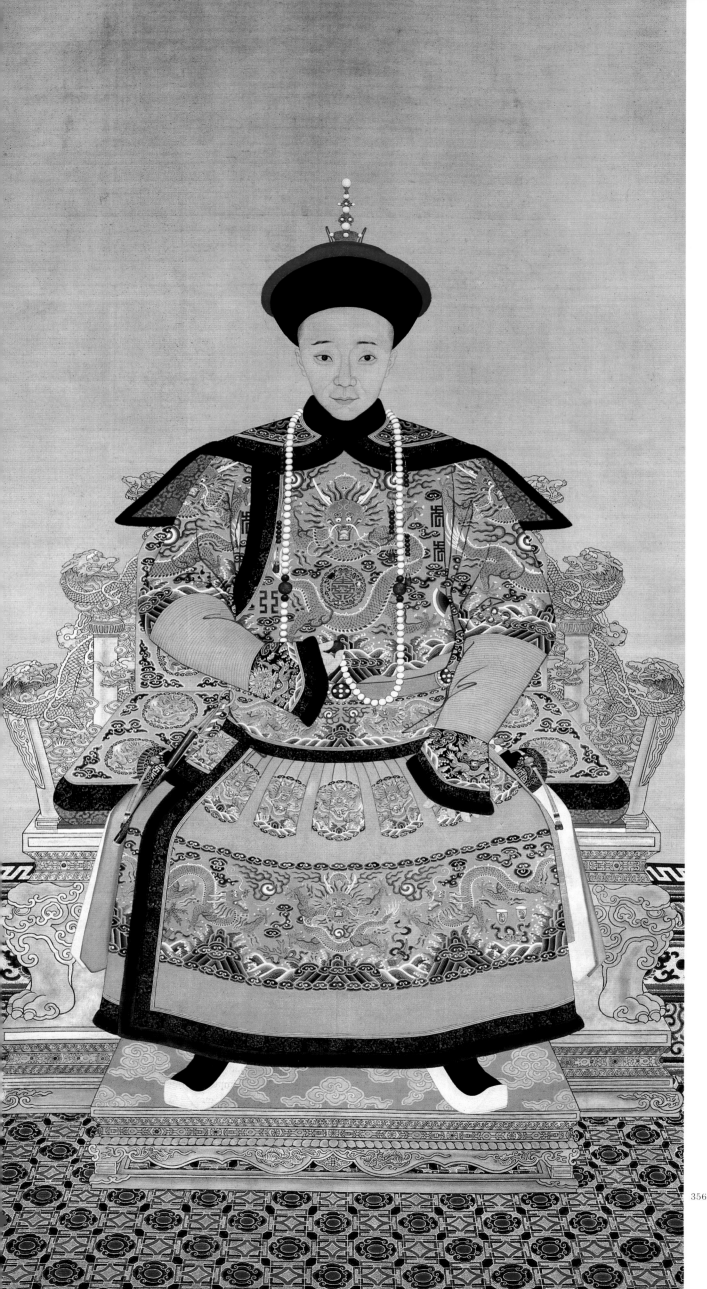

356. A portrait of Xian Feng in court dress. (267 cm × 191.6 cm)

Emperor Xian Feng (personal name, Yizhu) was born in the Hall of Clear Tranquillity in the Garden of Perfection and Brightness in the eleventh year of the Dao Guang period (1831). He was enthroned at the age of twenty and died following an illness in the eleventh year of his reign (1861) in the Hall of Refreshing Mists and Waves at the Summer Palace at Chengde. Emperor Xian Feng was an opera enthusiast.

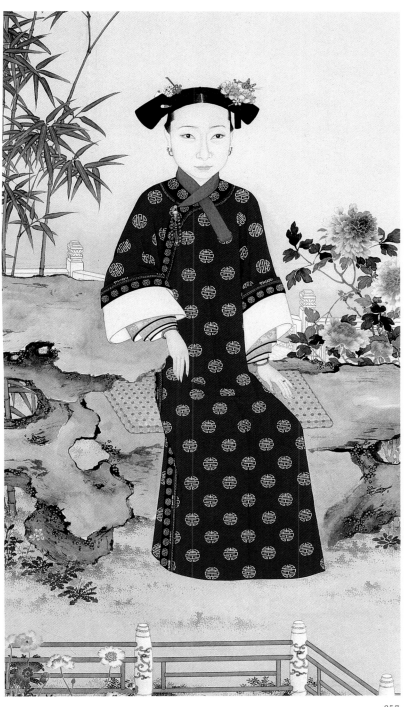

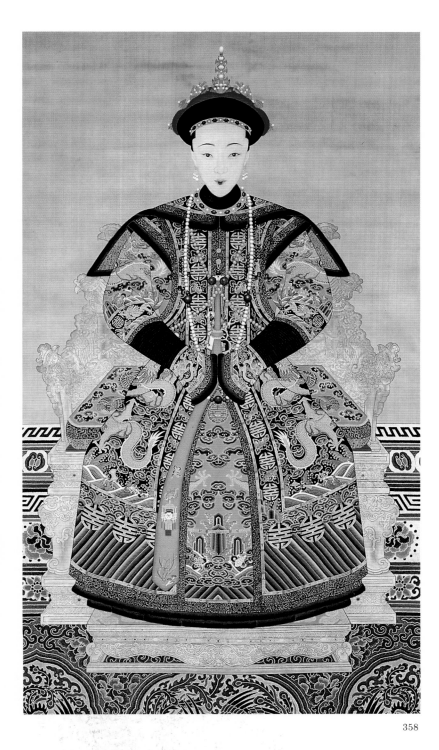

357

358

357. A portrait of Empress Xiao Zhen Xian in informal dress.

Empress Xiao Zhen Xian (named Niuhuru), also called Empress Dowager Ci An, was born in the seventeenth year of the Dao Guang reign (1837). She was granted the title of Consort Zhen in the second lunar month of the second year of Xian Feng's reign (1852) and was promoted to imperial consort in the fifth month and to empress in the tenth month of the same year. She was then only sixteen. When Emperor Tong Zhi succeeded to the throne, she was received as the empress dowager. Later she was honoured with the title Empress Dowager Ci An and, jointly with Empress Dowager Ci Xi, 'held court from behind the screen'. She died in the seventh year of the Guang Xu period (1881) at the age of forty-five.

358. A portrait of Empress Xiao De Xian in court dress. (240 cm × 117 cm)

Empress Xiao De Xian, named Sakeda, was betrothed to the Crown Prince Yizhu (later Emperor Xian Feng) in the twenty-seventh year of the Dao Guang period (1847) and honoured with the title imperial princess. She died two years later. After his accession, Emperor Xian Feng honoured her with the posthumous title of empress. This portrait of Empress Xiao De Xian was painted after her death.

PALACE
CUSTOMS

Palace customs are far too numerous to attempt a discussion of each one individually, but the most common customs fall into one of two categories: seasonal, including annual festivals and festivals relating to the four seasons; and personal, including childbirth, birthdays, weddings and funerals.

Many of the Qing palace customs relating to the seasonal festivals were adopted from those of the Ming dynasty or even earlier, while others were traditional Manchu practices. In this category of seasonal customs the most important were those linked with the New Year, the celebrations for which began at the turn of the twelfth lunar month.

The emperor wrote the first of the *fu* (happiness) characters on the first day of the twelfth lunar month. The first of these 'happiness' characters written by his hand was hung up in the main hall of the Palace of Heavenly Purity and those written thereafter were posted on the walls of the various halls in the Forbidden City or the imperial parks, or were presented to princes, dukes, ministers and academicians of the Inner Court. This custom was initiated in the Kang Xi period, although initially the precise date of writing the first character was not fixed. From the early years of the reign of Qian Long, however, the date was officially designated for the emperor to write the character for 'happiness' in the Study of Fresh Fragrance. It was considered the height of good fortune to be given the *fu* characters in the emperor's calligraphy.

The eighth day of the twelfth lunar month was, and for that matter still is, observed as *Laba* Day – the day on which Sakyamuni is said to have attained Buddha-hood. It was also the day on which, according to historical records, the farmers of the Jin dynasty (265–420) performed rites to prevent epidemics, and when both the ecclesiastical and secular population in the capital in the North Song period cooked and ate a special porridge of fruit and other ingredients. During the Qing period princes, dukes and ministers were sent by the court on that day to the Lamasery of Harmony and Peace to supervise the preparation of the porridge for offering to the Buddha, while in the Forbidden City, lamas would dust the emperor's robes and headgear to 'drive out evil'. The common people also observed this day by eating *Laba* porridge.

The twenty-third day of the twelfth lunar month was the day on which the common people offered sacrifices to the Kitchen God. In the Forbidden City a tablet inscribed to the Kitchen God would be placed in the Hall of Earthly Peace, together with candles, incense sticks and thirty-two offerings. In addition, according to time-honoured tradition, a gazelle was offered, and there was a special offering of malt-sugar donated by the Imperial Household Department at Fengtian (in north-east China, the cradle of the Manchu tribe). Both the emperor and the empress personally attended the ceremony to pay homage to the Kitchen God.

It was customary to post New Year couplets and pictures of the Door Gods in the Imperial Palace on the twenty-sixth day of the twelfth lunar month. These were taken down on the third day of the second lunar month of the following year. The couplets were written on white silk, a practice in contrast to that of the Han-Chinese, who used red paper.

On New Year's Eve and New Year's Day, the emperor and empress were mainly occupied in making offerings of incense to the Buddha and to the imperial ancestors and praying for divine blessings to be bestowed in the new year. Even in the later years of the Qing dynasty, when the empire was hastening towards collapse, this practice was observed as before. The records describe the activities of Emperor Guang Xu on New Year's Eve and New Year's Day in 1907. These activities began with prayers at 4 a.m., the rest of the day being filled with more acts of worship, present-giving and celebrations with other members of the imperial family. He ended the day by watching a theatrical performance.

The fifteenth day of the first lunar month is the *Shangyuan* Festival, when lanterns were hung up all over the Forbidden City and the rest of the city of Beijing. Hence it is also called the Lantern Festival, the origins of which can be traced back to the Han dynasty. In the Qing period the Imperial Palace would be festooned with beautiful lanterns of every description as well as the unique ice lanterns. During the reigns of Qian Long and Jia Qing, the emperors would go to the Lofty Mountains and Long Rivers Hall of the Garden of Perfection and Brightness to watch firework displays. The fifteenth day of the first lunar month was also

called the *Yuanxiao* Festival. On this night it was customary to eat *fuyuanzi* or 'floating balls' (dumplings made of flour and stuffed with sugar, sesame seeds, etc.) for the evening meal. Later these dumplings also became known as *yuanxiao*. On that evening not only the common people but also the emperor, the empress and the imperial concubines ate *fuyuanzi*.

On the Double-Fifth Festival (the fifth day of the fifth lunar month) it was the custom among the Han-Chinese to hold dragon-boat races, to eat *zongzi* (dumplings made with glutinous rice, stuffed with sweet things and wrapped in bamboo or reed leaves), put mugwort leaves on the doors and drink special wine which was supposed to be proof against poison and plague. The Manchus assimilated these customs after they crossed the Great Wall. In the early Qing period the emperor often entertained his ministers on pleasure boats in the Western Park. The Emperor Qian Long used to have breakfast with his mother, Empress Dowager Chong Qing, in the Hall of Universal Peace in the western part of the Garden of Perfection and Brightness and then they went together to the Jade Terrace on Fairy Islet to watch the dragon-boat race. At their meals from the first to the fifth day of the fifth month the emperor and the court ladies were served *zongzi* dumplings. These were also used as sacrificial offerings to the gods and the imperial ancestors.

The Double-Ninth Night, according to folk legend, was the one night a year on which the Herdsman (Aquila) was reunited with his beloved Weaving Maid (Vega) who was able to cross the Milky Way on a bridge of magpies. On that day the women of the Northern and Southern dynasties are described in contemporary records as decorating their chambers with flowers, holding needlework competitions where they threaded coloured silks into the eyes of seven needles, and displaying melons and other fruits in their courtyards to persuade the Weaving Maid to endow them with nimble fingers. The Qing palace regulations stipulated that forty-nine offerings were to be placed in the imperial gardens as sacrifices to the Herdsman and the Weaving Maid, and that the emperor and empress should move the memorial tablets of the ancestors into the imperial gardens for worship. In the Dao Guang period this took place at the Beautiful West Peak in the Garden of Perfection and Brightness. In the late Qing, the ceremony was conducted in the Purple Light Pavilion in the Western Park. The sacrifices were offered amidst the chanting of Buddhist sutras by four voices, ten people playing instruments and the presentation of plays such as *Seven Movements of Vega* and *Girls Beg for Nimble Fingers*.

The Mid-Autumn Festival was an important folk festival, to celebrate which mooncakes were prepared in the Imperial Palace on that night as offerings to the moon. In the Jin dynasty a jade hare was believed to be pounding the elixir of life on the moon, and so the common people also paid homage to paintings or clay sculptures of hares when offering sacrifices to the moon. Such paintings and sculptures have also been found in the Qing palace.

The Qing palace also adopted the Han-Chinese custom of ascending heights on the Double-Ninth Day (the ninth day of the ninth lunar month), allegedly to avert disasters. On that day, if the emperor was in Beijing he ascended the Fragrant Hills, but if he was out of the capital on one of his autumn hunting expeditions he merely roamed about the mountains of Mulan on horseback.

Childbirth was an important event in the Qing palace. The archives contain descriptions of the birth of the Emperor Tong Zhi to Concubine Yi (later Empress Dowager Ci Xi). Prior to her confinement her mother had been granted permission to stay with her. Two months before the birth a 'pit of happiness' was dug outside the east gate to the chamber of the rear hall of the Palace of Concentrated Beauty. The 'Song of Happiness' was sung and chopsticks (pronounced *kuaizi*, similar to *kuai sheng zi*, meaning 'bearing a son soon') and treasures were set out in splendid array. When her time was near, a broad sword was brought out and hung as a protection against evil, and an 'easy labour stone' was brought in. Shortly after Tong Zhi was born, the imperial physician examined him, opened his mouth and slipped a 'Happiness and Longevity Pill' into it. The baby received many gifts on such occasions as *xi nan* (bathing the baby on the third day after his birth), *shengyaoche* (his first day in the

cradle), *xiao manyue* (twelve days old), *manyue* (one month old), *bai lu* ('one hundred gifts', implying 'one hundred days old'; the term *bai ri* or 'one hundred days' was avoided because it could mean 'offering sacrifices to the dead one hundred days after death') and *zhousui* (first birthday).

On the first birthday the baby was given a test. This custom, known as *zuipan*, is recorded as far back as the Northern and Southern dynasties. Many different objects were placed on a tray to see which ones the baby grabbed first. From this it was inferred whether the child would grow up to be avaricious or incorruptible, intelligent or stupid.

The birthday of the emperor was listed as one of the three major festivals of the Qing court, especially the decade anniversaries, the celebration of which usually spread nationwide. When the Emperor Kang Xi celebrated his sixtieth birthday, the line of persons waiting to pay their respects extended from the Hall of Supreme Harmony all the way to the Gate of Heavenly Peace and beyond. Provincial officials who were unable to go to the capital went to chosen local sites to pay their respects, and erected stages to put on operas and built special shrines where Buddhist sutras were chanted – all in order to express the wishes for the emperor's happiness and longevity. In contrast, the birthdays of low-ranking imperial concubines were celebrated with a minimum of fuss.

It was the custom for the princes, dukes and ministers to offer tribute and auspicious *ruyi* sceptres to the emperor or the empress dowager on the occasions of their birthdays. The birthday gifts were divided into categories, each consisting of nine items. These included images of Amitabha – the Buddha who presides over the Western Paradise (and is associated with longevity) – articles made of gold and jade, jewellery, ornaments, paintings and calligraphy. Birthdays, therefore, offered the emperors a splendid opportunity for amassing wealth. On the Emperor Qian Long's eightieth birthday, the seven-mile road from the Garden of Perfection and Brightness to the West Flowery Gate was adorned on either side with decorative arches and other structures. On the previous day, when he returned from the garden to the palace, the procession was preceded and followed by the Guard of Honour and musicians waving streamers and banners and playing their instruments as they passed officials, soldiers and common people kneeling by the roadside to pay their respects to the emperor. It was a very impressive display. On the birthday itself, Emperor Qian Long first accepted congratulations of dignitaries in the Hall of Supreme Harmony, and then went to the Palace of Heavenly Purity to receive congratulations from the members of the Qing house. During the course of the banquet that followed, the imperial sons, grandsons, great-grandsons and great-great-grandsons, all dressed in their most festive clothes, took turns dancing and toasting the emperor.

In relation to marriage celebrations, the Qing palace inherited many of the customs of the Ming palace after they occupied Beijing. By the Qing dynasty, the ruling house had reduced the entire system to the procedures for presenting betrothal gifts, making wedding arrangements, collecting the bride from her home, drinking the nuptial cup, and the bride paying her respects to the empress dowager. These all involved elaborate formalities and fabulous expenditure, and applied only to the empress – not to imperial concubines of any rank.

A princess's wedding was a rather more simple occasion than that of an emperor. Initially, the would-be husband (*efu*) would send ahead a betrothal gift of nine items. (This was originally made up of one camel and eight horses, but it was later changed to nine sheep.) The emperor then gave a banquet in the Hall of Preserving Harmony in honour of the *efu* and those of his male family members who held any official posts. Meanwhile, the empress held a separate banquet in honour of the female members of his family. The day before the wedding, the *efu* brought his clansmen to pay their respects outside the Gate of Heavenly Purity, while officials of the Imperial Household Department took the princess's dowry to the bridegroom's home. On the wedding-day, before the ceremony, the bridegroom was expected to deliver eighty-one wedding gifts to the Meridian Gate. After the wedding banquet the bride rode in a sedan-chair to the home of her new husband for the ceremony of

drinking the nuptial cup. Nine days later the bride returned to the palace to thank the emperor for the favour shown to her. It was required that all the women who were involved with the wedding should have horoscopes with mutual affinities.

The funerary customs of the Qing imperial family were also influenced by the Han-Chinese, and the customs that prevailed in the earlier period underwent changes in later times. In the early period, when Nurhachi died, the funeral arrangements were relatively simple, since the Manchus were at that time still at war with the Ming empire. Even under those circumstances, however, three more people were required to die and were cremated with him (*xun zang*). During the funeral, music was played – a practice similar to the Han-Chinese custom of 'making a funeral a festive occasion'. Later the playing of music at Qing court funerals was abandoned.

The custom of *xun zang* was still observed after the Manchus had crossed the Great Wall. This was also followed by the common people of the time, with a wife or concubine being made to accompany her deceased husband to the grave, or a servant his or her deceased master. The practice became steadily less popular, however, in the Kang Xi period, during which no such occurrences are reported in the Imperial Palace. The early Qing practice of *xun zang* was similar to that observed in the early Ming period, when it was followed at the funerals of four emperors. *Xun zang* was, however, abolished in Ming times during the reign of Emperor Ying Zong (Zhu Qizhen), more than two hundred years before the Qing dynasty.

By the Qian Long period, under the increasing influence of Han-Chinese culture, the funerary customs of the Imperial Palace had become considerably ritualized. The funeral of an emperor was divided into a number of stages. These included placing the remains of the deceased emperor in his coffin; proclaiming his deathbed edict; performing libations; moving the coffin to the funeral palace; the initial sacrificial offering; the major sacrificial offering; the sacrificial offerings in the first month of the emperor's death; honouring him with a posthumous title; and the sacrificial offering on the hundredth day after his death. Prescribed rituals were performed at each stage of the funeral proceedings up to the interment of the coffin in the underground palace. Immediately following the death of an emperor, for instance, his successor and the princes, dukes and ministers were required to remove their headcoverings and to stamp their feet and wail. The empress and imperial concubines were expected to take off their earrings and other jewellery. While the deceased emperor was dressed in his grave clothes and placed in his coffin the new emperor had to stamp his feet and cry out. He and the deceased emperor's other sons and grandsons then had to change into white mourning-garments and cut off their queues. The empress, imperial concubines and other ladies of the Imperial Palace also had to don white mourning-garments and cut their hair short. The princes, dukes, civil and military officials, members of the imperial house and officials of the Imperial Household Department and the female members of their families also had to wear white garments and forgo jewellery. During the first hundred days after the emperor's death, when the new emperor issued a decree, he had to write in blue ink. After one hundred days he was still expected to go about in white for twenty-seven months, at which time a ceremony was held to mark the end of the mourning period.

Many of the funerary rites in the Qian Long period were inherited from the Han-Chinese customs of the Ming dynasty, but a number of the Manchu practices were retained, including the removal of headcoverings and cutting off men's queues and women's hair. The ceremonial burning of the garments of the deceased was also a practice foreign to the Han-Chinese.

Perhaps the most significant change in the funerary customs of the Qing house was the move away from the Manchu practice of cremation (as followed in the cases of Abahai and Shun Zhi) to the Han-Chinese practice of burial from the Kang Xi period onwards. In 1735, Qian Long explicitly banned cremation among the Manchus.

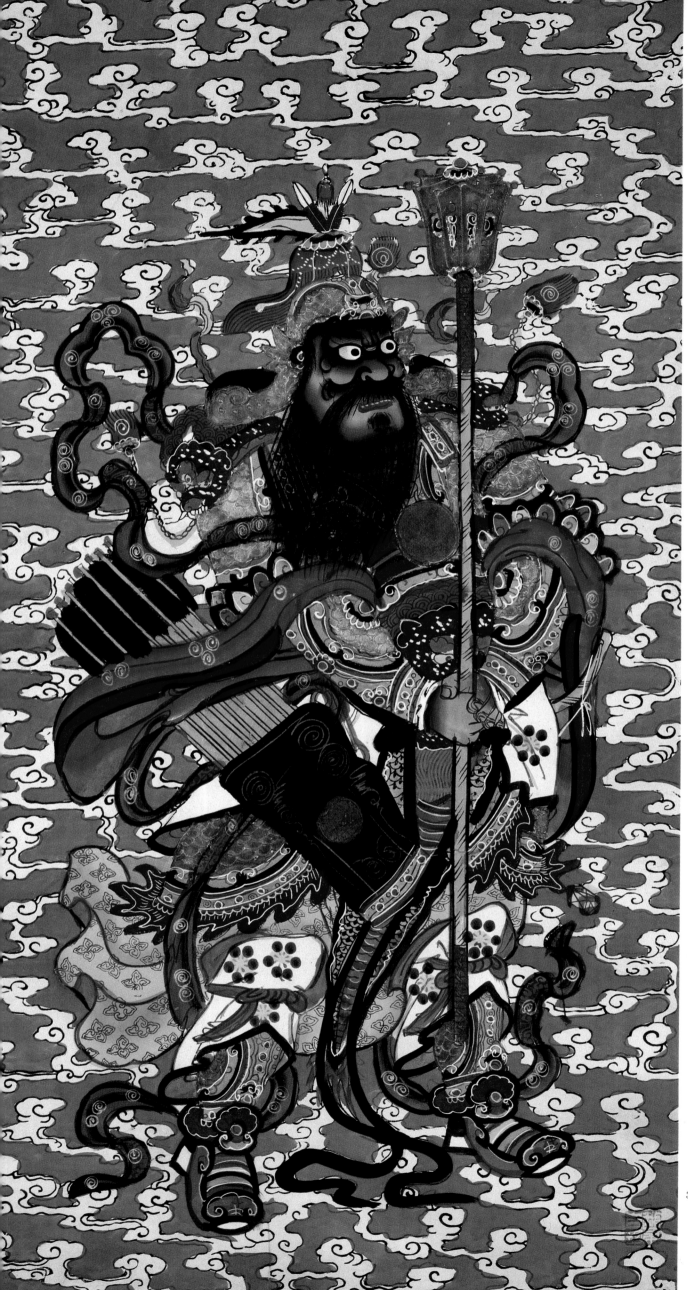

359. A Door God.

Pictures of Door Gods in the Imperial
Palace were painted on silk and moun-
ted to be hung and preserved. Accord-
ing to ancient Chinese legend, the
Door Gods, named Shen Tu and Yi Lei,
looked ferocious and offered protec-
tion against evil spirits. Post-Tang-
dynasty legend relates that once when
Emperor Tai Zong of the Tang dynasty
fell ill and heard the cries of ghosts
outside the door, he ordered two
renowned generals, Qin Shubao and
Yuchi Jingde, to stand guard in full
battle dress outside his room. The rest
of the night then passed uneventfully.
The following day the emperor
ordered a painter to draw the images of
both these men and they were hung on
the palace entrance to keep the evil
spirits away. The Door Gods in the
Qing palace were obviously inspired
by this legend. The example shown
here depicts Yuchi Jingde.

359

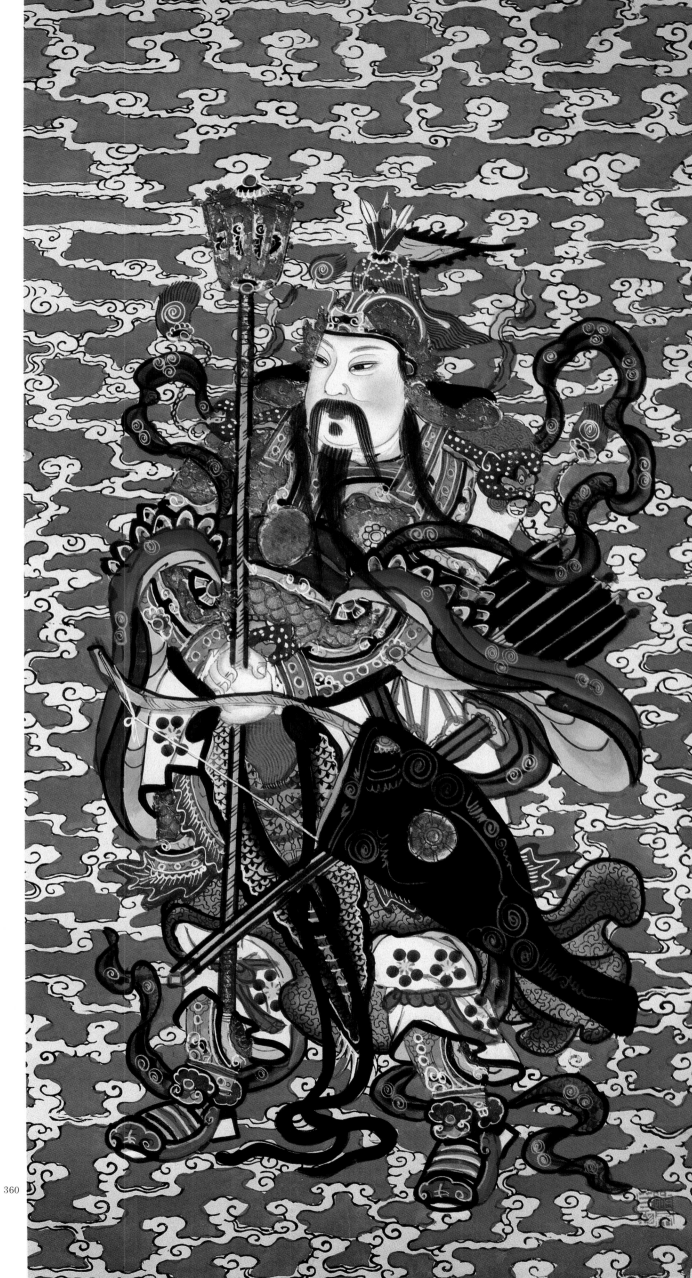

360. A Door God.

This painting depicts Qin Shubao.

360

361

362

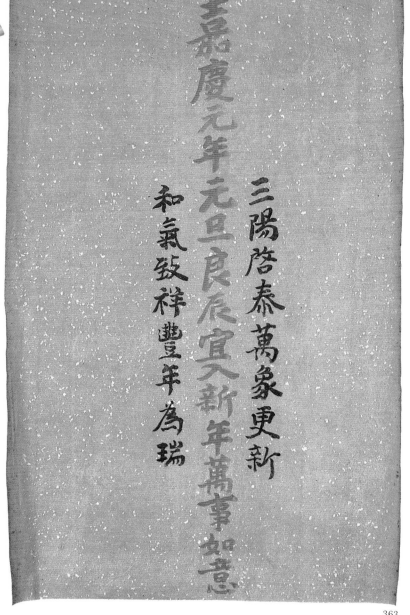

361. The character *fu* (happiness), in the calligraphy of one of the emperors.

In the twelfth lunar month of every year following the Kang Xi era, the Qing emperors wrote the characters *fu* (happiness) and *shou* (longevity) and gave them to the empress, imperial concubines, close attendants and ministers, as an expression of especial favour.

362. An 'evergreen' writing brush.

This brush was for the exclusive use of the emperor when writing auspicious characters on New Year's Day.

363. Auspicious characters in the calligraphy of Emperor Jia Qing.

Before dawn on New Year's Day, the emperor arose, washed his face, made an offering of incense and poured *tusu* wine. He then opened the writing brush and wrote several lines of auspicious characters in red and black ink as a prayer for good luck in the New Year.

363

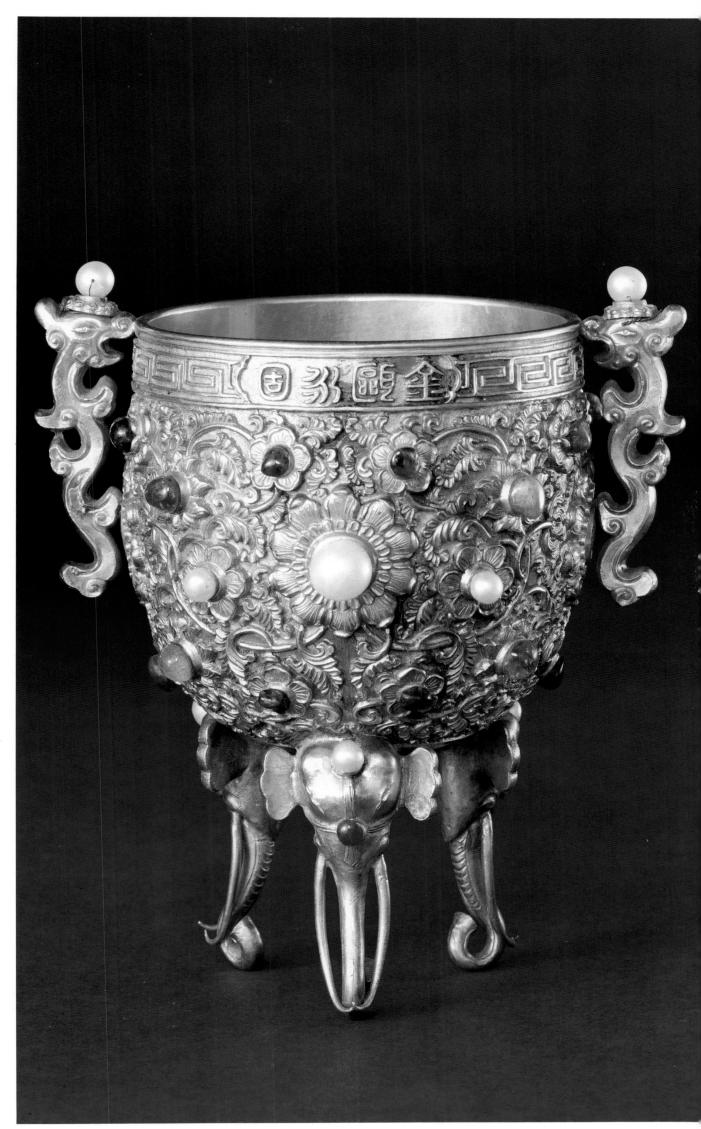

364. *Jin'ouyonggu* cup. (12.5 cm high, 8 cm at mouth, stem, 5 cm high)

This cup is made of gold and inlaid with pearls and precious stones. Before the emperor opened the writing brush, he poured *tusu* wine (a wine drunk on New Year's Day, apparently as a protection against pestilence) into the cup and prayed for safety, health and lasting rule.

364

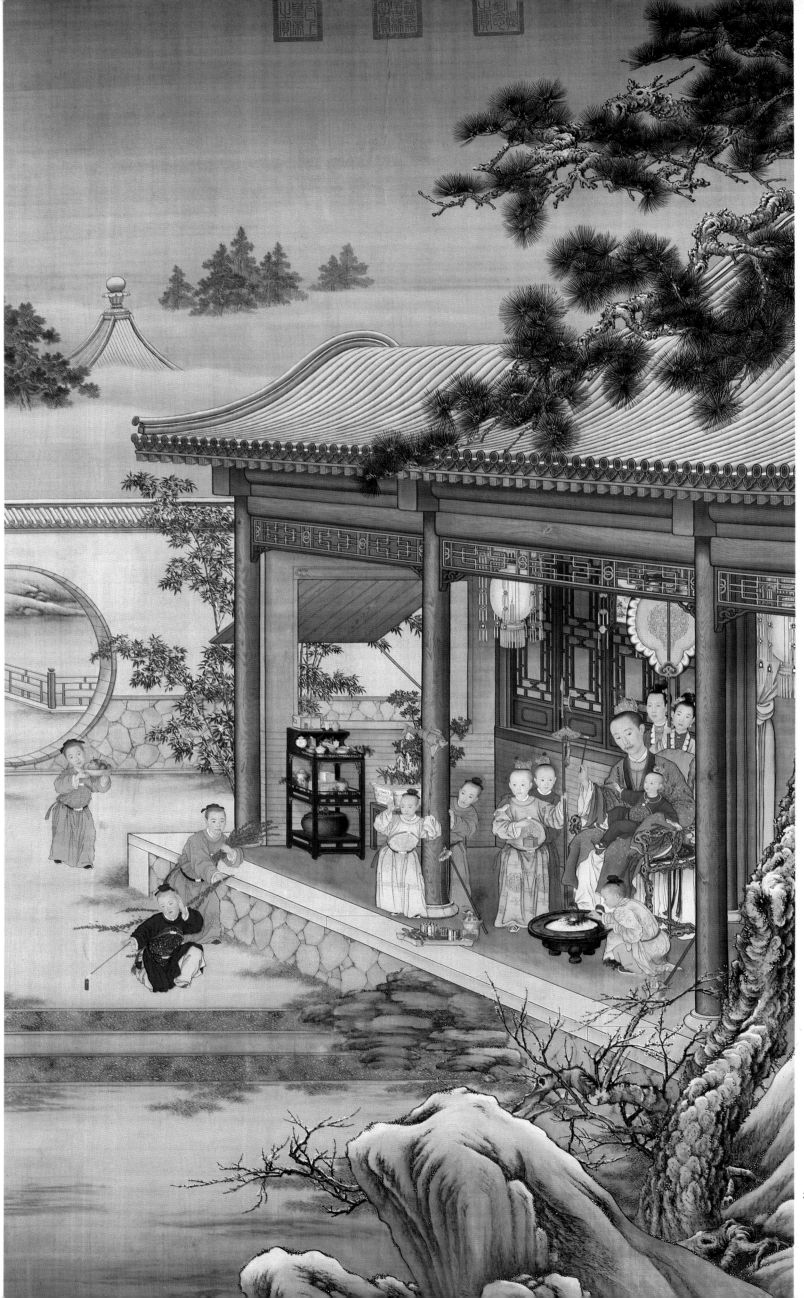

365. *Qian Long at Leisure on New Year's Eve*. (384 cm × 160.3 cm)

This painting, done in the mid-Qian Long period, depicts the emperor and his sons and grandsons, all dressed in Han-Chinese style, informally celebrating New Year's Eve. Qian Long is striking a musical stone (*qing*, which is a homophone of the character for 'felicity') which is hung on a halberd (*ji*, which is a homophone of the character for 'auspiciousness') over two fish (*yu*, which is a homophone of

the character for 'plentifulness'). One of the boys is setting off firecrackers, another is scattering sesame stalks (for seeing out the old year) and a third is offering a plate of fruit. The roof of the building is covered with snow, which supposedly portends a bountiful year. Qian Long appears to have been very fond of this painting, for even after he abdicated in favour of his son, he still admired it, and it bears the impression of the 'Seal of the Emperor's Father'.

366

367

366. An ornate gold *ruyi* sceptre inlaid with turquoise characters.

This sceptre was made in the Qian Long period. The Palace Museum has in its collection many such sceptres, which are identical in shape but bear different cyclical dates – shown by combinations of the Heavenly Stems and Earthly Branches. These were presumably made every New Year and inscribed according to this traditional method of designating the years.

367. A 'spring folder', presented by Yixin and Bao Liu.

The practice of presenting 'spring folders' to the emperor, empress or empress dowager on *Lichun* (Spring Begins) Day or other festive days, was popular in the Song dynasty and carried on into the Qing period. The customary procedure was for the grand ministers jointly to present one folder and the academicians of the Southern Study jointly to present another. Illustrated here is the 'spring folder' presented by Prince Gong (Yixin) and Grand Secretary Bao Liu while they were members of the Grand Council.

241

368. A spring scroll.

The four characters, *bai fu pian zhen*, mean 'felicities of all kinds come simultaneously'. Originally, the spring couplets were written on white according to Manchu custom, but later, under the influence of the Han-Chinese, red paper was used as a symbol of auspiciousness.

369. Auspicious paper slips applied to a picture made of gold and semi-precious stones.

These slips were put up all over the palace during the New Year festivities, presumably to add to the auspicious air of the occasion.

370. The 'Five Poisonous Creatures' embroidered on a pouch to wear for the Dragon-Boat Festival.

On the occasion of the Dragon-Boat Festival the Qing palace also followed the time-honoured custom of wearing rice dumplings, garlic, tigers or the 'Five Poisonous Creatures' (snake, toad, lizard, scorpion and centipede) – all made of cloth – as a protection against poison.

371. The other side of the 'Five Poisonous Creatures' pouch.

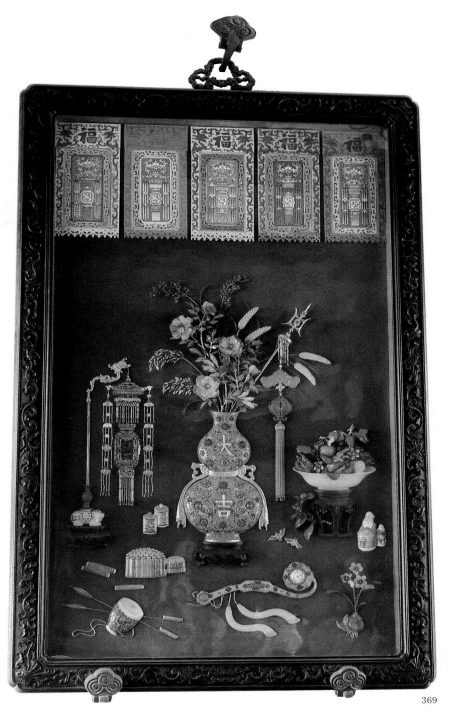

368

369

370

371

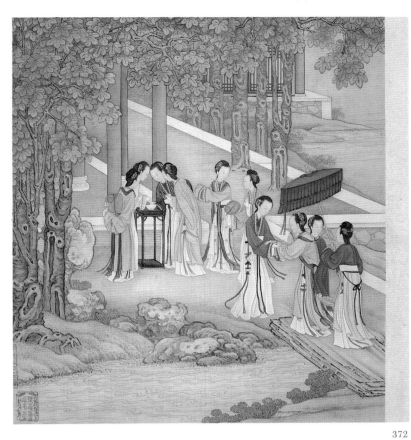

372

372. The painting *Begging for Nimble Fingers* in *Yuemanqing Youce*. (a silk painting in the twelve-part pictorial album, 37 cm × 31.7 cm)

On Double-Seventh Night, it was the custom to worship images of the Herdsman and the Weaving Maid and to pray for nimble fingers. Needlework contests were held, for putting coloured threads into the eyes of seven needles. This painting, by the court-artist Chen Mei around the time of the Emperor Yong Zheng, bears a poem written on it by Liang Shizheng in the third year of Qian Long's reign (1738). It reflects the popularity of the practice of praying for nimble fingers in the Qing palace.

373. The poem on the painting *Begging for Nimble Fingers*.

373

374. Old Man Hare.

The images of hares which were worshipped during the Mid-Autumn Festival were based on the Jin-dynasty (254–420) legend that there was a jade hare pounding the elixir of life on the moon. Some of the images were painted on paper and burnt the same night while others, fashioned from clay, were kept as ornaments. This particular clay example is a relic of the Qing palace.

374

375

376

375. An almanac of the Shun Zhi period.

Researching and compiling the almanac was the responsibility of the Board of Astronomy. Every year on the first day of the second lunar month, a sample almanac for the following year was submitted to the emperor for examination. After his approval, it was printed in book form. Following a ceremony, it was then issued for use by the whole nation. It contained detailed data of the *da yue* (solar month of thirty-one days), the *xiao yue* (solar month of thirty days) and the auspicious days and hours.

376. 'Dispelling the Cold in the Nine Periods of Nine Days'.

According to Han-dynasty custom, the Winter Solstice started the period of eighty-one days which was the coldest season of the year. In the Qing dynasty, Emperor Dao Guang once wrote nine characters, shown here, which may be translated as, 'The weeping willows in front of the pavilion take care of themselves in waiting for the caress of the spring breeze.' Each of the nine characters consisted of nine strokes, totalling eighty-one strokes, and he filled in one stroke in red ink each day. By the time all nine characters were filled in, spring had already arrived. Hence the name was 'Spring Fills the Writing Brush'.

377. A Kitchen God memorial tablet.

377

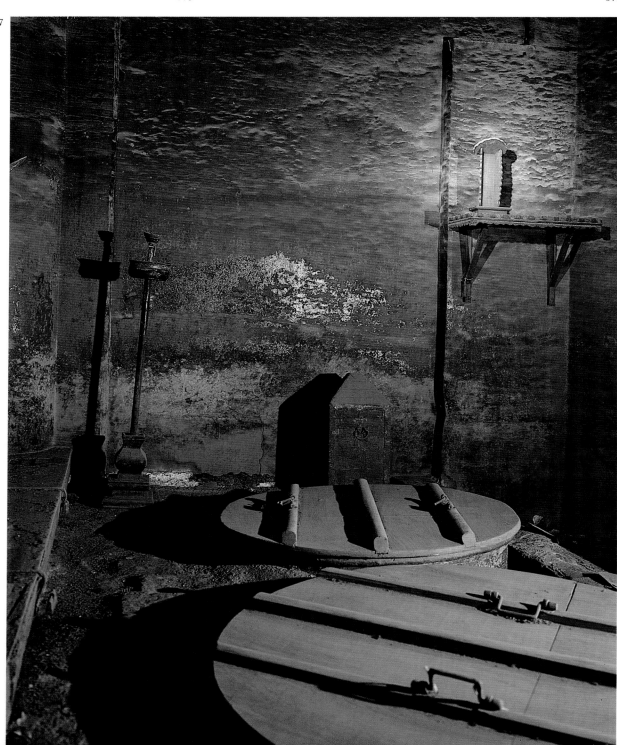

244

378

379

378. *Records of Consort Yi in Childbirth.*

This is the original record of Concubine Yi's (Empress Dowager Ci Xi) giving birth to Emperor Tong Zhi. It is now in the collection of the Palace Museum.

The cover is a fair copy, which refers to Concubine Yi as Consort Yi, since she had been rapidly promoted from concubine to consort after giving birth to an imperial son.

379. A page from *Records of Consort Yi in Childbirth.*

This page notes, in minute detail, the condition of Tong Zhi immediately after his birth.

380. Toys.

These are traditional toys of various kinds. They are made of clay or cloth and some are fitted with springs. They were used by imperial sons, imperial grandsons or child emperors. The two lions on the left have been made from copper coins of various periods.

380

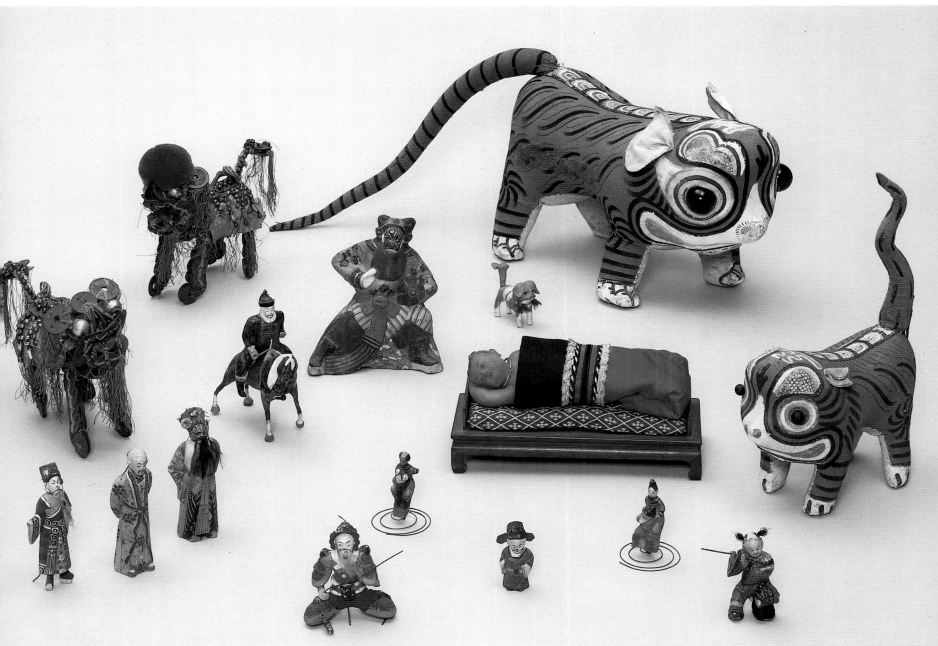

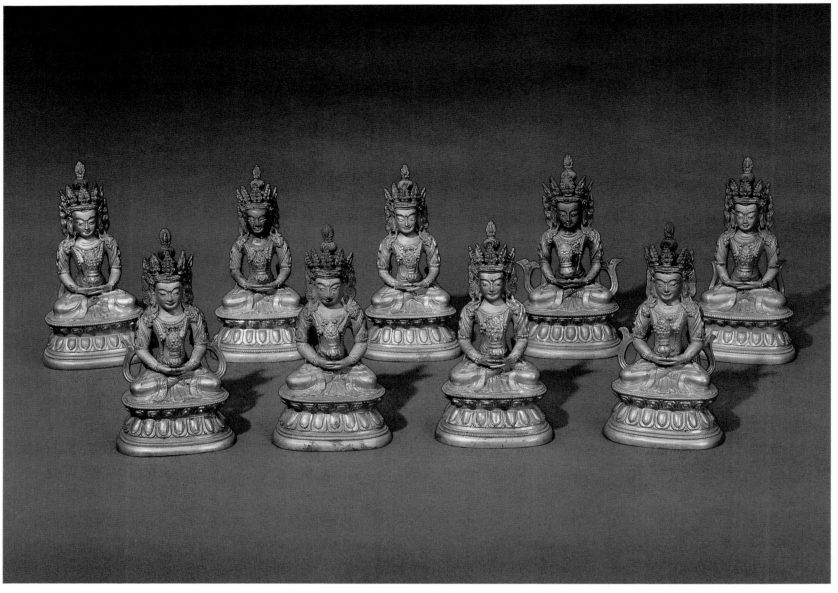

381

381. Gold Buddha figures.

Gold Buddha figures were important items among birthday presents in the Qing palace. They were always presented in groups of nine because nine was considered the highest positive number in the imperial palace.

382. A gold *ruyi* sceptre.

It was customary in the Qing palace for ministers to present *ruyi* sceptres to the emperor at the New Year, on imperial birthdays and on other occasions. This one, inscribed with the characters for longevity, was a birthday present.

382

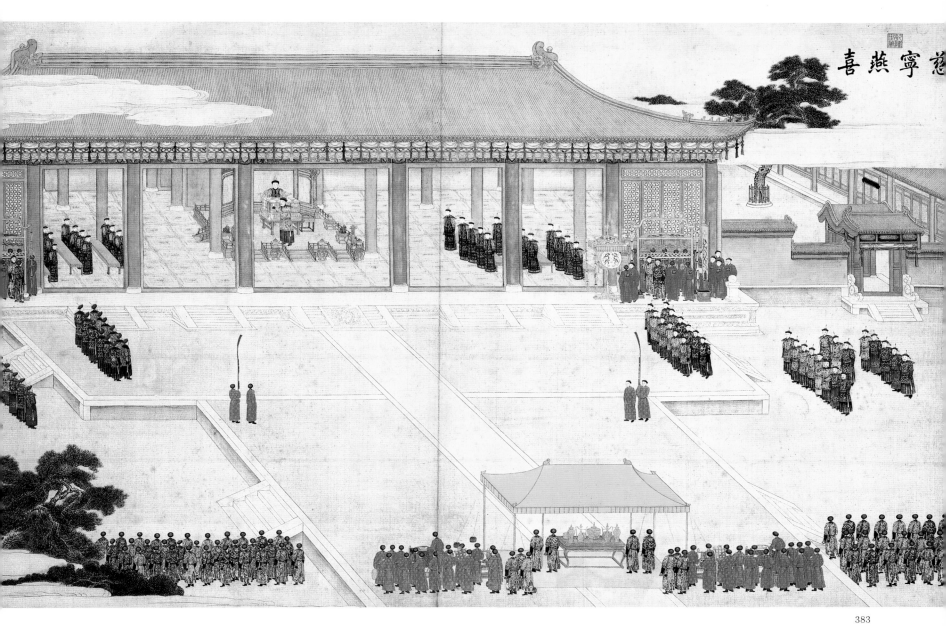

慈寧燕喜

383

383. *Birthday Celebrations in the Palace of Benevolent Peace.* (detail)

This large-scale scroll-painting by court artists depicts the celebrations held by Emperor Qian Long in honour of his mother, Empress Dowager Chong Qing. The empress dowager is seated on the throne and the man in front of her holding a cup in both hands is the emperor. The table in front of her is piled with all kinds of delicacies.

384. *Birthday Celebrations in the Palace of Benevolent Peace.* (detail)

This enlarged detail shows Emperor Qian Long toasting his mother at the birthday banquet in the Palace of Benevolent Peace.

384

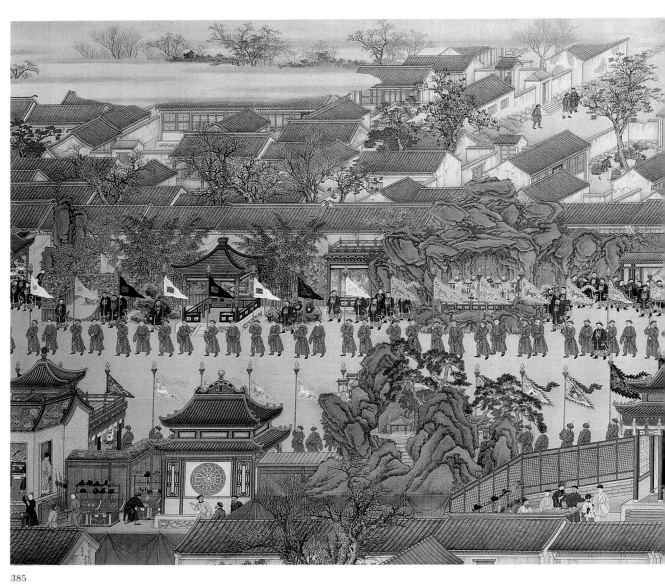

385

385. *Picturesque Scenes in Celebration of the Birthday of Empress Dowager Chong Qing.* (detail, 65 cm × 2778 cm)

When Emperor Qian Long celebrated the sixtieth birthday of his mother, Empress Dowager Chong Qing, there was much colourful pageantry along the route from the Garden of Clear Ripples to the West Flowery Gate. The painting was executed from memory, after the event. This section of the painting shows the scenes between Xinjiekou and Xisi.

386. *Picturesque Scenes in Celebration of the Birthday of Empress Dowager Chong Qing.* (detail)

Illustrated here is the section depicting the gold sedan-chair carrying the empress dowager, as well as her retinue of officials.

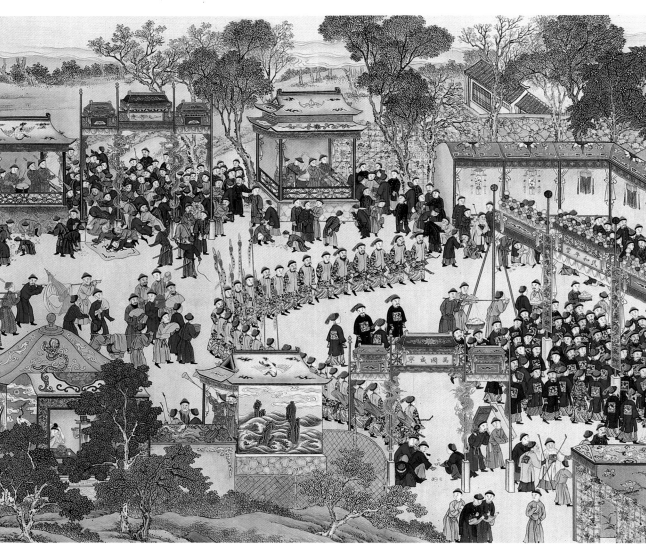

386

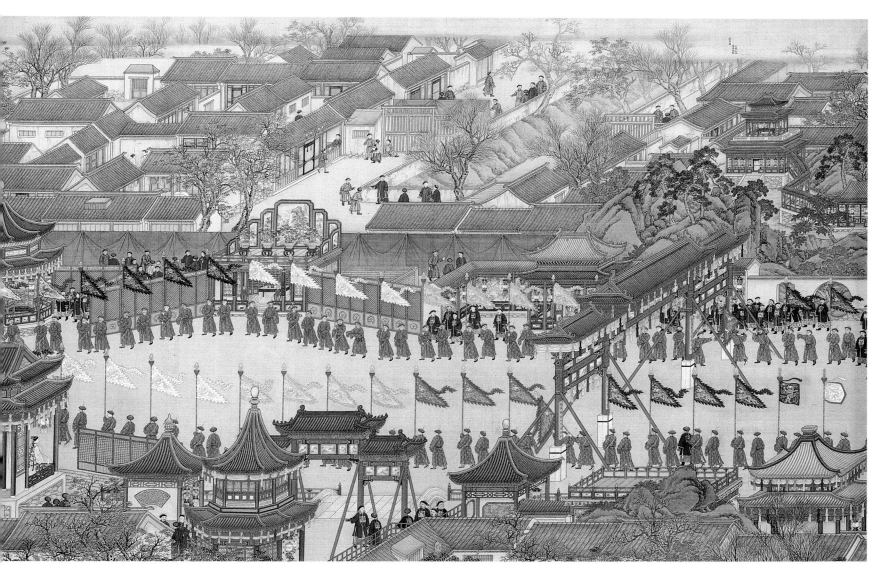

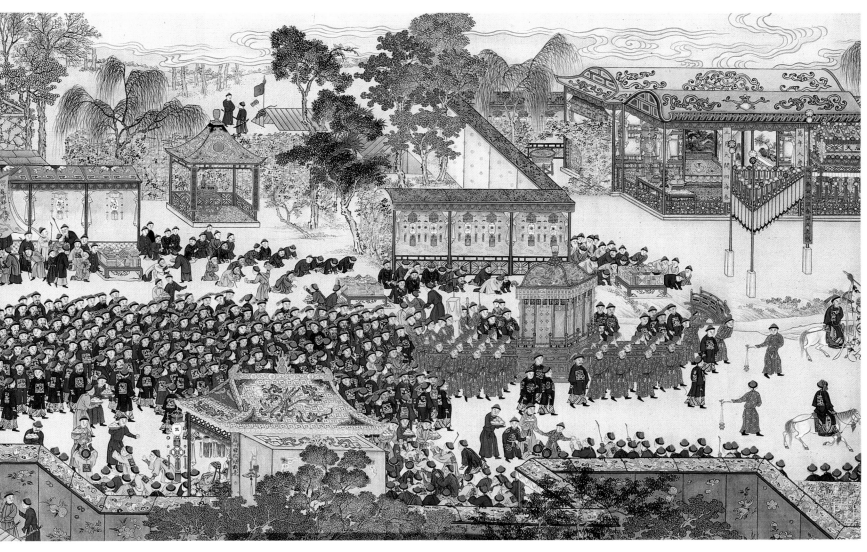

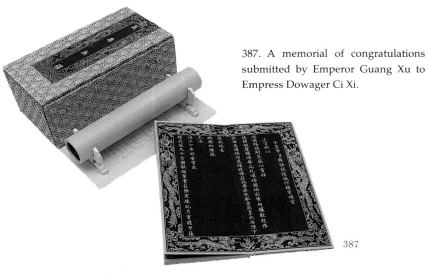

387. A memorial of congratulations submitted by Emperor Guang Xu to Empress Dowager Ci Xi.

387

388. A set of *Yuanyin Shoudie* seals.

The Grand Secretary, He Kun, presented a set of 120 *shoushan* stone seals to Emperor Qian Long in celebration of his eightieth birthday. These seals, called *Yuanyin Shoudie* (God of Perfection and Longevity), bear inscriptions of auspicious phrases taken from the emperor's poems and essays.

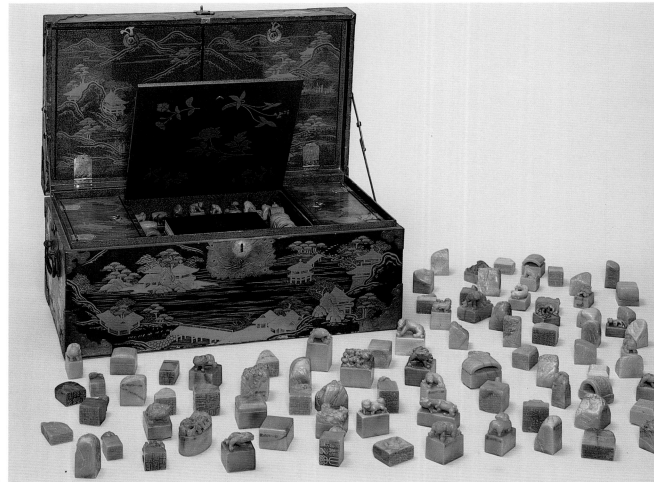

388

389. Impressions of the *Yuanyin Shoudie* seals.

389

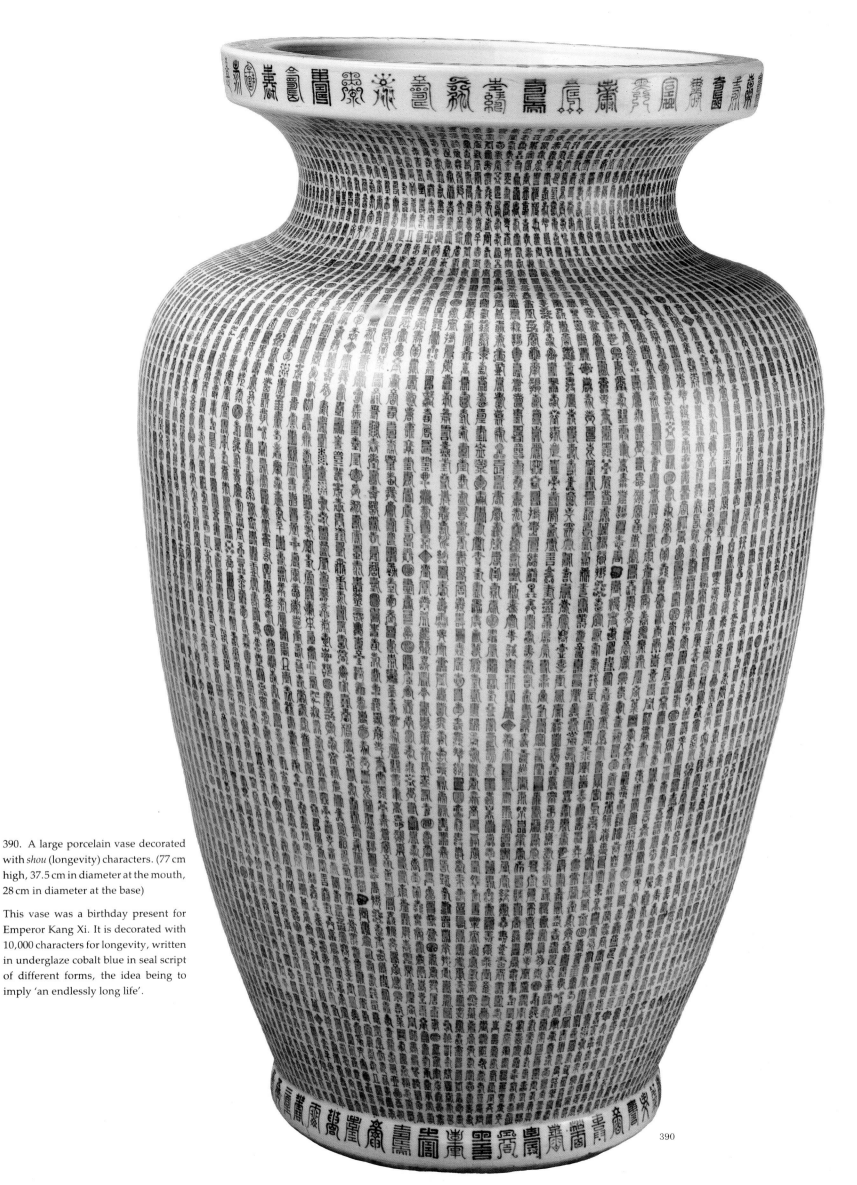

390. A large porcelain vase decorated with *shou* (longevity) characters. (77 cm high, 37.5 cm in diameter at the mouth, 28 cm in diameter at the base)

This vase was a birthday present for Emperor Kang Xi. It is decorated with 10,000 characters for longevity, written in underglaze cobalt blue in seal script of different forms, the idea being to imply 'an endlessly long life'.

390

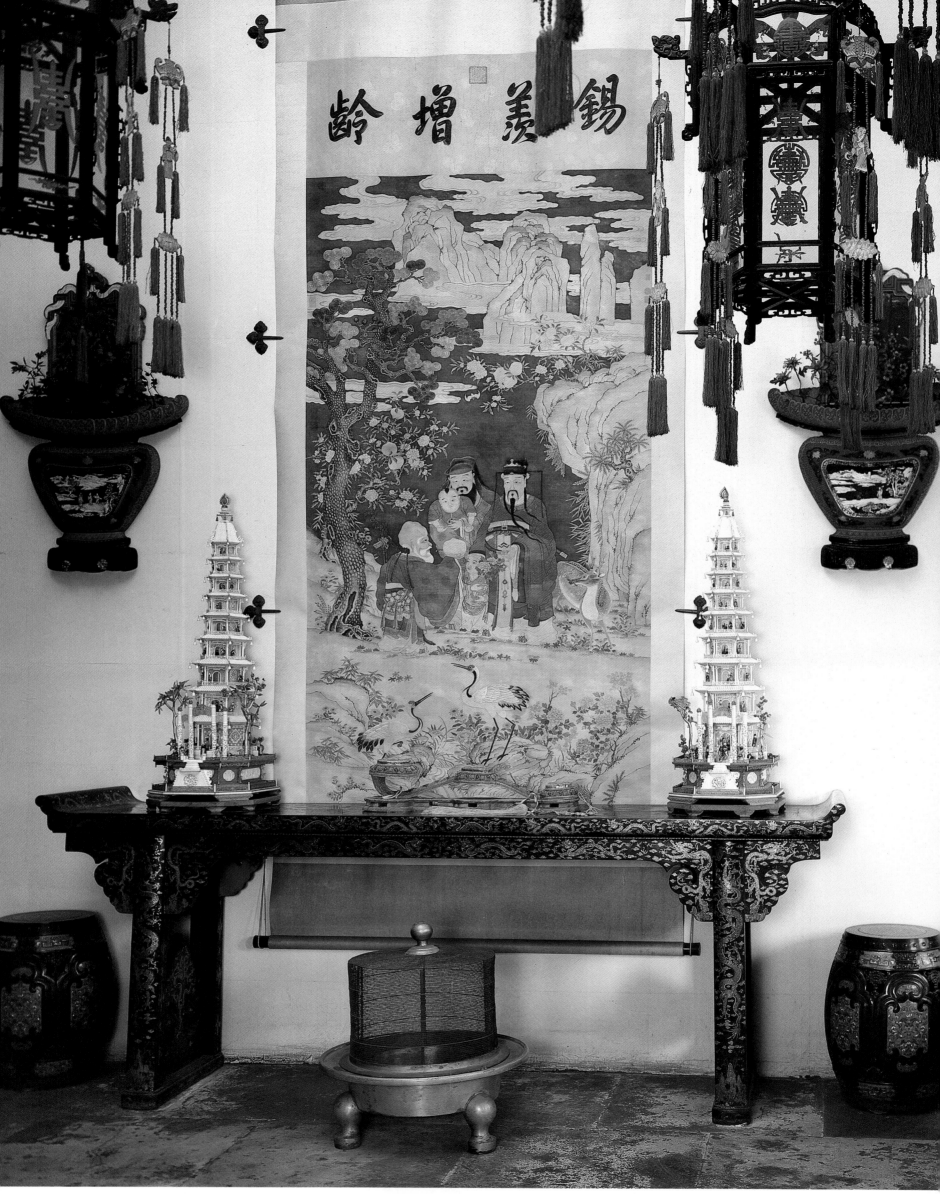

392

391. *The Three Star Gods of Happiness, Riches and Longevity*.

The scroll in silk and gold thread bears at the top an inscription of auspicious characters written by Emperor Qian Long. The tenor of it is: 'May the gods grant abundance and longevity.'

392. An imperial birthday tribute inventory. (1)

393. An imperial birthday tribute inventory. (2)

These inventories, submitted by princes and ministers together with their birthday presents for the emperor, list the name, materials and number of the gifts. The cover of the first inventory is inscribed with characters meaning 'ten thousand years of longevity without end', the second 'ten thousand years of longevity'.

393

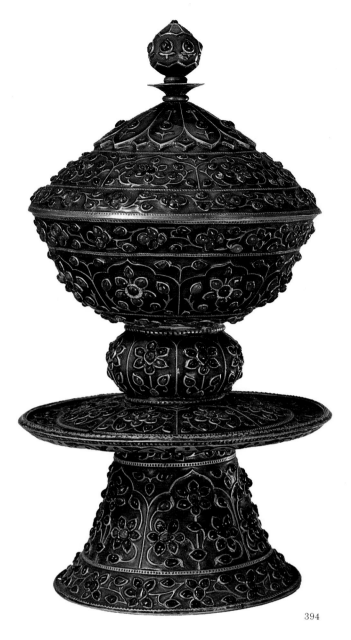

394

395

394. A gold-lidded vessel decorated in green enamel and inlaid with rubies.

This is a copy made by the palace workshops in the Qian Long period. The original vessel was presented by the Tibetan Panchen Lama to Emperor Qian Long in celebration of his seventieth birthday.

395. 'The Saddharmapundarika Sutra' in the emperor's calligraphy.

The text of the sutra, a birthday present for the empress dowager, was written in a putty-like substance containing gold powder. Several hundred years later, it is still as lustrous as the day it was written.

396. The text of the 'Saddharmapundarika Sutra', with an illustration.

妙法蓮華経卷第一

姚秦三藏法師鳩摩羅什奉 詔譯

序品第一

如是我聞一時佛住王舍城耆闍崛山中與
大比丘眾萬二千人俱皆是阿羅漢諸漏已
盡無復煩惱逮得己利盡諸有結心得自在
其名曰阿若憍陳如摩訶迦葉優樓頻螺迦
葉伽耶迦葉那提迦葉舍利弗大目揵連摩
訶迦旃延阿㝹樓馱劫賓那憍梵波提離婆
多畢陵伽婆蹉薄拘羅摩訶拘絺羅難陀孫
陀羅難陀富樓那彌多羅尼子須菩提阿難
羅睺羅如是眾所知識大阿羅漢等復有學
無學二千人俱摩訶波闍波提比丘尼與眷屬
六千人俱羅睺羅母耶輸陀羅比丘尼亦與
眷屬俱菩薩摩訶薩八萬人皆於阿耨多羅
三藐三菩提不退轉皆得陀羅尼樂說辯才

396

397. A table napkin.

This napkin, used at the wedding of Emperor Guang Xu, is embroidered with designs of dragons and phoenixes and the character for double happiness, as well as symbols of longevity and happiness and the eight Buddhist symbols.

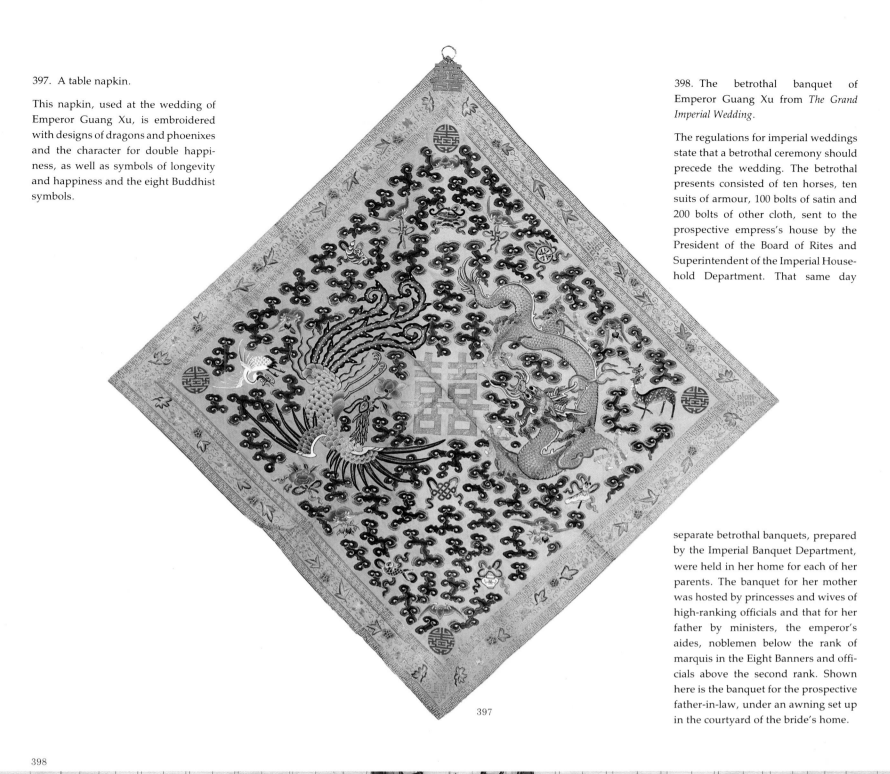

397

398. The betrothal banquet of Emperor Guang Xu from *The Grand Imperial Wedding*.

The regulations for imperial weddings state that a betrothal ceremony should precede the wedding. The betrothal presents consisted of ten horses, ten suits of armour, 100 bolts of satin and 200 bolts of other cloth, sent to the prospective empress's house by the President of the Board of Rites and Superintendent of the Imperial Household Department. That same day separate betrothal banquets, prepared by the Imperial Banquet Department, were held in her home for each of her parents. The banquet for her mother was hosted by princesses and wives of high-ranking officials and that for her father by ministers, the emperor's aides, noblemen below the rank of marquis in the Eight Banners and officials above the second rank. Shown here is the banquet for the prospective father-in-law, under an awning set up in the courtyard of the bride's home.

398

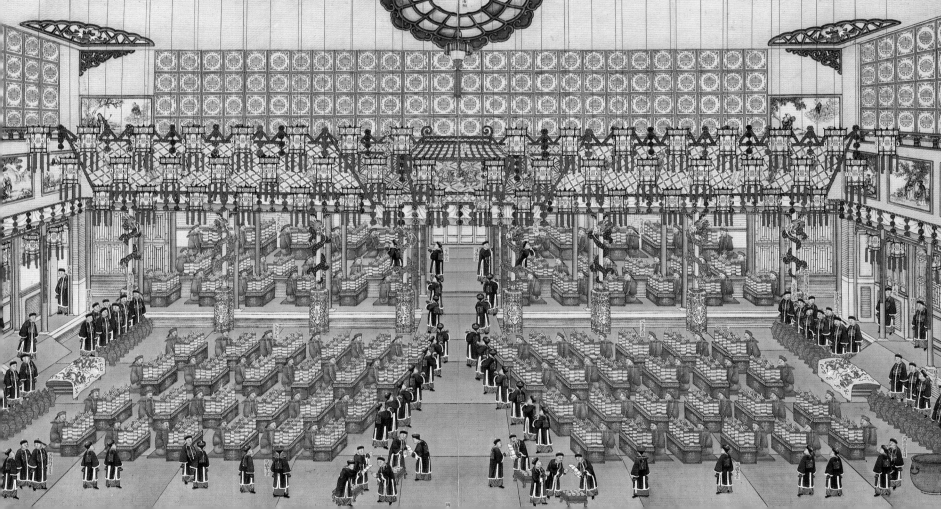

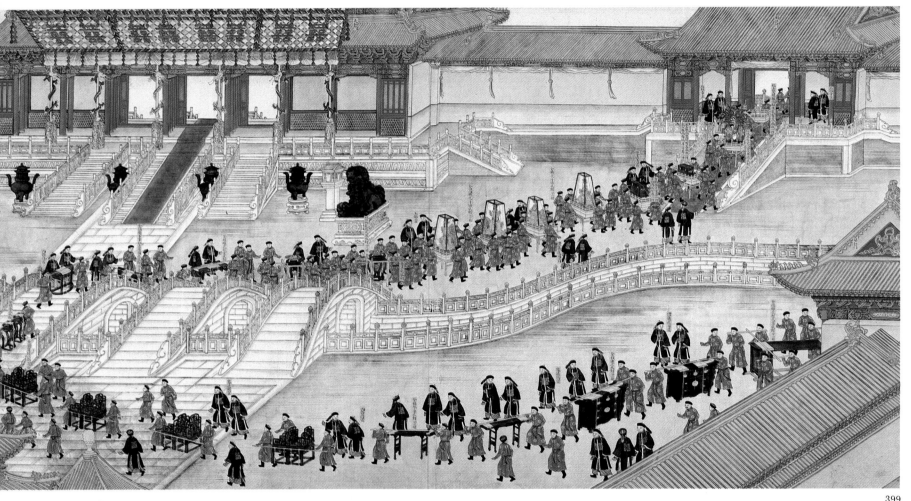

399. The dowry procession from the *Grand Imperial Wedding*.

There were 200 carrier-loads of dowry goods which came to Emperor Guang Xu according to the *Inventory of the Gold, Silver and Wooden Articles in the Empress's Dowry* in the Qing archives. Twenty-three of these loads are shown in this illustration of the section of the procession from the Gate of Harmony to the Gate of Luminous Virtue (to the left of the Gate of Supreme Harmony). Although court-wedding customs obviously involved much greater extravagance than those of the common people, the two were broadly similar in concept.

400. The phoenix sedan-chair.

The phoenix sedan-chair, which was sent by the emperor to carry his bride, is sumptuously decorated inside and out, with bright red cushions and hangings. With several characters for double happiness embroidered on its red coverings, it has a very festive air.

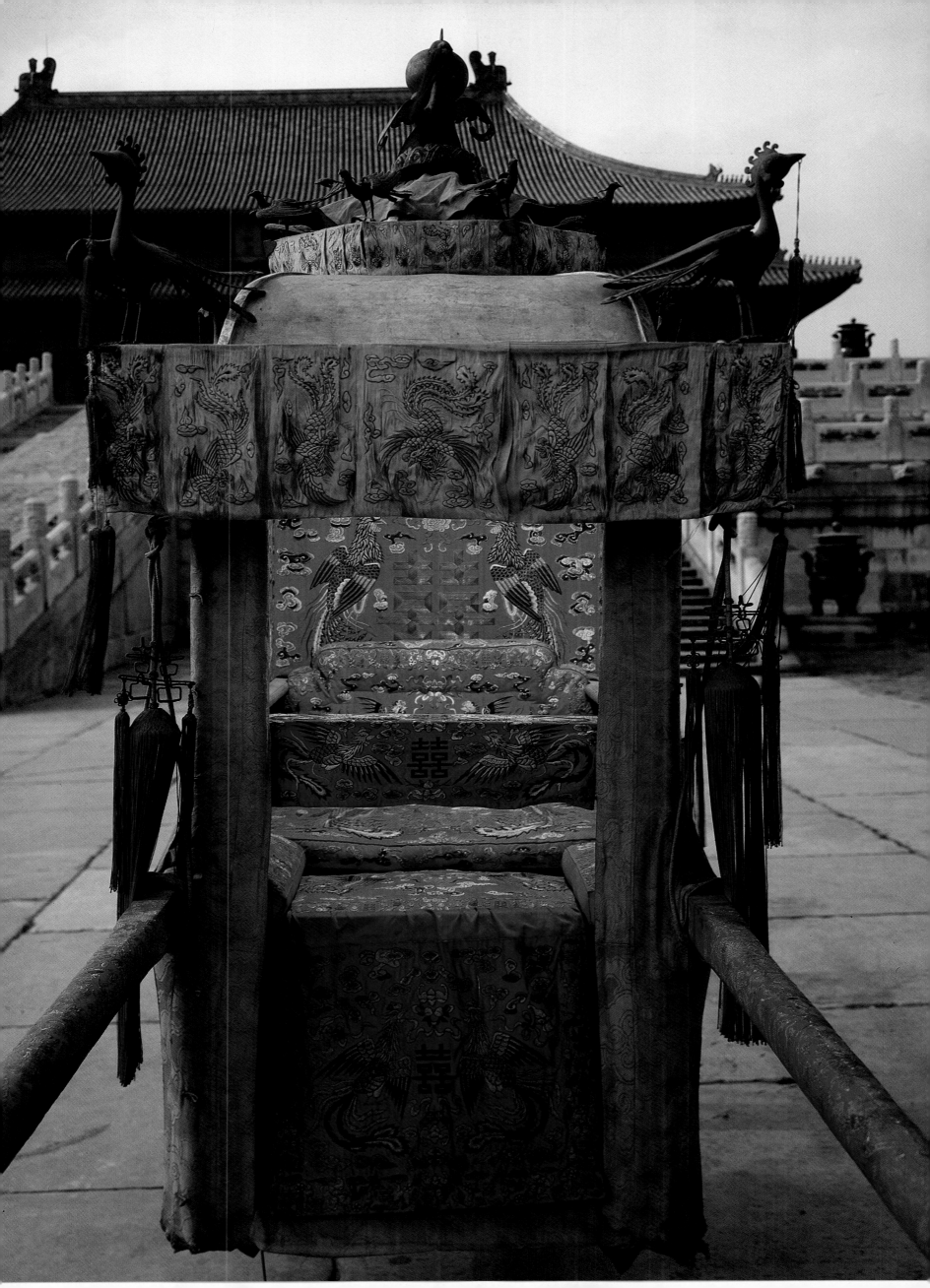

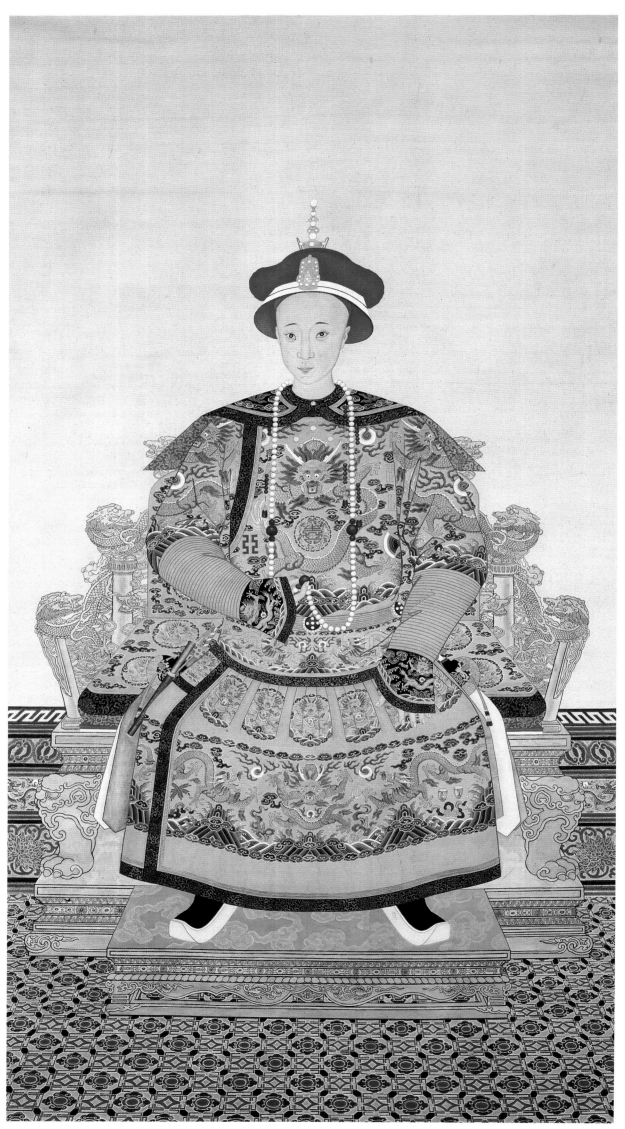

405. A portrait of Emperor Tong Zhi in court dress. (262 cm × 139.7 cm)

Emperor Tong Zhi (Zaichun) was the eighth Qing emperor after the Manchus made Beijing their national capital. He was born on the twenty-third day of the third lunar month in the sixth year of the Xian Feng reign (1856) in the rear part of the Palace of Concentrated Beauty to Concubine Yi (Yehonala, or Empress Dowager Ci Xi). He ascended the throne at the age of six, married at seventeen, took over the reins of government at eighteen and died at nineteen in the Hall of Mental Cultivation. Emperor Tong Zhi spent his entire life under the control of Ci Xi, and can be credited with no achievements of any note.

405

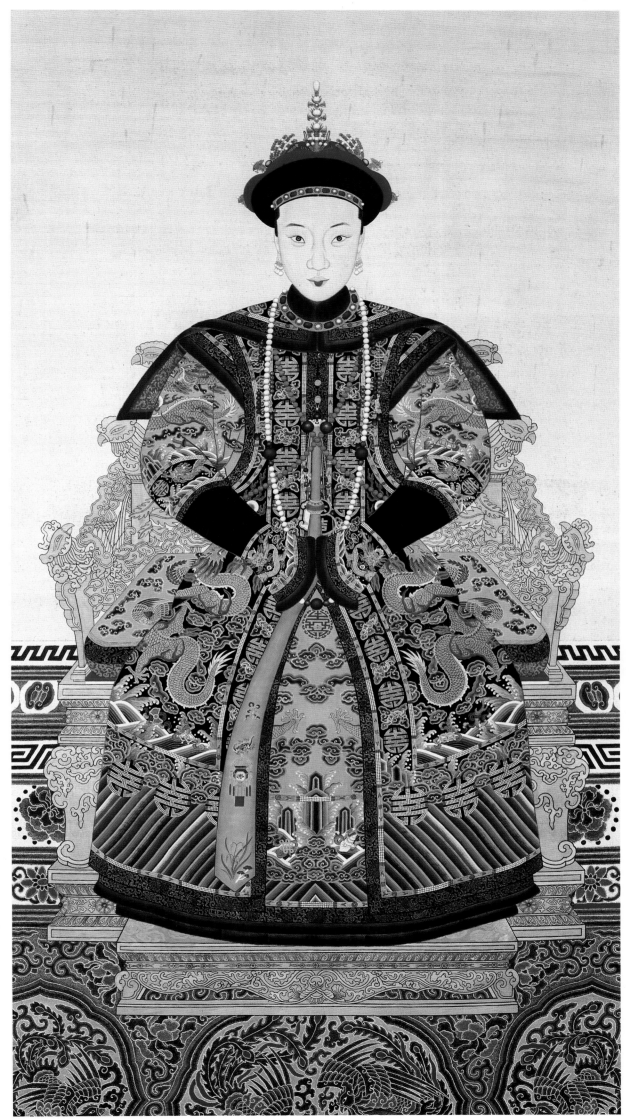

406. A portrait of Empress Xiao Zhe Yi in court dress. (239 cm × 112.5 cm)

Empress Xiao Zhe Yi was Mongolian in origin and came from the Alute clan. She was the empress of Tong Zhi, and the daughter of Chong Qi, President of the Board of Revenue. She lived in Banchang Lane inside the Gate of Peace and Stability before she was taken into the Imperial Palace. She died in the Forbidden City at the age of twenty-two, little more than seventy days after the death of Emperor Tong Zhi.

406

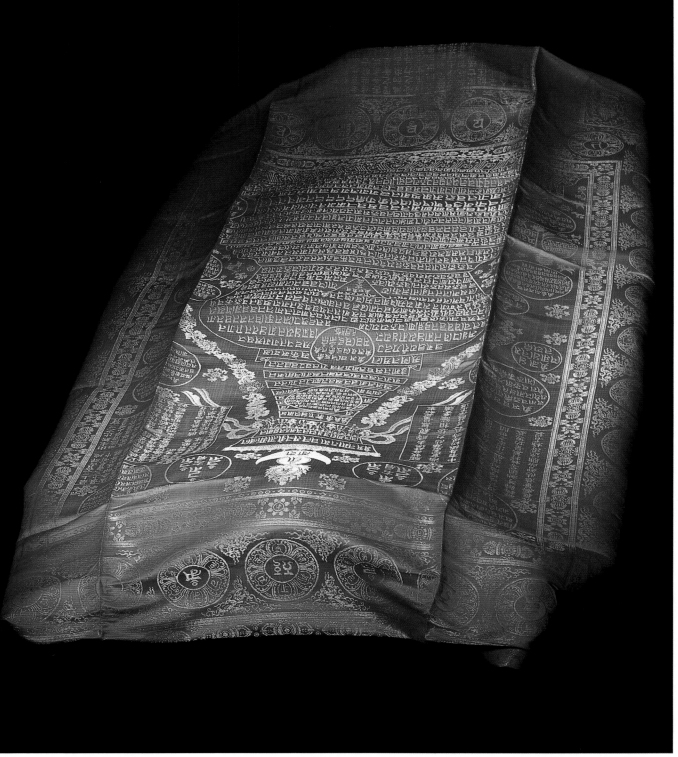

407. A Dharani Sutra quilt. (223 cm × 152 cm)

This is a funerary cover with the Sanskrit Dharani Sutra text woven in gold thread. The coffins of Qing emperors and empresses were made of cedarwood and called *zigong*. They were given forty-nine coats of paint before the final coat of gold lacquer. The coffins of imperial concubines of the first four ranks were called 'gold coffins' and the number of layers of paint decreased progressively with their rank, while those of the concubines of lower rank were called 'festoon coffins' and coated with red paint. Dharani Sutra quilts were used exclusively for the funerals of emperors, empresses dowager, empresses and imperial concubines of the first four ranks. The concubines below those ranks were not entitled to such quilts, although emperors did sometimes bestow these on them as a mark of special favour. The incantations woven into the quilt in gold thread were from the Dharani Sutra. According to Buddhist belief, they had boundless beneficence, and if the quilt was spread over the deceased, he or she would not be condemned to hell even if they had committed many sins in their lifetime, but would instead take up residence in the Western Paradise. The quilt illustrated here was a tribute to the emperor, made in the first year of Xuan Tong's reign (1909) under the supervision of Yu Xing, Superintendent of the Suzhou Imperial Silk Workshop.

407

408

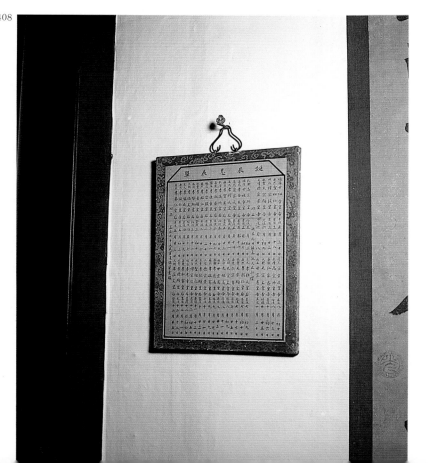

408. A list of anniversaries of births and deaths.

This list, hung in the Hall of Mental Cultivation, provided a reminder of the birthdays of Qing emperors and the anniversaries of the deaths of former emperors and empresses. On the birthdays, ministers were assigned to pay respects to the emperor, while on the anniversaries of deaths, civil and military officers were required to wear mourning-garments.

409. The imperial travelling lodge at Lianggezhuang.

Located approximately four miles east of the Western Tombs in Yixian County, this was a temporary palace for the emperor when he came to pay homage to his ancestors. It served also as a temporary resting-place for the coffins of Emperor Guang Xu and his favourite, Consort Zhen.

410. A chart of an imperial coffin-bearing team.

When an emperor's coffin was moved to the imperial mausoleum, it was carried by a team of eighty-eight bearers within the city, and 128 bearers on the outskirts. Once the coffin was carried out of the funeral palace, paper funeral money was scattered all the way to the mausoleum. In the case of the coffin of an imperial concubine of the first four ranks, paper money was scattered only when the coffin was outside the Forbidden City. In the case of a coffin of an imperial concubine below the first four ranks, money was scattered only when it was out of the city proper.

411. The Hall of Imperial Longevity.

In the Ming dynasty, the Hall of Imperial Longevity was located northeast of the central peak of Coal Hill. It was reconstructed at the back of that peak in the fourteenth year of Qian Long's reign (1749). Portraits of emperors of successive dynasties were hung in this hall, which also served as the temporary resting-place for the coffins of deceased emperors.

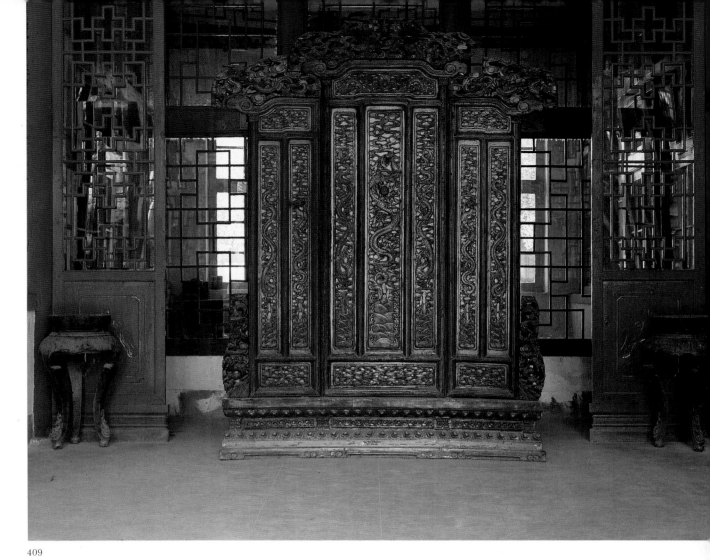

409

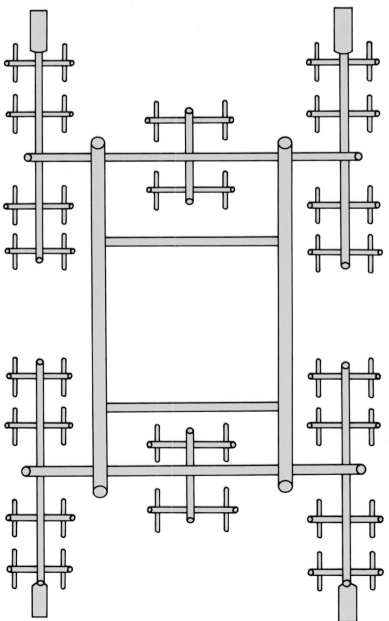

410

411

263

遊樂編

ENTERTAINMENTS

The principal places of entertainment for the members of the court were the imperial gardens and parks. Four of these, which were particularly noted for their exquisite buildings and beautiful layout, were the Imperial Garden, the garden of the Palace of Benevolent Peace, the garden of the Palace for the Establishment of Happiness and the garden of the Palace of Peaceful Old Age in the Imperial Palace. The Western Park near the Forbidden City was the largest imperial park in the capital, and its extensive and famous lake, then known as the Great Liquid Pool and now called North, Central and South Lake, was frequently visited by the imperial family. Large parks and gardens were also built at Haidian and in the Western Hills. On the sites of former travelling lodges found there, the Qing emperors expended lavishly, laying out a series of gardens and parks with the Garden of Perfection and Brightness at the centre. These extensive imperial gardens included the Garden of Joyous Spring, the Garden of Clear Ripples by Longevity Hill, the Garden of Tranquillity and Light by Jade Spring Hill and the Garden of Peacefulness by the Fragrant Hills, collectively known as the 'Three Hills and Five Gardens'. All that could be seen at the Western Hills and Haidian were the mist-enshrouded tops of trees and the curved eaves of pagodas and pavilions.

The construction of large parks and gardens by the Qing emperors was a predictable result of their lifestyle. The layout of the buildings within the Forbidden City was very formal and somewhat repetitive, and must have had a rather claustrophobic effect on those who lived in these surroundings for any length of time. All the emperors from Kang Xi down to Xian Feng lived for long periods of time with their families in the gardens of western Beijing. The emperor and empress spent the cold winter months in the warmth of the Imperial Palace, and then would leave for the gardens in the first lunar month, as soon as the various celebrations and memorial ceremonies had been completed. Thereafter they only returned to the palace when their presence was required for a particular ceremony or for the offering of sacrifices. Around the sixth lunar month they went to the Summer Palace at Chengde, and then to Mulan for the autumn hunting season. At the end of autumn the emperor returned to the palace or on occasion to the gardens in western Beijing. The Qing emperors formally returned to the palace at the beginning of the eleventh month. The gardens in the Imperial Palace itself were normally used very little, as the imperial family spent relatively little time in residence there.

The Imperial Garden is situated in the rear part of the Forbidden City. The Hall of Imperial Peace with its box-shaped roof and multiple eaves stands in the middle of the garden, while the House of Crimson Snow and the Studio of Character Cultivation face each other across the wide courtyard. The garden is laid out with precision and harmony, and is pervaded by an atmosphere of quiet dignity.

The garden of the Palaces of Benevolent Peace, which stood to the south of that palace, was reserved for the enjoyment of the empress and consort dowagers. The garden of the Palace of Benevolent Peace is formal and sombre in its layout, and lacks the vital beauty of the other gardens. There is very little to provide decorative relief.

The gardens of the Palaces for the Establishment of Happiness and Peaceful Old Age were built during the reign of Qian Long. Of all the Qing emperors, Emperor Qian Long was the most adept at enjoying a hedonistic lifestyle. After the death of his father he stayed in the Hall of Mental Cultivation for the twenty-seven months required by the funeral ritual. During this time he was extremely bored. Bearing in mind that in later years, when the empress dowager died, he would be required to endure a further twenty-seven months of similar boredom, he ordered the construction of the garden and Palace for the Establishment of Happiness. He stated that this palace was where he would 'observe the ritual of mourning when the empress dowager passed away'. The garden was not unduly large, but was considerably enhanced by the inclusion of pavilions and halls built at different levels and interspersed with rockeries, flowers and trees. However, when the empress dowager died, he did not observe the funeral ritual in the garden of the Palace for the Establishment of Happiness.

It was Qian Long's fervent wish to complete sixty years as emperor

and then to abdicate in favour of his heir. In 1771, with this in mind, he began to build the Palace of Peaceful Old Age, where he intended to live out the rest of his life as the father of the emperor. He thus particularly ordered that the garden be built on the same model as the garden of the Palace for the Establishment of Happiness, and in the event it exceeded the latter in all aspects.

However, Emperor Qian Long did not reside in the Palace of Peaceful Old Age after his abdication. Nevertheless, while still on the throne, he did on occasion go to the garden. In the late Qing period Empress Dowager Ci Xi lived for many years in the Palace of Peaceful Old Age and celebrated her sixtieth birthday there.

The Western Park with its Great Liquid Pool became the principal imperial park in the early Qing dynasty. Since it was adjacent to the Forbidden City, it was an important venue for political activities as well as recreation during the reigns of the Emperors Shun Zhi and Kang Xi.

Before the large-scale reconstruction of the gardens and parks in the western part of the city of Beijing began, the emperor and empress often lived in the Western Park during the summer in order to escape the heat. While they were there, they not only engaged in recreational pursuits, but also gave audiences to ministers. Indeed, the tradition of 'holding court at the palace gate' early in the morning was replaced by 'holding court on Sea Terrace Island', a small island in South Lake. With its winding paths and pavilions perched on the hillsides, ancient trees and strangely shaped rocks, green leaves, multi-hued flowers, terraces and archways, it resembled the fairy island in the sea depicted in paintings. Following the example of the Song emperors, who permitted their ministers to admire flowers and to fish in the rear garden of the Imperial Palace, Kang Xi had a net suspended by the bridge so that, after delivering their memorials, the ministers could fish in the lake.

The Five Dragon Pavilion on the north banks of the Great Liquid Pool was a favourite spot of Kang Xi's grandmother, Empress Dowager Xiao Zhuang Wen, and the emperor had some houses built to the north of the pavilion for his grandmother to reside in during the summer. When he was not engaged with affairs of state, he would go by small boat to pay his respects to her and wait on her during meals.

During the reign of Kang Xi the religious ceremony of the Feast of All Souls (for the deliverance of hungry ghosts) was held in the Western Park during the Buddhist Festival of Ghosts. In the seventh lunar month, when the moon rose to its zenith, eunuchs and palace maids, each carrying a lotus lantern, would stand around the lake, lining the shore like a string of shining pearls. Other eunuchs would float as many as a thousand coloured glass lanterns in the shape of lotuses on the lake itself. Then the monks and lamas from the Temple of Endless Blessings in the Western Park would begin to play Buddhist music and recite scriptures. Amidst their music and chanting, Emperor Kang Xi would board a boat at the Sea Terrace Island and, threading his way through the floating lotus lanterns, he would make his way around the lake to enjoy the spectacle. What had originally been a rather solemn Buddhist ceremony thus developed into a happy festival.

In midwinter watching ice-skating in the Western Park became a popular amusement. According to written accounts, skating as a recreation for the court began as early as the Song dynasty. The Qing court, attaching as they did such importance to military feats, combined skating with martial training. Every winter about a thousand people who were accomplished skaters were chosen from various parts of the country for training in the palace, then would demonstrate their skills on the Great Liquid Pool for the entertainment of the emperor and empress.

The emperor and empress often watched the skating displays in the Western Park from the Tower of Auspicious Clouds on the western side of the White Dagoba on North Lake. Whenever they went to watch, colourful awnings were erected all around the North Lake and multi-coloured banners and lanterns were displayed everywhere. A blazing charcoal fire would be burning in the Tower of Auspicious Clouds and the tables would be laid out with food and drink. From behind clear glass windows the emperor and empress would sit and watch the skaters.

Many types of skating were practised, including speed-skating, figure-skating and football on ice. The speed-skaters raced about like

meteors on the ice, while the figure-skaters executed such movements as 'Na Chi Exploring the Sea' and 'Hawk Making a Full Turn'. The ball game was played by two teams kicking the ball as they sped along on skates, chasing each other in their determination for victory. There was also an archery competition on the ice, which was known as 'Winding Dragons'. Three or four hundred skaters usually took part, following each other in single file, wheeling and circling on the ice. Seen from a distance, they looked like dragons writhing and coiling.

The largest pleasure parks of the Qing emperors were to be found at Haidian. There were to be found the rising peaks of the Fragrant Hills, Jade Spring Hill and Jar Hill, and the confluence of the waters from the springs of Wanquanzhuang formed a huge lake. Emperor Kang Xi greatly admired the scenery here and had the Garden of Joyous Spring, the first of the large imperial parks of the Qing dynasty, built in 1684. The lakes and hills in this garden were said to be so lovely that every time Emperor Kang Xi visited them his cares and worries melted away. From then on, the Garden of Joyous Spring became the place where Kang Xi could conduct affairs of state away from the clamour of the city. He usually lived in the garden for six months of every year.

Jade Spring Hill is in the north-western part of Haidian. Its springs were the main source of water in western Beijing. As early as the Jin dynasty, Emperor Zhang Zong built the Hall of Lotuses, an imperial travelling lodge, at the foot of Jade Spring Hill. The spring flowing out at that point is called 'Rainbow Floating over the Jade Spring' and was one of the Eight Great Views of Yanjing (Beijing). Before Emperor Kang Xi built the Garden of Joyous Spring, he instigated the renovation and repair of the Yuan- and Ming-dynasty travelling lodge at Jade Spring Hill, and had the Pure Heart Garden built on the site. This garden was renamed the Garden of Tranquillity and Light in the thirty-first year of Kang Xi (1692).

The large-scale construction of gardens and lodges in western Beijing for the benefit of the Qing imperial family reached a peak in the Qian Long period. The Garden of Perfection and Brightness and the gardens attached to it were all built or extended during this period. Of these gardens, the Garden of Perfection and Brightness had been built by Kang Xi with the express intention that it should invoke the mood of famous landscape paintings throughout the ages. The exquisitely beautiful scenery of the famous gardens of the south was reproduced and some of the features of classical gardens of the Occident were included. During the reigns of the Emperors Yong Zheng and Qian Long further work was carried out on the garden, and it became not only a centre for political activity, but to a much greater extent a centre for recreational pursuits which now transferred from the Western Park to Haidian.

The leisure activities of the imperial family here were far more varied and innovative than they were in the gardens and parks inside the confines of the capital. This was especially true in the Garden of Perfection and Brightness, where the activities included firework displays, dragon-boat races and strolls down the market streets. During the Qian Long period, firework displays were held for the emperor's guests every year around the time of the Lantern Festival in the Garden of Perfection and Brightness. As the emperor and his guests sampled various delicacies they were entertained by performances of dancing and singing organized by the Board of Music. After this the display of fireworks commenced, and continued well into the evening.

The Sea of Fortune was the largest lake in the Garden of Perfection and Brightness, and the structures on the small islet in the lake were just like those described in ancient fairytales. The scenery on this isle was therefore known as 'The Immortal World on the Fairy Isle'. During the Dragon-boat Festival, the traditional dragon-boat race was held on the Sea of Fortune, watched by Qian Long and his mother. The participating boats were colourfully painted and decorated with flying dragons and fabulous sea birds at the prow.

As the imperial family normally had no opportunity to experience the fun of visiting a temple fair or a market place, Qian Long had a market street built in the Garden of Perfection and Brightness. This street was crowded with shops, restaurants, teahouses and even jetties. Whenever Emperor Qian Long visited the street, eunuchs would play the part of

merchants, pedlars, residents and labourers. The shops were opened for business and all their goods put on display, and the jetties were made ready to receive boats. The street was crowded with people coming and going and no one appeared to notice the arrival of the emperor. Some eunuchs even pretended to be pickpockets, and as they attempted to relieve someone of their valuables, were caught red-handed and hauled off to gaol by officials. Sometimes weddings or funerals of common people were recreated on the street. Whenever he came to the market, Emperor Qian Long made many purchases.

To the west of the Garden of Perfection and Brightness there was another important pleasure-garden in Haidian. This was the Garden of Clear Ripples at the lakeside by Jar Hill. In 1750, the emperor had the Temple of Gratitude and Longevity built on top of Jar Hill in celebration of the sixtieth birthday of his mother, and Jar Hill was then renamed Longevity Hill. The lake in front of the hill was called Kunming Lake. In 1761, the park was given the name Garden of Clear Ripples. Later, Emperor Qian Long suddenly ordered the dismantling of the unfinished Longevity Pagoda and in its place built the Pavilion of Buddhist Incense, an octagonal three-storeyed structure with four tiers of eaves, built on the model of the Yellow Crane Tower in Hubei. During one of his tours to the south he had discovered the Pleasure Garden of the Qing family on the hill at Huishan in Wuxi. He decided then and there to have a similar garden built in the capital. When the garden was completed, Emperor Qian Long was so delighted with it that he said 'every pavilion and every path contributes harmonious delights'. The garden was therefore renamed the Garden of Harmonious Delights in the Jia Qing period.

During the late Qing most of the huge imperial parks and gardens in the west of the capital were destroyed and plundered by the armies of the British and French aggressors. After trying unsuccessfully to rebuild the Garden of Perfection and Brightness, Empress Dowager Ci Xi diverted funds earmarked for the building-up of the navy into the renovation and extension of the Garden of Clear Ripples. She renamed the latter the Garden of Good Health and Harmony (Yiheyuan), now popularly known as the Summer Palace. She lived in this garden for most of the year, only returning to the Forbidden City in the winter months. Ci Xi was a great enthusiast of opera, and to enable her to enjoy operatic performances at the Summer Palace, she had the Great Theatrical Stage built in the Garden of Harmonious Virtue in the eastern part. For staging operas which included the supernatural, the theatre was equipped with platforms above and below the stage. There was also a pond at the foot of the stage so that water might be spurted onto it during performances if necessary.

The Summer Palace at Chengde and the Jingji mountain resort in Jixian County were also places where the imperial family could relax. In the Summer Palace at Chengde, there was even an operatic stage (called the Pavilion of Clear Sounds) similar to the stage in the Summer Palace in Beijing.

412. Looking westward from the Pavilion of Imperial Prospect in the Imperial Garden.

The Pavilion of Imperial Prospect is a small, broach-roofed pavilion built on top of the Hill of Accumulated Refinement in the north-eastern part of the Imperial Garden. It is said that on the Double-Ninth Festival, the emperor, empress and other court ladies went up to this pavilion because of the wonderful panoramic view afforded by its location. Looking westward from the pavilion, in the foreground are the pines and cypresses in the garden, then come the box-shaped roof of the Hall of Imperial Peace and the glazed ceramic dragons on the roof of the Rain-Flower Pavilion.

413. The Studio of Character Cultivation in the Imperial Garden.

The Studio of Character Cultivation is in the south-western corner of the Imperial Garden. When the Qing emperors were not involved with affairs of state, they often came here to read and to recite poetry. There is a

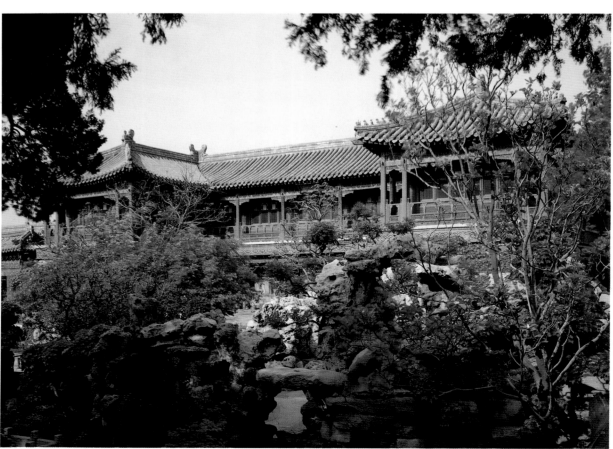

414 415

couplet inscribed in the studio that
reads, 'Although the forest and /
The waterfall are so lovely, /
Nevertheless here in my little room /
My eye can enjoy the sight of books.' It was com-
posed by Emperor Kang Xi when he
was recuperating in the studio.

414. The House of Crimson Snow in
the Imperial Garden.

The House of Crimson Snow is
opposite the Studio of Character
Cultivation. Several large crab-apple
trees used to stand in front of the
house, which derived its name from
the pink crab-apple blossoms that
bloomed in spring.

415. The Hall of Active Retirement in
the garden of the Palace of Peaceful
Old Age.

After reigning for sixty years, Emperor
Qian Long abdicated in favour of his
fifteenth son, thus fulfilling his early
wish to abdicate after sixty years on the
throne. He inscribed the signboard for
the hall in the garden of the Palace of
Peaceful Old Age, where it was his
intention to retire in his old age.

416. The Pavilion of Towering Beauty
in the garden of the Palace of Peaceful
Old Age.

The Pavilion of Towering Beauty is
built on a rocky elevation behind the
Hall of Active Retirement. In front of
the pavilion is a precipitous drop of
several metres. The pavilion com-
mands a panoramic view of the
garden.

416

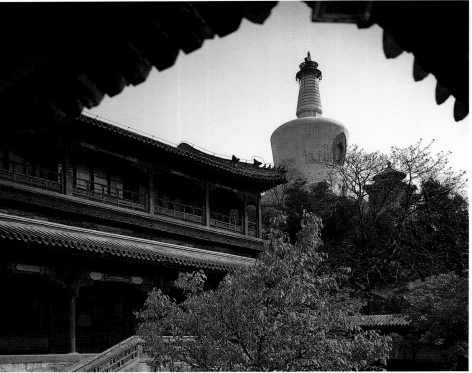

417 418

419

417. The Tower of Auspicious Clouds on North Lake.

The Tower of Auspicious Clouds stands half-way up the southern slope of White Dagoba Hill. The name of the tower implies that the building is so tall that it can reach the clouds. In winter Emperor Qian Long often came to this building with his mother to watch skaters demonstrating their skills.

418. 'Jade Islet in the Spring Shade' – one of the Eight Great Views of Yanjing.

The tablet that stands at the eastern side of Qionghua Islet was inscribed by Emperor Qian Long. When spring comes, the islet is covered in colourful and fragrant flowers, particularly around the tablet. Qian Long's inscription provides the finishing touch to the scene.

419. The Tranquil Heart Study on North Lake.

The Tranquil Heart Study, originally named Clear Mirror Study, is on the northern shore of the lake. It is a cluster of elegant buildings set in an exquisite garden, known as the 'garden within a garden'. It was a resting-place for Emperor Qian Long when he came to worship at the Buddhist shrine in the Western Park.

420. Sea Terrace Island in South Lake.

Sea Terrace Island in the South Lake of the Western Park was known as the Southern Terrace Island during the Ming period. Some reconstruction was done during the reign of Emperor Shun Zhi in the Qing dynasty. It was renamed Sea Terrace Island after a legendary fairy island, because it was as beautiful as an enchanted island in the sea.

421. The Precious Moon Tower of South Lake.

The Precious Moon Tower was built in the twenty-third year of Qian Long (1758) to relieve the monotony of the narrow strip of land on the southern shore of the lake. Emperor Qian Long wrote in a poem: 'The Precious Moon Tower brings memories of the past. But there is prosperity everywhere today. In this neighbourhood live the

Moslems. My heart goes out to the peaceful Western Region.' A note to the poem says: 'The tower faces Chang'an Boulevard. On the southern side of the street live Moslems from the Western Region. Their houses are built in their own style.' It was inferred from this that Emperor Qian Long had the Precious Moon Tower built to please the Moslem Consort Rong (commonly known as the Fragrant Concubine), but in fact the tower was built before Consort Rong entered the palace.

422. The Hanyuan Hall on Sea Terrace Island.

This was where Emperor Guang Xu was imprisoned by the Empress Dowager Ci Xi after the failure of the Reform Movement of 1898.

423. The Pavilion of Flowing Water Music in South Lake.

Floating their drinking-cups down a tiny winding stream was considered a refined pastime among ancient scholars and gentlemen. It originated with Wang Xizhi, a famous calligrapher of the Jin dynasty, when on one occasion he entertained his friends by the water's edge. Admiring this pastime, the Qing emperors had artificial cup-floating pavilions built in the Western Park and the garden of the Palace of Peaceful Old Age. Emperor Qian Long inscribed the name 'Flowing Water Music' for this pavilion in South Lake.

420

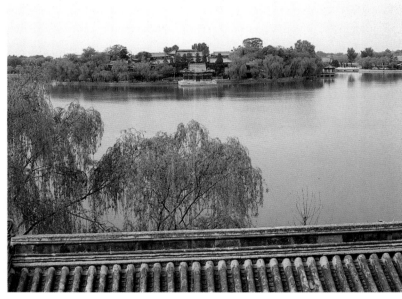

421

422

423

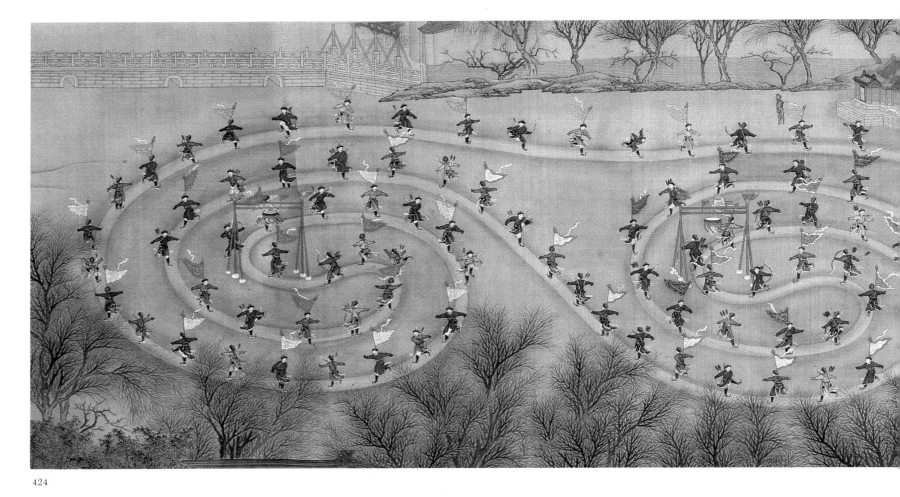

424. *Ice-Skating*. (35 cm × 578.8 cm)

This work by the Qing court-painter Jin Kun and others depicts the emperor, nobles and ministers watching proficient skaters demonstrating their ability to shoot at a ball and other skills by the Bridge of the Golden Turtle and Jade Rainbow on the Great Liquid Pool.

425. *Ice-Skating*. (detail)

The emperor, flanked by his ministers and bodyguards, watches skaters from his 'ice-boat'.

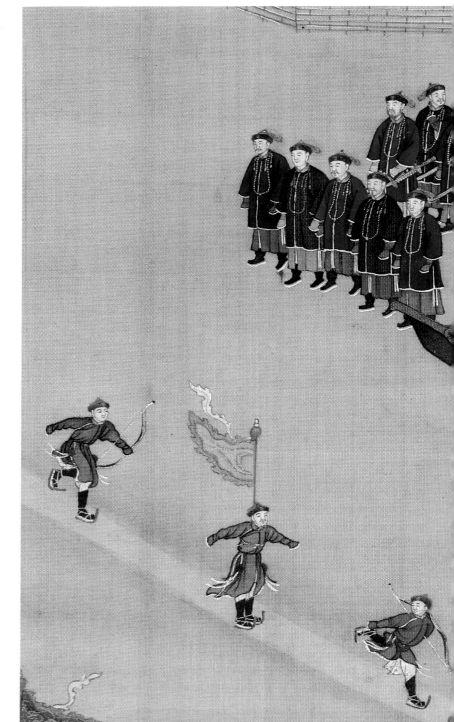

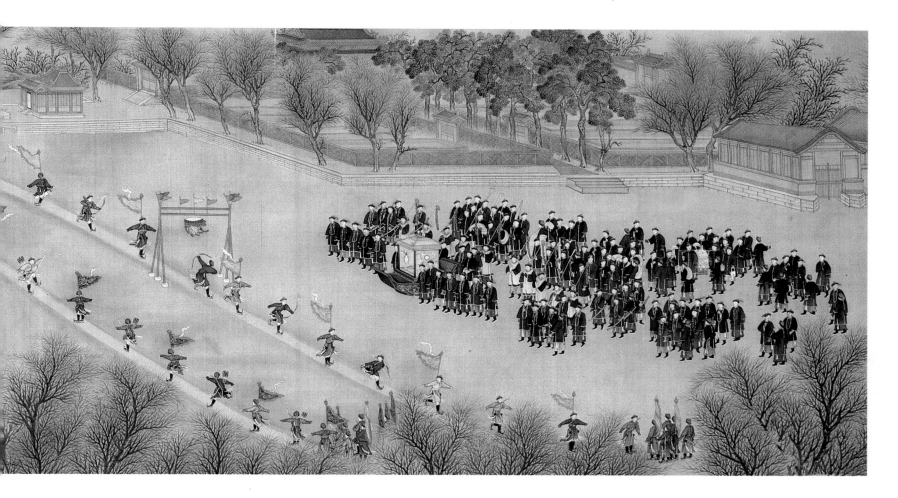

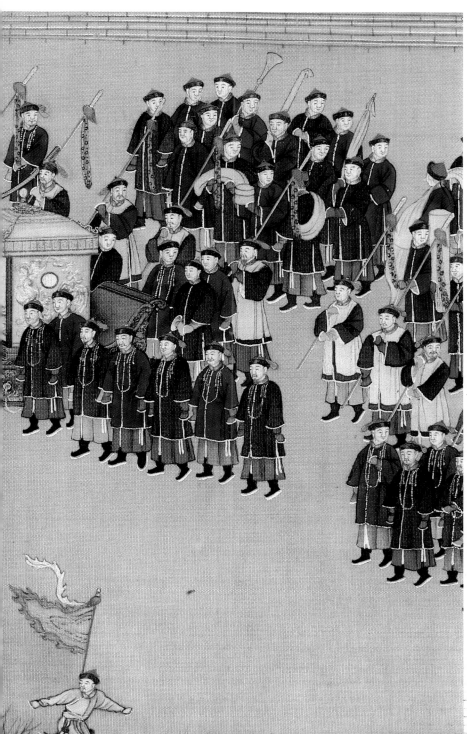

425

山高水長

426

426. *The Lofty Mountain and Long River Hall.*

Executed by a Qing-dynasty artist, this painting shows the Lofty Mountain and Long River Hall in the Garden of Perfection and Brightness.

427. *The Hall of Universal Peace.*

This painting, also dating from the Qing dynasty, depicts the Hall of Universal Peace in the Garden of Perfection and Brightness.

428. The site of the Hall of Universal Peace in the Garden of Perfection and Brightness.

The Hall of Universal Peace was a unique structure in the middle of a lake. Built in the shape of a Buddhist symbol (a fylfot), it was both warm in winter and cool in summer: pleasant in all seasons. It was a favourite spot of Emperor Yong Zheng, who often stayed here, and who inscribed the nine four-character names of the views from the winding corridors around the building.

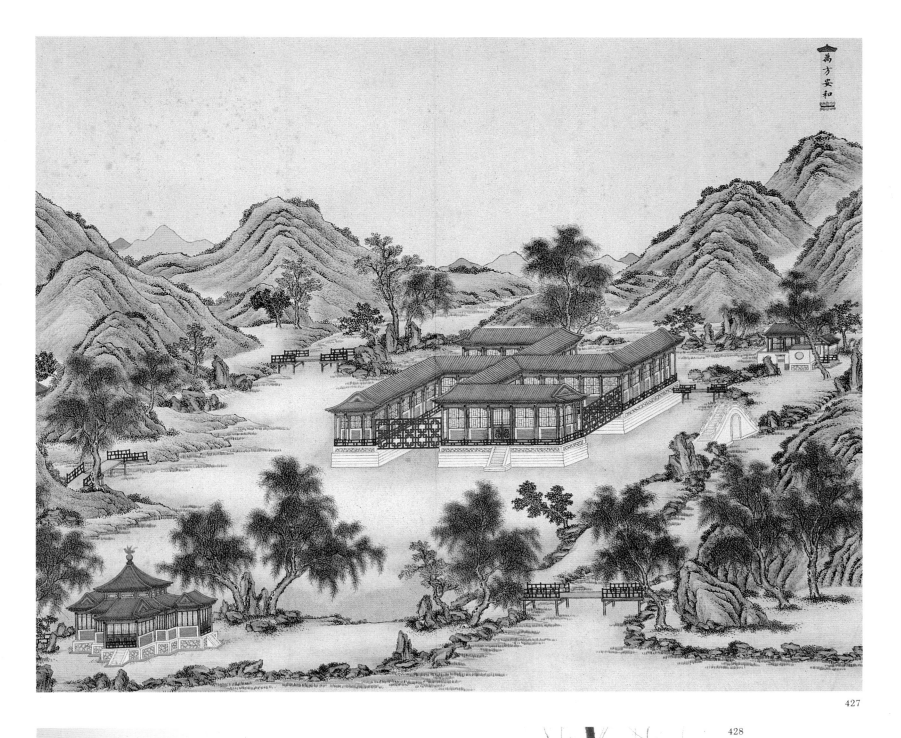

萬方安和

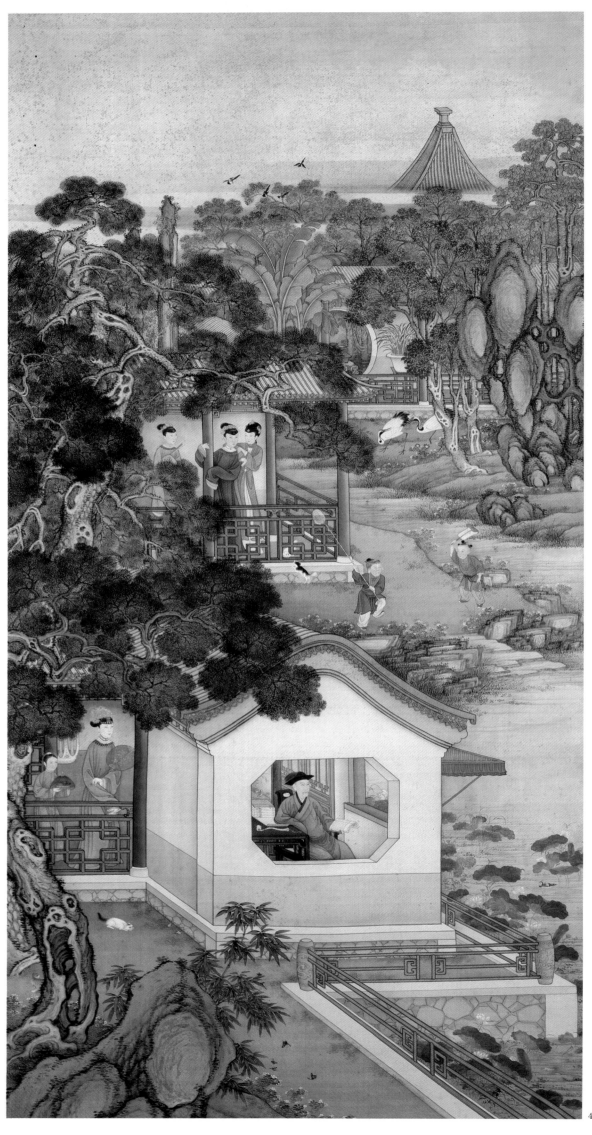

429. *Emperor Yong Zheng at Leisure.* (206 cm × 101.6 cm)

This was painted by a Qing-dynasty artist. Emperor Yong Zheng was noted for his frugality and his dislike of extravagance, but he was not without a lighter side to his character. For amusement, he often had his portrait painted wearing a wig and in western or Han costume. This painting shows the emperor and his court ladies (in Han-Chinese dress) at leisure in the Garden of Perfection and Brightness.

429

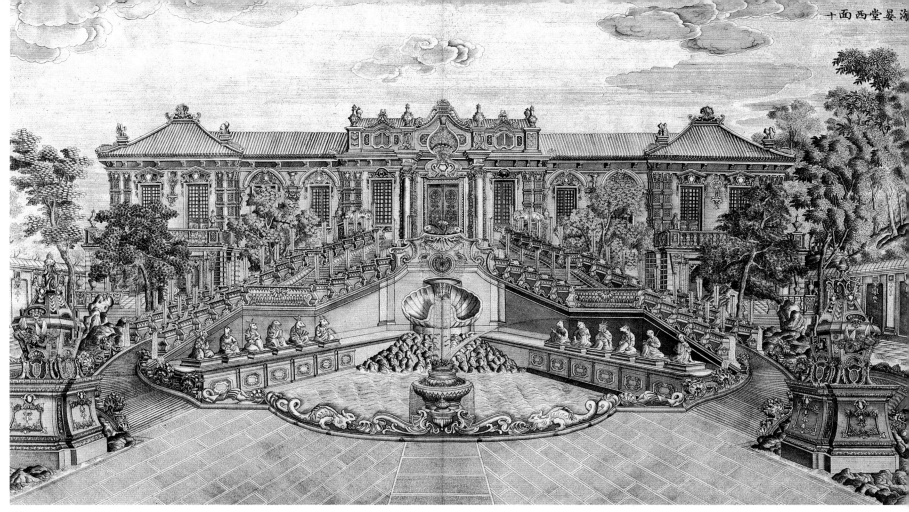

430

431

432

430. A copper engraving of Haiyan Hall in the Garden of Eternal Spring.

This engraving was done by a European missionary employed as an artist at the Qing court. Haiyan Hall was one of the European-style buildings in the Garden of Eternal Spring. The fountain with the twelve animals of the zodiac in front of the hall was designed and made by a French missionary.

431. The ruins of Haiyan Hall.

The invading Anglo-French army burnt down the entire Garden of Perfection and Brightness in the tenth year of Xian Feng (1860). The magnificent Haiyan Hall was also reduced to ashes; all that remained were a few fragments of carved stone as testaments to the tragedy.

432. The ruins of Shewei city in the Garden of Perfection and Brightness.

Shewei was a tiny city constructed in the Garden of Perfection and Brightness, and built according to the layout of an ancient Indian city. Buddhist statues and images were enshrined here, and many Buddhist scriptures were stored within its precincts.

277

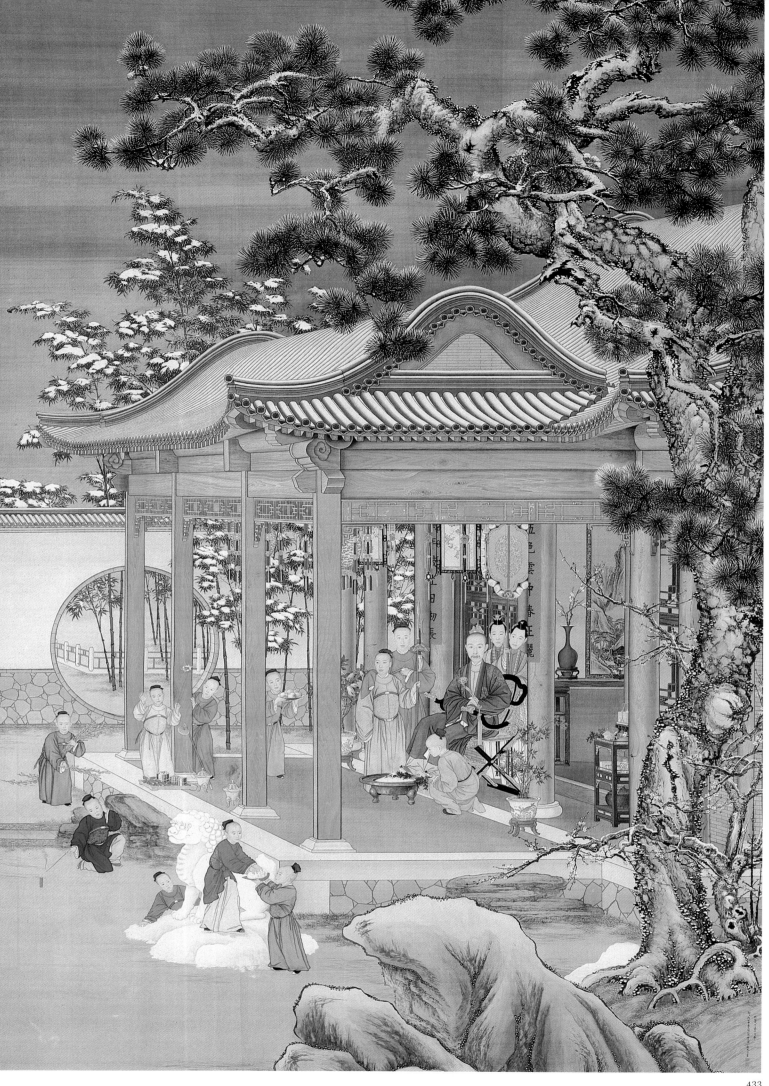

433

433. *Emperor Qian Long Enjoying the Snow.*

This picture was painted by the Italian missionary Giuseppe Castiglione together with the Qing court-painters Tang Dai, Chen Mei, Shen Yuan, Sun

Hu and Ding Guanpeng. It depicts Emperor Qian Long and his concubines watching their children playing in the snow.

434. *Emperor Dao Guang Enjoying the Autumn.* (181 cm × 205.5 cm)

Painted by a Qing artist, the picture portrays Emperor Dao Guang and the empress (or imperial consort) wearing informal dress and enjoying the balmy

autumn sunlight in the Garden of Perfection and Brightness. In this painting, which shows the happy family-life of the emperor, he is watching the princes and princesses playing with their dogs.

278

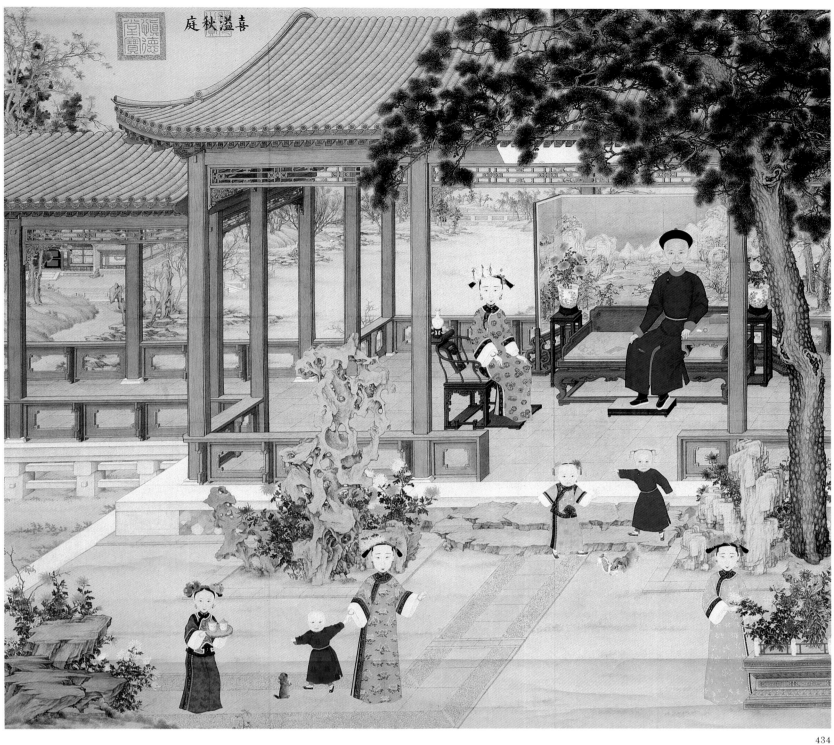

庭秋溢喜

434

435. Huishan Garden on Longevity
Hill.

Huishan Garden is at the eastern foot
of Longevity Hill. When Emperor Qian
Long toured the south in the sixteenth
year of his reign (1751), he was enchan-
ted by the Pleasure Garden in Wuxi.
He ordered painters to produce pic-
tures of the garden, and when he
returned to the capital he had Huishan
Garden built by Longevity Hill – com-
plete with ponds, various styles of
elegant buildings and the Zhiyu
Bridge. In the Jia Qing period, the
name of the garden was changed to the
Garden of Harmonious Delights, in
reference to a poem by Qian Long
which says, 'Every pavilion and every
path gives harmonious delights.'

435

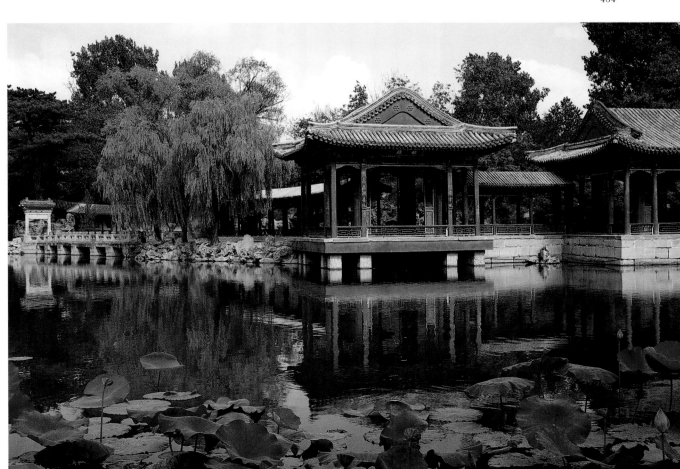

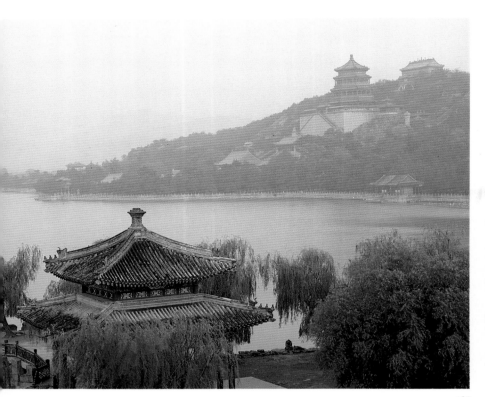

436

437

436. The Summer Palace (Yiheyuan).

Haidian in western Beijing benefits from a beautiful green hill and a lake of clear water. The Garden of Clear Ripples was built here during the reign of Emperor Qian Long and the hill and lake were named Longevity Hill and Kunming Lake. In summer the Qing emperors often went to observe naval exercises conducted on the lake. The area underwent reconstruction during the reign of Emperor Guang Xu and was renamed the Garden of Good Health and Harmony (Yiheyuan).

From here Empress Dowager Ci Xi often exercised her power and it was to the Summer Palace she retired in her old age.

437. The Jade Belt Bridge on Kunming Lake.

The Jade Belt Bridge is the only arched bridge on the western side of Kunming Lake. It is made of light grey stone with white marble balustrades. As the bridge is as pale as jade and arches like a belt, it was named the Jade Belt Bridge.

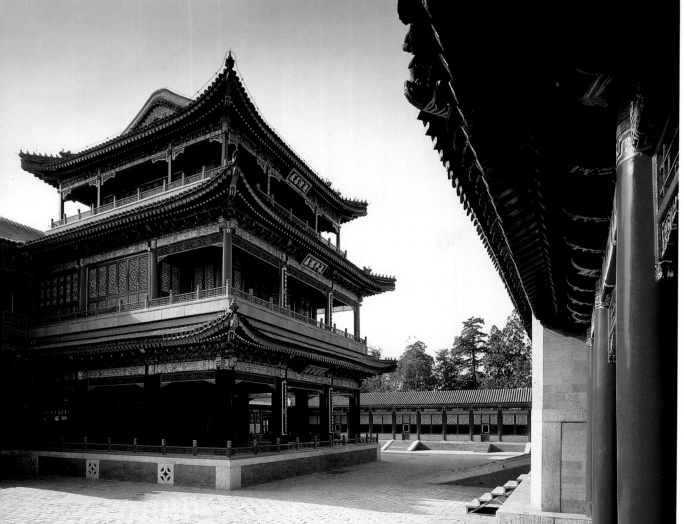

438

438. The Great Theatrical Stage in the Summer Palace (Yiheyuan).

The site of the Great Theatrical Stage in the Garden of Harmonious Virtue in the Summer Palace was originally that of the Hall of Joyous Spring in the garden known as the Garden of Clear Ripples. When Ci Xi lived in the Summer Palace, she had the Great Theatrical Stage built in place of the Hall of Joyous Spring so that she could conveniently indulge her passion for opera. Famous Beijing operatic performers such as Tan Xinpei and Yang Xiaolou came here to perform for her.

439. The bronze ox by Kunming Lake.

The bronze ox was cast in the twentieth year of Qian Long (1755). Cast on the back of the ox is the 'Essay on the Golden Ox' in eighty characters of seal script. The essay says that the bronze ox was cast to subdue floods, based on the legend that when Yu of the Xia dynasty was battling against the flood, he cast an iron ox to subdue the river waters.

440

440. *Panoramic View of the Garden of Peacefulness.*

This painting is by Dong Bangda, President of the Board of Works in the Qing dynasty. During the reign of Kang Xi, only a few imperial lodges were built in the Fragrant Hills. These lodges were unadorned, to preserve the natural look of the landscape of the area. After Emperor Qian Long visited the Fragrant Hills in the eighth year of his reign (1743), he had the lodges rebuilt and the garden established. He named it the Garden of Peacefulness. He also gave names to the twenty-eight scenic spots in the garden.

441

442

441. The Temple of Clarity in the Fragrant Hills.

This is a Lamaist temple of the Yellow Sect, built in the forty-fifth year of Qian Long (1780), when the Panchen Lama of Tibet came to the capital to present himself to the emperor. To win over the Mongolian and Tibetan aristocrats and to indicate respect for their countries and for the Yellow Sect of Lamaism, the emperor commissioned the building of the Temple of Clarity in the Fragrant Hills as a residence for the Panchen Lama during his visit. The temple was built in the style of the Panchen Lama's temple in Central Tibet.

442. The glazed ceramic pagoda of the Temple of Clarity.

443. The Temple of Azure Clouds in the Fragrant Hills.

This ancient temple was first built in the Yuan dynasty, and during the Zheng De period of the Ming dynasty, the eunuch Yu Jing had his tomb built behind the temple. In the Tian Qi

443

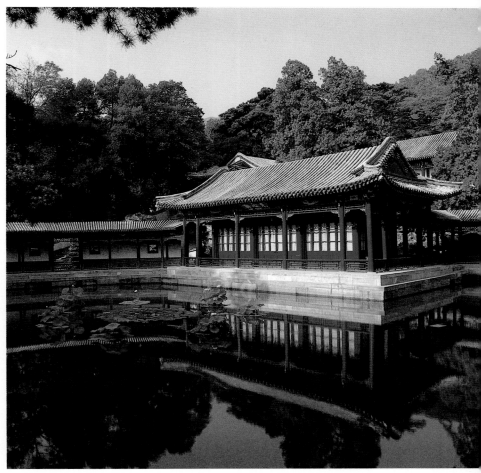

444

period, the eunuch Wei Zhongxian also had his tomb constructed there. In the thirteenth year of Qian Long (1748) a monk from the Western Region came to court bringing with him the drawings for a pagoda. Emperor Qian Long had a pagoda built in accordance with these drawings behind the Temple of Azure Clouds. The pagoda stands on foundations of white marble.

444. The Retreat for Revealing the Mind in the Fragrant Hills.

This is a small complex built around a courtyard at the foot of the hills. A clear pool in the courtyard is surrounded by winding covered galleries. To the east of the pool is Zhiyu Pavilion and to the west, the Retreat for Revealing the Mind, with its signboard inscribed by Emperor Jia Qing. The refreshing seclusion of the small courtyard is enhanced by the densely wooded Fragrant Hills behind it.

445. The Garden of Tranquillity and Light.

The garden lies on the south side of Jade Spring Hill. There was originally an imperial lodge here, built for Emperor Zhang Zong of the Jin dynasty (1115–1234). During the reign of Kang Xi the garden was constructed on the site of the old lodge. The pagoda was built during the reign of Qian Long in imitation of the one on Gold Hill in Zhenjiang. It is called 'Reflections of Jade Peak Pagoda', and is one of the sixteen scenic spots in the Garden of Tranquillity and Light.

446. Entrance to the courtyard of the Room for Convalescence at the Angler's Terrace.

The Angler's Terrace, originally called the Garden of Shared Happiness, is in the western suburbs of Beijing. After the Jin Emperor Zhang Zong had on one occasion fished here and given a feast for his ministers, it was renamed the Angler's Terrace. During the reign of Qian Long, the lake was dredged and an imperial lodge was built on its shore. The lodge's main hall was named the Room for Convalescence.

445

446

447. A sedan-chair.

There were strict regulations concerning the emperor's sedan-chairs, each used for different occasions. There were roughly four types: ritual, regular, light regular and informal. The sedan-chair shown here closely resembles the kind used by the common people in mountainous areas. In it the emperor was transported from one place to another within the palace on the shoulders of either eight or sixteen bearers.

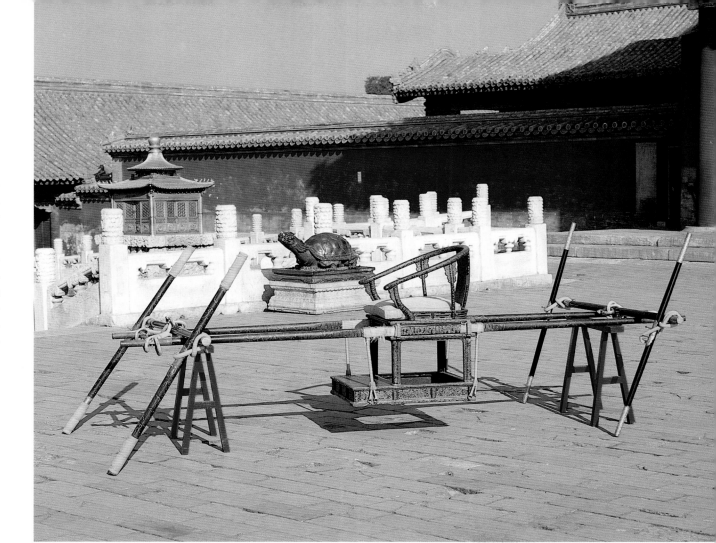

447

448

448. 'Ice-boats' from *Empress Dowager Chong Qing's Birthday Celebrations*. (detail)

In Qing times, during the winter months, people travelled by ice-boat on the rivers and moats. Ice-boating was a popular sport at this time.

285

449

449. *The Summer Palace at Chengde.*
(254.8 cm × 172.5 cm)

This painting is by the Qing court-painter Leng Mei. The Summer Palace at Chengde was built in 1704 to strengthen control over the Mongolian tribes and as a summer retreat. It was built beyond the Great Wall, to harmonize with the natural terrain. The structures were unpainted and undecorated. Its simplicity reflected the style of early Qing gardens and lake areas.

450. The Pavilions in the Heart of the Waters at the Summer Palace at Chengde.

The three square pavilions with double eaves stand on the shore. They comprise one of the thirty-six new scenic views added during the Qian Long period.

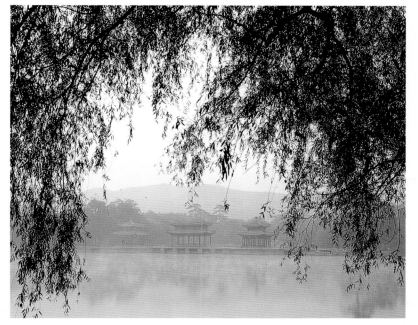

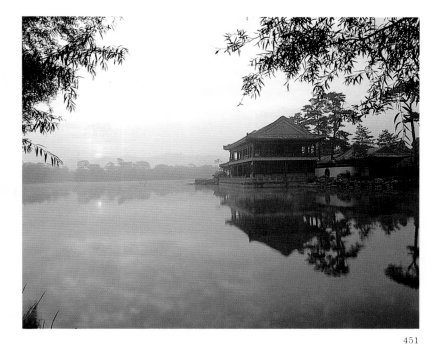

450

451

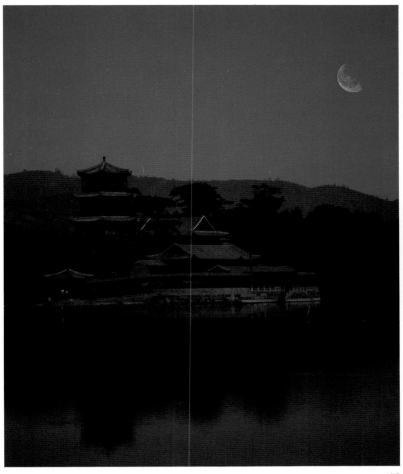

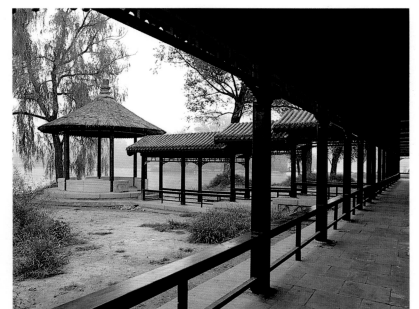

453

452

454. The Park of Ten Thousand Trees.

To the west of the Summer Palace amidst the trees, there is a large stretch of flat land carpeted with green grass. In the days of the Qing emperors, yurts were erected here, making it look very much like a scene from the Mongolian grasslands. Emperor Qian Long often held banquets for the nobles of various nationalities here, and entertained them with wrestling, shows of equestrian skill and musical and operatic performances.

454

451. The Tower of Mist and Rain at the Summer Palace at Chengde.

This is on Green Lotus Island, and is a copy of a tower of the same name at South Lake in Jiaxing, built in the Qian Long period. On a drizzly day, looking into the misty distance, the sky and water merge just like the scenery south of the Yangtze River.

452. The Temple of the Supreme Emperor at the Summer Palace in Chengde.

To the east of Ruyi Islet is a man-made rocky hill. There is a cave in the side of the hill and on its flat summit stands the Temple, similar to the Gold Hill

Temple in Zhejiang. Steps lead to the top.

453. The Landing for Gathering Water-Chestnuts.

To the west of the Zhijingyun Embankment of Ruyi Lake is a conical thatched pavilion with winding covered walks and halls behind. Because this tranquil spot was surrounded by water and green hills Emperor Kang Xi named it 'Green Ringed'. The Qing emperors came here to go boating and pick water-chestnuts. It was a favourite spot of Emperor Qian Long, who named it, and it became one of the thirty-six scenic spots of the resort.

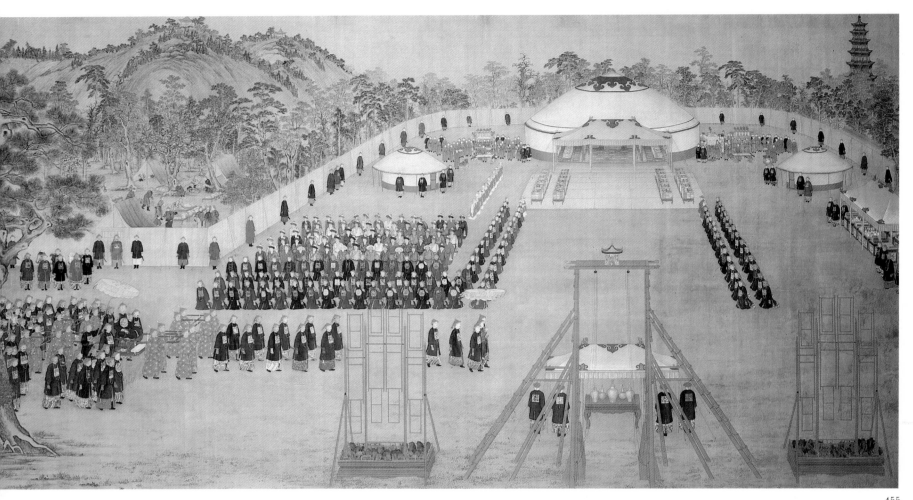

455. *Imperial Banquet at the Park of Ten Thousand Trees*. (221.2 cm × 419.6 cm)

This picture was painted by the Italian missionary Giuseppe Castiglione (1688–1766) and the French missionary Jean-Denis Attiret (1702–68), who served the Qing emperor as court-artists. During the reigns of Kang Xi, Yong Zheng and Qian Long, there was turmoil, and for scores of years the various tribes of the Eleut Mongs inhabiting the Xinjiang area fought against each other. Several times the Qing government sent forces to put down the disturbances. In the nineteenth year of the reign of Qian Long (1754), the chief of the Durbot tribe of the Eleut Mongs specifically expressed his wish to move inland and yield his allegiance to the Qing dynasty. Emperor Qian Long was delighted, and that summer received the chief of the Durbot tribe in the Park of Ten Thousand Trees in the Summer Palace at Chengde. The emperor gave a banquet in his honour and conferred a title of nobility upon him. Court-artists were called to Jehol (Chengde) to record the historic event in paintings.

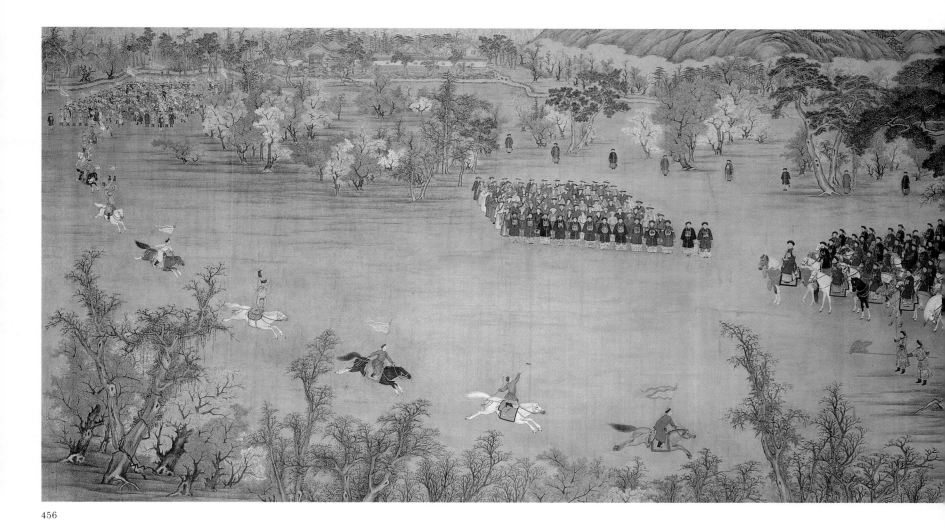

456

456. *Demonstration of Equestrian Skills.*
(225 cm × 425.5 cm)

Painted by Giuseppe Castiglione and
other artists. After receiving the chief
of the Durbot tribe, conferring a noble
title on him and holding a feast in his
honour, Emperor Qian Long invited
him to a demonstration of equestrian
skills and performances of singing and
dancing. This painting depicts Qing
soldiers of the Eight Banners
demonstrating their superb skills on
horseback, as the guests observe from
a distance.

SACRIFICES

祭祀編

Sacrificial ceremonies of various scales were among the most important rituals of the Qing court. Different sacrificial rites derived from the customs of the Manchus and the Han people. The sacrifices at the shrine to heaven (Tangzi) and to the gods at the Hall of Earthly Peace were specifically Manchu rites, while the memorial ceremonies for ancestors at the Imperial Ancestral Temple, the Hall of Ancestral Worship and the imperial tombs were more akin to the ceremonies traditional to the Han people.

There were nearly eighty sacrificial ceremonies presided over by the Board of Rites and about ten sacrifices associated with the imperial family, presided over by the Imperial Household Department. The emperor as head of both the state and the imperial house had to perform the important ceremonies personally, particularly sacrifices to the imperial ancestors as a mark of his filial piety.

Different memorial tablets, sacrificial vessels, jade objects, silk fabrics and sacrificial animals were laid down in the regulations for the different ceremonies. The emperor was expected to observe abstinence before some of the more important ceremonies, and during these times wooden boards were hung at all the court offices as a reminder, as well as at the Gate of Heavenly Purity. At the latter venue a bronze figure symbolic of abstinence was also put in place. The emperor had to abstain from the six indulgences, while the others who were to participate in the ceremonies were prohibited from eating meat or fish, drinking alcohol and even from spitting.

The offering of sacrifices to heaven was regarded as the most important of all the rituals and usually this was performed by the emperor personally. The ceremony was held every year on the day of the Winter Solstice to 'welcome the arrival of longer days'. In the three days preceding it the emperor observed abstinence in the palace and went through a series of elaborate preparations. The day before the ceremony, the emperor rode to the Temple of Heaven in the jade sedan-chair and spent the day in the Hall of Abstinence. On the day of the ceremony the emperor took up his position at the circular Altar of Heaven and went through the elaborate rituals of the sacrifice.

Every year, at an auspiciously appointed hour in mid-spring, the emperor went to the Altar of the God of Agriculture to offer sacrifices and reverence to Shen Nong (the God of Agriculture). After the formal ceremony the emperor ploughed three furrows on a designated plot of land. He held the handle of the plough in his right hand and a whip in his left, while two experienced court officials guided the oxen pulling the plough. Music was played and colourful flags waved along both sides of the plot of land. The emperor was followed by the Governor of Shuntian Prefecture (Beijing), who held the box of seeds, and the President of the Board of Revenue, who planted the seeds. They in turn were followed by an old peasant who actually covered the seeds with earth. After he had performed his ritual ploughing, the emperor ascended the observation platform to watch the princes and ministers as they ploughed.

The offering of sacrifices to the Goddess of Silkworms was the only state ceremony presided over by the empress during Qing times, and this ceremony had not been established before the Manchus took control of the whole country. During the reign of the Emperor Kang Xi, mulberry trees were planted in the Garden of Plenty in the Western Park as part of an experiment to try and raise silkworms in north China. The Altar of the Goddess of Silkworms was formally erected during the reign of Yong Zheng. The empress went to the altar accompanied by ladies of rank, and there performed six bows, three prostrations and three kowtows, offered three libations and received the sacrificial meat. Later, after the silkworms had hatched, the empress returned to the mulberry grove at the altar and performed the ceremony of picking the mulberry leaves. While musicians played special mulberry-leaf-picking music, the empress with a basket in one hand and hook in the other cut three mulberry twigs with the help of silkworm attendants. She then ascended the observation platform to watch the imperial concubines, princesses and other ladies of rank pick mulberry leaves.

At first Tangzi were set up in the homes of the ordinary people, but in 1636, Abahai proscribed this, and from then on, Tangzi provided a place of worship only for the Qing ruling houses. After the Qing had taken control of the whole country, a Tangzi was set up outside the left Gate of Eternal Peace. The most notable difference from the traditional shrines of preceding dynasties was that the circular-shaped hall for worshipping heaven faced north rather than south. During the ceremony the emperor and princes would each make their obeisances to heaven standing by their divine staffs. Kang Xi issued a decree exempting Han officials from the ceremony.

The most important of the Tangzi ceremonies were those of offering sacrifices to heaven on the first day of the new year, and that of sacrificing to the battle flags before an expedition or after a victorious return from battle. These rituals were performed by the emperor in person. The sacred tablets representing the various gods were usually kept in the Hall of Earthly Peace. They were moved to the Tangzi on the twenty-sixth day of the twelfth lunar month in preparation for the ceremony on New Year's Day, and after the ceremony the tablets were once more returned to the palace. Standards were set up outside the inner gate of the Tangzi, and the emperor at the head of the expeditionary force would salute the flags before marching off. These rituals were supplemented by offering sacrifices to the gods at the Hall of Earthly Peace. When no ceremony was being performed at the Tangzi, the tablets of the various gods were kept in a shrine in the Palace of Purity and Tranquillity. In the early Qing the Hall of Earthly Peace was converted into a sacrificial hall in accordance with the former system of the Palace of Purity and Tranquillity.

At the Hall of Earthly Peace sacrifices were offered to the gods of different religions. Sakyamuni, Guanyin (the Goddess of Mercy) and Guandi (the God of War), for instance, were worshipped in the morning, while the God Mulihan, the Painted God and the Mongolian God were worshipped in the evening. The emperor and empress did not attend the morning and evening rituals when two pigs were killed in front of the tablets to the gods and then cooked in big cauldrons in the hall. The ceremony was conducted by the ritual official (saman), who beat a drum and chanted, accompanied by music from a three-stringed sanxian, a multi-stringed pipa and clappers. After the ceremony, the meat was distributed as laid down in the regulations.

There were shrines to the Buddha and other gods in various sleeping-palaces of the emperor and empress. However, no large-scale ceremonies were held in these places.

The Imperial Ancestral Temple was the principal venue for the Qing emperors to worship their ancestors. An ancestral temple was built by Abahai in Shenjing (today's Shenyang) when he still lived in the north-east. Sacrificial ceremonies were performed on the anniversaries of the births and deaths of the early emperors as well as on Qing Ming (Day of Pure Brightness). Every month appropriate seasonal offerings were made to the ancestors. After Emperor Shun Zhi gained control over the whole country he adopted Ming customs and took the ancestral temple of the Ming dynasty as his own ancestral temple. There were two types of sacrificial ceremony held at the Imperial Ancestral Temple: the seasonal offerings and the sacrifices at the end of the year. The seasonal offerings were made in the first ten days of spring and on the day of the first new moon in summer, autumn and winter. The emperor was required to fast before the ceremony and, on the appointed day, to go to the Imperial Ancestral Temple, offer sacrifices, burn incense and salute his ancestors. The sacrificial ceremony at the end of the year took place on the day before New Year's Eve. The memorial tablets of the ancestors were moved to the front hall. When he was sixty-two Qian Long decided he was too old to perform the ceremony, since he believed that any clumsy move during the ceremony might appear disrespectful to his ancestors. From that year, he always had princes accompany him. It was only when he was eighty-five and on the verge of abdicating, that he once again came alone, in order to show his special respect for his ancestors.

The tombs of the Qing emperors, empresses and imperial concubines were collectively known as lingqin, but more precisely, the tombs of the emperors and empresses were ling, while those of the imperial concubines were yuanqin. There are three Qing tombs at Shengjing, in what is today Liaoning Province in north-east China, as well as the Eastern

Tombs in Zunhua County, Hebei Province, and the Western Tombs in Yixian County, Hebei Province.

When Nurhachi (Emperor Tai Zu) and Abahai (Emperor Tai Zong) died, they were buried in Shengjing at Tianzu Hill and Longye Hill, respectively. Their tombs are known as the Fuling and the Zhaoling, and together with the Yongling (the ancestral Qing tombs at the foot of Qiyun Hill in Xingjing – now Xinbin County, Liaoning Province), they are known as the three tombs of Shengjing.

According to legend, the site of the Eastern Tombs was chosen when Emperor Shun Zhi was on a hunting expedition. The construction of the Xiaoling began there in 1661, but was not completed by the time he died. He was, however, buried there after its completion in 1663. The Empresses Xiao Kang and Xiao Xian were also buried there. Thirteen more tombs were built there.

The tomb area is divided into two parts – the Front Circle and the Rear Dragon – by the Changrui Hills in the middle. All around the area of the tombs were circles of green, red and white posts marking the boundaries. The gathering of firewood, grazing of animals and ploughing were all prohibited within the area enclosed by the posts. The area of the entire tomb site was about 2,500 square kilometres.

The Western Tombs are at the foot of the Yongning Hills west of the county town of Yixian in Hebei Province, about 120 kilometres west of Beijing. The tomb of the Emperor Yong Zheng was the first to be built here. Like the Eastern Tombs it was surrounded by red, white and green posts. In the tomb area were more than a thousand halls, pavilions and towers, and over a hundred stone structures and stone sculptures, although the area is smaller in total than that of the Eastern Tombs.

At both the Eastern and Western Tombs there were officials of the Imperial Household Department, the Board of Rites and the Board of Works responsible for repairs and the offering of sacrifices in the tomb area. The tombs themselves were guarded by soldiers of the Eight Banners and the boundaries of the area were guarded by soldiers of the Green Battalions. A full-scale mausoleum for a Qing emperor would include the following main structures along the Sacred Way leading to the tomb itself: a marble archway, Great Red Gate, ornamental stone columns, greater stele tower (containing the tablet recording the exploits and extolling the virtues of the deceased emperor), several pairs of stone sculptures, a Dragon and Phoenix Gate, a lesser stele tower and a multi-arched bridge. At the end of the Sacred Way was the Gate of Eminent Favour – the main entrance to the tomb buildings. On the east and west sides of the gate were the guard-houses and tomb kitchens. Further to the east of the eastern kitchen was the Sacred Larder for storing the sacrifices. Inside the Gate of Eminent Favour was the huge Hall of Eminent Favour which was used for the worship of ancestral tablets and performing sacrificial ceremonies. The hall had two wings – the ancestral ritual tablets were kept in the eastern wing, while the western wing was used by the lamas for the chanting of scriptures. There were two furnaces installed just inside the Gate of Eminent Favour, where the sacrifices were burned after the ceremony. Behind the Hall of Eminent Favour was a three-arched gate followed by a two-column gate, five sacrificial stone vessels, a square wall, a tomb tower and at the end the tomb wall and Holy Pinnacle. The emperor's coffin rested beneath the Holy Pinnacle in an underground palace. The tombs of empresses were generally smaller than those of emperors, and the imperial concubines were usually buried in groups.

According to Qing custom, large-scale ceremonies were held on Qing Ming (the Day of Pure Brightness), the Festival of Ghosts, the Winter Solstice, at the end of the year, on the anniversary of the death of an emperor and on days of national celebration. Minor ceremonies were performed on the days of the new moon and full moon.

When a reigning emperor came to pay homage at the tomb of one of his ancestors, he was required to change into mourning-garments, to offer three libations in front of the tomb wall and to salute before withdrawing. If the emperor attended one of the grand ceremonies in person, sacrifices were placed in the Hall of Eminent Favour.

The ceremony began with the emperor, clad in white, entering the Hall of Eminent Favour by the left door. He knelt before the sacrificial table, burned incense and performed the three prostrations and nine kowtows. After this there was the First Offering, the reading of the invocation, the Second Offering and the Third Offering. At each offering the emperor and his retinue had to perform the three prostrations and nine kowtows. At the end of this part of the ritual, the offerings were burned. After watching the burning of the sacrifices, the emperor went out by the left door and entered the tomb courtyard, also by the left door, and walked to the tomb tower. There, he stood facing the west and wailed in ceremonial mourning. When the grand ceremony was on the day of the Winter Solstice or on one of the days of national celebration, court dress was worn and there was no ceremonial wailing

The Qing court also continued the Ming-dynasty custom of holding a ceremony to pile fresh earth onto the tombs every year at Qing Ming. An official helped the emperor to carry loads of earth to the tomb tower, and then (wearing yellow protective shoes) they mounted the tomb wall to the east of the stone balustrade. When they came to the place in the middle of the Holy Pinnacle where the earth was to be piled, the official knelt and presented the earth to the emperor who in his turn received it on his knees. The emperor then raised the earth above his head and piled it onto the tomb. This was followed by the giving of seasonal offerings. In the Ming dynasty it had been the custom to pile up thirteen baskets of earth, and this practice was adopted by the early Qing emperors. However, when the Emperor Qian Long came to the throne he considered that piling thirteen baskets of earth was 'too troublesome', and the requirement was changed to only one basket.

Of all the Qing emperors, the one who made most frequent visits to the tombs was Emperor Qian Long. During his sixty years as reigning emperor and the three years he lived as father of the emperor, he visited the tombs almost every year. Only when he was old did he omit one or two visits. He visited the Eastern and Western Tombs even in the sixtieth year of his reign (1795), and also in the first year of Jia Qing (1796), when he was over eighty years old, in order to show his sincere respect for his ancestors.

There were no written regulations concerning the number or types of articles to be buried with Qing emperors and empresses. There exists, however, a written record of the items buried in the tomb of Empress Dowager Ci Xi. There were in all over 33,560 pearls on the grave clothes and covers as well as filling the spaces of the coffin. There were more than 3,660 rubies, sapphires, cat's-eyes and emeralds and over 350 articles of carved jade, gold Buddhas, jade Buddhas, and arhats, horses and trees made of coral. It would hardly be exaggerating to say that the empress dowager was 'buried in precious stones'. Their value even exceeded that of the 'jade clothing sewn with gold thread' in which the Han princes were buried.

457

457. The Altar of Heaven.

The Altar of Heaven (part of the Temple of Heaven) is outside the Zhengyang Gate in the south-east, an area historically known as the southern outskirts. The altar was used by the Qing emperors when they reported and offered sacrifices to heaven. This circular altar, built in the ninth year of the emperor Jia Jing (1530) in the Ming dynasty, is a structure in three tiers, representing the ninth, seventh and fifth heavens, respectively. It is paved with white stone and encircled by balustrades of carved white marble. Four flights of steps lead to the top from the north, south, east and west. The first time the Altar of Heaven was used in the Qing dynasty was on the first day of the tenth month in the first year of Shun Zhi (1644), that is, the day Emperor Shun Zhi was enthroned. After the Manchus had conquered China, Dorgon (the Prince of Rui) wanted to show that the crossing of the Great Wall by the Qing army and the enthronement of Fulin were the will of heaven and a response to the feelings of the people. To this end, he specially arranged for the emperor to perform the ritual of reporting to heaven at the Altar of Heaven before the ceremony of enthronement.

458

458. The Hall of Prayer for a Good Year.

This circular hall with its three-tiered roof to the north of the Altar of Heaven was first built during the Jia Jing period of the Ming dynasty, and the three tiers of the roof were initially covered with blue, yellow and green glazed tiles. Originally named the Great Offerings Hall, it was the place where the Qing emperors prayed for a good harvest in the first month of the year, but in the sixteenth year of Qian Long (1751), a minister pointed out that,

459

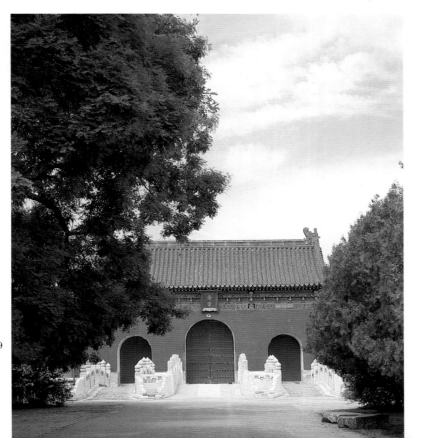

while the Great Offerings Ceremony was performed there in the autumn, the prayer for a good harvest was also offered there in the spring, and the name of the hall should therefore be changed. On this advice Emperor Qian Long changed the name to the Hall of Prayer for a Good Year and had all three tiers of the roof covered with blue glazed tiles.

459. The Hall of Abstinence at the Altar of Heaven.

To show his piety when performing the sacrificial ceremony to heaven, the emperor had to observe abstinence for three days before the ceremony. The first two of these days were observed in the palace, but the third night, that prior to the day of the ceremony, had to be spent at the Hall of Abstinence to the west of the Altar of Heaven.

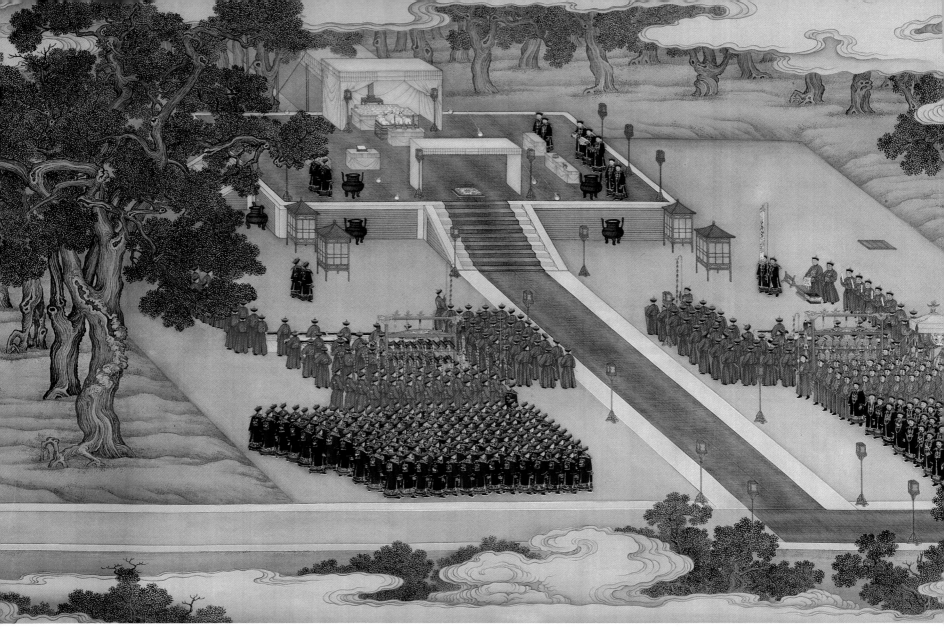

460

460. *Emperor Yong Zheng Sacrifices at the Altar of the God of Agriculture.*

The Altar of the God of Agriculture is located to the south-west of the Zhengyang Gate. The square platform shown in the middle of the picture is the sacrificial altar, where a yellow canopy has been erected to protect the tablet of Shen Nong, the God of Agriculture. Below the altar are civil and military officials in court costume, an orchestra and a dance ensemble dressed in red, all respectfully waiting for the arrival of the emperor.

461. The Altar of Land and Grain.

The square Altar of Land and Grain is on the right of the Gate of Correct Demeanour. The altar was covered with green, white, red, black and yellow earth, representing the east, west, south, north and centre of the land of China. Every year, in mid-spring and mid-autumn, the emperor burned incense at this altar, to show reverence to the God of Land and the God of Grain.

461

462. A court robe worn during the offering of sacrifices at the Altar of the Moon.

Every year on the day of the autumn equinox, the emperor went to the Altar of the Moon in the western suburbs to sacrifice to the moon. For this occasion, he wore a blue robe embroidered with clouds and golden dragons.

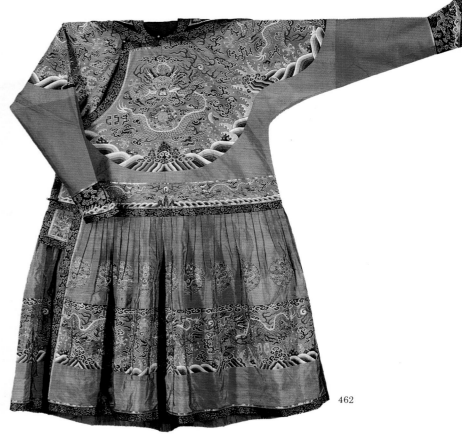

462

463

463. The Altar of the Goddess of Silkworms.

The Altar of the Goddess of Silkworms is in the north-eastern corner of the Western Park. There is a mulberry orchard to the east of it and behind it are the mulberry observation platform and the Pool for Washing Silkworms. After performing the sacrificial ceremony at the Altar of the Goddess of Silkworms, the empress went to the mulberry orchard to pick mulberry leaves. In spring, after the silkworms had spun their cocoons, the empress revisited the altar and unreeled three basins of cocoons as an indication of the importance attached to sericulture by the court.

464. A coral court necklace.

This coral necklace was worn by the Qing emperors when they offered sacrifices at the altars.

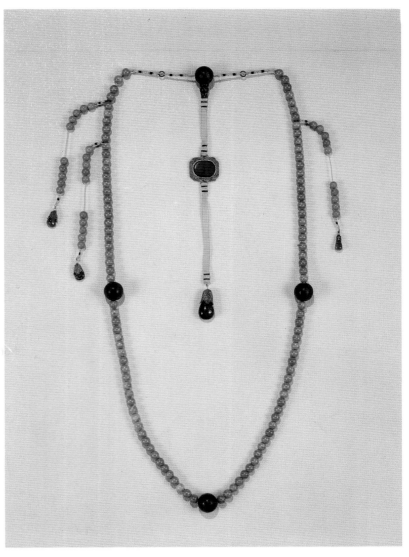

464

465

465. The Lamasery of Harmony and Peace.

The Lamasery of Harmony and Peace in the north-eastern corner of the capital was originally the residence of Yinzhen, Prince Yong, the fourth son of the Emperor Kang Xi. After Yinzhen's ascension to the throne, the residence was renamed the Palace of Harmony and Peace. It was converted into a lamasery during the reign of Qian Long and a huge gilded bronze statue of Tsongkhapa, the founder of the Yellow Sect of Lamaism, more than ten metres in height, was enshrined in it. In the rear hall is a sandalwood statue of the Buddha which is eighteen metres high. The Lamasery of Harmony and Peace is the largest lamasery in the capital.

466. The Hall of the Wheel of the Law in the Lamasery of Harmony and Peace.

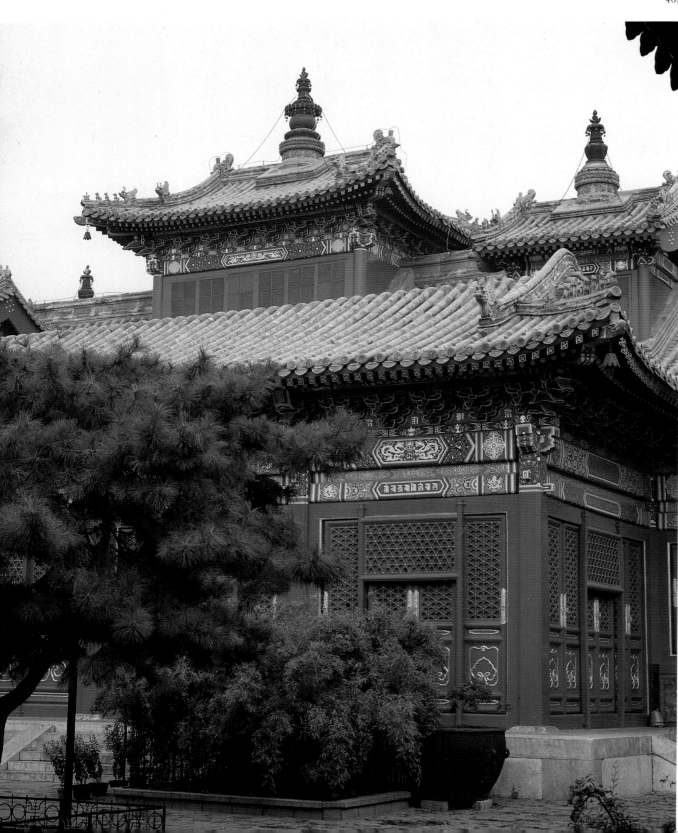

466

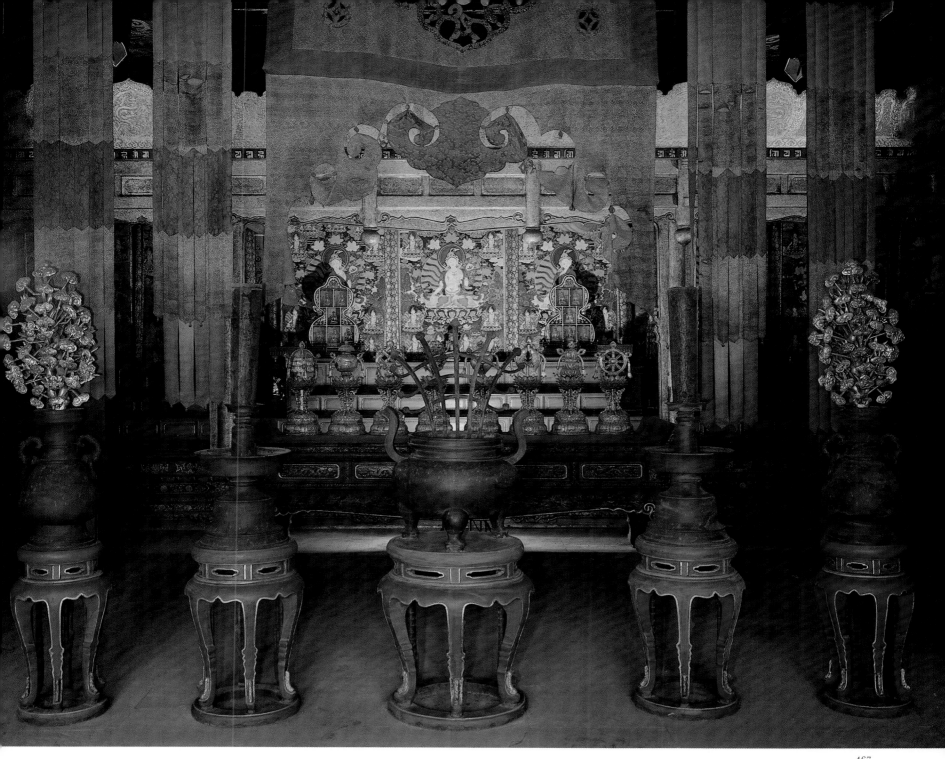

467. The Buddhist shrine in the Hall for Worshipping Buddhas.

The Hall for Worshipping Buddhas is a square, pavilion-like hall in the garden of the Palace of Benevolent Peace. In it were Buddhist images, musical instruments and ritual objects. It was the place where empresses and consort dowagers worshipped Buddha.

468. The Rain-Flower Pavilion.

The Rain-Flower Pavilion was an important Buddhist shrine in the palace. It is a three-storeyed building with a broach roof covered with gilt-bronze tiles and with a gilt-bronze flood-dragon at each of the four corners. It housed many Buddhist statues.

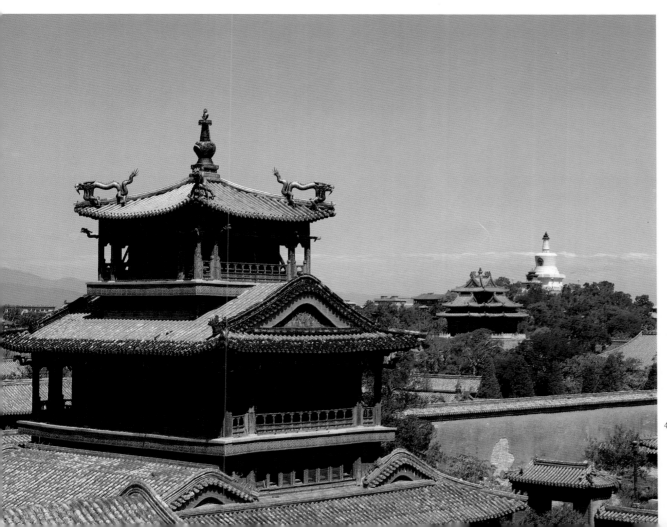

468

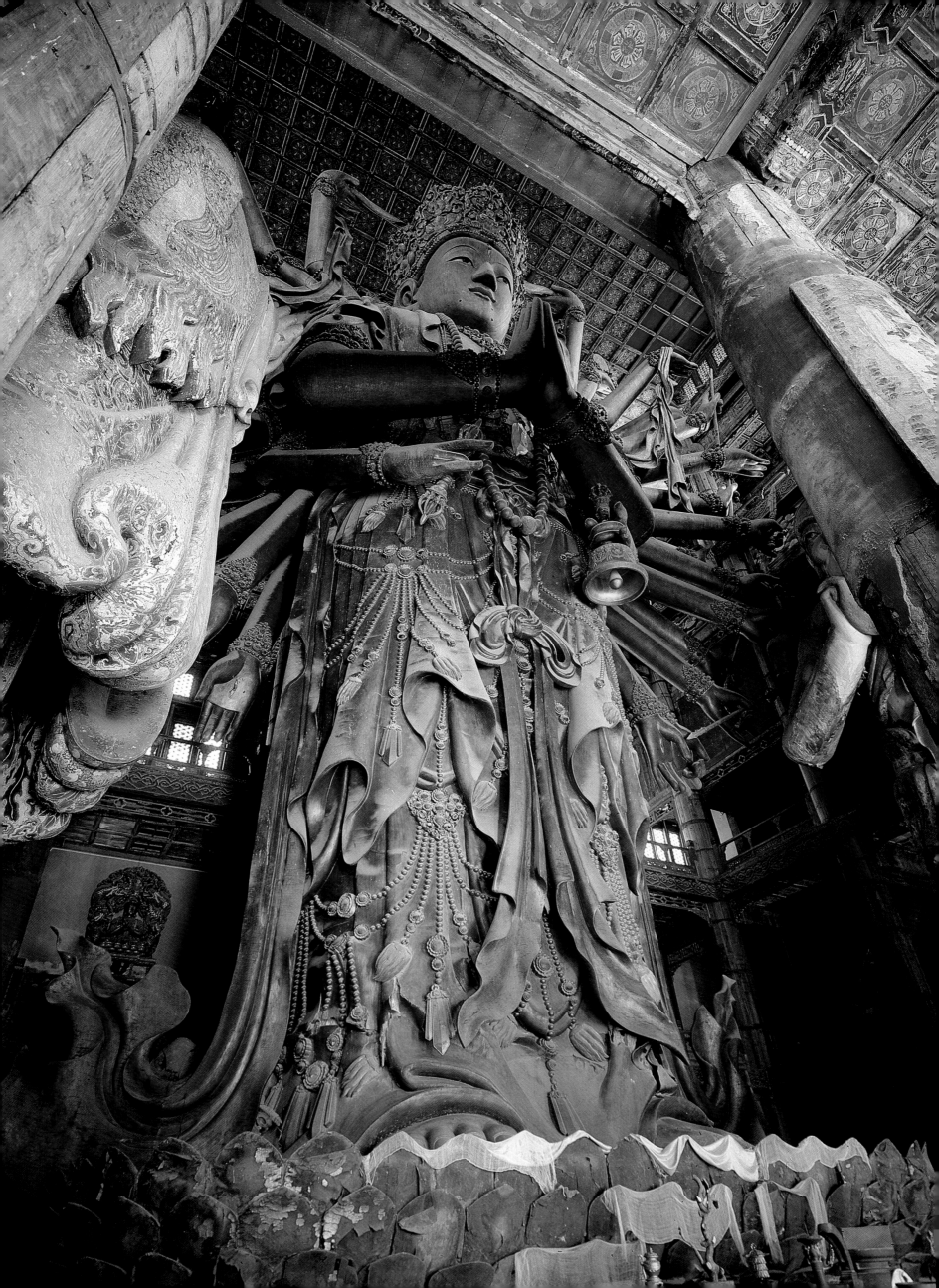

469. The thousand-eyed, thousand-armed Guanyin (Goddess of Mercy) in the Hall of the Great Vehicle of the Temple of Universal Peace. (22.28 m)

In order to strengthen the control of the Qing dynasty over the empire, the Emperors Kang Xi and Qian Long tried to gain the approval of the Mongolian and Tibetan aristocrats by closely integrating religion with politics and honouring the Yellow Sect of Tibetan Buddhism. Emperor Qian Long sent draughtsmen to make drawings of temples in Tibet and, in the twentieth year of his reign (1755), built the Temple of Universal Peace by the Wulie River in Chengde, on the model of the Samye Temple in Tibet. The Hall of the Great Vehicle is the principal structure in the temple. The wood-carved statue of the thousand-armed, thousand-eyed Guanyin in the hall has forty-two arms with an eye in each palm and holds a Buddhist emblem in each hand. The head of the statue is gilded and there are three eyes on her forehead, symbolizing insight into the past, present and future. The Buddha seated on her head and the tiny Buddha in her head-dress are her teachers. The statue, for all its arms and eyes, is well proportioned, with the drapery falling in flowing, natural lines; it is a work of considerable sculptural merit.

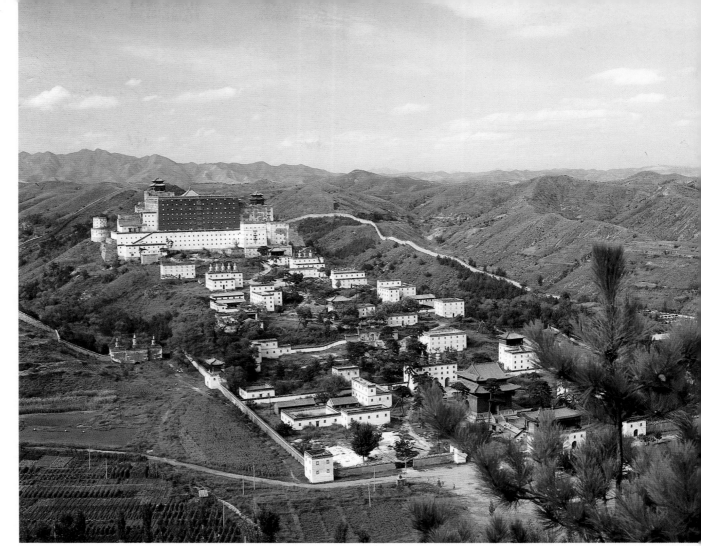

470

470. The Little Potala.

This is the largest lamasery built by Emperor Qian Long in Chengde. In the doctrine of Lamaist Buddhism, the Potala of the Vehicle is the most holy place. Emperor Qian Long always regarded Tibet as 'the gathering point of the tribes who pledge allegiance to Buddhism', because Tibet was the centre of the Yellow Sect of Lamaism, and the Dalai Lama who lived in the Potala Palace in Lhasa was a sacred ruler in the eyes of the Mongolian and Tibetan tribes. If the emperor were able to control the high-ranking lamas, he would then be able to rule the Mongolian and Tibetan areas with relative ease. The sixtieth birthday of Emperor Qian Long fell in the thirty-fifth year of his reign (1770) and the eightieth birthday of Empress Dowager Chong Qing in the following year, and the heads of the tribal groups in Inner and Outer Mongolia, Xinjiang and Qinghai were all due to come to Chengde to celebrate these two birthdays. In order to win over the nobles of these tribes, who were devout followers of the Yellow Sect of Lamaism, Emperor Qian Long had the Little Potala built in Chengde on the model of the Potala Palace in Lhasa.

471

471. The Temple of Sumeru Happiness and Longevity.

Another Living Buddha of the Yellow Sect was Panchen Erdeni, who lived in the Tashilhunpo Temple in Xigazê, Tibet, and the Emperor Qian Long considered that 'since there is a Potala, there ought to be a Tashilhunpo'. He therefore ordered the construction of the Temple of Sumeru Happiness and Longevity in Chengde after the model of the Tashilhunpo Temple, to celebrate the occasion of his seventieth birthday, when the Sixth Panchen Erdeni was to attend the festivities. Sumeru is the name of a mountain in the Buddhist scriptures and, in Tibetan, is 'lhunpo'. 'Tashi' in Tibetan means happiness and longevity. Together they mean 'happiness and longevity as long-lasting as Sumeru Mountain'. The main structures of the temple are the Great Red Terrace and the Exalted and Dignified Hall. The broach roof of the hall is covered with gilt-bronze fish-scale tiles, and each of the four roof-ridges is surmounted by two flying dragons, which give a splendid decorative quality to the temple. The Sixth Panchen Erdeni expounded Buddhism in this hall when he stayed in Chengde.

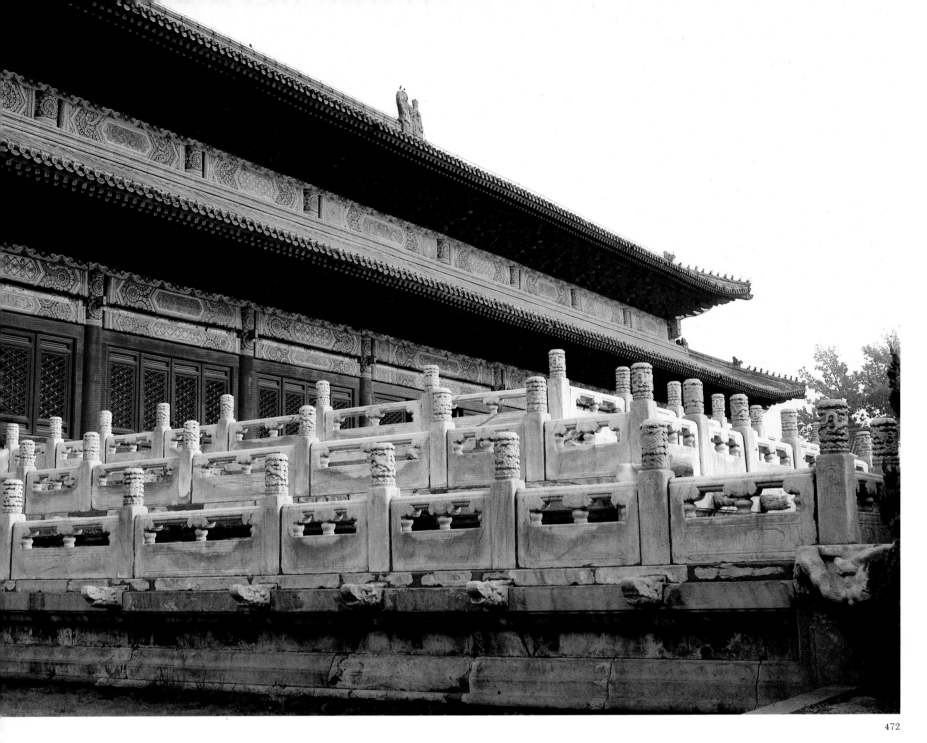

472

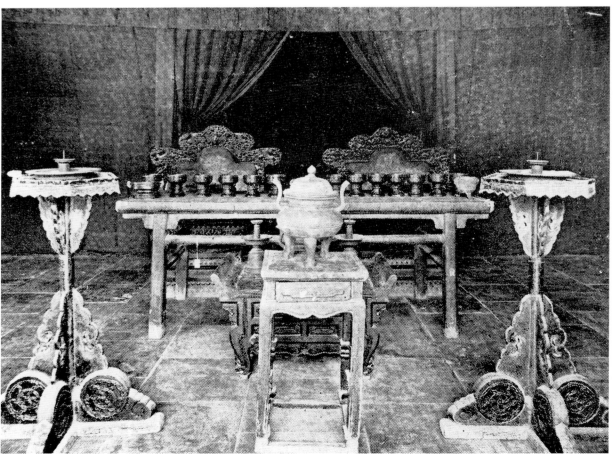

473. The Imperial Ancestral Temple.

This consists of three main halls, large-scale ancestor worshipping ceremonies being held in the front hall. Memorial tablets for Nurhachi and his descendants were placed in the middle hall. There were shrines to four ancestors of Nurhachi in the rear hall. The Qing emperors came to the Imperial Ancestral Temple to pay their respects to their ancestors.

473. The interior of the rear hall of the Imperial Ancestral Temple.

The rear hall was the Shrine of Remote Ancestors. In 1648, when the Qing court was codifying the ceremonial procedures, Nurhachi's great-great-grandfather, his great-grandfather, his grandfather and his father were all honoured with posthumous titles. These four were thus known as 'the four ancestors' and enshrined in this hall.

473

474. The interior of the rear part of the Hall of Ancestral Worship.

Divided into front and rear parts, this was the family temple of the Qing imperial house, and the memorial tablets of the deceased emperors and empresses were usually kept in the rear section of the hall. Since the Hall of Ancestral Worship was a family temple, the emperor would come himself, or send a relative on the day of the new moon to make seasonable offerings, such as carp and young chives in the first month of the year, and lettuce and spinach in the second month, to show his filial piety and to enable his ancestors to enjoy the greatest range of delicacies as soon as they were available.

475. The sacrificial area in the Hall of Earthly Peace.

Inside the door on the right of the picture is the place where the meat that was to be sacrificed to the gods was cooked. The throne on the left was where the emperor ate the meat during the sacrificial ceremony.

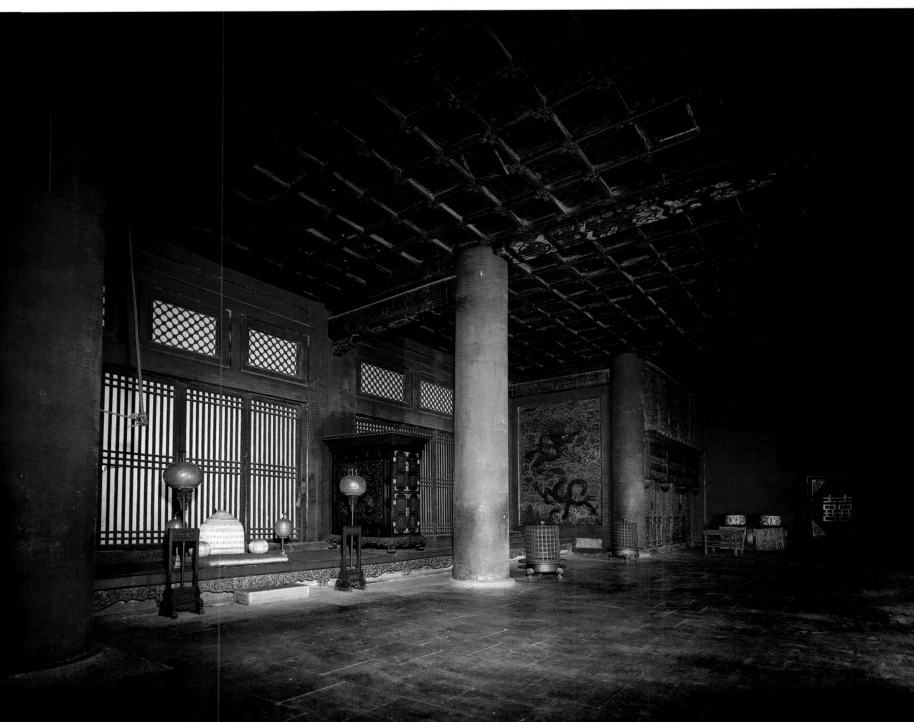

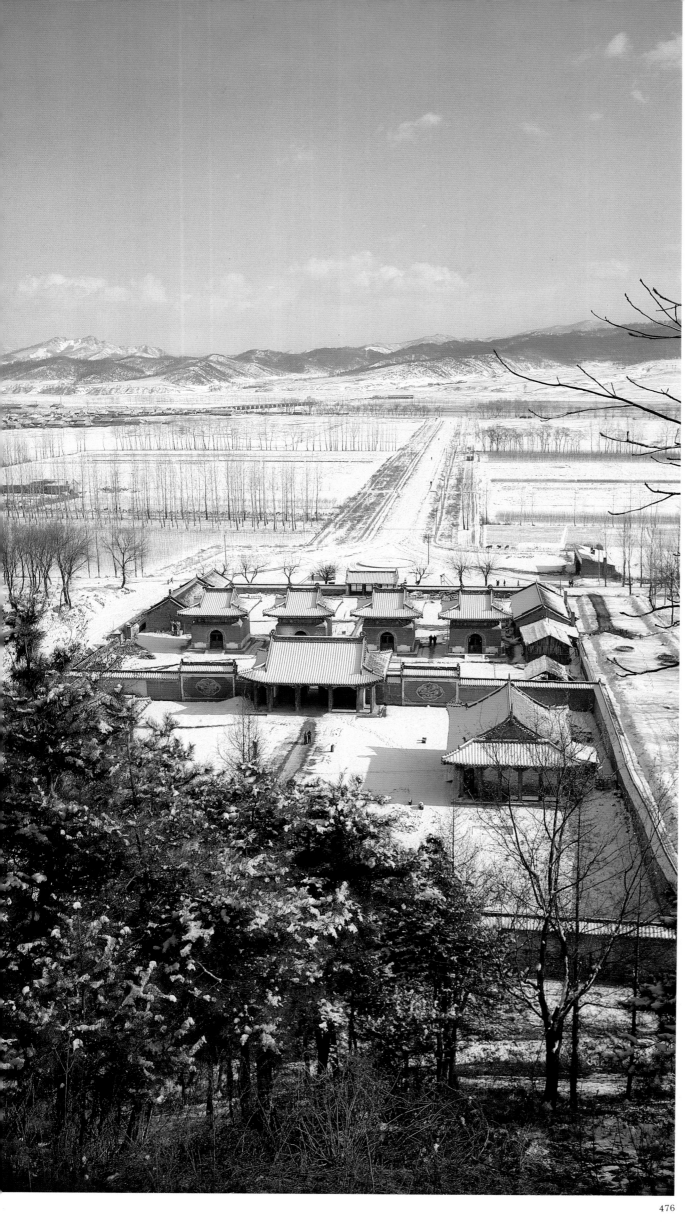

476. A view of the Yongling Mausoleum.

The Yongling Mausoleum, originally called the Xingjingling, is situated by the Suzi River at the foot of Qiyun Hill to the north-west of the town of Xingjing. First built in the twenty-sixth year of the Ming Emperor Wan Li (1598), it was rebuilt several times during the reigns of Kang Xi and Qian Long in the Qing dynasty. The ancestors of the Qing emperor Nurhachi – his great-great-grandfather, Mönge Tumür (Prince Ze), his great-grandfather, Fuman (Prince Qing), his grandfather, Giocangga (Prince Chang), his father, Taksi (Prince Fu), and his uncles, Lidun and Tachapiangu, and their wives – were buried in this mausoleum.

476

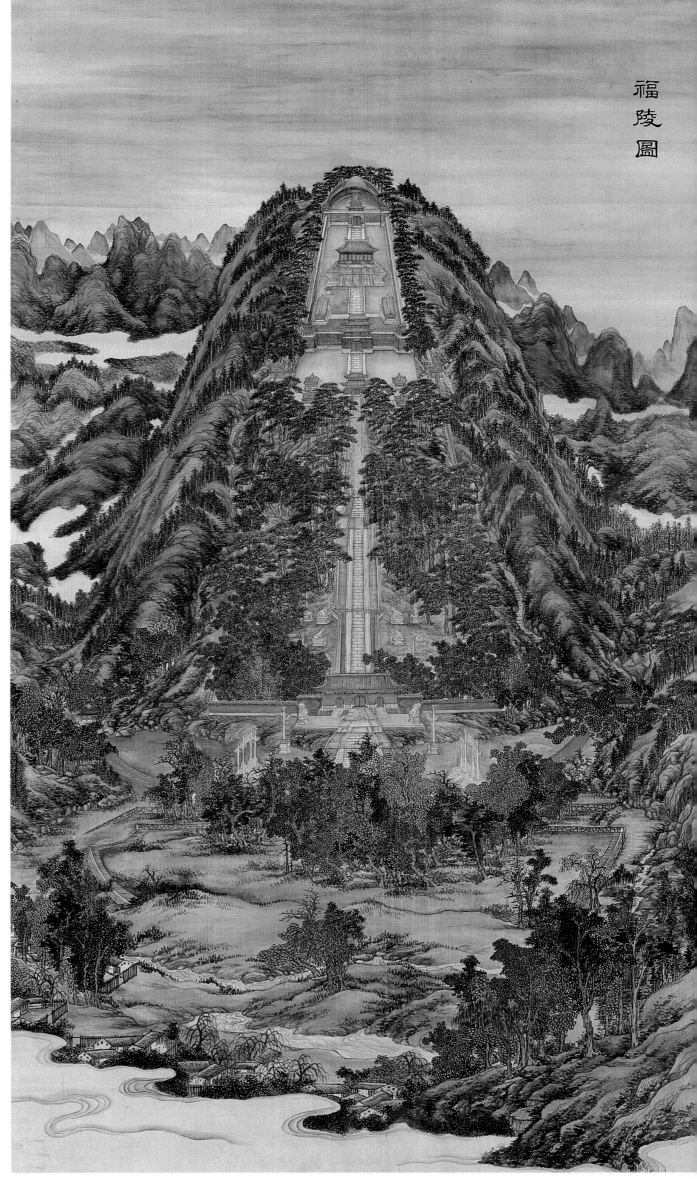

福陵圖

477. *Fuling Mausoleum.* (156 cm × 88 cm)

The Fuling, which is located in the eastern outskirts of Shenyang on Tianzhu Hill on the northern bank of the Hun River, is the tomb of Nurhachi, Emperor Tai Zu of the Qing dynasty, and Yehonala, Empress Xiao Ci Gao. It was popularly known as the Eastern Mausoleum. Building began in the third year of Tian Cong (1629) and the complex was completed in the eighth year of Shun Zhi (1651).

477

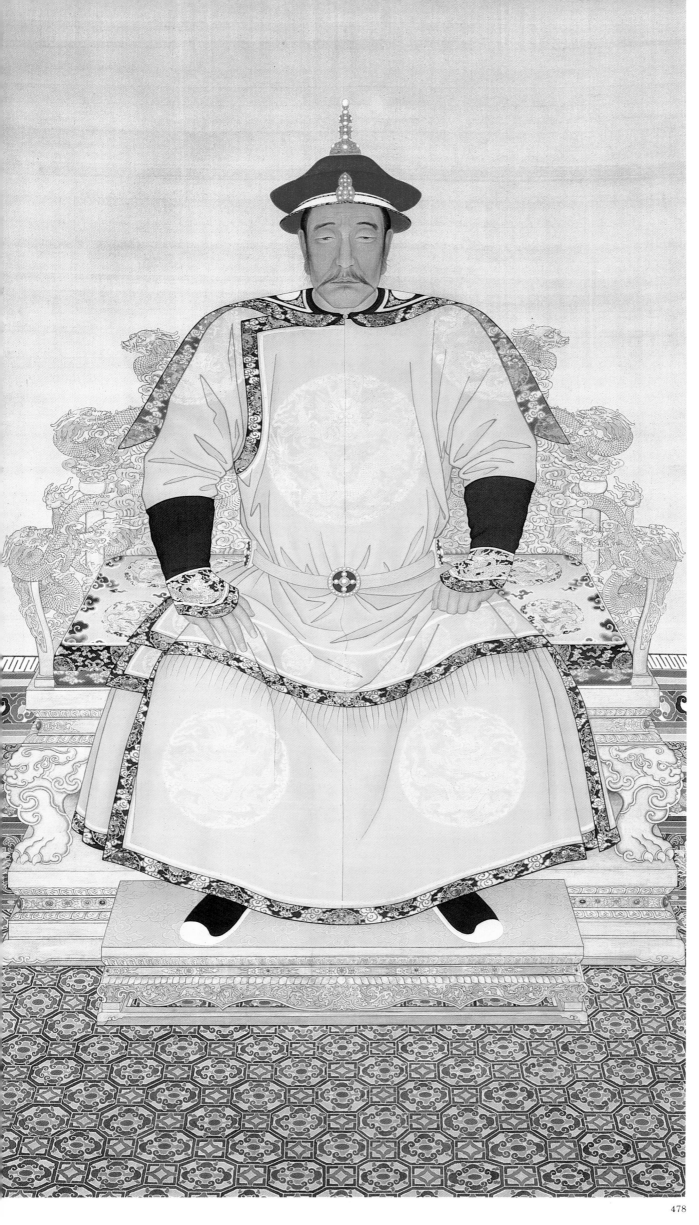

478. A portrait of Nurhachi, Emperor Tai Zu of the Qing dynasty. (276 cm × 166 cm)

Aisin-Gioro Nurhachi was an outstanding statesman and the founder of the Qing dynasty. He served first as a general of the Ming dynasty and founded the Later Jin regiment in the forty-fourth year of Wan Li (1616) in Hetuala in north-east China, calling the reign-period Tian Ming. Nurhachi was born in the thirty-eighth year of the Jia Jing era of the Ming dynasty (1559). He was seriously wounded in the Battle of Ningyuan in the first month of the eleventh year of the Tian Ming period (1626) and died, twenty kilometres from Shenyang, on the eleventh day of the eighth month of that year, at the age of sixty-eight.

478

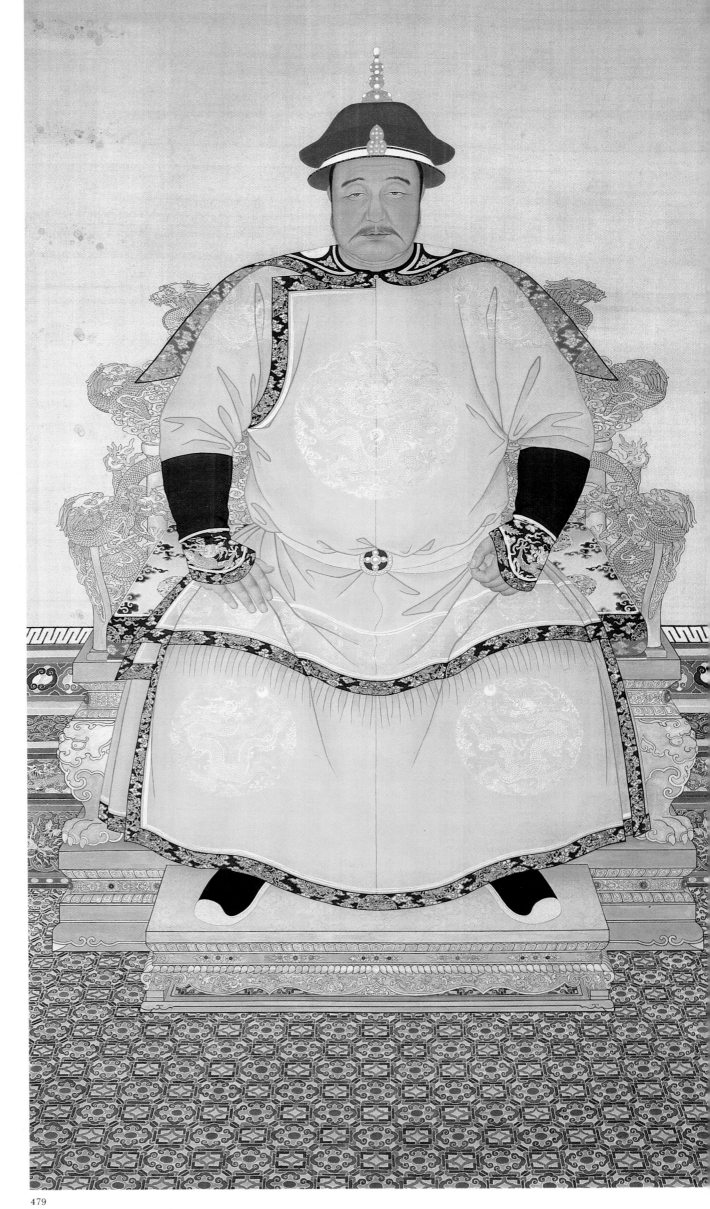

479. A portrait of Abahai, Emperor Tai Zong. (272.5 cm × 142.5 cm)

Emperor Tai Zong of the Qing dynasty was the eighth son of Nurhachi; born in the twentieth year of the Wan Li period of the Ming dynasty (1592) in Hetuala, he was an eminent statesman and military strategist. He served as one of the chief commanders of the Eight Banner army and for decades was actively engaged on the battlefield, making a considerable contribution to the founding of the Qing dynasty. When Nurhachi died Abahai succeeded to the title of Khan and named his reign Tian Cong. He formally assumed the title of emperor ten years later and named his dynasty the Great Qing and his reign Chong De. He died in the eighth month of the eighth year of his reign (1643) in the palace in Shenyang, at the age of fifty-two.

479

morning.

493. The Hall of Eminent Favour at the Tailing Mausoleum.

The Tailing, the earliest and largest of the Western Tombs, is the mausoleum of Emperor Yong Zheng. The Hall of Eminent Favour was where the sacrificial ceremonies were held. All the exposed columns in the hall are gilded and the beams and rafters are decorated with harmonious designs. There are three alcoves in the hall, where the memorial tablets of the dead were kept, and three large tables in front of the alcoves, where sacrificial vessels and offerings were placed. Thrones are positioned behind the tables and, during memorial ceremonies, the memorial tablets were placed on these thrones.

494. The Tailing Mausoleum at night.

494

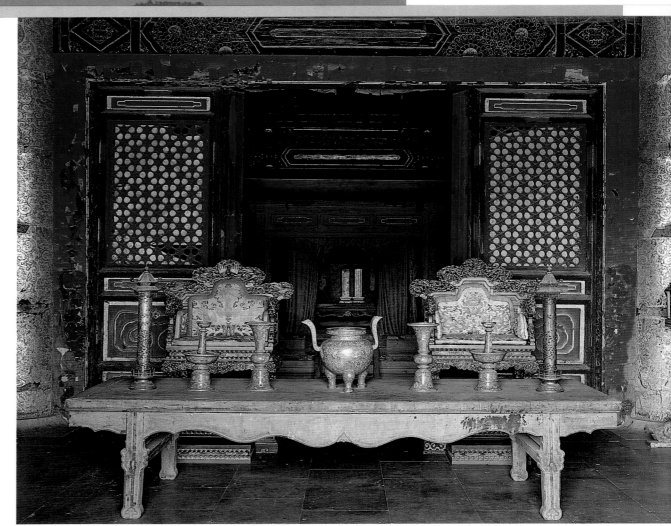

493

495. A view of the Tailing Mausoleum.

496. The bridge and memorial archway covered with glazed tiles at the Tailing Mausoleum.

495

496

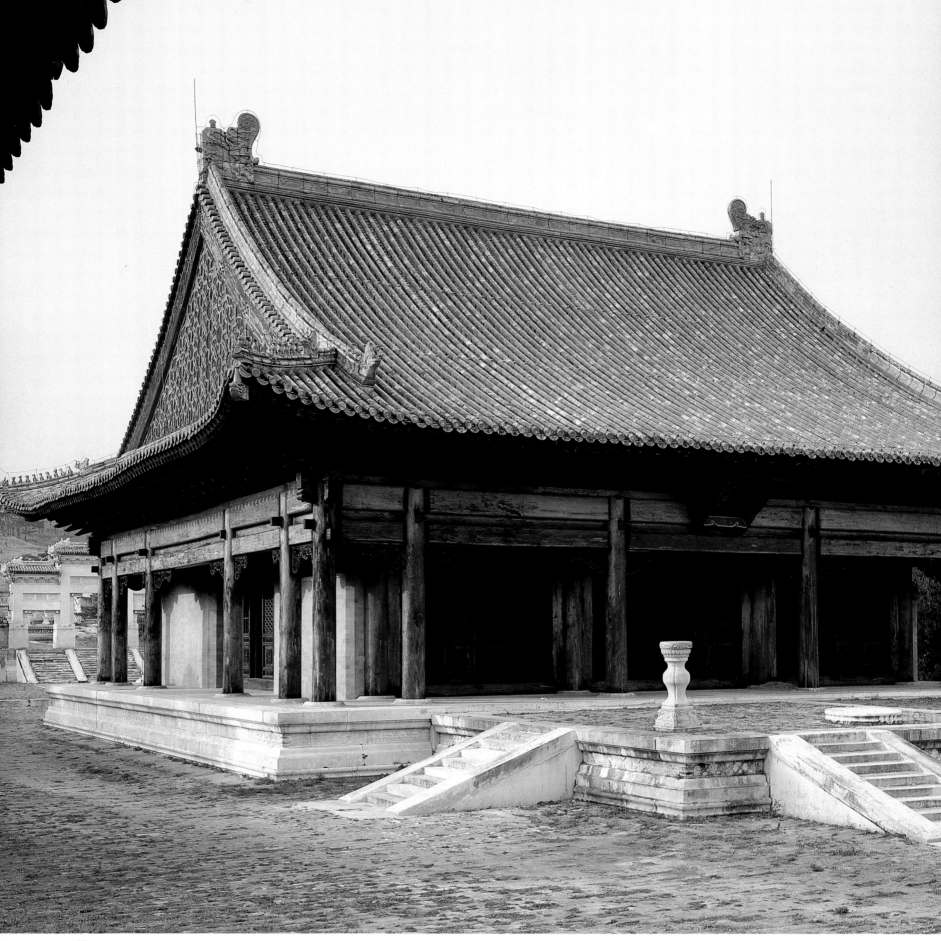

497

498

497. The Hall of Eminent Favour at the Muling Mausoleum.

498. The Ceiling of the Hall of Eminent Favour of the Muling Mausoleum.

The Muling is the tomb of Emperor Dao Guang. When he ascended the throne, Emperor Dao Guang followed the edict of Emperor Kang Xi that the tombs of the imperial family were to be built alternately at the Eastern and Western Tombs, and he spent seven years building his tomb in Baohuayu at the Eastern Tombs. However, in the eighth year, water began to seep into the underground palace, and Emperor Dao Guang looked upon this as a bad omen. He had the officials responsible punished and the whole project was completely dismantled. He then chose an auspicious site at the Western Tombs and started again. Construction of the new tomb began in the twelfth year of his reign (1832) and was completed four years later. The architectural style of Muling is different from that of all the other tombs. There is no tomb tower in front of the tomb. The Hall of Eminent Favour is built entirely

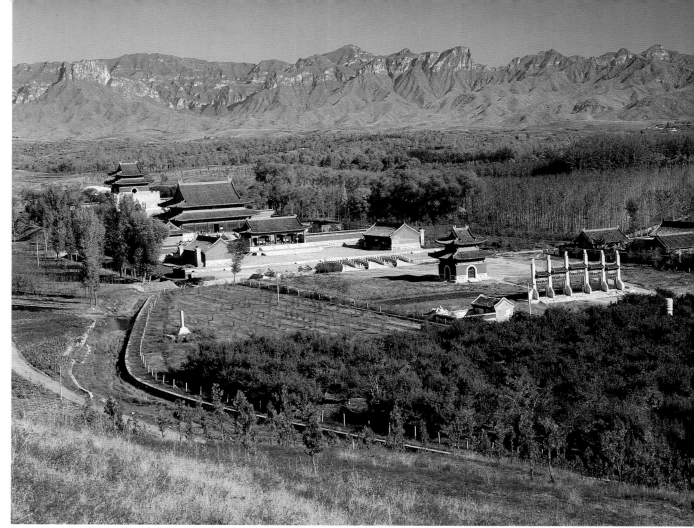

499

500

of cedarwood and is unpainted. The ceiling is also panelled with cedarwood carved with flying or coiled dragons, forming a scene of 'ten thousand dragons gathering and spouting fragrance from their mouths'.

499. A view of the Chongling Mausoleum.

500. The Tombs of the Consorts Jin and Zhen.

Emperor Guang Xu's consorts, Jin and Zhen, are buried at the Chongling. The two concubines were sisters, the daughters of Vice-President Chang Xu of the Tatala clan. Consort Jin died in 1924. Zhen displeased Empress Dowager Ci Xi because she supported the reforms instigated by Emperor Guang Xu, and in the seventh month of the twenty-sixth year of Guang Xu (1900), when Beijing was invaded by the Eight-Power Allied Forces, Empress Dowager Ci Xi murdered Zhen by having her thrown into a well behind the Palace of Peaceful Old Age, before herself fleeing the city. Zhen's body, after being removed from the well, was kept at Tiancun outside the Xizhi Gate of Beijing and temporarily buried at the touring palace at Lianggezhuang in March 1913. It was re-buried at Chongling in November of that year with the ceremonies befitting a high consort.

APPENDIXES 附錄

A CHRONOLOGICAL TABLE OF THE QING EMPERORS

Title of Reign	Temple Title	Posthumous Title	Name	Year and Place of Birth	Year and Place of Death	Age at Death	Date of Accession	Age at Time of Accession	Years of Reign	No. of Years
Tian Ming	Tai Zu	Emperor Gao	Nurhachi	1559	1626, Aijibao	68	First day, first month, first year of Tian Ming	58	1616–26	11
Tian Cong and Chong De	Tai Zong	Emperor Wen	Abahai	1592, Hetuala	1643, Palace of Purity and Tranquillity	52	First day, ninth month, eleventh year of Tian Ming	35	1627–43	17
Shun Zhi	Shi Zu	Emperor Zhang	Fulin	1638, Palace of Lasting Happiness, Shengjing	1661, Hall of Mental Cultivation	24	Twenty-sixth day, eighth month, eighth year of Chong De	6	1644–61	18
Kang Xi	Sheng Zu	Emperor Ren	Xuanye	1654, Palace of Great Benevolence	1722, Garden of Joyous Spring	69	Nineteenth day, first month, eighteenth year of Shun Zhi	8	1662–1722	61
Yong Zheng	Shi Zong	Emperor Xian	Yinzhen	1678	1735, Garden of Perfection and Brightness	58	Twentieth day, eleventh month, sixty-first year of Kang Xi	45	1723–35	13
Qian Long	Gao Zong	Emperor Chun	Hongli	1711, Yongqin Mansion	1799, Hall of Mental Cultivation	89	Third day, ninth month, thirteenth year of Yong Zheng	25	1736–95	60
Jia Qing	Ren Zong	Emperor Rui	Yongyan	1760, Tiandiyijiachun, Garden of Perfection and Brightness	1820, Summer Palace at Chengde (Jehol)	61	First day, first month, first year of Jia Qing	37	1796–1820	25
Dao Guang	Xuan Zong	Emperor Cheng	Minning	1782, Hall of Gathering Fragrance	1850, Hall of Care and Virtue, Garden of Perfection and Brightness	69	Twenty-seventh day, eighth month, twenty-fifth year of Jia Qing	39	1821–50	30
Xian Feng	Wen Zong	Emperor Xian	Yizhu	1831, Hall of Clear Tranquillity, Garden of Perfection and Brightness	1861, Hall of Refreshing Mists and Waves, Summer Palace at Chengde	31	Twenty-sixth day, first month, thirtieth year of Dao Guang	20	1851–61	11
Tong Zhi	Mu Zong	Emperor Yi	Zaichun	1856, Palace of Concentrated Beauty	1874, Hall of Mental Cultivation	19	Ninth day, tenth month, eleventh year of Xian Feng	6	1862–74	13
Guang Xu	De Zong	Emperor Jing	Zaitian	1871, Huaiyin Study, Taipinghu Mansion	1908, Hanyuan Palace, Sea Terrace Island	38	Twentieth day, first month, first year of Guang Xu	4	1875–1908	34
Xuan Tong			Puyi	1906, Prince Chun's Mansion, Shichahai	1967, Capital Hospital, Beijing	62	Ninth day, eleventh month, thirty-fourth year of Guang Xu	3	1909–11	3

Name of Tomb	Location of Tomb	Buried with	Name of Father	Name of Mother	Seniority Among Brothers	Number of Children		Date of Entombment
						Sons	Daughters	
Fuling	Shenyang	Empress Xiao Ci Gao	Xian Zu	Empress Xuan (Hitala)	First	16	8	Thirteenth day, second month, third year of Tian Cong, removed to Fuling
Zhaoling	Shenyang	Empress Xiao Duan Wen	Tai Zu	Empress Xiao Ci Gao (Yehonala)	Eighth	11	14	Eleventh day, eighth month, first year of Shun Zhi
Xiaoling	Eastern Tombs, Zunhua	Empresses Xiao Kang Zhang and Xiao Xian Duan Jing	Tai Zong	Empress Xiao Zhuang Wen (Borjigit)	Ninth	8	6	Sixth day, sixth month, second year of Kang Xi
Jingling	Eastern Tombs, Zunhua	Empresses Xiao Cheng Ren, Xiao Zhao Ren, Xiao Yi Ren, Xiao Gong Ren and Imperial Consort Jing Min	Shi Zu	Empress Xiao Kang Zhang (Tunggiya)	Third	35	20	First day, ninth month, first year of Yong Zheng
Tailing	Western Tombs, Yixian	Empress Xiao Jing Xian and Imperial Consort Dun Su	Sheng Zu	Empress Xiao Gong Ren (Uya)	Fourth	10	4	Second day, third month, second year of Qian Long
Yuling	Eastern Tombs, Zunhua	Empresses Xiao Xian Chun and Xiao Yi Chun, and Imperial Consorts Hui Xian, Zhe Min and Shu Jia	Shi Zong	Empress Xiao Sheng Xian (Niuhuru)	Fourth	17	10	Fifteenth day, ninth month, fourth year of Jia Qing
Changling	Western Tombs, Yixian	Empress Xiao Shu Rui	Gao Zong	Empress Xiao Yi Chun (Wei)	Fifteenth	5	9	Twenty-third day, third month, first year of Dao Guang
Muling	Western Tombs, Yixian	Empresses Xiao Mu Cheng, Xiao Shen Cheng and Xiao Quan Cheng	Ren Zong	Empress Xiao Shu Rui (Hitala)	Second	9	10	Second day, third month, second year of Xian Feng
Dingling	Eastern Tombs, Zunhua	Empress Xiao De Xian	Xuan Zong	Empress Xiao Quan Cheng (Niuhuru)	Fourth	2	1	Twenty-second day, ninth month, fourth year of Tong Zhi
Huiling	Eastern Tombs, Zunhua	Empress Xiao Zhe Yi	Wen Zong	Empress Xiao Qin Xian (Yehonala)	First	–	–	Twenty-sixth day, third month, fifth year of Guang Xu
Chongling	Western Tombs, Yixian	Empress Xiao Ding Jing	Yihuan, Prince Chun	Sister of Ci Xi (Yehonala)	Second	–	–	Sixteenth day, eleventh month, second year of the Republic
	Babaoshan Cemetery		Zaifeng, Prince Chun	Suwangua'erjia	First	–	–	—

A CHRONOLOGICAL TABLE
OF THE QING EMPRESSES

Posthumous Title	Clan Name	Wife of	Year of Birth	Year of Death	Age at Death
Empress Xiao Ci Gao	Yehonala	Nurhachi	1575	1603	29
Empress Xiao Duan Wen	Borjigit	Abahai	1599	1649	51
Empress Xiao Zhuang Wen	Borjigit	Abahai	1613	1687	75
Empress Xiao Hui Zhang	Borjigit	Shun Zhi	1641	1717	77
Empress Xiao Kang Zhang	Tunggiya	Shun Zhi	1640	1663	24
Empress Xiao Xian Duan Jing	Donggo	Shun Zhi	1639	1660	22
Empress Xiao Cheng Ren	Hesheli	Kang Xi	1653	1674	22
Empress Xiao Zhao Ren	Niuhuru	Kang Xi	—	1678	
Empress Xiao Yi Ren	Tunggiya	Kang Xi	—	1689	
Empress Xiao Gong Ren	Uya	Kang Xi	1660	1723	64
Empress Xiao Jing Xian	Ulanara	Yong Zheng	—	1731	
Empress Xiao Sheng Xian	Niuhuru	Yong Zheng	1692	1777	86
Empress Xiao Xian Chun	Fucha	Qian Long	1712	1748	37
Empress Xiao Yi Chun	Wei	Qian Long	1727	1775	49
Empress Xiao Shu Rui	Hitala	Jia Qing	—	1797	
Empress Xiao He Rui	Niuhuru	Jia Qing	1776	1849	74
Empress Xiao Mu Cheng	Niuhuru	Dao Guang	—	1808	
Empress Xiao Shen Cheng	Tunggiya	Dao Guang	—	1833	
Empress Xiao Quan Cheng	Niuhuru	Dao Guang	1808	1840	33
Empress Xiao Jing Cheng	Borjigit	Dao Guang	1812	1855	44
Empress Xiao De Xian	Sakeda	Xian Feng	—	1849	
Empress Xiao Zhen Xian	Niuhuru	Xian Feng	1837	1881	45
Empress Xiao Qin Xian	Yehonala	Xian Feng	1835	1908	74
Empress Xiao Zhe Yi	Alute	Tong Zhi	1854	1875	22
Empress Xiao Ding Jing	Yehonala	Guang Xu	1868	1913	46

Marriage and Conferment of Titles	Tomb	Children
Taken to palace in sixteenth year of Wan Li of the Ming dynasty (1588); conferred posthumous title Empress Xiao Ci Wu, first year of Chong De (1636), and Empress Xiao Ci Gao in the first year of Kang Xi (1662)	Fuling, Shengjing (buried with the emperor)	The emperor's eighth son, Abahai (Emperor Tai Zong)
Taken to palace in forty-second year of Wan Li (1614); made empress dowager, eighth year of Chong De (1644), when Shun Zhi succeeded to the throne	Zhaoling, Shengjing (buried with the emperor)	The emperor's second, third and eighth daughters, Princesses Wenzhuang, Duanjing and Yong'an (Duanzhen)
Taken to palace, tenth year of Tian Ming (1625); conferred title Consort Zhuang of the Palace of Lasting Happiness, first year of Chong De (1636); honoured as empress dowager, first year of Shun Zhi (1644); made grand empress dowager, eighteenth year of Shun Zhi, following Kang Xi's enthronement	Zhaoxiling, Zunhua	The emperor's fourth, fifth and seventh daughters, Princesses Yongmu, Shuhui and Duanxian, and ninth son, Fulin (Emperor Shun Zhi)
Married and became empress, eleventh year of Shun Zhi (1654); became empress dowager, eighteenth year of Shun Zhi, when Kang Xi ascended the throne (1661)	Xiaodongling, Zunhua	
Taken to palace as consort; honoured as empress dowager, first year of Kang Xi (1662)	Xiaoling, Zunhua (buried with the emperor)	The emperor's third son, Xuanye (Emperor Kang Xi)
Conferred title Consort Xian, thirteenth year of Shun Zhi (1656); promoted to imperial consort, twelfth month of the same year; honoured as empress posthumously	Xiaoling, Zunhua (buried with the emperor)	The emperor's fourth son, Prince Rong
Married and became empress, fourth year of Kang Xi (1665)	Jingling, Zunhua (buried with the emperor)	The emperor's first son, Chengyou, and second son, Yunreng
A consort when taken to the palace; made empress, sixteenth year of Kang Xi (1677)	Jingling, Zunhua (buried with the emperor)	—
Became high consort, sixteenth year of Kang Xi (1677); promoted to imperial consort, twentieth year of Kang Xi (1681); became empress, twenty-eighth year of Kang Xi (1689)	Jingling, Zunhua (buried with the emperor)	The emperor's eighth daughter
Conferred title Imperial Concubine De, eighteenth year of Kang Xi (1679); promoted to Consort De, twentieth year of Kang Xi (1681); honoured as empress dowager, sixty-first year of Kang Xi (1722), when Yong Zheng ascended the throne	Jingling, Zunhua (buried with the emperor)	The emperor's fourth son, Yinzhen (Emperor Yong Zheng), sixth son, Yunzuo, fourteenth son, Yunti, seventh daughter, ninth daughter, Princess Wenxian, and twelfth daughter
Emperor Yong Zheng's first wife; made empress, first year of Yong Zheng, when he ascended the throne	Tailing, Yixian (buried with the emperor)	The emperor's first son, Honghui
Known as Ge Ge and served Yong Zheng at his local residence, forty-third year of Kang Xi (1704); made Consort Xi, first year of Yong Zheng (1723), and later promoted to high consort; honoured as empress dowager, thirteenth year of Yong Zheng, when Qian Long succeeded to the throne (1735)	Taidongling, Yixian	The emperor's fourth son, Hongli (Emperor Qian Long)
Emperor Qian Long's first wife before he assumed the throne; made empress, second year of Qian Long (1737)	Yuling, Zunhua (buried with the emperor)	The emperor's second son, Yonglian, seventh son, Yongcong, first daughter and third daughter, Princess Hejing
Taken to palace as concubine, tenth year of Qian Long (1745), and made imperial concubine later the same year; promoted to consort (1749), high consort (1759) and imperial consort (1765); honoured as empress posthumously, sixth year of Qian Long (1795)	Yuling, Zunhua (buried with the emperor)	The emperor's fourteenth son, Yonglu, fifteenth son, Yongyan (Emperor Jia Qing), sixteenth son, seventeenth son, Yonglin, seventh daughter, Princess Hejing, and ninth daughter, Princess Heke
Emperor Jia Qing's first wife; made empress, first year of Jia Qing, after he succeeded to the throne (1796)	Changling, Yixian (buried with the emperor)	The emperor's second son, Minning (Emperor Dao Guang), second daughter and fourth daughter, Princess Zhuangjing
Emperor Jia Qing's concubine; made high consort, first year of Jia Qing (1796), following his succession to the throne and promoted to imperial consort, tenth month of the same year; made empress (1801); honoured as empress dowager, twenty-fifth year of Jia Qing (1820), when Dao Guang became emperor	Changxiling, Yixian	The emperor's third son, Miankai, fourth son, Mianxin, and seventh daughter
Emperor Dao Guang's first wife; made empress posthumously, after Dao Guang assumed the throne (1820)	Muling, Yixian (buried with the emperor)	—
Emperor Dao Guang's wife before he became emperor; made empress, second year of Dao Guang (1822)	Muling, Yixian (buried with the emperor)	The emperor's first daughter, Princess Duanmin
Conferred title imperial concubine, first year of Dao Guang; promoted to consort, third year of Dao Guang (1823), high consort (1825) and imperial consort (1833), to take charge of all the emperor's wives; made empress (1834)	Muling, Yixian (buried with the emperor)	The emperor's fourth son, Yizhu (Emperor Xian Feng), third daughter, Princess Duanshun, and fourth daughter, Princess Shou'an
Taken to palace as concubine; promoted to imperial concubine in the sixth year of Dao Guang (1826), consort (1827), high consort (1834) and imperial consort (1840); honoured as empress dowager, fifth year of Xian Feng (1855)	Mudongling, Yixian	The emperor's second son, Yigang, third son, Yiji, and sixth daughter, Princess Shou'en
Emperor Xian Feng's first wife; honoured as empress posthumously when Xian Feng succeeded to the throne, thirtieth year of Dao Guang (1850)	Dingling, Zunhua (buried with the emperor)	—
Conferred title imperial concubine, second year of Xian Feng (1852); promoted to high consort and then made empress the same year; honoured as empress dowager, eleventh year of Xian Feng (1861), when Emperor Tong Zhi assumed the throne	Dingdongling, Puxiangyu, Zunhua	—
Taken to palace as concubine, first year of Xian Feng (1851); promoted to imperial concubine (1854), consort (1856), high consort (1857); honoured as empress dowager (1861), when Tong Zhi became emperor; and as grand empress dowager when Xuan Tong was enthroned (1908)	Dingdongling, Putuoyu, Zunhua	The emperor's first son, Zaichun (Emperor Tong Zhi)
Married and became empress, eleventh year of Tong Zhi (1872); honoured as 'Jia Shun' Empress, thirteenth year of Tong Zhi (1875), when Guang Xu assumed the throne	Huiling, Zunhua (buried with the emperor)	—
Married and became empress, fifteenth year of Guang Xu (1889); honoured as empress dowager, thirty-fourth year of Guang Xu (1908), when Xuan Tong was enthroned	Chongling, Yixian (buried with the emperor)	—

INDEX

SELECT BIBLIOGRAPHY

1 .《清實錄》，清宮寫本。

2 .《清會典》〔清〕托津等編，嘉慶刊本。

3 .《清會典事例》〔清〕托津等編，嘉慶刊本。

4 .《東華錄》〔清〕王先謙編，光緒刊本。

5 .《清朝文獻通考》〔清〕嵇璜等編，乾隆武英殿刊本。

6 .《清史稿》趙爾巽等修，1977 年中華書局鉛印本。

7 .《康熙政要》〔清〕章梫纂，宣統二年鉛印本。

8 .《聖駕五幸江南恭錄》，清宣統二年鉛印本。

9 .《南巡盛典》〔清〕高晉等編，乾隆武英殿刊本。

10 .《熱河志》〔清〕和珅等修，乾隆武英殿刊本。

11 .《簷曝雜記》〔清〕趙翼撰，光緒刊本。

12 .《嘯亭雜錄》〔清〕昭槤撰，宣統元年鉛印本。

13 .《養吉齋叢錄》〔清〕吳振棫撰，光緒刊本。

14 .《周禮》，1919 年商務印書館影印明刊本。

15 .《南巡扈從紀略》〔清〕張英撰，光緒鉛印本。

16 .《國朝宮史》〔清〕于敏中等編，1925 年鉛印本。

17 .《國朝宮史續編》〔清〕慶桂等編，1932 年鉛印本。

18 .《石渠寶笈》〔清〕紀昀等編，1918 年石印本。

19 .《西清古鑑》〔清〕梁詩正等編，光緒石印本。

20 .《清聖祖御製詩》，清武英殿刊本。

21 .《清高宗御製詩》，清武英殿刊本。

22 .《帝京歲時紀勝》〔清〕潘榮陛撰，1961 年鉛印本。

23 .《燕京歲時記》〔清〕富察敦崇撰，1961 年鉛印本。

24 .《宮中現行則例》，清嘉慶刊本。

25 .《荊楚歲時記》〔晉〕宗懍著，1936 年中華書局鉛印本。

26 .《風俗通義》〔漢〕應劭撰，1937 年商務印書館影印本。

27 .《日下舊聞考》〔清〕于敏中等編，乾隆刊本。

28 .《禮部則例》〔清〕特登額等編，道光刊本。

29 .《皇朝禮器圖式》〔清〕允祿等編，乾隆刊本。

30 .《西陂類稿》〔清〕宋犖撰，光緒鉛印本。

31 .《總管內務府現行則例》，〔清〕咸豐內府寫本。